How to see everything in a day
PATENT APPLIED FOR.

Barbara Kirshenblatt-Gimblett

Destination Culture

Tourism,

Museums,

and

Heritage

University of California Press Berkeley Los Angeles London

Halftitle: "How to see everything in a day. PATENT APPLIED FOR." A comment on the Centennial Exposition in Philadelphia from *Harper's Weekly* (3 June 1876): 452.

Page 327: "The End." Mount Cook and Southern Alps, Canterbury, New Zealand. Copyright Colourview Publications, Oamaru, New Zealand.

University of California Press
Berkeley and Los Angeles, California

University of California Press
London, England

Library of Congress
Cataloging-in-Publication Data

Kirshenblatt-Gimblett, Barbara.
 Destination culture: tourism, museums, and
 heritage / Barbara Kirshenblatt-Gimblett.
 p. cm.
 Includes bibliographical references and
 index.
 ISBN 0-520-20467-0 (cloth : alk. paper).—
 ISBN 0-520-20966-4 (pbk : alk. paper)
 1. Ethnological museums and collections.
 2. Museum exhibits. 3. Tourist trade.
 4. Culture. I. Title.
GN36.K57 1998
306'.074—dc21 96-52399
 CIP

Printed in the United States of America
22 21 20 19 18
11 10 9
The paper used in this publication meets
the minimum requirements of American
National Standard for Information Sciences —
Permanence of Paper for Printed Library
Materials, ANSI Z39.48-1984.

For Max

Contents

Illustrations

Acknowledgments

These essays were written between 1988 and 1995. "Objects of Ethnography" grew out of my presentation at the conference held at the International Center of the Smithsonian Institution in 1988. The essay was published in *Exhibiting Cultures: The Poetics and Politics of Museum Display*, edited by Ivan Karp and Steven D. Lavine (Washington, D.C.: Smithsonian Institution Press, 1991) and it appears here in a somewhat fuller form.

Revised for this volume, "Exhibiting Jews" inaugurated the Jewish Museum's distinguished lecture series in 1989 and was a plenary address at the Société Internationale d'Ethnologie et de Folklore in Bergen, Norway, in 1990. It appeared as "From Cult to Culture: Jews on Display at World's Fairs" in *Tradition and Modernisation: Plenary Papers Read at the Société Internationale d'Ethnologie et de Folklore* edited by Reimund Kvideland (Turku: Nordic Institute of Folklore, 1992), and, in revised form, as "Jüdische Geschichte und Kultur auf Weltausstellungen" in the inaugural volume of *Wiener Jahrbuch für Jüdische Geschichte, Kultur und Museumswesen* (Vienna: Jewish Museum, 1994).

"Confusing Pleasures" is an elaboration of my remarks in 1991 at a conference to evaluate the 1990 Los Angeles Festival. "New Geographies of Performance: Cultural Representation and International Exchange on the Edge of the Twenty-First Century" was organized by the Getty Cen-

ter for the History of Art and the Humanities, the Los Angeles Festival, and the UCLA World Arts and Cultures Program, with support from the Rockefeller and Ford foundations and the Getty Center. This essay was electronically published in Ethnomusicology Research Digest (ERD) in 1992 and benefited greatly from the comments it generated via Ethno-FORUM, a "global ethnomusicology forum" on the Internet. "Confusing Pleasures" appears in *The Traffic in Culture: Refiguring Art and Anthropology*, edited by George E. Marcus and Fred R. Myers (Berkeley and Los Angeles: University of California Press, 1995) and was further revised for the present volume.

 "Secrets of Encounter" grew out of my summation at the symposium "Secrecy, Knowledge, and Art: Approaches to Epistemology in Africa," which coincided with the exhibition, *Secrecy: African Art That Conceals and Reveals,* of the Museum for African Art in New York City in 1993. This essay appeared in the *Journal of American Folklore* 107 (1994). Two essays, "Ellis Island" (as "Producing Ellis Island") and "Disputing Taste" (in an earlier form as "Who's Bad: Accounting for Taste"), appeared in *Artforum* in 1990 and 1991, respectively. "Plimoth Plantation" appeared in a somewhat different form as the foreword to Steven Eddy Snow's masterful book, *Performing the Pilgrims: A Study in Ethnohistorical Role-Playing* (Jackson: University Press of Mississippi, 1993).

 "Destination Museum" is drawn from an ongoing project that began with an invitation from Martha Ward and Teri J. Edelstein to discuss museums and tourism in a keynote address, "Destination Museum: How Tourism Informs Museum Practice and Experience," at the symposium "Museums, Nations, Identities," which accompanied the exhibition *Chicago's Dream, a World's Treasure: The Art Institute of Chicago, 1893–1993*. I first developed the heritage argument in a keynote address, "The Dilemmas of Heritage Politics in the Context of Tourism," at the Sixth National Folklife Conference, "Traditions and Tourism: The Good, the Bad, and the Ugly," sponsored by the Australian Folk Trust and the Victorian Folklife Association, University of Melbourne (9–10 July 1994). The address appeared as "Tourism and Heritage" in the conference proceedings. "Producing Heritage for Tourists: The Role of Museums and Festivals" was presented at the symposium on International Folklore

Studies and Indigenous Peoples, National Library of Australia (Canberra, July 1994). I thank Gwenda Davey and Susan Faine for these invitations. Exploring developments in New Zealand, I addressed the Museum Directors Federation of Aotearoa/New Zealand at a seminar entitled "Destination Museum: Issues of Heritage, Museums & Tourism." The seminar took place at the City Gallery (Wellington, 15 August 1994) and the proceedings were published shortly thereafter. I also presented this work before the joint conference of the Museums Association of Aotearoa New Zealand Te Rotu Hanga Kaupapa Taonga and Museum Education Association of New Zealand (Palmerston North, September 1994). I thank John Leuthart and John McCormack for inviting me to speak in New Zealand, and Anne Salmond, Karen Nero, Judith Huntsman, and Mark Mosco of the Department of Anthropology, University of Auckland, for providing an academic home during my stay. "Actualities, Virtualities, and Other Dilemmas of Display," the subject of the Annual Charles Seeger Lecture that I delivered at the annual meeting of the Society for Ethnomusicology (Milwaukee, October 1995), appeared as "Theorizing Heritage" in *Ethnomusicology* 39, no. 3 1995, 367–380. I express my appreciation to Anthony Seeger, Mark Slobin, Kay Shelemay, and Jeff Titon. Current debates surrounding cultural tourism policy in Australia informed my keynote address, "Museums, Tourism, Heritage," at the annual meeting of Museums Australia (Brisbane, 21–25 November 1995), which was devoted to the theme "Communicating Cultures." I thank Tony Bennett and Christopher Saines.

I owe special gratitude to Edward M. Bruner, who introduced me to the richness of tourism as a research subject when we taught together in the International Honors Program of the International School of America (1983–1984). We collaborated on studies of tourist productions during our stays in Japan, Bali, India, Egypt, Kenya, and Israel.

The final preparation of the manuscript was undertaken in the spring of 1996, while I was Winston Fellow of the Hebrew University of Jerusalem and part of the research group "Visual Culture and Modern Jewish Society" at the Institute for Advanced Studies. I thank Richard I. Cohen and Ezra Mendelsohn, who organized the research group, and the Institute, which supported our residencies. For their help in readying the manuscript

and illustrations for publication, I am grateful to Sharon Assaf and Erin Mee.

For their lively engagement of the issues addressed here, I acknowledge my colleagues Tamar Katriel, who was part of the research group at the Institute for Advanced Studies; Thomas F. Reese, Deputy Director, the Getty Center for the History of Art and the Humanities; Neil Harris at the University of Chicago; Faye Ginsburg and Fred R. Meyers (Department of Anthropology) and Brooks McNamara, Peggy Phelan, and Richard Schechner (Department of Performance Studies) at New York University. To Elliott Oring, I owe gratitude for his thoughtful reading of my work in progress. To those who debate and those who also do the kind of work discussed here, special thanks: Roger Abrahams, Robert Baron, Richard Bauman, Jane Beck, Dan Ben-Amos, Regina Bendix, Charles Briggs, Martha Cooper, Amanda Dargan, the late Gerald L. Davis, Burt Feintuch, Archie Green, Bess Lomax Hawes, Mary Hufford, Marjorie Hunt, Alan Jabbour, Ivan Karp, Barbro Klein, Deborah Kodish, Richard Kurin, Michael Owen Jones, Susan Levitas, Margaret Mills, Maxine Miska, Judith Mitoma, Jessica Payne, Sheldon I. Posen, the late Ralph Rinzler, Joseph Sciorra, Jeffrey Shandler, Amy Shuman, Roberta Singer, Steve Siporin, Nicholas Spitzer, Shalom Staub, Jack Tchen, and Steven Zeitlin.

Max Gimblett, whose love knows no bounds, read the manuscript with a keen eye and helped bring it to completion in ways big and small.

Introduction

Why look at a shard of pottery, an old shoe, a scribbled poem? Two hall-marks of display are the foreignness of objects to their contexts of presentation and the location of meaning at their destination. Working toward a political economy of showing, *Destination Culture* deals with agencies of display in museums, festivals, world's fairs, historical recreations, and tourist attractions. Drawing on the history of the avant-garde and the implications of its practices, *Destination Culture* attempts to theorize the artifact and the logic of exhibition in the context of lively debates about the death of museums, ascendancy of tourism, production of heritage, limits of multiculturalism, social efficacy of the arts, and circulation of value in the life world.

The essays in this volume tackle aspects of a single project—the agency of display—even as they are prompted by various provocations, invitations, and long-standing interests. Among the provocations are the statement of Svetlana Alpers in 1988 that visual interest should determine what is exhibited; the comment by Peter Sellars in 1991 in which he identified authenticity with confusion; and the recent admonition of John Comaroff that folklore is one of the most dangerous words in the English language—Walter Benjamin spoke of the "appreciation of heritage" as a "catastrophe."[1]

An invitation from the Museum for African Art, on the occasion of an inaugural exhibition in its new home in Lower Manhattan, lead to an essay that reflects on secrecy in social life, ethnography, and museum exhibitions. The opening of the Ellis Island Immigration Museum prompted a critical analysis of the site. A crisis in museum identity and concern with the place of museums within cultural tourism brought opportunities to address museum professionals in the United States, New Zealand, and Australia on the relationship of museums and tourism.

From my long-standing interest in how Jews are constituted by disciplines, institutions, and display practices—some of which I have engaged in myself—arises a history of Jewish participation in world's fairs.[2] All the essays—but specially the last chapter on taste—are informed by my ongoing concern with vernacular culture and the aesthetics of everyday life, both lived and exhibited.

However diverse the occasions for the essays, the larger project consistently, even insistently, asks the question: "What does it mean to show?"

The opening essay, "Objects of Ethnography," explores the paradox of showing things that were never meant to be displayed. When the value of such things has little to do with their appearance, showing them—asking that one look at them—unsettles the certainty that visual interest is a prerequisite for display. The very absence of visual interest (in a conventional sense) points to ways that interest of any kind is created and vested. Particular kinds of interest not only guide the fragmentation and collection of the world and its deposit in museums, but also endow those fragments with their autonomy as artifacts. Ethnographic objects are a prime site for exploring these concerns.

I proceed from the proposition—the tautology, if you will—that ethnographic objects are objects of ethnography. They are artifacts created by ethnographers when they define, segment, detach, and carry them away. Such fragments become ethnographic objects by virtue of the manner in which they have been detached. They are what they are by virtue of the disciplines that "know" them, for disciplines make their objects and in the process make themselves. For this reason, exhibitions, whether of objects or people, display the artifacts of our disciplines. They are also exhibits of those who make them.

This is not to deny the power of those who make and claim these objects in the first instance to determine their meaning and fate. Rather, I want to suggest that ethnographic objects are made, not found, despite claims to the contrary. They did not begin their lives as ethnographic objects. They *became* ethnographic through processes of detachment and contextualization. Whether in that process objects cease to be what they once were, is an open and important question. That question speaks to the relationship of source and destination, to the political economy of display. The answer tests the alienability of what is collected and shown.

Detachment is more than a necessary evil. Fragmentation is vital to the production of the museum both as a space of posited meaning and as a space of abstraction.[3] Posited meaning derives not from the original context of the fragments but from their juxtaposition in a new context. As a space of abstraction exhibitions do for the life world what the life world cannot do for itself.[4] They bring together specimens and artifacts never found in the same place at the same time and show relationships that cannot otherwise be seen.

Exhibitions are fundamentally theatrical, for they are how museums perform the knowledge they create. I distinguish in this essay between in situ displays (dioramas, period rooms, and other mimetic re-creations of settings) and in-context displays (objects arranged according to such conceptual frames of reference as a taxonomy, evolutionary sequence, historical development, set of formal relationships). These two modes of display differ in their approach to the performativity of objects and the nature of their mise-en-scène. In-context displays as we know them from the history of museums depend on the drama of the artifact. Objects are the actors and knowledge animates them. Their scenario is what George Brown Goode, director of the U.S. National Museum (Smithsonian Institution), characterized in 1881 as "an intelligent train of thought." Their script is a series of labels. Scenes are built around processes of manufacture and use. The larger narrative may be a story of evolution or historical development. The performative mode is exposition and demonstration. The aesthetic is one of intelligibility.

In situ displays are immersive and environmental. They privilege "experience" and tend to thematize rather than set their subject forth. At

their most fully realized, as in the case of Plimoth Plantation, they re-create a virtual world into which the visitor enters. This effect is modeled on the experience of travel and the pleasures of engaging the life world as the ultimate exhibition of itself. Indeed, it has been argued that exhibitions produce "an effect *called* the real world" that is anterior, if subsequent, to the representation.[5] Live displays, and specifically the display of humans, are central to the completeness of in situ exhibitions. "Objects of Ethnography" concludes with an exploration of the history and conventions of live displays.

Distinctions between doing and showing, demonstrating and performing, presenting and representing govern this essay and the case studies that follow. "Exhibiting Jews" examines Jewish participation in world's fairs from 1851 to 1940 in three national contexts (France, England, and the United States). Unlike the states and empires that built great national pavilions, Jews were a diaspora without territorial sovereignty. Though citizens of the many countries represented at world's fairs, they were anomalous. Willy-nilly the "Jewish question" determined the basis for their display as a race, religion, or nation. This essay explores how a diaspora negotiated a transnational space of display in relation to struggles for emancipation, social integration, and national self-determination.

I begin with the exhibition of a private collection of "Israelite art" in 1878 in the Palais du Trocadéro at the Exposition Universelle in Paris. The display featured ceremonial objects from the collection of Isaac Strauss, an Alsatian Jew and the grandfather of Claude Lévi-Strauss. Judaism, not Jews, was the main subject of this exhibition, which classified synagogue appurtenances as art and integrated things Jewish into the discourse of civilization, thereby recasting Jewish particularism in universalistic terms. In contrast, the Anglo-Jewish Historical Exhibition in London (1887) showed historical documents and artifacts that affirmed Jewish presence in England. To attract the general public, the organizers included "Jewish ecclesiastical art," including the Strauss collection. To the degree that Torah crowns and ark curtains showed evidence of non-Jewish influences, they also demonstrated the cosmopolitan effects of Diaspora life, according to the organizers.

In the United States, from the Centennial Exhibition in Philadelphia in 1876 to the New York World's Fair in 1939–1940, Jews defended such uni-

versal values as religious freedom (without singling out Judaism), continued to frame the presentation of Jewish subjects in the cosmopolitan terms of art and civilization, secured for Judaism a central place in the history of religion, and defined themselves variously as a Bible people or as a nation about to become a state. Jews exhibited themselves retrospectively and prospectively.

Of special importance is the work of Cyrus Adler, who between 1888 and 1897 mounted exhibitions that included Jewish material for the U.S. National Museum at international expositions in Cincinnati, Atlanta, Chicago, and Nashville. Adler's work reveals how Jews were constituted as a subject by scholars, curators, and collectors, how disciplines were institutionalized in museums as an outcome of exhibitions and the collections they required, and how scientific and popular displays were implicated in the fight against religious intolerance, racism, and other forms of xenophobia.

Adler used his speciality, Semitic studies, to integrate "civilization"— and by that route, Jews—into the anthropology department at the U.S. National Museum and to avoid subjecting Jews to the ways that "primitive" societies were studied and displayed. Semitic studies not only offered a legitimate context for Bible studies as a nonsectarian enterprise at a time when Americans were preoccupied with religion but also positioned Jews advantageously in the history of religion. Adler mounted exhibitions of biblical antiquities and the history of religion in the Government Building and arranged the concessions for several foreign villages on the Midway Plaisance at the 1893 World's Columbian Exposition in Chicago.

His exhibitions of biblical antiquities included three types of things: first, objects recently made in Bible lands that were similar to what was known from the archaeological record; second, objects created anywhere and anytime in response to a biblical injunction (for example, an eighteenth-century German Sabbath lamp); and third, specimens collected from the natural environment of the region, including dust from Jerusalem and water from the Jordan River.

Adler's displays of the history and comparative study of religions focused on underlying religious ideas, not church history or theology. In this way Adler not only fostered religion as a field of scientific study that would encourage religious tolerance, he also succeeded in treating Judaism as a unified religion and Jews as a unified religious community,

even as he denationalized religion. He thereby integrated Jews conceptually into the larger category of Western civilization and won for them a privileged position at the beginning of the history of monotheism. To make religion exhibitable, Adler displayed artifacts associated with cult and through them tried to communicate creed.

Finally, the board of directors of the 1893 Chicago World's Columbian Exposition made Adler the commissioner to Turkey, Persia, Egypt, Tunis, and Morocco. He was to arrange the concessions for foreign villages on the Midway Plaisance. Although there was no "Jewish Village," Jews were present, albeit not as Jews. Most of the Turks in the Turkish Village, for example, were Jewish. There were several reasons why Jews did not exhibit themselves in live ethnographic displays, not least of which was an "aversion against being paraded as a 'dime museum freak,'" in the words of an observer of the time. By the last decades of the nineteenth century, the mass migration of eastern and central European Jews was well under way and scientific racism was guiding the display of the world's peoples. Anyone interested in a "Jewish foreign village" had only to visit Chicago's Jewish immigrant quarter.

By World War I, Jewish immigrants in American cities were re-creating the Diaspora as a world's fair in miniature, and by the twenties, the projection of a Jewish homeland in Palestine became more common. The essay concludes with a discussion of Zionist pageants and pavilions in Chicago and New York mounted by Meyer Weisgal in 1932, 1933, and 1939–1940. By following the model of national buildings, the Jewish Palestine Pavilion constituted the state symbolically before it was legally formed. Everything in the pavilion came from Palestine and was intended to demonstrate that to all intents and purposes a Jewish state was already in operation. In striking contrast with Adler's broad notion of biblical antiquities, Weisgal's strict guidelines for the pavilion—only products of Palestine—precluded the exhibition of ceremonial art created in the Diaspora.

The concern of this chapter is not so much with the image or even the representation of the Jew, as with the agency of display. I argue that display not only shows and speaks, it also *does*. Clues to its agency lie in the processes from which it emanates and in which it eventuates. This is the

subject of "Destination Museum," which explores the role of exhibition in the production of heritage. Based on observations in New Zealand, Australia, and the United States, the essay begins with the proposition that tourism stages the world as a museum of itself, even as museums try to emulate the experience of travel. Indeed, museums—and the larger heritage industry of which they are part—play a vital role in creating the sense of "hereness" necessary to convert a location into a destination.

While the life world may be the ultimate in situ installation, it has the disadvantage of low density, for not everything of interest to the visitor is close at hand. Tourism organizes travel to reduce the amount of down time and dead space between high points. Museums, for their part, are high-density sites, giving the visitor the best they have to offer within a compact space and tight schedule. Yet, museums are experiencing a crisis of identity as they compete with other attractions within a tourism economy that privileges experience, immediacy, and what the industry calls adventure. Forced to depend more than ever on earned income, museums are becoming more service oriented. They also worry that objects can no longer draw visitors the way they once did. They are depending increasingly on installation as an art form in its own right. So is tourism, which not only compresses the life world, but also displaces it, thereby escalating the process by which a way of life becomes heritage.

While it looks old, heritage is actually something new. Heritage is a mode of cultural production in the present that has recourse to the past. Heritage thus defined depends on display to give dying economies and dead sites a second life as exhibitions of themselves. A place such as Salem, Massachusetts, may be even more profitable as an exhibition of a mercantile center than it was as a mercantile center.

The problematic relationship of objects to the instruments of their display, a theme that runs through the volume, is central to the production of heritage, if not its primary diagnostic. Display is an interface that mediates and thereby transforms what is shown into heritage. By conflating a sense of the actual historical site with the techniques for producing this effect, Colonial Williamsburg, the heritage production, is represented as indistinguishable from colonial Williamsburg, the historical actuality, particularly in the marketing of the site. Not only does the heritage pro-

duction have its own history *as* a heritage production, but the display interface—the style of architectural restoration, use of costumed "animators," approach to historical reenactment, handling of historical time (does it stand still or unfold?)—is a critical site for conveying meanings other than the message of heritage. Curatorial interventions may attempt to rectify the errors of history, and make the heritage production a better place than the historical actuality it represents.

Theatricalized performances of heritage in developing countries exemplify the strategic use of the interface to convey messages of modernity that stand in contrast with the heritage on display. The state-of-the-art amphitheater where Bomas of Kenya performs Maasai and other dances outside Nairobi—indeed the professional performance troupe itself—conveys messages of national identity, modern statehood, transcultural communication, and technological development. Such stagings of national heritage foreground the interface. To hide the interface is to foster the illusion of no mediation, to produce "tourist realism," which is itself a highly mediated effect.[6]

In contrast, sites like Splendid China, which opened in 1993 in Kissimee, Florida, near Orlando, produce heritage by foreclosing what is shown. They actively implicate exhibition in the disappearance of what is on view—namely, the monuments, palaces, temples, and religious and cultural practices of ethnic minorities featured there. Not surprisingly, this 76-acre park has become the focus of protest demonstrations.[7] "The World-Folklore Theme Park" under development in Guangzhou, China, invites visitors to "enjoy the splendour of the world's folklore by way of direct participation in the exotic life of people with outlandish customs and habits."[8] The very term "folklore" signifies a special relationship to what it designates, whether that relationship is marked by burlesque, nostalgia, irony, or dismay. "Errors" become safe—they acquire value—as archaisms and exoticisms. Display enables playful participation in a zone of repudiation once it has been insulated from the possibility of anyone going native.

The processes whereby errors become archaisms, objects become ethnographic, and ways of life become heritage test the alienability of what was found at the source. They also test the limits, even the violations, of a sec-

ond life as heritage, particularly in the presence of the not yet dead. While exhibition may capitalize on visual interest, these processes are driven by a political economy whose stakes lie elsewhere—in foreclosures and inalienabilities.

In that economy, virtualities, even in the presence of actualities, show what can otherwise not be seen. Tourists travel to actual destinations to experience virtual places. They set out for the very spot where the Pilgrims of Plimoth Plantation once lived, the foundations from whence the Abby Church of Saint Peter and Saint Paul in Cluny once rose, the Registry Hall where immigrants traveling steerage to America once stood, only to find that the actual spot is remarkably mute. Hence, the need for a re-created Pilgrim village, computer simulation of the reconstructed church, and restoration and interpretation of Ellis Island.

"Ellis Island" explores how a defunct federal office is reborn as a shrine. Not a place but an aperture, Ellis Island outlived its usefulness as an immigration center when restrictive legislation from 1921 to 1965 stemmed the flow of newcomers. Abandoned, the site became an evocative ruin. Restored, it has become a repository of patriotic sentiment and exemplar of institutional memory under the aegis of corporate sponsorship. In their collaboration, the tourism and heritage industries are ensuring that more tourists will pass through Ellis Island than did immigrants during the peak of its operation.

Now the premier site for "experiencing" what it was like to be an immigrant, Ellis Island *thematizes* immigration. It offers the perfection of the restoration as a remedy for the imperfections of history. As a heritage production, Ellis Island has become the master port of entry, no matter what historical period or what the conditions of a person's arrival. So inclusive is Ellis Island, so encompassing is the theme of immigration, that the site subsumes prior and subsequent historical sites—from the *Mayflower* and the Middle Passage to Fort Chafee and Los Angeles International Airport. Even the Pilgrims can find a place on the American Immigrant Wall of Honor if their descendants will pay one hundred dollars to have their names inscribed on it. Plimoth Rock is just another port of entry for just another group of immigrants. But not at Plimoth Plantation, where everyone who came to America is an honorary Pil-

grim. Though they differ in display logic, Ellis Island and Plimoth Plantation, the subject of the fifth essay, are characteristic of an era of historical identification by consent (and dissent) rather than descent.

At Plimoth Plantation, where the year 1627 "lives forever," the world of the first settlers is re-created in meticulous detail, complete with living representatives of the historical inhabitants of this village. By making time stand still, freeze-frame also interrupts the inexorable narrative of origins and displaces the unbroken line of its exclusive genealogy; descent has become irrelevant. Billed as the "Living Museum of Everyman's History," Plimoth Plantation achieves its democratic effect by paying attention to the "nobodies not less than the somebodies" and allowing everybody—not just those who can trace their lineage back to Pilgrim ancestors—to enter the Pilgrim world and walk among the living dead. Just how this site achieves these effects is the subject of this essay.

Plimoth Plantation is an unscripted ensemble performance. Improvisational and environmental, it aligns itself with experimental theater. The display history of the site reveals a shift from ceremony to virtuality, from commemoration to exploration, from authoritative narrative to ongoing conversation, from discrete moments, objects, and scenes to the waking dream of a virtual Pilgrim world. Much of the site's appeal derives from its failure as the perfect time machine. It promises an experience of transport to the year 1627. But what the visitor experiences is the juxtaposition of 1627 and 1995 and the willful forgetting by the Pilgrims in the village today of all that occurred after 1627. The visitor has the uncanny sense of seeing into a future that those locked into an eternity of 1627 are not supposed to know. Actors and visitors collaborate in a jumbling of time by sustaining one small slice of it indefinitely, even while abutting it with the present moment.

The delight of such effects is the subject of "Confusing Pleasures," an exploration of the 1990 Los Angeles Festival. This event featured thousands of artists from the Pacific Rim—Korean shamans, Eugene O'Neill's *Hughie* in English and Chinese, Jemez Pueblo Matachines, and performers from Samoa, Alaska, Thailand, Australia, Mexico, and Indonesia. Events were staged across the city, in parks and churches, on streets, and in train stations.

Examining performance at the interface of cultural encounter, this essay is guided by questions of reception. What are the preconditions for creating interest in what audiences do not understand? How has the avant-garde prepared audiences to watch and value what they do not know how to react to? The Los Angeles Festival located authenticity in a moment of reception, rather than in the performances themselves. Authenticity occurred when audiences confronted the incomprehensible. Not only did the organizers of the Los Angeles Festival insist that meaning created at the source is inaccessible, they also valued unintelligibility at the destination. In addition to avoiding "ethnographic" and "entertainment" approaches, they tried to "undo" the ethnographic through a process of theatrical mediation. By restaging as art what might otherwise be treated as an ethnographic object, the Los Angeles Festival made possible the reception of Javanese court dance and Korean shamans as if they had emanated from the avant-garde itself.

A mode of reception in which confusion is pleasurable opens up possibilities for the exhibition of African art, while keeping alive the issue of what can and cannot be shown or known. This is the subject of "Secrets of Encounter," an analysis of the inaugural exhibition of the Museum for African Art in Lower Manhattan. *Secrecy: African Art That Reveals and Conceals* features objects that withhold information by design. The exhibition explores the logic and procedures of concealment. It shows respect for what must not be revealed and humility in the face of what cannot be known. Visitors to the Guggenheim Museum on the corner or the New Museum of Contemporary Art a few doors away already know how to enjoy what is not explained to them. It is easier to display secrets without revealing them when African masks and textiles are exhibited as art than when they are shown as artifacts.

The volume concludes with "Disputing Taste," an excursus on the social location and circulation of values in the museum of the life world, where everyone is a curator of sorts. Taking as a point of departure two books—*The Encyclopedia of Bad Taste* and *Quintessence: The Quality of Having It*—this essay begins with a paradox. The coherence of taste as a category derives from its power to distinguish those who make the distinctions. But not all those who value happy-face decals or Chihuahuas are

unified by what they have in common. Far from homogenizing all those who consume them, Hummel dolls and heavy metal, leisure suits and Liberace redraw the terrain of taste at every turn.

The *Encyclopedia of Bad Taste* posits a *golem* let loose in a world of sno-globes and lava lamps, astroturf, shag rugs, and black velvet paintings. Slick picture books like *Quintessence* imagine a homunculus of good taste in a universe of Spalding balls that are "sincere." Ivory soap is "inno-cent," Tupperware is "pure," and peanut butter is "classic." One can count on clean and honest lines, truth to material, and form following function. *Quintessence* mystifies taste by lodging it in the instinct of the well-bred. It suggests that taste cannot be learned (though it can be refined) and that it is a property inherent to things and practices. Taste, like class, becomes racist when the capacity for it is a matter of breeding, when it masquerades as the natural attribute of an elite, when it has re-course to the "quintessential" attributes of people and things. *Quintes-sence* writes pedigrees for objects that test their universality, singularity, and timelessness. Are they perfect, classic, abiding objects above the vi-cissitudes of fashion? If good taste withstands the test of time, bad taste is bad timing. Short of the death inflicted by evanescence, taste goes bad when it is out of step with its moment—when the hemline does not rise or fall quickly enough. That some of the same objects appear in both books for such utterly different reasons returns us to the questions raised throughout this volume: the location of meaning at the destination rather than at the source, the vested nature of interest, and the foreign-ness of objects to their contexts of presentation, in this case encyclopedias of taste. Objects in these two books are anchored not in the social space of their purported consumers but in the conceptual space of the inventory, a quality they have in common with museums and encyclopedic projects more generally.

Kitsch returns us to the transvaluation of the outmoded and Walter Benjamin's faith in its potential as a source of revolutionary energy. What some fads lacked in exclusivity during their first life, they gain the next time round through operations of recoding and transvaluation. "Disput-ing Taste" concludes with a consideration of modernist critiques of

kitsch. The avant-garde disarticulated not only art, beauty, and pleasure but also taste, style, and culture. This process inaugurated a complex remapping of simplistic categories of high and low, sublime and paltry, in Milan Kundera's terms, and returns us to the possibilities of confusing pleasures, the location of interest, and the agency of display.

The Agency of Display

Objects of Ethnography

Moon rocks, a few small strips of meat dried Hidatsa-style before 1918, dust from Jerusalem, "a knot tied by the wind in a storm at sea," bottle caps filled with melted crayon made for skelley (a New York City street game), "a drop of the Virgin's milk," pieces of the dismantled Berlin Wall.[1] Each object is shown to the public eye protected and enshrined. Were the criterion of "visual interest" to determine what should be exhibited, such rocks, bits of meat, dust, knots, and toys, if saved at all, would await attention of another kind—perhaps by microscope, telescope, laboratory test, nutritional analysis, written description, diagram, or report of miracles. Why save, let alone display, things that are of little visual interest? Why ask the museum visitor to look closely at something whose value lies somewhere other than in its appearance?

To suggest that objects lacking visual interest might be of historical or cultural or religious or scientific interest, while seeming to offer an answer, actually compounds the problem because it leaves unexplored several fundamental assumptions, first among them the notion of artifactual autonomy. It is precisely this autonomy that makes it possible to display objects in and of themselves, even when there is little to inspect with the eye.[2]

Ethnographic artifacts are objects of ethnography. They are artifacts created by ethnographers. Such objects become ethnographic by virtue of

being defined, segmented, detached, and carried away by ethnographers. They are ethnographic, not because they were found in a Hungarian peasant household, Kwakiutl village, or Rajasthani market rather than in Buckingham Palace or Michelangelo's studio, but by virtue of the manner in which they have been detached, for disciplines make their objects and in the process make themselves. It is one thing, however, when ethnography is inscribed in books or displayed behind glass, at a remove in space, time, and language from the site described. It is quite another when people are themselves the medium of ethnographic representation, when they perform themselves, whether at home to tourists or at world's fairs, homelands entertainments, or folklife festivals—when they become living signs of themselves.

Exhibiting the Fragment

The artfulness of the ethnographic object is an art of excision, of detachment, an art of the excerpt. Where does the object begin, and where does it end? This I see as an essentially surgical issue. Shall we exhibit the cup with the saucer, the tea, the cream and sugar, the spoon, the napkin and placemat, the table and chair, the rug? Where do we make the cut?

Perhaps we should speak not of the ethnographic object but of the ethnographic fragment. Like the ruin, the ethnographic fragment is informed by a poetics of detachment. Detachment refers not only to the physical act of producing fragments but also to the detached attitude that makes that fragmentation and its appreciation possible. Lovers of ruins in seventeenth- and eighteenth-century England understood the distinctive pleasure afforded by architectural fragments, once enough time had passed for a detached attitude to form. The antiquarian John Aubrey valued the ruin as much as he did the earlier intact structure.[3] Ruins inspired the feelings of melancholy and wonder associated with the sublime. They stimulated the viewer to imagine the building in its former pristine state. They offered the pleasure of longing for the irretrievable object of one's fantasy. Nor were ruins left to accidental formation. Aesthetic principles guided the selective demolition of ruins and, where a ruin was lacking, the building of artificial ones.[4] Restoration may be re-

"Dried meat, Hidatsa style. Collected by Gilbert Wilson, pre-1918? Beef."

From the exhibition *The Way to Independence: Memories of a Hidatsa Indian Family,* 1987. Photo by Randy Croce, Minnesota Historical Society.

sisted in cases in which the power of the ruin is its capacity to signify the destructive circumstances of its creation; the skeleton of the Atomic Bomb Dome in Hiroshima does just this. In the case of the Ellis Island restoration, a fragment of the ruin is exhibited as such, in a vitrine, as part of the story of the site. A history of the poetics of the fragment is yet to be written, for fragments are not simply a necessity of which we make a virtue, a vicissitude of history, or a response to limitations on our ability to bring the world indoors. We make fragments.[5]

In Situ

In considering the problem of the ethnographic object, it is useful to distinguish *in situ* from *in context*, a pair of terms that call into question the nature of the whole, the burden of interpretation, and the location of meaning.

The notion of in situ entails metonymy and mimesis: the object is a part that stands in a contiguous relation to an absent whole that may or may not be re-created. The art of the metonym is an art that accepts the inherently fragmentary nature of the object. Showing it in all its partiality

enhances the aura of its "realness." The danger, of course, is that museums amass collections and are, in a sense, condemned ever after to exhibit them. Collection-driven exhibitions often suffer from ethnographic atrophy because they tend to focus on what could be, and was, physically detached and carried away. As a result, what one has is what one shows. Very often what is shown is the collection, whether highlights, masterpieces, or everything in it. The tendency increases for such objects to be presented as art.

The art of mimesis, whether in the form of period rooms, ethnographic villages, re-created environments, reenacted rituals, or photomurals, places objects (or replicas of them) in situ. In situ approaches to installation enlarge the ethnographic object by expanding its boundaries to include more of what was left behind, even if only in replica, after the object was excised from its physical, social, and cultural settings. Because the metonymic nature of ethnographic objects invites mimetic evocations of what was left behind, in situ approaches to installation tend toward environmental and re-creative displays. Such displays, which tend toward the monographic, appeal to those who argue that cultures are coherent wholes in their own right, that environment plays a significant role in cultural formation, and that displays should present process and not just products. At their most mimetic, in situ installations include live persons, preferably actual representatives of the cultures on display.

In-situ installations, no matter how mimetic, are not neutral. They are not a slice of life lifted from the everyday world and inserted into the museum gallery, though this is the rhetoric of the mimetic mode. On the contrary, those who construct the display also constitute the subject, even when they seem to do nothing more than relocate an entire house and its contents, brick by brick, board by board, chair by chair. Just as the ethnographic object is the creation of the ethnographer, so too are the putative cultural wholes of which they are part. The exhibition may reconstruct Kwakiutl life as the ethnographer envisions it before contact with Europeans, or Hungarian peasant interiors, region by region, as they are thought to have existed before industrialization. Or the display may project a utopian national whole that harmoniously integrates regional diversity, a favorite theme of national ethnographic museums and Ameri-

can pageants of democracy during the first decades of this century. "Wholes" are not given but constituted, and often they are hotly contested.[6]

Representational conventions guide mimetic displays, despite the illusion of close fit, if not identity, between the representation and that which is represented.[7] Indeed, mimetic displays may be so dazzling in their realistic effects as to subvert curatorial efforts to focus the viewer's attention on particular ideas or objects. There is the danger that theatrical spectacle will displace scientific seriousness, that the artifice of the installation will overwhelm ethnographic artifact and curatorial intention.

In Context

The notion of in context, which poses the interpretive problem of theoretical frame of reference, uses particular techniques of arrangement and explanation to convey ideas. The notion expressed in a 1911 history of the British Museum that "the multifarious objects in the Ethnographical Gallery represent so many starting-points in the world's civilization" places those objects in context, not in situ.[8] That context is signaled by the title of the chapter devoted to the Ethnographical Gallery, "Civilization in the Making."

Objects are set in context by means of long labels, charts, diagrams, commentary delivered via earphones, explanatory audiovisual programs, docents conducting tours, booklets and catalogs, educational programs, lectures and performances. Objects are also set in context by means of other objects, often in relation to a classification or schematic arrangement of some kind, based on typologies of form or proposed historical relationships. In-context approaches to installation establish a theoretical frame of reference for the viewer, offer explanations, provide historical background, make comparisons, pose questions, and sometimes even extend to the circumstances of excavation, collection, and conservation of the objects on display. There are as many contexts for an object as there are interpretive strategies.

In-context approaches exert strong cognitive control over the objects, asserting the power of classification and arrangement to order large num-

"Room of Sárköz from the second half of the nineteenth century."

Béri Balogh Ádám Museum. Photo by Gabler Csaba. Copyright Képzömüvészeti Alap Kiadóvállalata, Budapest.

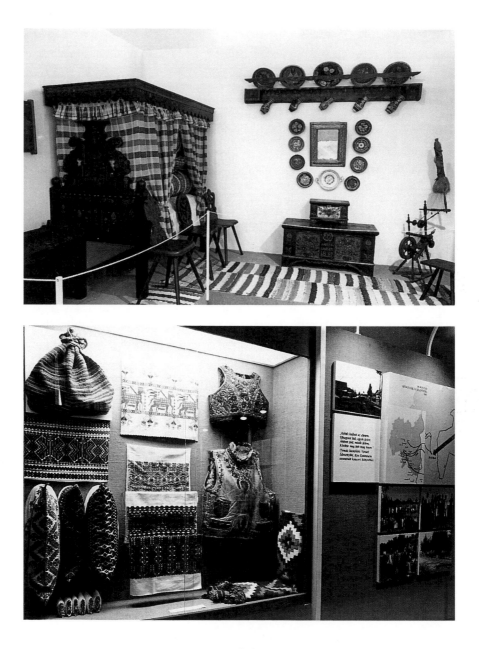

"Popular art relics of the Bukovinian Székelys."

Béri Balogh Ádám Museum. Photo by Gabler Csaba. Copyright Képzömüvészeti Alap Kiadóvállalata, Budapest.

bers of artifacts from diverse cultural and historical settings and to position them in relation to one another. Plants and animals arranged according to the Linnaean classification affirmed the goodness of the divine plan in Charles Willson Peale's museum in Philadelphia during the late eighteenth and nineteenth century. A. H. L. F. Pitt Rivers preferred to arrange his series of weapons according to formal criteria, from the simplest to the most complex, to tell the story of mankind's inexorable evolution through stages of racial and cultural development.[9] Even when the objects themselves are not arranged according to such conceptual schemes but according to geographic area, the viewer may be encouraged to "frame for himself a few general principles for which he can seek out specimens."[10]

Whether they guide the physical arrangement of objects or structure the way viewers look at otherwise amorphous accumulations, exhibition classifications create serious interest where it might otherwise be lacking. "Than the Ethnographical Gallery in the British Museum there is no department the educational significance of which is so likely to be unappreciated," wrote Henry C. Shelley in 1911, adding that visitors are inclined to indulge in laughter and jokes when confronted with "objects illustrating the manners and customs of what are known as the savage races."[11] For instruction to supplant amusement, viewers needed principles for looking. They required a context, or framework, for transforming apparently grotesque, rude, strange, and vulgar artifacts into object lessons. Having been saved from oblivion, the ethnographic fragment now needed to be rescued from trivialization. One way of doing this was to treat the specimen as a document.

Rescuing the Fragment from Trivialization

The problematic relationship of in situ and in context, which are by no means mutually exclusive approaches, is signaled by Oleg Grabar in his comment about Islamic objects: "[T]hey are in fact to be seen as ethnographic documents, closely tied to life, even a reconstructed life, and more meaningful in large numbers and series than as single creations."[12] Such objects, in Grabar's view, are inherently multiple, documentary, and con-

The Artist in His Museum.

1822, by Charles Willson Peale. Oil on canvas, 103 3/4 in. × 79 7/8 in. Acc. no.: 1878.1.2. Courtesy of the Museum of American Art of the Pennsylvania Academy of Fine Arts, Philadelphia. Gift of Mrs. Sarah Harrison (The Joseph Harrison, Jr. Collection).

tingent. They were never intended to hold up to scrutiny as singular creations. Moreover, they are at their most documentary when presented in their multiplicity, that is, as a collection. Grabar diffuses their status as artifacts by according them higher value as "documents," as signs that point away from themselves to something else, to "life." At the same time, he hyperbolizes their status as artifacts by advocating that they be examined in "large numbers and series," a task anticipated and facilitated by the collecting process itself and well suited to typological exhibition arrangements.

Though once multiple, many ethnographic objects become singular, and the more singular they become, the more readily are they reclassified and exhibited as art. The many become one by virtue of the collection process itself. First, collecting induces rarity by creating scarcity: escalating demand reduces the availability of objects. Second, collectors create categories that from the outset, even before there is demand, are marked by the challenges they pose to acquisition: "By creating their own categories, all collectors create their own rarities."[13] Third, the very ubiquity of the kinds of objects that interest ethnographers contributes to their ephemerality. Commonplace things are worn to oblivion and replaced with new objects, or are viewed as too trivial in their own time to be removed from circulation, to be alienated from their practical and social purposes, and saved for posterity.[14] But no matter how singular the ethnographic object becomes, it retains its contingency, even when, by a process of radical detachment, it is reclassified and exhibited as art.[15]

Indeed, the litmus test of art seems to be whether an object can be stripped of contingency and still hold up. The universalizing rhetoric of "art," the insistence that great works are universal, that they transcend space and time, is predicated on the irrelevance of contingency. But the ability to stand alone says less about the nature of the object than about our categories and attitudes, which may account for the minimalist installation style of exhibitions of "primitive art." By suppressing contingency and presenting the objects on their own, such installations lay claims to the universality of the exhibited objects as works of art.

Ethnographic objects move from curio to specimen to art, though not necessarily in that order. As curiosities, objects are anomalous. By definition, they defy classification. Nineteenth-century advocates of scientific

approaches to museum exhibition complained repeatedly about collections of curiosities that were displayed without systematic arrangement. But how could exhibitors be expected to arrange systematically objects that in their terms were unclassifiable? In what category might one exhibit the knot tied by the wind during a storm at sea that was donated to Peale's Museum at the end of the eighteenth century? Probably indistinguishable in appearance from a knot tied by human hands on land during calm weather, this object was an episode in an amazing story waiting to be retold rather than a member of a class of objects relevant to scientific taxonomies of the period.

What we see here are objects that had outlasted the curatorial classifications that once accommodated them in Renaissance cabinets and galleries. Singularities, chance formations that resulted from the "shuffle of things," did fall into a broad category, namely, *mirabilia*.[16] This category included the very large and the very small, the misshapen and the miraculous, and the historically unique: for example, a hat with bullet holes associated with a specific historic event.[17] By the nineteenth century, such objects were anomalous to natural historians interested in taxonomies of the normal, not the singularities of chance formation, though figures such as Joseph Dorfeuille continued to make teratology (the study of the malformed or monstrous) a major attraction in their museums.[18]

Exhibition classifications, whether Linnaean or evolutionary, shift the grounds of singularity from the object to a category within a particular taxonomy. For a curiosity to become classifiable it had to qualify as representative of a distinguishable class of objects. Peale, for example, was reluctant to show items that fell outside the Linnaean classification ac-

"Specialized Tests for Sense of Elegance. Quality in Fur.... Arrange these ten samples in the order of your feeling for their elegance if made into a woman's 'best coat'.... Be guided by your own personal liking or feeling of appreciation.... Be not influenced by knowledge of cost or fashion— try to respond to real quality."

cording to which he arranged objects in his museum in Philadelphia during the late eighteenth and early nineteenth century. His exhibits of plants and animals were normative: they featured typical members of each class. The comprehensiveness of the classification and orderly arrangement of Peale's collection testified to the purposiveness and goodness of God's creation, a message reinforced by quotations from the Bible mounted on the walls. With his fine American specimens, Peale intended to refute the view of Buffon, an eighteenth-century naturalist, that New World species were inferior to those of Europe. A mark of the seriousness and scientific nature of such exhibitions was the absence of freakish aberrations.[19]

In contrast, the exhibit for the International Eugenics Conference at the American Museum of Natural History in 1932 subjected to orderly arrangement the very anomalies (trembling guinea pigs, triplets, a picture drawn by a color-blind man, deformed eyeballs) that a century earlier would have appeared as curiosities defying classification. The structure of genetic inheritance now provided the matrix for the orderly display of nature's mistakes, long an attraction in cabinets and freak shows, and for eliminating such errors in the future—sterilization, antimiscegenation laws, and selective mating.[20] A logical outgrowth of the exhibition of racial types and the evolution of mankind, such eugenics exhibitions offered classifications that included the visitors themselves. These were interactive displays, for attendants handed out pedigree charts and blank schedules issued by the Eugenics Record Office and encouraged visitors to take tests for taste threshold and artistic capacity, for example, to rank fur samples. A "Eugenic Sterilization" exhibit was nearby.

Displays in the dime museum tested credulity—Ripley's Believe It or Not. Scientific exhibits struggled to achieve intelligibility—the object lessons of Dr. George Brown Goode, director of the U.S. National Museum. Exhibitions of art faced a different challenge. Refusing to define the objects in his collection either as curios (singular anomalies) or as ethnographic artifacts (representative examples of a class of objects), Hadji Ephraim Benguiat, a prime lender of Jewish ceremonial art to the Smithsonian Institution at the turn of the century, thought of his possessions as objects of art, a status derived from their perfection and his connoisseurship. Benguiat identified the classificatory skills of the art collector with his powers of discrimination. At the climactic instant of acquisition—each time he or she accepts or rejects an object—the collector "classifies." Benguiat was interested in only one category, the perfect. This category was coterminous with his entire collection, seen as a supreme singularity made up of many singular artifacts. They were displayed accordingly.

Jewels and gems dazzle. They invite appreciation, not analysis. There is no place in this empire of things, ruled by the collector of collectors, for copies, photographs, models, homologues, dioramas, or tableaus. There is no place here for displaying continuous series of objects—without regard for the artistic excellence of each and every one—to make some historical point, no place for a system of classification that would array objects within theoretical hierarchies. Unmitigated excellence in everything shown, ubiquitous singularity, and the unifying principle of the collector's power—this is the message of the jewel box.

No matter how perfect this collection and each object within it, however, Benguiat's treasures could be reclassified for scientific purposes, and in the various exhibitions where they were featured, they moved from category to category.[21]

The Limits of Detachment

Not all that the ethnographic surgeon subjects to cognitive excision can be physically detached, carried away, and installed for viewing. What happens to the intangible, the ephemeral, the immovable, and the animate? The in-

"Collection of Oriental Arms and Armor." Some of the arms shown here "belonged to the notorious brigand 'Katirjiani,' who was such a lover of fine arms that he frequently attacked a caravan and sacrificed the lives of his men just to acquire other specimens of arms, as the jewelled or inlaid decoration was always executed according to the personal taste of the owner, so that there are seldom two alike."

From *Fine Art Portfolio Illustrating Some of the Exhibits of the H. Ephraim Benguiat Museum Collection and the Historical Damascus Palace* (St. Louis: Louisiana Purchase Exposition, 1904), 29.

tangible, which includes such classic ethnographic subjects as kinship, worldview, cosmology, values, and attitudes, cannot be carried away. The ephemeral encompasses all forms of behavior—everyday activities, story-telling, ritual, dance, speech, performance of all kinds. Now you see it, now you don't. The immovable, whether a mesa, pyramid, cliff dwelling, or landform, can be recorded in photographs but presents formidable logistical obstacles to those who would detach and carry it away. The animate has been collected, both dead and alive. Dried, pickled, or stuffed, botanical and zoological specimens become artifacts for the museum. Alive, flora and fauna present storage problems that are solved by gardens and zoos in which living collections are on view. But what about people? Bones and mummies, body parts in alcohol, and plaster death masks may be found in museums. Living human specimens have been displayed in zoos, formal exhibitions, festivals, and other popular amusements.

If we cannot carry away the intangible, ephemeral, immovable, and animate, what have we done instead? Typically, we have inscribed what we cannot carry away, whether in field notes, recordings, photographs, films, or drawings. We have created ethnographic documents. Like ethnographic objects, these documents are also artifacts of ethnography, but true to what I would call the fetish-of-the-true-cross approach, ethnographic objects, those material fragments that we can carry away, are accorded a higher quotient of realness. Only the artifacts, the tangible metonyms, are really real. All the rest is mimetic, second order, a representation, an account undeniably of our own making. We have here the legacy of Renaissance antiquarians, for whom "visible remains" were used to corroborate written accounts. Objects, according to Giambattista Vico, were "manifest testimony" and carried greater authority than texts, even contemporaneous ones.[22]

Textualizing Objects/Objectifying Texts

The priority of objects over texts in museum settings was reversed during the second half of the nineteenth century. Goode operated according to the dictum that "the most important thing about an exhibition was the label," a point restated by many who worked with him.[23]

The people's museum should be much more than a house of specimens in glass cases. It should be a house full of ideas, arranged with the strictest attention to system.

I once tried to express this thought by saying *"An efficient educational museum may be described as a collection of instructive labels, each illustrated by a well-selected specimen* (emphasis in original).[24]

Museums were to teach "by means of object lessons," but objects could not be relied on to speak for themselves.[25]

The curatorial charge was to create exhibitions that would "furnish an intelligent train of thought" by using objects to illustrate ideas.[26] Reacting to the apparent lack of logical arrangement in displays of art collections in many European museums and the low status to which so many private museums in America had descended, Goode had long insisted that the museum of the past was to be transformed from "a cemetery of bric-a-brac into a nursery of living thoughts."[27] His model for the public museum was the public library, though he believed that exhibitions had even greater potential as a medium of popular education. Objects were to be read like books: "Professor Huxley has described the museum as a 'consultative library of objects.'"[28] Curators were to objectify texts and textualize objects, hence the importance of an organizational scheme for arranging objects and labels to explain them and the willing acceptance of copies, casts, impressions, photographs, diagrams, and other surrogates for primary artifacts. Since the main purpose of a public museum was to educate, "for the purposes of study a cast was as good as an original," and in some cases better.[29] Copies came to play a special role.

Though proclaimed as a new approach to the exhibiting of objects, the textualized object was not new; it had been featured in demonstrations and illustrated lectures for centuries. Anatomy lessons were conducted at public dissections as early as the fourteenth century in Bologna, where, as the scholar read the anatomy text, the demonstrator dissected the body, and the ostensor, the one who showed, pointed a wand at the part of the body under consideration.[30] The French anatomy lesson during the seventeenth century was "a great social event that the whole town attended, with masks, refreshments, and diversions."[31]

The increasing emphasis on ostension—on showing—during the nineteenth century suggests a shift in the foundation of authoritative knowledge from a reliance primarily on rhetoric to an emphasis on information, particularly in the form of visual facts.[32] By the end of the eighteenth century, Peale could boast that in the lecture room of his museum, presentations were illustrated with real specimens from his collection, consistent with Jean-Jacques Rousseau's admonition that "teachers never substitute representation for reality, show for substance—to teach, in short, from actual objects."[33] In this respect, Peale was in tune with a more general tendency of the period toward the "decidedly empirical or evidential nature of lecturing," though even under the guise of science, objects were used for their dramatic effect: "William Hazlitt was appalled at one of Carlisle's lectures on human emotions to find a dissected heart and brain being circulated among the audience."[34]

In many ways, the approach to museum exhibitions advocated by Goode during the latter part of the nineteenth century should be seen in relation to the illustrated lecture, its history and requirements. Complaining in 1891 about the decline of "entertainments worthy of civilized communities—concerts, readings, lectures"—and the rise of illustration, including the diagram, blackboard, and stereopticon, Goode wanted the museum to fill the gap left by the decline of lectures and scientific, literary, and artistic societies.[35] The written label in an exhibition was a surrogate for the words of an absent lecturer, with the added advantage that the exhibited objects, rather than appear briefly to illustrate a lecture, could be seen by a large public for a longer period of time.

It is precisely in these terms that Washington Matthews introduced his lecture "Some Sacred Objects of the Navajo Rites" at the Third International Folk-Lore Congress of the World's Columbian Exposition in Chicago in 1893.

> Someone has said that a first-class museum would consist of a series of satisfactory labels with specimens attached. This saying might be rendered: "The label is more important than the specimen." When I have finished reading this paper, you may admit that this is true in the case of the little museum which I have here to show: A basket, a fascicle of plant fibres; a

few rudely painted sticks, some beads and feathers put together as if by children in their meaningless play, for the total of the collection. You would scarcely pick these trifles up if you saw them lying in the gutter, yet when I have told all I have to tell about them, I trust they may seem of greater importance, and that some among you would be as glad to possess them as I am. I might have added largely to this collection had I time to discourse about them, for I possess many more of their kind. It is not a question of things, but of time. I shall do scant justice to this little pile within an hour. An hour it will be to you, and a tiresome hour, no doubt; but you may pass it with greater patience when you learn that this hour's monologue represents to me twelve years of hard and oft-baffled investigation. Such dry facts as I have to relate are not to be obtained by rushing up to the first Indian you meet, notebook in hand. But I have no time for further preliminary remarks, and must proceed at once to my descriptions.[36]

In this demonstration of connoisseurship, the ethnographer is a detective who toils long and hard to decipher material clues. This master of induction competes both with the native informant and with other ethnographers, not for the objects, but for the facts that comprise his descriptions. His lecture is a long label, a performed description that elevates what would otherwise be viewed as "trifles." Neither the modest specimens nor the dry facts are expected to interest the listener. Rather, it is the ethnographer's own expenditure of time and effort—his expertise—that creates value.

This effect is achieved rhetorically, for the more unprepossessing the evidence, the more impressive the ethnographic description. Characterizing his own recounting of the facts as "minute to a tedious degree" and "not one half the particulars that I might appropriately have told you," Matthews admits to having reached the limits of his ability to describe when challenged by the drumstick on the table. Not even the Navajo can describe in words how the drumstick is made, "so intricate are the rules pertaining to its construction." Apologizing for not having fresh yucca on hand with which to demonstrate the process, Matthews offers to take anyone who is interested to the "yucca-covered deserts of Arizona" where he can "show him how to make a drum stick." In this way, Matthews con-

fronts two basic problems in ethnographic display. First he makes the apparently trivial interesting by performing ethnography (the illustrated lecture). Then he addresses the limitations of verbal description by offering to play Indian (the demonstration).[37] The profusion of facts that Matthews presents to his listeners, his apologies for their dry and tedious character notwithstanding, is a classic case of what Neil Harris has identified as the operational aesthetic—"a delight in observing process and examining for literal truth."[38]

Exhibiting Humans

Not only inanimate artifacts but also humans are detachable, fragmentable, and replicable in a variety of materials. The inherently performative nature of live specimens veers exhibits of them strongly in the direction of spectacle, blurring still further the line between morbid curiosity and scientific interest, chamber of horrors and medical exhibition, circus and zoological garden, theater and living ethnographic display, scholarly lecture and dramatic monologue, cultural performance and staged re-creation. The blurring of this line was particularly useful in England and the United States during the early nineteenth century because performances that would be objectionable to conservative Protestants if staged in a theater were acceptable when presented in a museum, even if there was virtually nothing else to distinguish them. This reframing of performance in terms of nature, science, and education rendered it respectable, particularly during the first half of the nineteenth century. If in the scientific lecture the exhibitor was the performer, ethnographic displays shifted the locus of performance to the exhibit proper and in so doing, made ample use of patently theatrical genres and techniques to display people and their things.

In what might be characterized as a reciprocity of means and complementarity of function, museums used theatrical crafts of scene painting for exhibits and staged performances in their lecture rooms, while theaters used the subjects presented in museums, including live exotic animals and humans, and the technologies demonstrated there in their stage productions. Museums served as surrogate theaters during periods when

theaters came under attack for religious reasons, while theaters brought a note of seriousness to their offerings by presenting edifying entertainment. In the drama of the specimen, the curator was a ventriloquist whose task it was to make the object speak. Through scenarios of production and function, curators converted objects into stories: they showed the process by which ceramics and textiles were manufactured, step-by-step, or how they were used in daily life and ceremony. The Smithsonian anthropologist Otis T. Mason was explicit on this point in 1891 when he defined "the important elements of the specimen" as "the dramatis personae and incidents."[39]

Living or Dead

Human displays teeter-totter on a kind of semiotic seesaw, equipoised between the animate and the inanimate, the living and the dead. The semiotic complexity of exhibits of people, particularly those of an ethnographic character, may be seen in reciprocities between exhibiting the dead as if they are alive and the living as if they are dead, reciprocities that hold for the art of the undertaker as well as the art of the museum preparator.

Ethnographic displays are part of a larger history of human display, in which the themes of death, dissection, torture, and martyrdom are intermingled. This history includes the exhibition of dead bodies in cemeteries, catacombs, homes, and theaters, the public dissection of cadavers in anatomy lessons, the vivisection of torture victims using such anatomical techniques as flaying, public executions by guillotine or gibbet, heads of criminals impaled on stakes, public extractions of teeth, and displays of body parts and fetuses in anatomical and other museums, whether in the flesh, in wax, or in plaster cast.[40] The body parts arrived not only as by-products of dissections but also as a result of amputations, for example, the trigger finger of a villain.[41] Effigies of men tortured and executed in the very cages in which they were displayed were an attraction at the Münster Zoo.[42]

Ethnographic subjects were easily incorporated into such modes of display.[43] The remains of the dead—tattooed Maori heads, Aztec skulls, and

bones removed from Indian graves—had long been excavated and shown as ethnographic specimens. Live subjects provided expanded opportunities for ethnographic display. While live, human rarities figured in museological dramas of cognitive vivisection. When dead, their corpses were anatomized and their bones and fleshy body parts incorporated into anatomical exhibits. The *vanitas mundi* was a way of exhibiting dissected materials: one such anatomical allegory was created out of the skeleton of a fetus, tiny kidney stones, a dried artery, and a hardened vas deferens. Articulated skeletons, taxidermy, wax models, and live specimens also offered conceptual links between anatomy and death in what might be considered museums of mortality.[44]

"Specimens on Shelf." Wax models, circa 1850–1920. Top, left to right: Recklinghausen's disease of breast; active erysipelas on face; gangrenous ulceration of lip and nares; rupia (tertiary syphilis) of face. Bottom, left to right: arms of infants bearing vaccinia (cowpox) on sixth to eighth day, on ninth to tenth day, and on fourteenth to sixteenth day; arm bearing roseola varicella (chicken pox).

Collection of the Mütter Museum of The College of Physicians of Philadelphia. Photo Arne Svenson, copyright 1993.

Wax models as a form of three-dimensional anatomical illustration were commonly used to teach medicine, especially pathologies of the skin, and were featured in anatomical displays open to the public. Rackstrow's Museum of Anatomy and Curiosities, which was popular in London during the mid-eighteenth century, offered visitors wax replicas of the human body in various states of health and disease, inside and out, including reproductive organs and fetuses, some of them preserved in alcohol rather than represented in wax.[45] With the rising interest in racial typologies and evolution during the mid-nineteenth century, Sarti's Museum of Pathological Anatomy in London, and others like it, became the place to exhibit culturally constructed anatomical pathologies (parts of a Moorish woman's anatomy), missing links in the evolutionary sequence (wax figures of African "savages" with tails), and wax tableaus of ethnographic scenes.[46] As early as 1797, Peale had completed wax figures for "a group of contrasting races of mankind" that included natives from North and South America, the Sandwich Islands, Otaheite, and China. The faces are thought to have been made from life casts. The figures were outfitted with appropriate clothing and artifacts. Half a century later, the Gallery of All Nations in Reimer's Anatomical and Ethnological Museum in London featured "the varied types of the Great Human Family," including the Aztec Lilliputians that shortly before had appeared live in the Liverpool Zoo.[47]

The "gallery of nations" idea, which since the late sixteenth century had served as the organizing principle for books devoted to customs, manners, religions, costumes, and other ethnographic topics, was easily adapted to the exhibition of ethnographic specimens.[48] A logical spinoff was the monographic display. Nathan Dunn's celebrated Chinese collection, which was installed in Peale's museum in 1838 and moved to London in 1841, offered, according to a diarist of the period, "a perfect picture of Chinese life."

> Figures of natural size, admirably executed in clay, all of them portraits of individuals, are there to be seen, dressed in the appropriate costume, engaged in their various avocations and surrounded by the furniture, implements and material objects of daily existence. The faces are expressive, the

attitudes natural, the situation & grouping well conceived, and the aspect of the whole very striking and lifelike. Mandarins, priests, soldiers, ladies of quality, gentlemen of rank, play-actors and slaves; a barber, a shoemaker and a blacksmith employed in their trades; the shop of a merchant with purchasers buying goods, the drawing room of a man of fortune with his visitors smoking and drinking tea & servants in attendance; all sitting, standing, almost talking, with the dress, furniture and accompaniments of actual life. Some of the costumes are of the richest and most gorgeous description. Models of country houses and boats, weapons, lamps, pictures, vases, images of Gods, and porcelain vessels, many of them most curious and beautiful, and in number, infinite. Mr. Dunn was in the room himself and explained to us the nature and uses of things.[49]

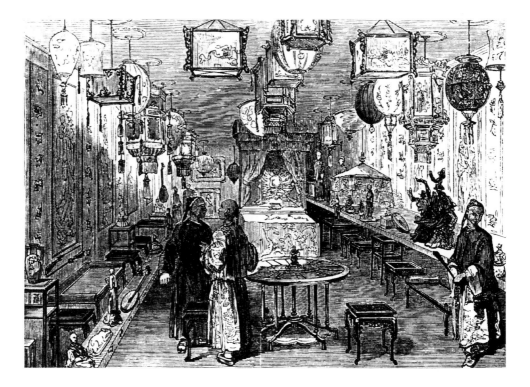

Saloon of a Chinese junk.

From *Illustrated London News*, 20 May 1948. Photo courtesy Guildhall Library, Corporation of London.

The attention in this description to the individuation of faces reflects the more general preoccupation with "types" and the notion of physiognomy as a key to moral character.[50]

Physiognomic types and their racial implications were presented not only in galleries of nations and in the later "types of mankind" exhibitions but also in crowd scenes and group portraits of life in contemporary European and American cities, as well as in the literature of the period. So great was the fascination with physiognomy that at Peale's museum, where portraits of great men "etched the outlines of genius" and those of "savages" revealed their physiognomy, museum visitors could take home as a souvenir their own silhouette, made with great exactitude thanks to a mechanical device, the "physiognotrace," invented in 1803 and demonstrated in the museum gallery.[51]

Dunn's Chinese exhibition inspired other such displays, notably, scenes of daily life at the Oriental and Turkish Museum during the 1850s in London. Viewers were astonished by the wax figures, which a journalist of the time praised for their realism: "[T]he arms and legs of males are rough with real hair, most delicately applied—actual drops of perspiration are on the brows of the porters."[52] Clearly, the mannequins were more than clothes hangers, for not only ethnographic artifacts but also physiognomy was on display.

It is precisely the mimetic perfection of such installations, and perhaps also their preoccupation with physiognomy, that so disturbed Franz Boas, who resisted the use of realistic wax mannequins in ethnographic re-creations. They were so lifelike they were deathlike. Boas objected to "the ghastly impression such as we notice in wax-figures," an effect that he thought was heightened when absolutely lifelike figures lacked motion.[53] Furthermore, wax as a medium more nearly captured the color and quality of dead than living flesh, and in their frozen pose and silence wax figures were reminiscent of the undertaker's art, a connection that wax museums capitalized on in deathbed and open casket scenes featuring famous persons.

Fear of verisimilitude did not inhibit Artur Hazelius, who in his effort to present Sweden "in summary" began installing wax tableaus—"folk-life pictures"—in the 1870s. Inspired by genre paintings, these senti-

mental scenes in wax integrated costumes, furniture, and utensils that Hazelius had collected in Sweden and other parts of Scandinavia. Featured not only in his Museum of Scandinavian Ethnography, which opened in 1873, but also at world's fairs in 1876 (Philadelphia) and 1878 (Paris), these displays utilized techniques Hazelius had seen at the many international expositions and museums he visited. He used the habitat group, a fixture of natural history museums. He turned to the wax tableau, which, like the *tableau vivant,* was often modeled on a painting or sculpture and captured a dramatic moment in a narrative. He also drew on the period room and travel panorama. By 1891, he had realized his dream of exhibiting Swedish folklife in "living style" at Skansen, his open-air museum. In addition to buildings, plants, and animals, the museum featured peasants in native dress, traditional musicians and artisans,

The Infant's Death, one of several "Swedish character groups" in the main building of the Centennial Exposition, Philadelphia, 1876. This "living picture" was based on Amalia Lindegren's painting (1858) and was shown again in 1878 at the *Exposition Universelle* in Paris.

From *Frank Leslie's Illustrated Newspaper,* 26 August 1876, p. 409.

costumed receptionists and guides, restaurants, craft demonstrations, and festivals. Hazelius's Skansen museum became the prototype for hundreds of other open-air museums throughout Europe, many of them still functioning today.[54]

Animal or Actor

People have been displayed as living rarities from as early as 1501, when live Eskimos were exhibited in Bristol. A Brazilian village built by Indians in Rouen in the 1580s was burned down by French soldiers, an event that pleased the king so much that it was restaged the following day.[55] "Virginians" were featured on the Thames in 1603.[56] Over a period of five centuries, audiences flocked to see Tahitians, Laplanders, "Aztecs," Iro-

Open-air museum of Skansen.

quois, Cherokees, Ojibways, Iowas, Mohawks, Botocudos, Guianese, Hottentots, Kaffirs, Nubians, Somalis, Sinhalese, Patagonians, Tierra del Fuegans, Ilongots, Kalmucks, Amapondans, Zulus, Bushmen, Australian aborigines, Japanese, and East Indians. They could be seen in various cities in England and on the Continent, in taverns and at fairs, on the stage in theatrical productions, at Whitehall, Piccadilly, and Vauxhall Gardens, along the Thames, at William Bullock's London Museum (better known as Egyptian Hall because of its architectural style), in zoos and circuses, and, by the latter half of the nineteenth century, at world's fairs.[57]

Basically, there were two options for exhibiting living ethnographic specimens: the zoological and the theatrical. During the first half of the nineteenth century, the distinction between zoological and theatrical approaches was often unclear and both were implicated in the staging of wildness, particularly in Carl Hagenbeck's productions. The zoological option depended on traditions of displaying exotic animals, including the circus, which featured trained animals, and the zoo, where live exotic specimens were shown in cages, in fantastic buildings, and, eventually, in settings re-creating their habitat in realistic detail, though here too animal acts could be found. It was not uncommon in the nineteenth century for a living human rarity to be booked into a variety of venues—theaters, exhibition halls, concert rooms, museums, and zoos—in the course of several weeks or months as part of a tour.

London Museum, or Egyptian Hall, was dubbed the "ark of zoological wonders" by at least one observer of the period, because of the wide range of live exhibits, human and animal, presented there.[58] While the term "ark" evokes the discourse of natural theology, as opposed to natural history, and suggests that the sheer variety of divine creation rather than scientific classification was the focus, Bullock found in environmental displays a fine way to combine theatrical effect, the experience of travel, and geographic principles.

During the eighteenth and early nineteenth century, geography was also an omnibus discipline devoted to all that is on the earth's surface, including people in their environment; geography subsumed anthropology and ethnography as subfields. Location on the earth's globe and relationships of specimens to landforms, climate, and local flora and fauna offered an alternative principle for arranging exhibitions of animals and people

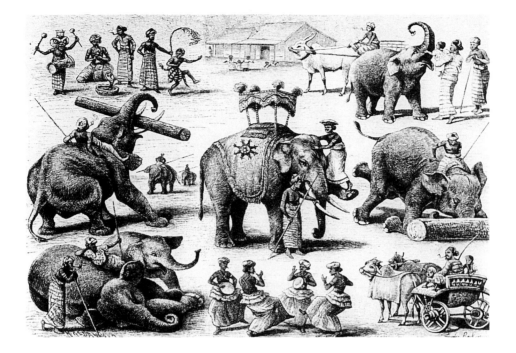

and encouraged environmental displays that showed the interrelation of elements in a habitat. Those who collected their own specimens, had firsthand knowledge of their habitat, and controlled how their materials were exhibited were more likely to present animals and people in their home environments. Like Bullock, who collected material for his displays while traveling and then tried to re-create the places he had visited, Peale hunted for many of his specimens himself, mounted them, and created settings for them based on his observations while hunting.

The passion for close visual observation on the spot had transformed how landscapes were experienced and described during the eighteenth century and shaped how specimens brought into galleries were exhibited, to the point that the experience of travel became the model for exhibitions about other places.[59] Visitors were offered the display as a surrogate for travel, and displays in turn participated in the discourse of travel, the

subject of chapter 3. Billed as travel experiences, panoramas were narrated by travelers who served as guides-at-a-distance through landscapes they had personally traversed. Individuals who had assisted hunters and collectors abroad were brought into exhibitions both to complete the scene and to comment on it, thus transferring to the re-created travel setting the roles of native guide and animal handler.

Returning from Mexico in 1823 with casts of ancient remains, ethnographic objects, specimens of plants and animals, and a Mexican Indian youth, Bullock designed an exhibition that would make visitors feel like they were in Mexico enjoying a panoramic view of Mexico City (painted on the wall) and intimate contact with its inhabitants. An observer of the period reported that "[i]n order to heighten the deception, and to bring the spectator actually amidst the scenes represented, [he presented] a *fac simile* [*sic*] of a Mexican cottage and garden, with a tree, flowers, and fruit; they are exactly the size of their natural models, and bear an identity not to be mistaken." To complete the effect, Bullock installed the Mexican Indian youth in the cottage and had him describe objects to the visitors "as far as his knowledge of our language permits," thus making him do double duty as ethnographic specimen and museum docent.[60]

William Bullock's exhibit of Mexico.

Lithograph by A. Aiglo, 1825. Photo courtesy Guildhall Library, Corporation of London.

The moment live people are included in such displays the issue arises: what will they do? In considering the options for presenting people in "living style," it is useful to distinguish staged re-creations of cultural performances (wedding, funeral, hunt, martial arts display, shamanic ritual) and the drama of the quotidian (nursing a baby, cooking, smoking, spitting, tending a fire, washing, carving, weaving).[61]

In a highly popular African display mounted in 1853 at St. George's Gallery, Hyde Park, thirteen Kaffirs "portrayed 'the whole drama of Caffre life' against a series of scenes painted by Charles Marshall. They ate meals with enormous spoons, held a conference with a 'witch-finder' . . . , and enacted a wedding, a hunt, and a military expedition, 'all with characteristic dances,' the whole ending with a programmed general mêlée between the rival tribes."[62] Two decades earlier, in 1822, Bullock had a Laplander family and live reindeer perform at Egyptian Hall, where they drove their sledge around a frosty panorama fitted out with their tents, utensils, and weapons. The Laplanders had been brought to care for the reindeer, who, it was hoped, could be introduced into England, but when this proved impractical, the Laplanders were recycled as ethnographic exhibits.[63] Ethnologists in London kept track of new ethnographic arrivals and took advantage of their presence for their research.[64]

Whereas the notion that native life was inherently dramatic allowed it to be staged and billed as theater, the ability of natives to perform, and particularly to mime, was taken by some viewers as evidence of their humanity. Charles Dickens, who was otherwise disdainful of the people in live ethnographic displays, commented on seeing the Bushmen in Egyptian Hall in 1847, "Who that saw the four grim, stunted, abject Bush-people at the Egyptian Hall—with two natural actors among them out of that number, one a male and the other a female—can forget how something human and imaginative gradually broke out in the ugly little man, when he was roused from crouching over the charcoal fire, into giving a dramatic representation of the tracking of a beast, the shooting of it with poisoned arrows, and the creature's death."[65] The Bushmen were installed against a scenic African background, and in addition to offering the "cultural performances" that so captivated Dickens, they slept and smoked, nursed an infant, and otherwise went about the business of daily

William Bullock's exhibit of Laplanders.

Engraving by Thomas Rowlandson, 1822. Photo courtesy Guildhall Library, Corporation of London.

Bushmen, with their agent, on display at Egyptian Hall.

From *Illustrated London News,* 12 June 1847. Photo courtesy Guildhall Library, Corporation of London.

life.[66] What is so extraordinary about Dickens's statement is the implication that what makes the Bushmen human is not their ability to hunt but their ability to mime the hunt—that is, their ability to represent.

As the everyday life of others came into focus as a subject for exhibition, ethnography offered, at least for some, a critique of civilization. In his 1911 account of the British Museum, Henry C. Shelley commented, "Perhaps the hilarity with which the ordinary visitor regards the object lessons of ethnography arises from his overweening conceit of the value and importance of his own particular form of civilization. No doubt he has much in common with that traveller who lost his way on his journey and described the climax of his experience in these words: 'After having walked eleven hours without having traced the print of a human foot, to my great comfort and delight, I saw a man hanging upon a gibbet; my pleasure at the cheering prospect was inexpressible, for it convinced me that I was in a civilized country.'"[67] This is the ethnological effect in reverse: our own barbarity is experienced as civilized.

Exhibiting the Quotidian

Genre Errors

The drama of the quotidian feeds on what John MacAloon calls a genre error: one man's life is another man's spectacle.[68] Exhibitions institutionalize this error by producing the quotidian as spectacle, and they do this by building the role of the observer into the structure of events that, left to their own devices, are not subject to formal viewing. Following Dean MacCannell's analysis of "staged authenticity," such exhibitions "stage the back region," thereby creating a new front region.[69] In what is a logical corollary of the autonomous object, people, their realia and activities, are mounted in a hermetic aesthetic space—fenced off in a zoological garden, raised up on a platform in a gallery, placed on a stage, or ensconced in a reconstructed village on the lawn of the exhibition grounds—and visitors are invited to look.

There is something about the seamlessness of the commonsense world, its elusiveness, that makes such genre errors so appealing. For the quotidian, by virtue of its taken-for-grantedness, presents itself as given, natural,

just there, unnoticed because assumed. It becomes available for contemplation under special conditions, most commonly through the repetition that produces boredom, or through the comparisons (induced by contrast, incongruity, violation, and impropriety) that call the taken-for-granted into question.[70] The task of creating fissures that offer evidence that the ordinary is really there propels the fascination with penetrating the life space of others, getting inside, burrowing deep into the most intimate places, whether the interior of lives or the innermost recesses of bodies. In making a spectacle of oneself, or others, "what is private or hidden becomes publicly exhibited; what is small or confined becomes exaggerated, grand or grandiose."[71] The everyday lives of others are perceptible precisely because what they take for granted is not what we take for granted, and the more different we are from each other, the more intense the effect, for the exotic is the place where nothing is utterly ordinary. Such encounters force us to make comparisons that pierce the membrane of our own quotidian world, allowing us for a brief moment to be spectators of ourselves, an effect that is also experienced by those on display.

Imagine being installed in a room at an exhibition where one's only instruction was to go about one's daily chores just like at home—making coffee, reading the *New York Times*, working at the computer, talking on the phone, walking the dog, sleeping, flossing, opening the mail, eating granola, withdrawing cash from a money machine—while curious visitors looked on. The challenge in such displays is to avoid "performance," that is, to maintain an asymmetrical reciprocity, whereby those who are

"Great Excitement—Indian Lady Throwing Out Dishwater" at the World's Columbian Exposition.

From *Chicago Sunday Herald,* 17 September 1893.

Contents of a New York apartment.

Displayed at the New-York Historical Society, 1995. *Inventory,* an installation by Christian Boltanski for *Lost: New York Projects,* a Citywide Project of the Public Art Fund. Photo by Dorothy Zeidman.

being watched go about their business as if no one were paying attention to them, though we have long known that what we observe is changed by virtue of being observed. Or, closer to home, imagine that the contents of your apartment are removed—everything in your medicine cabinet, kitchen cupboards, and wardrobe, your refrigerator and sofa, vacuum cleaner and radio, socks and laxatives—and installed in a local museum. Christian Boltanski effected precisely such a removal at the Baden-Baden Kunsthalle in 1973 and more recently at the New-York Historical Society in 1995. Titled "Inventory," the installation served as "an ironically pathetic museum dedicated to an anonymous person," someone close at hand and very much alive, though the experience was more like viewing the personal effects of the deceased—perhaps forensic evidence gathered by the police from the scene of a crime—or the possessions of a displaced person, whether confiscated or abandoned.[72]

The reciprocity of the museum effect can be triggered by a simple "turn of the head," which bifurcates the viewer's gaze between the exotic display and her own everyday world. A visitor to the Bushman exhibition at Egyptian Hall in 1847 commented, "It was strange, too, in looking through one of the windows of the [exhibition] room into the busy street, to reflect that by a single turn of the head might be witnessed the two extremes of humanity."[73] The pane of glass that separated the illusion of being somewhere else from the immediacy of life on London streets was eliminated in presentations that depended in part for their effect on intensifying just such incongruities. In George Catlin's display in London in 1844, "[t]he spectacle of Red Indians encamped [in four wigwams] and demonstrating their horsemanship on the greensward at Vauxhall, where eighteenth-century beaux had strolled with the belles of Fanny Burney's set, must have been one of the more striking sights of the day."[74]

"Fête Champêtre at Charlton House—the North American Indians encamped in the park."

Sketched by G. Harrison. *Illustrated London News,* 5 July 1845.

To those who complained that "to place the savage man in direct contrast with the most elaborate of man's performances is too abrupt a proceeding, besides being useless," Dr. John Conolly, president of the Ethnological Society of London, answered in 1855 that the inclusion of ethnological exhibits at the Crystal Palace in Sydenham offered valuable contrasts. In his view, these displays "set off the splendour of . . . [man's] performances when his social advantages are enlarged" and showed that everyone can "emerge from barbarism and want to refinement and enjoyment"—a message both of British superiority and of optimism in the perfectibility of humankind.[75]

The incongruity of intercalating two different quotidians reaches an apotheosis of sorts in displays that presented exotic people not in their native habitat but in ours. Ironically, at least one observer of pygmies playing the piano in a well-appointed drawing room on Regent Street in 1853 thought this arrangement preferable to having them "set up on a platform to be stared at, and made to perform distasteful feats," for among other things, "the visitor literally gives them a call, and becomes one of their society," which is to say one's own society. These pygmies had learned English and acquired the "rudiments of European civilization."[76]

The Museum Effect

Once the seal of the quotidian is pierced, life is experienced as if represented: the metaphors of life as a book, stage, and museum capture this effect with nuances particular to each metaphor. Like the picturesque, in which paintings set the standard for experience, museum exhibitions transform how people look at their own immediate environs. The museum effect works both ways. Not only do ordinary things become special when placed in museum settings, but the museum experience itself becomes a model for experiencing life outside its walls. As the gaze that penetrated exhibitions of people from distant lands was turned to the streets of European and American cities, urban dwellers such as James Boswell reported that walking in the streets of London in 1775 was "a high entertainment of itself. I see a vast museum of all objects, and I think with a kind of wonder that I see it for nothing."[77]

Bleeding into the ubiquity of the commonsense world, the museum effect brings distinctions between the exotic and the familiar closer to home. Calibrations of difference become finer. The objects differentiated draw nearer. One becomes increasingly exotic to oneself, as one imagines how others might view that which we consider normal: writing about the *danse du ventre* in the Little Cairo area of the Midway Plaisance at the 1893 World's Columbian Exposition in Chicago, Frederic Ward Putnam commented that visitors might assume wrongly that this dance was "low and repulsive" because they did not understand it, but that "the waltz would seem equally strange to these dusky women of Egypt."[78]

In America and England during the 1890s, recently arrived immigrants became the ethnographic other, in part as a way of creating social distance under the threatening conditions of physical proximity. A paper entitled "Mission-Work among the Unenlightened Jews," which was delivered at the Jewish Women's Congress in 1893 at the Chicago World's fair, characterized immigrants in London and New York as "half-dressed, pale-skinned natives in our own towns" and noted that "Borrioboola Gha has been supplanted by 'Whitechapel,' 'Mulberry Bend,' and the nearest district tenements."[79]

The trope of the city as dark continent and the journalist and social reformer as adventurer-ethnographer was common in such mid-nineteenth-century accounts as Henry Mayhew's *London Labour and the London Poor* (1861–1862).[80] One of the attractions of poor neighborhoods was their accessibility to the eye, their "intimacy at sight." Any stranger could see openly on the streets what in better neighborhoods was hidden in an inaccessible domestic interior, a closed carriage, or under layers of clothing. At the turn of the twentieth century in New York City, one writer remarked,

> Mankind is not only the noblest study of man, but the most entertaining. People are more interesting than things or books, even newspapers. The East Side is especially convenient for observation of people because there are such shoals of them always in sight, and because their habits of life and manners are frank, and favorable to a certain degree of intimacy at sight. Where each family has a whole house to itself and lives inside of it, and

the members never sally out except in full dress—hats, gloves, and manners—it is hopeless to become intimately acquainted with them as you pass on the sidewalk. You may walk up and down Fifth Avenue for ten years and never see a Fifth Avenue mother nursing her latest born on the doorstep, but in Mott or Mulberry or Cherry Street that is a common sight, and always interesting to the respectful observer. When the little Fifth Avenue children are let out, if they don't drive off in a carriage, at least they go with a nurse, and are clothed like field daisies, and under such restraint as good clothes and even the kindest nurses involve. But the East Side children tumble about on the sidewalk and pavement hour after hour, under slight restraint and without any severe amount of oversight, hatless usually, barehanded and barefooted when the weather suffers it.[81]

Maypole on a Lower East Side street.

From E. S. Martin, "East Side Considerations," *Harper's New Monthly Magazine* 96 (May 1898).

The blend here of repulsion and attraction, condemnation and celebration, so typical of the reception of ethnographic displays in exhibition halls, reveals that the source of the critique is also the basis of the appeal. "Intimacy at sight," which suggests a kind of social nakedness, combines with the "view from the sidewalk" to verge on what might be termed social pornography—the private made public. Or rather, disparities in class and in cultural definitions of private and public are exploited here: the discrepancy between what others make public that we consider private also generates voyeuristic excitement in zoos, particularly in primate displays. Similarly, in madhouses, which from the early seventeenth century in Europe also combined confinement with display, the public was free to enter and observe the ravings of lunatics.[82] While respectability has the power to control access to sight, to conceal, poverty, madness, children, animals, and the "lower" orders of humankind reveal by exposing themselves fully to view. Historically, ethnography has constituted its subjects at the margins of geography, history, and society. Not surprisingly, then, in a convergence of moral adventure, social exploration, and sensation seeking, the inner city is constructed as a socially distant but physically proximate exotic—and erotic—territory. Visits to this territory tempt the adventurer to cross the dangerous line between voyeurism and acting out.[83]

Slumming, like tourism more generally, takes the spectator to the site, and as areas are canonized in a geography of attractions, whole territories become extended ethnographic theme parks. An ethnographic bell jar drops over the terrain. A neighborhood, village, or region becomes for all intents and purposes a living museum in situ. The museum effect, rendering the quotidian spectacular, becomes ubiquitous.

The Panoptic Mode

In contrast with the panoramic perspective of all-encompassing classifications, in situ approaches to the display of the quotidian work in a panoptic mode whereby the viewer sees without himself being visible. The panoramic approach lays out the whole world conceptually in a Linnaean classification or evolutionary scheme or experientially in a scenic effect, which makes such technologies of seeing as the eidophusikon, a small mechanical theater, and the related theatrical panorama and dio-

rama, so appealing. Offered a supreme vantage point, the viewer is master of all that he surveys. The view is comprehensive, extensive, commanding, aggrandizing. As a prospect, it holds in it scenarios for future action.[84]

In contrast, the panoptic approach offers the chance to see without being seen, to penetrate interior recesses, to violate intimacy. In its more problematic manifestations, the panoptic mode has the quality of peep show and surveillance: the viewer is in control, like a warden in a prison. In its more benign mode, the panoptic takes the form of hospitality, a host welcoming a guest to enter a private sphere.[85] A recent guide to ethnographic re-creations of "homes" at the Field Museum in Chicago exemplified the panoptic mode: "Each of the houses has had part of the walls and roof removed so you may peek inside."[86] The issue is the power to open up to sight differentially, to show with respect to others what one would not reveal about oneself—one's body, person, and life.

Live exhibits as a representational mode make their own kinds of claims. Even when efforts are taken to the contrary, live exhibits tend to make people into artifacts because the ethnographic gaze objectifies. Where people are concerned, there is a fine line between attentive looking and staring. To make people going about their ordinary business objects of visual interest and available to total scrutiny is dehumanizing, a quality of exhibitions that was not lost on some viewers in London during the nineteenth century who complained about live displays on humanitarian grounds.[87]

Live displays, whether re-creations of daily activities or staged as formal performances, also create the illusion that the activities you watch are being done rather than represented, a practice that creates the effect of authenticity, or realness. The impression is one of unmediated encounter. Semiotically, live displays make the status of the performer problematic, for people become signs of themselves. We experience a representation, even when the representers are the people themselves. Self-representation is representation nonetheless. Whether the representation essentializes (you are seeing the quintessence of Balineseness) or totalizes (you are seeing the whole through the part), the ethnographic fragment returns with all the problems of capturing, inferring, constituting, and presenting the whole through parts.

"War Dance—Indian Department," at the Metropolitan Fair in Manhattan, 1864, one of several Sanitary Fairs organized during the Civil War. Such performances, in combination with displays of artifacts, helped raise money for the medical care of the wounded, who had been dying in large numbers because of unhygienic conditions. The reciprocity of disappearance and exhibition, the former a condition for the latter, is expressed by one reporter, as follows:

In the Fourteenth Street Buildings BIERSTADT'S INDIAN WIGWAM has been constantly crowded by visitors desiring to study the habits and peculiarities of the aborigines. Several performances have been given daily by the Indians. Our sketch represents a WAR DANCE, as given on several occasions to the intense gratification of all spectators. Historically, no feature of the fair has greater interest than this in which the life of those who, only a little while ago, held undisputed possession of our continent, is reproduced by a handful of the once absolute tribes for the pleasure of the pale-faced race, whose ancestors pushed them into obscurity and historical oblivion.

Harper's Weekly (23 April 1864): 260.

Performing Culture

We might distinguish between the museum as a form of interment—a tomb with a view—and the live display, which is not without its own relationship to disappearance, as Native American performances in the nineteenth century attest. These metaphors have roots in the history of interment and incarceration as display traditions in their own right. Differences between them are expressed in the sensory organization of display.

The Senses Compartmentalized

The partiality so essential to the ethnographic object as a fragment is also expressed in the fragmentation of sensory apprehension in conventional museum exhibitions. With the important exceptions of popular entertainment, opera, masques and banquets, and avant-garde performance, among others, the European tendency has been to split up the senses and parcel them out one at a time to the appropriate art form. One sense, one art form. We listen to music. We look at paintings. Dancers don't talk. Musicians don't dance. Sensory atrophy is coupled with close focus and sustained attention. All distractions must be eliminated—no talking, rustling of paper, eating, flashing of cameras. Absolute silence governs the etiquette of symphony halls and museums. Aural and ocular epiphanies in this mode require pristine environments in which the object of contemplation is set off for riveting attention. Rules posted at the entrance and guards within ensure that decorum prevails. When reclassified as "primitive art" and exhibited as painting and sculpture, as singular objects for visual apprehension, "ethnographic artifacts" are elevated, for in the hierarchy of material manifestations the fine arts reign supreme. To the degree that objects are identified with their makers, the cultures or civilizations represented by works of art also rise in the hierarchy.

In contrast with conventional exhibitions in museums, which tend to reduce the sensory complexity of the events they represent and to offer them up for visual delectation alone, indigenous modes of display, particularly the festival, present an important alternative. As multisensory, multifocus events, festivals may extend over days, weeks, or months. They

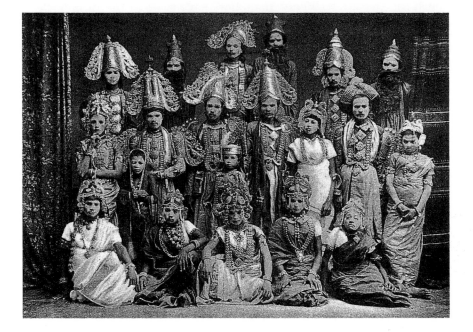

require selective disattention, or highly disciplined attention, in an environment of sensory riot. The closeness of focus we expect to sustain in silence for a one-hour concert is inappropriate for events so large in scale and long in duration. Participants in the Ramlila, a festival and ritual drama that extends over many days in northern India, bring food, sleep through parts of the event, talk to their neighbors, get up, walk around, leave, return. All the senses—olfactory, gustatory, auditory, tactile, kinesthetic, visual—are engaged. The experience tends to be environmental, as episodes of the drama are enacted in various locations, rather than hermetically sealed into an aesthetic space created by a proscenium, frame, or vitrine. Sensory saturation rather than sensory atrophy or single-sense epiphany is the order of the day. Sensory apprehension and attention must be structured differently in such events.

The festival, both as it occurs locally and as an anthology of ethnographic displays, can be seen as a form of environmental performance. Though museum exhibitions can also be considered a form of environmental theater—visitors moving through the space experience the mise-en-scène visually and kinesthetically—they tend to proceed discursively. Arts festivals are generally less didactic and less textual. They depend more on performance, reserving extended textual analysis, to the degree that it is offered, for the program booklet, in this way avoiding the awkwardness of discoursing about living people in their very presence.

There is a convergence of sensibility here between ethnographers interested in the festival as a display genre and the discovery by the historical avant-garde of the theatricality of everyday life and their interest in vernacular genres. Rejecting the conventions of classical European theater, with its dependence on the dramatic text, formal theater architecture, and mimetic conventions, Antonin Artaud, Bertolt Brecht, and eastern European directors working during the interwar years looked to Balinese and Chinese performance and European folk and popular forms for new artistic possibilities. Their artistic sensibility valorized forms that were otherwise of strictly local or ethnographic interest and offered the possibility of experiencing them with a distinctly modernist sensibility as models of pure theatricality. They created new audiences for "ethnographic performances" and a hospitable climate for festivals that excerpted and re-presented them.

Tourists who have difficulty deciphering and penetrating the quotidian of their destination find in festivals the perfect entrée. Public and spectacular, festivals have the practical advantage of offering in a concentrated form, at a designated time and place, what the tourist would otherwise search out in the diffuseness of everyday life, with no guarantee of ever finding it. Typically, local festivals are simply put on the tourist itinerary. A 1981 brochure issued by India's Department of Tourism does just this.

> Why festivals? Because they celebrate the joy of life. The Indian calendar is a long procession of festivals. The traveller may come when he pleases,

a spectacle always awaits him. If you find yourself in the right place at the right time, it is possible to go through the calendar with a festival daily! It may be the harvest in the south, the golden yellow of short-lived spring in the north, the seafront spectacle of Ganesh's immersion in Bombay, the fantastic car festival of Puri, the snake-boat races in Kerala or the Republic Day pageant in New Delhi. Each is different. Every region, every religion has something to celebrate. . . . Take in a festival when you come to India. No land demands so much of its legends—or, in celebrating the past, bedecks the present so marvellously.

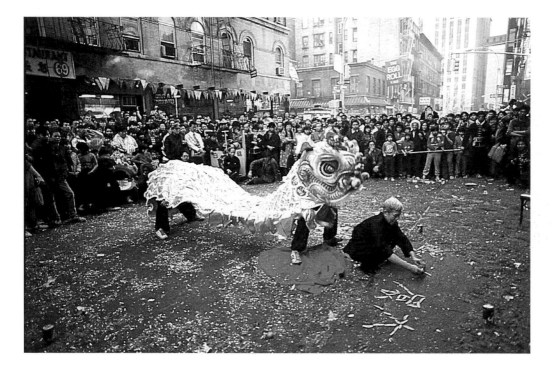

Chinese New Year.

Chinatown, New York, 1985. Lion dance by Pak Hok martial arts club in front of a restaurant. Photo by Barbara Kirshenblatt-Gimblett.

While large festivals can usually absorb tourists with ease, producers may take steps to keep casual observers away from smaller events they might overwhelm. Still other local ceremonies that are extremely costly to produce thrive as a result of tourist interest and dollars: cremations in Bali, which require vast sums of money, can now occur on a larger scale and more often thanks to the revenues generated by tourists who pay to attend them.

Festivals are cultural performances par excellence. Their boundaries discernable in time and space, they are particularly amenable to encapsulation. Because whole festivals generally offer more than the casual traveler can consume, and because such complex events do not travel well, entrepreneurs often excerpt local festivals and incorporate their parts into other kinds of events. In an effort to make such attractions more profitable, as well as to restrict the access of tourists to areas of local life declared off-limits, events are adapted to the special needs of recreational travelers. Events staged specifically for visitors are well suited for export because they have already been designed for foreign audiences on tight schedules. Exported events developed for international expositions may be brought back home in the hope of attracting tourists into the local economy. Balinese performances developed for the Colonial Exposition in Paris in 1931 were brought back to Bali, where versions of them continue to be presented to tourists.

Import the tourist? Or export the village and festival? These processes are reciprocal. Ethnographic displays are not only a way to re-create the travel experience at a remove. Increasingly, these displays are introduced at the travel destinations themselves, where they may displace the travel experience altogether. All of Polynesia is represented on forty-two acres of the Hawaiian island Oahu, at the Polynesian Cultural Center: according to a 1985 promotional brochure, "[m]ore people come to know and appreciate Polynesia while touring these beautifully landscaped grounds than will ever visit those fabled islands."[88]

As mass tourism has grown in the postwar period, festivals of all kinds have proliferated with the explicit intention of encouraging tourism. A 1954 guide to festivals in Europe makes this very point.

[The abundance of festivals] means fun for everyone who wants to frolic with our friends abroad when they are in their most festive moods, or they can frolic with us if they are so inclined. . . . [Americans want to satisfy their] curiosity about how other people live. . . . As everyone knows, just about the best time to see the most people in any region is at a festival. That is also a fine time to learn what interests or amuses them, because a festival invariably reflects the character of the region in which it takes place and dramatizes the economic and recreational attractions, as well as the spiritual and aesthetic aims of the people.[89]

We have here the major tropes of ethnographic display, from the perspective of the tourism industry—the promise of visual penetration; access to the back region of other people's lives, the life world of others as our playground; and the view that people are most themselves when at play and that festivals are the quintessence of a region and its people.[90] To "frolic with our friends abroad" becomes the paradigm for intercultural encounter. The foreign vacationer at a local festival achieves perfect synchrony: everyone is on holiday, or so it seems. But to know a society only in its festival mode, filtered through the touristic lens of spectacle, is to raise another set of problems—the illusion of cultural transparency in the face of undeciphered complexity and the image of a society always on holiday. To festivalize culture is to make every day a holiday.

Folkloric Performance

The living quality of such performances does not make them any less autonomous as artifacts, for songs, tales, dances, and ritual practices are also ethnographically excised and presented as self-contained units, though not in quite the same way as material artifacts. You can detach artifacts from their makers, but not performances from performers. True, artifacts can be photographed and performances can be recorded. But artifacts are not photographs and performances are not recordings. While the pot can survive the potter (though it too will eventually crumble to dust), music cannot be heard except at the moment of its making. Like dance and other forms of performance, musical performance is evanescent and in

Purim.

Williamsburg, Brooklyn, 1982. Hasidic children, one costumed as the Biblical high priest Aaron and the other wearing an apron in the form of a Yiddish eye chart, deliver customary gifts of prepared food. Photo by Barbara Kirshenblatt-Gimblett.

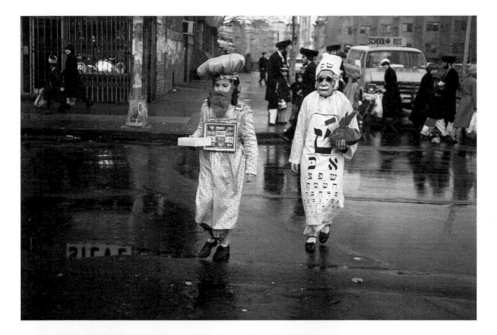

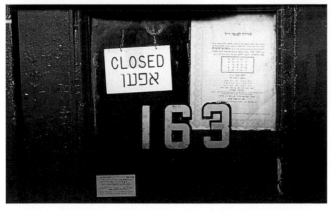

Storefront in Hasidic Williamsburg, Brooklyn, 1982. The sign says "CLOSED" in English and "OPEN" in Yiddish.

Photo by Barbara Kirshenblatt-Gimblett.

need of constant renewal. To achieve for drumming the sense of "realness" conveyed by the physical presence of the drum, we need the drummer. But a drummer drumming is no less an ethnographic fragment. The proscenium stage, master of ceremonies, and program booklet are to the drummer what the vitrine, label, and catalog are to the drum. The centrality of human actors in performance and the inseparability of process and product are what distinguish performances from things. While an artifact may be viewed as a record of the process of its manufacture, as an indexical sign—process is there in material traces—performance is all process. Through the kind of repetition required by stage appearances, long runs, and extensive tours, performances can become like artifacts. They freeze. They become canonical. They take forms that are alien, if not antithetical, to how they are produced and experienced in their local settings, for with repeated exposure, cultural performances can become routinized and trivialized. The result may be events that have no clear analogue within the community from which they purportedly derive and that come to resemble one another more than that which they are intended to re-present.

Embedded in the flow of life, artifacts and performances that have historically interested ethnographers are contingent: they are not generally made to stand alone, set off for exclusively aesthetic attention. Forms that are perfectly satisfying in their indigenous setting—chants, drumming, a cappella ballads, repetitive dance steps—challenge audiences who are exposed to them on stages where they are used to seeing opera and ballet. Professional folkloric companies adapt such forms to European production values. To hold the interest of new audiences, folkloric troupes design a varied and eclectic program of short selections. They also depend on musical accompaniment (such as piano or orchestra), European harmony, concertized arrangements and vocal styles on the model of European opera, and movement styles on the order of ballet to reduce the strangeness and potential boredom of a cappella song, unison music, and repetitive (and not apparently virtuosic) dance for unfamiliar audiences. To meet strict time requirements and deliver exactly what has been advertised and announced in a printed program, improvisation may be curtailed, if not eliminated. A tightly coordinated ensemble of trained professionals, often more or less the same age and physical type, wear stylized,

often uniform, costumes while executing highly choreographed routines with great precision. A frontal orientation accommodates the proscenium stage, to which is added theatrical effects (sound, lighting, sets). There is a tendency toward the virtuosic, athletic, dramatic, and spectacular.

The repertoires of folkloric troupes typically include excerpts from festivals and rituals—weddings, healing ceremonies, and hunting rituals are favorites. While such excerpts allude to the contingent nature of music and dance, they partake of theater, having been severed from their local social and ceremonial settings and reclassified as art. At the same time, the proprietary rights to the material have been transferred from local areas to the "nation," where regional forms are declared national heritage. National troupes typically perform traditions from across the land, no matter what the personal histories of the performers. Since everyone can perform everything and everything belongs to everyone, differences do not differentiate. Polyglot programs, besides offering variety, generally represent an "imagined community" in which diversity is harmoniously integrated. Difference is reduced to style and decoration, to spice of life. Cultural difference is then praised for the variety and color it adds to an otherwise bland scene.

Such choices in repertoire and style are ideologically charged. Folkloric troupes attempt to find a middle ground between exotic and familiar pleasures and to bring these forms (and their performers) into the European hierarchy of artistic expression, while establishing their performances as national heritage. The more modern the theater where the troupe performs the better, for often there is a dual message: powerful, modern statehood, expressed in the accoutrements of civilization and technology, is wedded to a distinctive national identity. The performance offers cultural content for that identity. Such assertions are not confined to the concert stage. They are implicated in claims to territorial sovereignty, the drawing of political boundaries, the choice of official language, and many other matters of vital concern in the tension among nation, state, and culture. Claims to the past lay the foundation for present and future claims. Having a past, a history, a "folklore" of your own, and institutions to bolster these claims, is fundamental to the politics of culture: the possession of a national folklore, particularly as legitimated by a national museum and troupe, is cited as a mark of being civilized.

Folk Festival

As a venue for the representation of culture, the festival derives its celebratory tone and environmental approach to staging from the joyful events associated with the traditional feasts and fêtes that honor a religious anniversary, event, or personage. But unlike feasts (the etymological root of *festival*), which do what they are about, festivals of the kind that interest us here re-enact, re-present, and re-create activities and places in a discrete performance setting designed for specular (and aural) commerce.[91] Such events acquire a distinctive (if plural) semiotic status. Quivering with issues of authenticity and iconicity, these events tend to make a clear separation between doers and watchers—or among kinds of doers—even with efforts to encourage "participation."

These issues are dramatized by the highly successful Festival of American Folklife, produced annually since 1967 on the Mall in Washington, D.C., by the Office of Folklife Programs at the Smithsonian Institution. This pioneering program is sensitive to the issues raised here and addresses them by experimenting with new ways to present folklife to the public. Two cases are particularly instructive here: the Festival of India and the Old Ways in the New World programs. Seen in historical perspective, these programs blend the national and state pavilions and ethnographic villages, long a staple feature of world's fairs, and the homelands exhibitions and festivals that celebrated immigrant "gifts" during the first half of this century.[92]

Festival of India Recognizing the festival as a readymade genre of presentation, the 1975 guidelines for the Festival of American Folklife advised the following:

> Because many genres survive in the context of esoteric community celebrations and rituals, large scale traditional celebration events should be used as organizing structures for "Old Ways in the New World" programs. Such events can be parades, processions, picnics, festivals, religious ceremonies, wedding festivities, or any similar event in which performing arts are closely associated with other traditional expressive forms. . . . Celebration events should allow direct participation by Festival visitors.[93]

However connected it may be to what communities do at home, the festival within a festival is a re-creation. At its most mimetic, it offers a sumptuous alternative to the sensory atrophy of the bare stage.[94] The festival-within-a-festival format also presents formidable ethnographic and logistical challenges, particularly at the points where the two festivals are incompatible.

This insight guided the decision in 1985 to embed a festival within a festival within a festival—the mela within the Festival of India within the Festival of American Folklife.

> The Mela program on the Mall is really a fair within a fair. It is a composite mela, compressing both space and time to present selectively only a few of India's many traditions. Just as a mela would in India, the program encourages visitors to learn about and participate in Indian culture. The structures on the Mall have been built largely with natural and handcrafted materials from India, while the site itself has been designed to reflect indigenous Indian concepts.[95]

The *mela*, the fair that accompanies religious festivals in India, did indeed offer an ingenious format for displaying many kinds of artifacts, activities, and people (dance, music, acrobatics, street performers, religious observance, food, architecture, crafts) as they are integrated in their native setting. But of course this mela was to occur during a festival of our own making, and our festival and those of India are not necessarily compatible. Smithsonian festivals are events produced for the public with the taxpayers' dollars: they are not-for-profit ventures and studiously avoid the slightest hint of commercialism. Things are not for sale, except at the one small gift shop inconspicuously positioned at the edge of the main events. Goods are carefully selected for their appropriateness, and salespersons are expected to be well informed about the objects, their makers, and their makers' communities. They offer items relating to all the exhibits.

Indian fairs, by contrast, are full of things to buy. Each craftsperson and stall keeper competes with the others to sell goods. The Smithsonian mela on the Mall was a representation of a commercial environment,

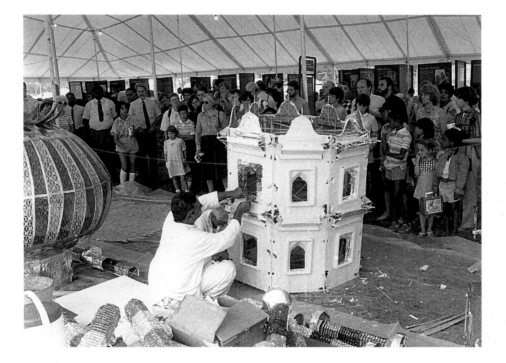

which, while mimetically very complete, paradoxically stopped short of commercial exchange. Indeed, it was necessary to post signs in the stalls to indicate that the goods were *not* for sale. Perhaps as a concession to authenticity, visitors were actually allowed to make purchases at a few designated stalls as well as in the sales tent. What do you get when a commercial Indian fair is embedded inside a noncommercial Smithsonian festival? Stalls of goods for sale that cannot be sold.[96]

Food presented a similar problem. Clearly, the Department of Health would not countenance unlicensed vendors from India feeding visitors to the Mall. Instead, an Indian hotel chain catered the festival from a central

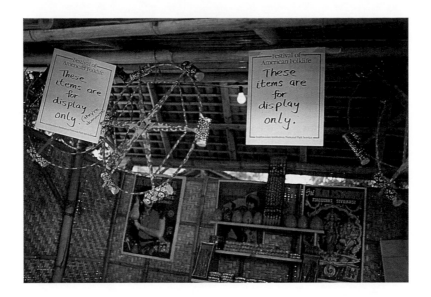

"These items are for display only," with graffiti "(they're dummies)," on signs in a market stall.

Mela exhibition, Festival of American Folklife, Washington, D.C., 1985. Photo by Barbara Kirshenblatt-Gimblett.

post in the mela. Even were Department of Health requirements to be met, festival planners would probably encounter the resistance of local vendors to any intrusion on their economic turf by traditional cooks brought in for the day. Local commerce effectively inhibits efforts to re-create the culinary environment of traditional festivals.

Though intended as an evocative re-creation, ethnographically accurate and authentic in most details, the festival-within-the-festival is a distinct type of performance event, and the visitor inevitably experiences it as such. Though the intention may be to create the illusion of being in India, it is the re-creation itself that is experienced, with all of its tensions and ambiguities. When carried to extremes, as in the case of first-person interpretation at Plimoth Plantation, visitors experience the thrill of the hyperreal and at the same time perceive the fragility of the membrane that has been constructed to separate the present place and time from that which has been reconstructed.[97]

"Old and New at Caesarea's Ancient Theatre." Israeli folk dance ensemble at an archeological site near Haifa, ca. 1966.

Copyright by "Palphot," Herzlia.

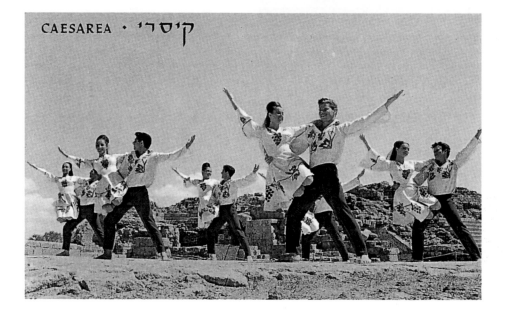

Old Ways in the New World Raising yet another set of problems, the Old Ways in the New World program integrated the national pavilion, foreign village, and homelands exhibition in an attempt to juxtapose folk artists in immigrant communities with their counterparts in their home countries. This was also a way to involve foreign countries in a festival of American folklife. But the assumption of a Jewish "old world" presented insurmountable problems. There was no Old World, as the European Jewish communities, from which most American Jews derive, were largely destroyed during the Holocaust.[98] Eliding differences between Old World and homeland, Israel was selected as the Jewish Old World for the purposes of the festival. But the "old ways" of American Jews were not to be found in the newly formed Jewish state, which was itself a case of new ways in a New World. Nor was Israel willing to be cast as the repository of the old ways of American Jews—quite the contrary.

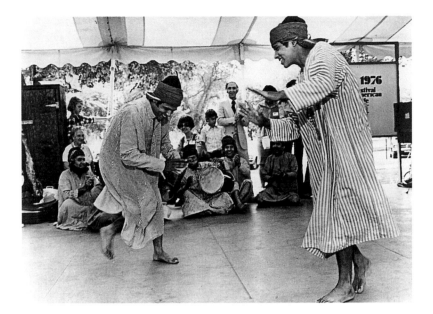

When working with the Ministry of Education and Culture in Israel to identify appropriate performers for the Jewish section of the Bicentennial Festival of American Folklife in 1976, I was instructed to bring the finest exponents of "authentic" traditional art forms. Some of the performers who met this standard were born in Yemen, Morocco, or Iraq and were advanced in years. Israeli cultural officials wanted to send Israeli folk dance troupes, arguing that they were young, athletic, lively, versatile, and specially adapted for the stage. Not only were the professional folk dance troupes costumed and choreographed, but, I was told, they had been trained to perform the music and dance of the many different Jewish communities living in Israel, as well as the horas and other dances associated with the new state. Their performances conformed to professional standards and were stylized to reduce their strangeness. These were precisely the groups the Smithsonian's Office of Folklife Programs had in-

structed me *not* to bring. The Israeli officials complained further that my choices would present entirely the wrong image of contemporary Israel and would offer a poor performance to boot: Israel and its culture were not to be represented by old immigrants performing exotic music of the Diaspora. Even to the extent that we succeeded in bringing traditional performers of our choice, we still faced the problem of relating these traditions to those of Jewish immigrants in America.

Staging Culture

A key to the appeal of many festivals, with their promise of sensory saturation and thrilling strangeness, is the insatiable and promiscuous human appetite for wonder. The irreducibility of strangeness, a feature of tourist discourse more generally, inscribes on the geography of the exotic a history of receding thresholds of wonder: as exposure exhausts novelty, new ways to raise the threshold of wonder must be found.[99] The passion for wonder also accounts for the primacy of spectacle as a presentational mode and for the tension between the very unspectacular nature of much material that we might want to present and the audiences' expectation that they will get a good show. Given the special way that spectacle works (clear separation of observer and actor, primacy of the visual mode, and an aggrandizing ethos), the spectacle of festival evokes what MacAloon has characterized as diffuse wonder or awe and precipitates intellectual and moral ambiguity, even with the various efforts to mitigate the effects.

We complain of ritual degenerating into spectacle, into sheer show. Historically, however, we have long valued the inscrutable strangeness of the exotic as an end in itself. The appeal of the villages on the Midway of the World's Columbian Exposition in Chicago depended largely on such mystification, and many multicultural festivals today still feed this appetite while at the same time encouraging understanding and reflection by offering "interpretation." That we objectify culture has long been recognized; festivals, however, also objectify the human performers and implicate them directly in this process. This is an inherently problematic way to confront cultural questions, for spectacle, by its very nature, displaces analysis and tends to suppress profound issues of conflict and marginalization. The more ethnographic festivals and museum exhibitions

succeed in their visual appeal and spectacular effect, the more they re-classify what they present as art and risk appealing to prurient interest.

Fighting the spectacular and the illusion of re-creation, the Office of Folklife Programs at the Smithsonian Institution has long advocated what might be called an ascetic approach to staging.

> Costumes used only for stage performances, or for other exoteric purposes, are not appropriate for the Festival. This matter should be thoroughly re-viewed in the field and reiterated in formal invitations and correspondence with participating groups and individuals.
>
> In 1974, all the Greek-American participants, and most of the foreign Greek participants wore ordinary clothes throughout the five-day presentation. Costume was not a part of the two Greek-American *glendis* held on the Mall, because it is not customarily worn at *glendis* in this country. A few elderly participants from Greece wore traditional clothes every day, as they always do at home.[100]

The concern that costumes that are worn only for stage performances not be donned for the Smithsonian presentation presents a paradox: from the perspective of many participants, the folklife festival is a stage performance, so why not wear costumes? There is a conflict here between two aesthetics.

As the Smithsonian's guidelines suggest, festivals organized by domi-nant cultural institutions such as museums and state folklife programs or funded by state and federal agencies share a performance discourse that often stands in contrast (if not in opposition) to the ways communities stage themselves. These differences are more than matters of taste and style; they offer different approaches to the marking of authenticity. Hall-marks of the festivals mounted by professional folklorists in the past in-clude a focus both on performers who claim the forms they perform as their birthright and on the traditional components of their repertoire. Performance practices that entail an adaptation to the concert stage are discouraged, despite the fact that communities have often developed their own troupes, costumes, repertoires, choreography, musical arrangements, interpretations, dramatizations, and other conventions for presenting their performing arts on the concert stage for themselves and for outsiders.

Such adaptations, often derided as touristic kitsch, are studiously avoided by folklorists in favor of a very different set of conventions, many of which have evolved specifically for the "folklife festival." Typically, solo performers and ensembles are selected from among those who normally play at a community's festivities. Wearing ordinary clothing, they play on a bare stage within a large tent, the audience seated on bleachers or benches, or they play on a concert stage in an indoor auditorium. High-tech sound equipment and professional stage technicians ensure the best possible acoustics and documentary recording of the event. Explanatory text panels may be mounted near the entrance to the tent, and a large photomural of the performer's home environment may serve as a back-drop. An informed "presenter" introduces the performers, with sensitive explanations about the history, context, and meaning of what the audience is about to hear. The program booklet supplements the presentation with illustrated essays about the communities and traditions featured at the festival. Formal concerts are complemented by interactive and didactic workshops, demonstrations, lectures, and films.

Performers are discouraged from the use of electronic instruments (though there are exceptions), "ethnic costumes," nontraditional repertoires, concertized performance styles, choreography adapted for the stage, and other overtly theatrical concessions. There is thus a suppression of *representation* markers and a foregrounding of *presentation* markers, an avoidance of the suggestion of "theater" and an attempt to achieve the quality of pure presence, of a slice of life. Given the history of national troupes and pavilions and homelands exhibitions, it is easy to see why groups would expect to appear in costume and in organized troupes. This is, after all, the public face, as they have constructed it, of their private lives. And given the way that spectacle brings authenticity into question, it is easy to see why an ascetic aesthetic to staging should appeal to festival producers aiming to present rather than represent that life.

Performing Difference

The interest in displaying performance or in using performance as a way of displaying culture is, like the series of objects arranged to show a con-

tinuous historical process, linked to particular theoretical orientations. First, performance-oriented approaches to culture place a premium on the particularities of human action, on language as spoken and ritual as performed. Such approaches resist stripping the observed behavior of contingency in order to formulate norms, ideals, and structures of competency.[101] Second, cultural performances as units of analysis have offered a distinct methodological advantage to those grappling with large and complex societies, where approaches that worked well in small settings are inadequate.[102] The Manchester school of social anthropology found in "social dramas"—events that involved a breach of some kind and efforts to deal with it—a useful way to focus cultural analysis.[103] The sociologist Erving Goffman brought a dramaturgical approach to the analysis of ordinary social life in his own milieu. Third, performance, whether a focus for research or the basis of ethnographic display, is compatible with efforts among folklorists, ethnomusicologists, and anthropologists to deal with issues of diversity, pluralism, cultural equity, and empowerment, particularly when participants can control how they are represented.[104]

The issue of who is qualified to perform culture is thorny because it reveals the implicit privileging of descent over consent in matters of cultural participation.[105] Though the guidelines for producing folklife festival programs stress visitor "participation," they are also usually clear in specifying that the "performers" at the festival are to be those to whom the arts "belong" by virtue of their having been acquired in a traditional manner and setting, that is, by insiders from insiders—by descent, though this distinction is not rigidly applied. "Outsiders," those who have chosen to learn the art even though they were not born into the communities that transmit it, are generally considered revivalists and may be excluded on this count, though here too the matter is more complicated. Thus those who are licensed to do are distinguished from those who are mandated to watch. The event is to be structured, however, in ways that will allow the watchers to "participate," a notion that generally stops short of permitting them to perform the tradition themselves, except as they are invited to join a procession or the group dancing and singing.

The curatorial problem in folk festivals is the delicate one of determining not only what meets certain standards of excellence but, first

and foremost, what qualifies as authentic folk performance. As a result, performances at folk festivals are often artifacts of the discipline of folklore, whatever else they may be. We speak of the Child ballads, the Grimm *märchen,* the Perrault fairy tales, and other traditional forms that have been canonized in printed collections, museum exhibitions, commercial recordings, and folk festivals. We also create the criteria by which the multiplicity of forms we find can be sorted into their "preferred" and "residual" categories.[106]

There is a danger in what Stuart Hall calls self-enclosed approaches, which, "valuing 'tradition' for its own sake, and treating it in an ahistorical manner, analyze cultural forms as if they contained within themselves from their moment of origin, some fixed and unchanging meaning or value."[107] Further, those who organize folk festivals must accept the responsibility for representing those they include in "their most traditionalist form."[108] While folklife festivals attempt to represent traditions that would otherwise not be exposed, it is also the case that those who perform tend to be represented exclusively in traditional terms.

Following Hall, we might consider the opposition of folklore/not folklore, not as a descriptive problem or a matter of coming up with the right inventory of cultural forms, but rather in terms of the "forces and relations which sustain the distinction, the difference" between what counts as a genuine tradition, a revival, fakelore, or elite culture. Hall suggests that the categories tend to remain, though the inventories change, and that institutions such as universities, museums, and arts councils play a crucial role in maintaining the distinctions: "The important fact, then, is not a mere descriptive inventory—which may have the negative effect of freezing popular culture into some timeless descriptive mould—but the relations of power which are constantly punctuating and dividing the domain of culture into its preferred and its residual categories."[109] Similarly, by aestheticizing "folklore"—no matter what is gained by the all-inclusive definition of folklore as the arts of everyday life—we are in danger of depoliticizing what we present by valorizing an aesthetics of marginalization.

Though there are still many festivals devoted to the traditions of a single ethnic group, large-scale events sponsored by city, state, and federal

Factory workers in Troy, New York, present a Ukrainian wedding party, as remembered from their native village, at the homelands exhibition in the State Educational Building in Albany, New York, 1920.

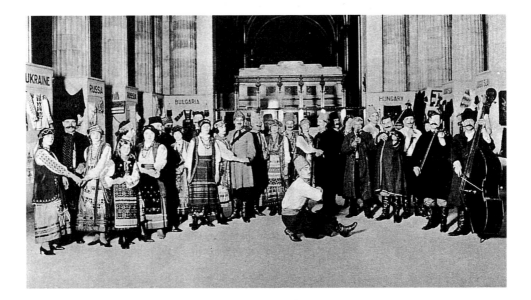

agencies are generally multicultural in nature. They participate in the discourse of pluralism, of unity in diversity. They risk what might be termed the "banality of difference," whereby the proliferation of variation has the neutralizing effect of rendering difference (and conflict) inconsequential.[110] This is the effect, by design, of the pageants of democracy so popular during the first decades of this century.[111] Though offered as an alternative to the brutal efforts of nativists to suppress difference and preserve the preeminence of Anglo stock and culture, the unity-in-diversity discourse can also have a neutralizing effect.

In festivals of cultural performances, respectability and decorum, values of the dominant cultural institutions that stage the event, tend to diffuse the oppositional potential so essential to festivals. For this and other reasons, these festivals have a tendency to reinforce the status quo even as enlightened organizers and performers struggle to use them to voice oppositional values. Carnival represented is carnival tamed. In the case of the

homelands exhibitions and festivals, immigrant organizations were already doing a good job of supporting a wide variety of cultural activities. "National festivals" organized by immigrant groups in American cities during the last decades of the nineteenth century attracted tens of thousands of participants. In the homelands exhibitions and festivals organized during the first half of this century, "cooperation" between Americanization agencies and immigrant groups, however well-intentioned, also involved co-optation. Homelands exhibitions were designed to gain the trust of immigrants, who, it was hoped, would allow themselves to be helped by Americanization organizations. These events were not simply displays of immigrant gifts—crafts, music, dance, and wholesome values. Equally important—and the organizers were explicit on this point—they were good public relations for the Americanization workers and social reformers, who were themselves on display. Through such exhibits and festivals, they could show their success in working with immigrants and lobby for increased support.

Exhibitions, whether of objects or people, are displays of the artifacts of our disciplines. They are for this reason also exhibits of those who make them, no matter what their ostensible subject. The first order of business is therefore to examine critically the conventions guiding ethnographic display, to explicate how displays constitute subjects and with what implications for those who see and those who are seen. Museum exhibitions, folkloric performances, and folklife festivals are guided by a poetics of detachment, in the sense not only of material fragments but also of a distanced attitude. The question is not whether an object is of visual interest, but rather how interest of any kind is created. All interest is vested.

Exhibiting Jews

The Crystal Palace, which opened in London in 1851, ushered in an era of international expositions. Though rooted in an earlier history of trade fairs and industrial exhibitions, the great world's fairs of the late nineteenth and early twentieth century were unprecedented in scale and extravagance. In spectacular exhibition halls, the nations of the world compared themselves, competed for preeminence, and projected a utopian future built on the machine, international trade, and world peace. Whole cities were built to accommodate these fairs, and millions of people attended them. Coming as they did with the growing military and economic power of modern nation-states, the consolidation of large colonial empires, the mass migration of populations, and the rapid rise of industrialization, world's fairs offer for analysis a virtual phantasmagoria of "imagined communities" and "invented traditions."[1]

Between 1851 and 1940 Jews represented themselves at international expositions in Europe and America in a wide range of ways. They defended such universal values as religious freedom. They framed the presentation of Jewish subjects in terms of art and civilization and secured for Judaism a central place in the history of religion. By the early twentieth century, immigrants in American cities were re-creating the Diaspora as a world's fair in miniature. Jews in Europe and America were also

envisioning through pageants and pavilions the establishment of a Jewish homeland in Palestine. Each exhibition meditated on the unresolvable question of how Jews were to be defined and represented, not as an idle exercise, but with a larger social and political project in mind—religious tolerance, social justice, freedom of expression, group survival, and statehood. What the Jewish displays at international expositions suggest so vividly is that representations are constitutive. They do not simply mirror or present an image: exhibition classifications and hierarchies, discursive conventions, and representational practices constitute subjects and in the process, set out the terms for action.

My goal is to delineate how Jews represented themselves at international expositions from 1851 to 1940 in three national contexts—France, England, and the United States. Unlike the states and empires that built great national pavilions, Jews were a diaspora without territorial sovereignty. Though citizens of the many countries in which they resided, they were anomalous. Whether explicitly or implicitly, the "Jewish question" and variations on it shaped the way they represented themselves. Were Jews identifiable strictly by religion and therefore indistinguishable from other citizens but for their faith? Were they a race with immutable and inherited characteristics, inassimilable aliens, a threat to the racial purity of the national stock? Were they a nation within a nation, with their own civilization and ancient homeland, living temporarily as citizens of the Diaspora and divided in their national loyalties? I will explore how these issues informed Jewish displays and were in turn informed by them.

That said, it is important to note that Jewish presence at international expositions is an elusive subject. There is no obvious place to look for Jewish participation, no national pavilion (before Jewish Palestine pavilions made their debut) on the international avenue and no foreign village in the amusement zone. There was even resistance to Jewish displays, as will emerge below. The Jewish press of the period, recognizing that there was often little, if any, official Jewish participation, published guides to the fairs that identified exhibits of special interest to the Jewish visitor. These guides not only reviewed displays and events on Jewish subjects but also made special note of any exhibitors who happened to be Jewish. Jews were avid visitors to international expositions from the outset. Those at-

tending the Centennial Exhibition in Philadelphia in 1876, for example, could avail themselves of a kosher restaurant on the fairground. It catered to lodges, societies, and organizations whose members came to the fair as groups. What Jewish visitors found interesting offers a map of sorts for this study. Jews were also entrepreneurs and impressarios, helping to raise money for fairs and managing whole divisions of them.

This essay examines how a diaspora negotiates the transnational space of world's fairs. These events moved from place to place, they drew exhibitors and visitors from across the globe, and they were widely reported. Even those who never visited a fair in person knew what it was like from the newspapers, magazines, fair publications, photography, and, eventually, cinema. Jews negotiated how and where they would be seen in the world staged by these fairs. Their approach to this question illuminates the constitutive power of display.

Exposition Universelle, Paris, 1878

Thirteen million people visited the 1878 Paris exposition. In the Palais du Trocadéro, one of the most spectacular buildings at the fair, visitors could see "a remarkable collection of works of Israelite art ... probably the only one of its genre in existence," according to the catalog.[2] The exhibition featured eighty-two items from the private collection of Isaac Strauss, an Alsatian Jew who had moved to Paris in 1827. It was located in Room 10 of the section devoted to "les arts rétrospectifs." A century after the Paris exposition, his great-grandson Claude Lévi-Strauss was moved to see Isaac's name inscribed above the entrance to a room at the Musée de Cluny dedicated to the family heirlooms. Tangible objects that Claude remembered from his childhood had been "consecrated in a permanent manner." As Claude explained, they stored memories that resoldered links in a chain that connected Claude with other centuries.[3] Those links were intensely personal and autobiographical. Having devoted a lifetime to collecting the culture of others, Claude discovered that part of himself had been museumized.

These were not, however, the terms that governed the 1878 installation of Isaac Strauss's collection at the Trocadéro Palace. Mounted in the aftermath of the Franco-Prussian War, the 1878 Paris exposition was in-

tended as an affirmation of French preeminence in the wake of military defeat. Where, in the French program of cultural unity and superiority as a civilization, was there place for an exhibition of Jewish ritual objects? Having relinquished their corporate autonomy for emancipation, Jews were ostensibly French citizens of the Mosaic faith, patriotic confreres indistinguishable from other French citizens except by religion, though a series of anti-Semitic incidents—the Damascus Affair in 1840 and the Mortara case in 1858—were an indication that full acceptance had yet to be achieved. What could Jews show, and what would they be saying about themselves?

First, this exhibition presented Jewish manuscripts, candlesticks, oil lamps, and Torah ornaments as the possessions of an individual collector. Isaac Strauss was praised for his "passion for art and rare perseverance" in gathering together scattered treasures. Second, the items on display were explicitly defined as "objects d'art religieux hébraïques," the term *hébraïque* conferring a biblical aura. That the objects were offered so explicitly as evidence of Jewish artistic capabilities indicated that there was reason for doubt: the catalog noted such ostensible deterrents to Jewish artistic expression as the Second Commandment, which prohibits the making of graven images, and the persecution and incessant wandering of the Jews. Third, the catalog cited contact between Jews and Christians as a positive influence on the development of Jewish art.

Jews were living proof, the argument went, that artistic instincts, a universal attribute of humankind, were powerful enough to override deterrents created by religious prohibitions and historical circumstances. Such affirmations defended Jews against arguments to the contrary. To deny Jews artistic sensibility, for whatever reason, was after all to deny them what the catalog defined as a universal human instinct. Similarly, the affirmation of Jewish-Christian contact defended Jews against charges of isolation and exclusivity. It did however accept for Jewish art the inferior position of being influenced.

These themes, familiar in the era of emancipation, shaped not only what was shown but also how objects were installed, captioned, and cataloged. Not surprising, then, that the artifacts in Strauss's collection should be described primarily in terms of material, technique, craftsmanship,

and decorative motifs and to a lesser extent in terms of ceremonial function, Jewish iconography, Hebrew inscription, and the communities that made or used them. Attention to the physical attributes of artifacts played down their Jewish specificity and played up their status as objects of art. Because objects were classified in relation to their generic ceremonial contexts, the synagogue and the home, and then grouped together in a series (all the Hanukkah lamps, all the spice boxes), Judaism, rather than Jews, became the main subject.

Pl. X.

Nº 42. — *Gobelet* כוס

"Goblet. This vessel of hexagonal form in gilded silver is mounted on a very short circular foot. Each side bears chased and repoussé embellishment, artistically somewhat primitive, and two inscriptions, whose text presents the two versions of the fourth commandment: . . . Remember the Sabbath to sanctify it.

This object is used for the benedictions on Saturdays and holidays." Such kiddush cups, as they are known in English, are used for blessing the wine on the Sabbath, including Friday night.

Collection of Isaac Strauss. From [Georges Stenne], *Description des objets d'art religieux hébraïques exposés dans les galeries du Trocadéro, à l'Exposition universelle de 1878* (Poissy: Typographie de S. Lejay, 1878), plate x.

Most important, by reclassifying Jewish ceremonial objects as art, the exhibition integrated things Jewish into the discourse on civilization and recast Jewish particularism in the universalistic terms of art. Aesthetic appreciation and creativity were considered attributes of civilization and figured in world's fairs precisely in these terms. Where competition and hierarchy prevailed, those who had art were more civilized than those who did not. And those who influenced, enjoyed higher standing than those who were influenced.

While noteworthy at the time for being an "exclusively Israelite" exhibition, the Strauss collection was not the only way Jews made their appearance at the 1878 and earlier Paris expositions. The Franco-Jewish press took careful stock of every form of Jewish participation, including Jewish notables in attendance, Jewish exhibitors in industry and manufacture, Jews who received medals, Jewish institutions that made a showing, and performers, artists, and artistic subjects that could be identified as Jewish. Indeed, *Archives israélites*, like reports in the Anglo-Jewish press on the Crystal Palace in 1851, saw its "duty" to present the "facts" of Jewish achievement and patriotism as proof positive that anti-Semitic insults had no foundation. By exhibiting these facts for all to see, the fair became the Jews' tribunal and world opinion the jury. Realizing the power of this forum, newly formed organizations dedicated to Jewish defense and relief, like the Alliance Israélite Universelle (established 1860), became regular exhibitors.

The more conservative *l'Univers israélite* took a different approach. In its pages, which featured statements from the chief rabbis of France, S. Bloch condemned the 1855 exposition of idolatry for worshipping man and his creations in "Temples of Industry." Speaking of the 1867 exposition, he complained further that "Judaism is not represented by anything, not by a work, not by a word, not by a souvenir; it is effaced, it is absent, it is ignored. There is not even a kosher restaurant." In his report on the 1878 fair, which he characterized as a Tower of Babel, he exhorted his readers to find in Judaism itself the ultimate exposition—no ticket is needed to admire the beauty of Jewish ritual and sacred texts.[4]

Over the course of five Paris fairs (1855, 1867, 1878, 1889, 1900), Jewish participation steadily increased. Whereas in 1855, the Jewish press

complained that Jews were not sufficiently present, by 1889 reporters were responding to anti-Semitic complaints that Jews were everywhere. Indeed, Jews were now so well represented that writers could no longer hope to present a complete list of participants for their Jewish readers.

Anglo-Jewish Historical Exhibition, London, 1887

In 1887, a year before Isaac Strauss died, his collection, now somewhat enlarged, was again exhibited, this time at the Anglo-Jewish Historical Exhibition in Royal Albert Hall in London. Though not part of a world's fair, the Anglo-Jewish Historical Exhibition served as a model for organizing at subsequent world's fairs displays of Jewish ceremonial objects, as well as artifacts representing other religions. It also inaugurated several of the themes that were to emerge in those displays.

The Anglo-Jewish Historical Exhibition was a grand collaboration led by the folklorist Joseph Jacobs and the historian Lucien Wolf. As *The Jewish Chronicle* proclaimed, "You may have exhibitions often, but a Jewish exhibition is not an everyday affair."[5] With broad and ecumenical participation of exhibition committees, lenders, and various scientific and social organizations, Jacobs and Wolf aimed "to revive, we might almost say to create, interest in the history of the Jewish race in England." By assembling artifacts and documents and arranging them systematically, they hoped to provide a sound footing for the "scientific and impartial study of Anglo-Jewish history."[6] This exhibition aimed to legitimate the Anglo-Jewish community and foster the study of its history.

Apprehensive that a display of historical documents would bore the public, the organizers quickly decided to include beautiful ceremonial artifacts and Jewish antiquities from various countries. Here too the exhibition catalog addressed such questions as, Are Jews lacking in artistic sympathy? and What is Jewish about their ceremonial objects? Though they classified Jewish ritual artifacts as art, the curators reflected on alleged Jewish deficiencies of artistic sympathy and the ostensible reasons for this lack, such as the Second Commandment, the "stupendous catastrophe of the Diaspora," wandering, misery, influences of the surroundings, and the absence of leisure time. Jacobs and Wolf explained that,

"[L]ike the jargons of the Hebrew people, their manners and customs, their superstitions and other phenomena of their social life, their art is little more than a composite deposit of the contrastful impressions of a wide geographic dispersion, and of a varied and chequered history."[7] Clearly, the Hebrew inscription, ritual function, and iconographic elements were distinctive, in their view, but not the overall design. Jews were said to show less interest in beauty for its own sake and more interest in costly ornamentation, which indicated their "reverence for ritual paraphernalia" or affection for the recipient of a gift. To its credit, they continued, Jewish ecclesiastical art, while not considered original or distinctive in design, was cosmopolitan. In this way, the curators transvalued the Jewish dispersion and the "influences" of non-Jews on Jewish art.

The objects were arranged according to what became known as "the Jewish plan," namely, by ritual setting—synagogue, home, and person (life cycle events). Through the objects, the catalog presented Anglo-Jewry as civilized and patriotic. The Jewish home, for example, was "the source of all human comfort with which his [the Jew's] sorrows were soothed." Religious ceremonies enhanced "the sacred character of his home" and indicated the Jew's "affection for the domestic hearth, and his reverence for his faith."[8] Victorian visitors would have responded warmly to these affirmations of home, family, and faith. Specifically Anglo-Jewish practices were noted, particularly those that demonstrated patriotism: "In English synagogues the *Prayer for the Royal Family* is generally placed so that it can be read by the congregation."[9] The intimate Jewish connections to the Holy Land and to the Bible—their glorious past before the Diaspora—were affirmed by the model of the Temple of Solomon and in the section on antiquities, many of which were supplied by the Palestine Exploration Fund. As *The Jewish Chronicle* noted, "[A]nything biblical has a charm" and would interest a wider public than would Anglo-Jewish documents.[10]

Centennial Exhibition, Philadelphia, 1876

Quite the opposite tactic was adopted when Jews represented themselves at the 1876 Centennial Exhibition in Philadelphia by means of an alle-

Religious Liberty. Marble statue by Sir Moses Jacob Ezekiel, 1876. "Dedicated to the People of the United States by the Order B'nai B'rith and Israelites of America in Commemoration of the Centennial Anniversary of American Independence," on Thanksgiving Day, 1876, in Philadelphia. The statue was relocated to the grounds of the National Museum of American Jewish History, on Independence Mall, in 1985.

Photo courtesy the National Museum of American Jewish History.

gorical statue in white marble on the theme of *Religious Liberty.* This time the sponsor was the Independent Order Benai Berith, which was established as a fraternal order by German Jews in New York in 1843. They offered mutual assistance and attempted to raise the status of Jews through "self-improvement" and image management.[11] The artist was Moses Jacob Ezekiel, a Jew of Sephardic background who was born in 1844 in Richmond, Virginia. He had studied art in Europe and was knighted three times. Art, in his view, was a matter of conscience, independent of country or sect: he was vehement that in his career he did not want "to be stamped with the title 'Jewish sculptor.'"[12]

The choice of theme, genre, style, and artist was entirely consistent with the values of those who sponsored the monument and with the personal views of the artist. Ezekiel's allegory of religious liberty universalized the theme—no reference was made to Jews—by fusing neoclassical style with republican iconography and inscriptions from the U.S. Constitution. One of six American ethnic and religious groups to erect monuments on the fairgrounds, Jews were the only group to make no explicit reference to their own history and historical figures. German Americans featured Humboldt holding a globe, and Italian Americans presented a monument to Columbus. Catholics, Presbyterians, and "colored citizens" commemorated men who had played an important role in church history.[13] In contrast, Jews drew on the idiom of Western civilization and upheld the U.S. Constitution's guarantees of religious freedom as a way of universalizing the problem. Where there was religious liberty, everyone was protected, including Jews.

It was at this time, in the wake of the Civil War, that Jews and Catholics were attacked by a conservative Protestant lobby that proposed a constitutional amendment that would explicitly identify the United States as a Christian (that is, Protestant) nation.[14] With fundamental constitutional guarantees of religious freedom now under attack, the Benai Berith fought back on constitutional grounds. Liberty for all religions, rather than a defense of Judaism, was appropriately registered in the genteel and universalizing medium of fine art. For the larger project of religious liberty to be credible, Jewish proponents had to divorce it from sectarian issues and from any trace of Jewish particularism. This move was entirely consistent with the Reform Jewish movement's emphasis on Judaism as a repository of enduring ethical values, prominent among them tolerance and social justice.

Cyrus Adler and the Smithsonian Exhibits, 1888–1897

When Cyrus Adler began arranging exhibitions in the United States in 1888, he addressed many of the same issues allegorized by Ezekiel, but with a critical difference. Ezekiel's authority derived from his standing as a Sephardic Jew born in America and a fine artist of international ac-

claim. Adler, who came from an elite German Jewish family that moved to Philadelphia from Arkansas, was the first person to receive a Ph.D. in Semitic studies from an American university. While Ezekiel was commissioned by a Jewish fraternal order and defense organization, Adler worked for the U.S. National Museum. Ezekiel spoke in the universalizing idiom of fine art. Adler appealed to the truth of science.[15]

Following the policy of the U.S. National Museum, Adler treated objects, no matter how beautiful, as specimens or documents. Since their purpose in displaying objects was to illustrate ideas, Adler and his colleagues viewed the label as the most important part of the exhibition and found casts and copies acceptable, if not preferable in some cases, to original artifacts. Though Adler exhibited the very same kinds of things that Isaac Strauss had shown at the Trocadéro and Joseph Jacobs and Lucien Wolf had featured in the Anglo-Jewish Historical Exhibition, he treated these items as object lessons in the history of Western civilization and in the history of religion more generally. He directed viewers' attention to the label rather than to the artistic value of the artifact. Indeed, preoccupation with the objects as art undermined his curatorial mission, which was to subordinate the things on display to the ideas they illustrated. Such an approach demystified artifacts by diffusing their aura as heirlooms while textualizing them. Carefully labeled specimens logically arranged in glass cases were a hallmark of "scientific" museum displays.

By the last two decades of the nineteenth century, the mass migration of eastern and central European Jews was well under way and scientific racism, which had established itself in museums and universities, was guiding displays of the world's peoples. Instead of protesting obliquely by means of allegory, art, and transcendent universalism, as had the Benai Berith, Adler used disciplinary divisions of knowledge and museum classifications of objects to define Jews and Judaism as subjects and to integrate Jews into the frameworks of biblical antiquities and the history of religion. Contracted by the organizers of the Chicago World's Columbian Exposition, he was also instrumental in arranging for several of the foreign villages on the Midway Plaisance, in which Jews were present but not visible as such. The prestigious context of the U.S. National Museum gave scholarly credibility and governmental authority to Adler's repre-

sentations. His work sheds light on how Jews were constituted as a subject by scholars, curators, and collectors, the role of exhibitions in the formation and institutionalization of disciplines in museums and universities, and the uses of scientific and popular representations in the fight against religious intolerance, racism, and other forms of xenophobia.

Biblical Antiquities

Between 1888 and 1897, Adler and his colleagues organized displays at international expositions in Cincinnati, Atlanta, Chicago, and Nashville on two subjects—biblical antiquities and the history of religion. Typically, a great international exposition would prompt the U.S. National Museum to organize a display and to collect objects for this purpose; after the exposition was over, the assembled material often came back to the museum to form the basis for permanent collections. These collections might then stimulate the formalization of new disciplinary divisions within the institution. It was precisely by mounting exhibitions and collecting objects for display that Adler helped establish within the anthropology department of the National Museum divisions of historic religions and old world archaeology and within them important collections of Jewish ceremonial art. During the late nineteenth century, disciplinary specialties proliferated rapidly, each competing for floor space in museums and expositions, a niche in the university, and a role in public life. With the redrawing of disciplinary terrain, curators such as Adler had to contend with collections that had been formed according to earlier divisions of knowledge and had either dispersed a subject he wished to consolidate or excluded aspects he considered important.

Adler used his specialty, Semitic studies, both to integrate "civilization"—and by that route, Jews—into the anthropology department, which was primarily concerned with "primitive" cultures, and to avoid the ways that so-called primitive cultures were studied and displayed. Semitic studies brought the disciplines of archaeology, ethnology, paleography, philology, and the history of religion to bear on the peoples and civilizations of the Mediterranean. This field was particularly congenial to Jewish scholars in America for several reasons. First, while it included

the study of the Bible, it was much broader. Second, Semitic studies offered a safer context for pursuing Bible studies because it required rigorous scholarship unencumbered by sectarian loyalties and theological issues. Third, Semitic studies positioned Jews advantageously in the history of civilization and, by extension, enhanced their standing in Adler's own day.

Semitic studies thus provided a sympathetic disciplinary context for Adler's exhibitions of biblical archaeology, a subject that he defined broadly to encompass the "language, history, social life, arts, and religion of the Biblical nationalities." Stressing that biblical science, as he called it, entailed the scientific study of facts, not "dogmatic theology," Adler expanded the subject beyond the ancient world: "Owing to the intense conservatism of oriental peoples, a careful study of the modern inhabitants of western Asia may exhibit in a new aspect the manners and customs of former times." Biblical science thus conceived encompassed five thousand years of history, the entire Mediterranean region (western Asia and Egypt), including not only its ancient inhabitants but also their modern descendants, among them Bedouins and European Jewry. All could be subsumed under the heading "people of Bible lands."[16]

The assumption that objects currently in use in Palestine and surrounding lands "differ in no wise from those used in ancient times" enlarged the scope of specimens that could be exhibited, since dress, ornaments, musical instruments, and household utensils from the "unchanging east" were assumed to be "essentially the same at the present day as in Bible times" and useful for explaining or illustrating "many allusions in the Scriptures."[17] A nexus was thus formed between biblical passages, modern objects, and ancient reliefs (usually presented as plaster casts) illustrating similar objects in ancient contexts.

In this way Adler could present the ancient Israelites through modern "objects of Jewish ceremonial," including European circumcision implements and a Sabbath lamp "used by German Jews in their houses" and "manufactured in the eighteenth century in Fellheim, Germany"—a procedure justified by the principle that these objects "had their origin in and are based upon Biblical ordinances."[18] Stripped of the much later Diaspora contexts in which they had been made and used, such objects be-

came biblical, whether as an illustration of Scripture, the fulfillment of a biblical precept, or living antiquity. Similarly, the "people of Bible lands" concept allowed Adler to integrate Jews (and not just Judaism), without singling Jews out, and to treat the subject of Jews and Judaism in a non-sectarian and nonparochial fashion, by the standards of his own day. The comparative perspective, which related Jewish circumcision implements to the practice of circumcision in other cultures, also served to make such customs less uniquely Jewish and less strange to Christian visitors.

Adler's work makes particularly clear how crucial were exhibition classifications for the constituting of their subjects. His colleagues in the Department of Anthropology were preoccupied with racial typologies and evolutionary approaches to the study of culture, which they displayed by means of plaster casts of heads and wax mannequins in national dress or by arranging objects in a series from simple to complex to illustrate cultural evolution. Adler was interested not in externals, not in bodily characteristics or dress, but in religious concepts. He focused on what he considered the glorious beginnings of Western civilization, on the enduring value of such ancient religions as Judaism, not on evolution from the lowly stage of savagery. Alternative chronologies, like alternative disciplines, provide alternative exhibition classifications and position their subjects accordingly.[19] Adler's conceptualization of biblical antiquities, which served the very practical purpose of allowing him to combine two collections (oriental antiquities and religious ceremonials) for the purposes of the Atlanta (1895) and Nashville (1897) exhibitions, ensured a prestigious place for the exhibition of Jews and Judaism at the center of a great story.[20]

History of Religion

So too did his notion of the history and comparative study of religion and how religion was to be exhibited. When the time came to organize a religion exhibition in the U.S. Government Building at the World's Columbian Exposition in Chicago in 1893, Adler insisted that the basic unit of exhibits on religion, a classical anthropological subject, be religion itself, not geographic areas. He felt that the integrity of a religion would

"Knife and Cup of Circumcision" and "Silver Spice Box" for "*Habdalah* (or separation), the service of the Sabbath." "The rite of circumcision (*milah*) is practiced in pursuance of Genesis xvii, 10–12: 'This is My covenant, which ye shall keep, between Me and you and thy seed after thee; every male among you shall be circumcised. And ye shall be circumcised in the flesh of your foreskin; and it shall be a token of a covenant betwixt me and you. And he that is eight days old shall be circumcised among you, every male throughout your generations.' In early times circumcision was performed with stone knives. The later Jews used iron or steel knives. With the performance of the rite of circumcision was combined the naming of the child. Circumcision was common in Egypt as early as the fourth dynasty. At the present day it prevails among the Kaffirs and some negro tribes of Africa, in parts of Australia, in many of the South Sea Islands, and it is said to be practiced by the Abyssinian Christians as a national custom. Early Spanish travelers found it to be prevalent in the West Indies, Mexico, and among tribes in South America. It is a common rite among Mohammedans everywhere."

From Cyrus Adler and I. M. Casanowicz, *Biblical Antiquities: A Description of the Exhibit at the Cotton States International Exposition, Atlanta, 1895* (Washington, D.C.: Government Printing Office, 1898), plate 18.

be lost if exhibits were divided up according to the many countries in which one religion was found. In this way, Adler deemphasized the historical and regional particularities of the objects and the communities from which they came in favor of a normative treatment of cult and creed.

For Adler, each object was an opportunity to describe ritual practice in normative terms. Indeed, he offers little if anything about materials and techniques. Instead, a catalog description for a yellow silk "Cover for the Reading Desk" is a little disquisition on the rudiments of the synagogue service, interspersed with etymologies: "When the time arrives for the reading of the Torah, which is about the middle of the service, the scroll is taken out of the Holy Ark and carried in procession, the congregation standing, to the *bima* (from the Greek $\beta\tilde{\eta}\mu\alpha$) or *almemer* (corrupted from the Arabic *al-minbar*, pulpit). This is a table or desk standing upon a raised platform, upon which the scroll is unrolled. . . . This table or desk is covered with a costly cloth similar to the curtain of the Holy Ark."[21]

Adler also insisted that a religion be presented from the perspective of its adherents, that all religions be treated with respect, and that displays focus on underlying religious ideas, not church history, this being his way of fostering religion as a field of scientific study and, through it, encouraging religious tolerance. The challenge was to make religion, as he conceived it, exhibitable, for there was the question "whether the abstract ideas which group themselves about the word 'religion' could be adequately or even fairly portrayed through ceremonial objects, numerous as they might be."[22] Noting that "[r]eligion consists of what men believe concerning the supernatural and what they do in consequence of that belief, in creed and cult," Adler proposed that it was "the cult which most readily lends itself to museum exhibition," though he asserted that "there are devices by which even creeds may be shown in museum collections."[23] Adler was so impressed with the arrangement of ceremonial art at the 1887 Anglo-Jewish Historical Exhibition that he proposed that the so-called Jewish plan—the classification of objects according to the setting in which they were used—be adopted for all the religions exhibited by the U.S. National Museum. Adler, it should be noted, was an observant Jew and an important figure in the history of Conservative Judaism in

"Ceremonials of the Jewish Religion" are exhibited along the back wall of the gallery.

World's Columbian Exhibition, Chicago, 1893. Smithsonian Institution Archives, Record Unit 95, Photograph Collection, 1850s—, Negative F12350.

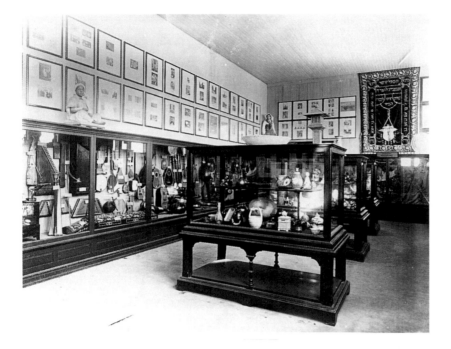

America, which accounts in part for his sympathetic attitude to ceremony.

Given the Diaspora and the debates over the status of Jews as a nation, race, or religion, Adler's approach was an ingenious way to present Judaism as a unified religion and, by implication, Jews as a unified religious community, while "denationalizing" religion. Drawing on Semitic studies as a framework, Adler could also stress commonalities among the peoples of Bible lands and avoid exclusivity in the treatment of Judaism. His exhibit integrated Jews, if only conceptually, into the larger category of Western civilization.[24] Adler's approach was consistent with a more general policy of the National Museum, which treated "special subjects independently of areas or national limitations in order to show the history

of given ideas or endeavors in the human race treated as an entity."[25] The heterogeneity of the United States as a nation of immigrants may have added to the appeal of such integrative arrangements.

Crucial to Adler's success was Hadji Ephraim Benguiat, an antique dealer and great collector of Judaica who had come to Boston in 1888. The Benguiat family, which traced their lineage to eleventh-century Spain, had lived in Damascus, Smyrna, and Gibraltar and established branches of their antique business in major European and American cities. Adler persuaded Benguiat to loan his Judaica collection to the National Museum and to allow the objects to be displayed at the Chicago world's fair in 1893. Some years later, Ephraim's son Mordecai reflected on the ironies of Adler's exhibition.

> It may be a mere coincidence but it is interesting to observe that for the additional education and delight of millions of visitors to a World's Fair for the Celebration of the 400th anniversary of the Discovery of this new world by Columbus, and for the Inauguration of which the Duke of Veragua, a descendent of Columbus, was invited as the Guest of this Nation, one Spanish Jew, whose ancestors were expelled in 1491 from Spain, should lend the Museum of the United States Government for Exhibition in the Government building at the Fair, a Collection of Jewish Ceremonials, including the original Inquisitors' robes, all to help in the celebration of this free land discovered by Spain.[26]

For Mordecai Benguiat, the objects conveyed more than timeless religious ideas. Attending to the specificity of their provenance, he read a history of religious persecution and saw irony in the implications of the exhibit.

Foreign Villages

Live ethnographic displays were a featured attraction at international expositions in Europe and America where entire environments were re-created complete with inhabitants. The displays in Paris in 1889 inspired the planners of the Chicago world's fair to create a special area, the Midway Plaisance, for the foreign villages, as these displays were called.

Though Jews were certainly present on the Midway, they were not installed in a "Jewish village." Where were they? Isador Lewi, in his account of "Yom Kippur [Day of Atonement] on the Midway," reported that

> about four-fifths of the inhabitants of the Turkish village on the Midway Plaisance at the Chicago Exposition were Jews. Merchants, clerks, actors, servants, musicians, and even the dancing girls, were of the mosaic faith, though their looks and garb would lead one to believe them Mohammedans. . . .
>
> The Turkish mosque was so arranged that it could be used as a Jewish house of worship. . . .
>
> It was in this gorgeously equipped and dimly lighted mosque that the oriental Jews assembled on Tuesday evening, September 19, 1893, and read the Kol Nidre services. . . .
>
> They came from all parts of the Orient. Constantinople had the largest representation, though there were men from Adrianople, Tunis, Tripoli, Damascus, Smyrna, Bombay, Calcutta, from Algeria and other Eastern points, and two men from New York. And here it was seen how wise were those who made Hebrew the language of prayer for the Jews. Coming from lands far apart, unfamiliar with one another's language, unable to converse with one another in many instances, still in prayer, by the use of the same language, they were united.[27]

Adler, who had read about the Rue du Caire, the Egyptian Village, at the 1889 Exposition Universelle in Paris, claims that he was the one to suggest to the board of directors of the 1893 World's Columbian Exposition that "having gathered together the products of the world, . . . they ought to go one step further and try to gather together the peoples of the world and show them at their work."[28] It was Sol Bloom who actually visited the 1889 Paris fair. Fascinated with the Algerian Village he saw there, Bloom arranged for the exclusive right to exhibit it in the Americas for two years and became the concessioner for it at the 1893 Chicago fair. Frederic Ward Putnam, the Harvard anthropologist, was in charge of all the anthropological exhibits at the fair, including the Midway, but as it became clear that the Midway was more show business than ethnology, Bloom, a young impressario, was hired to manage it.[29]

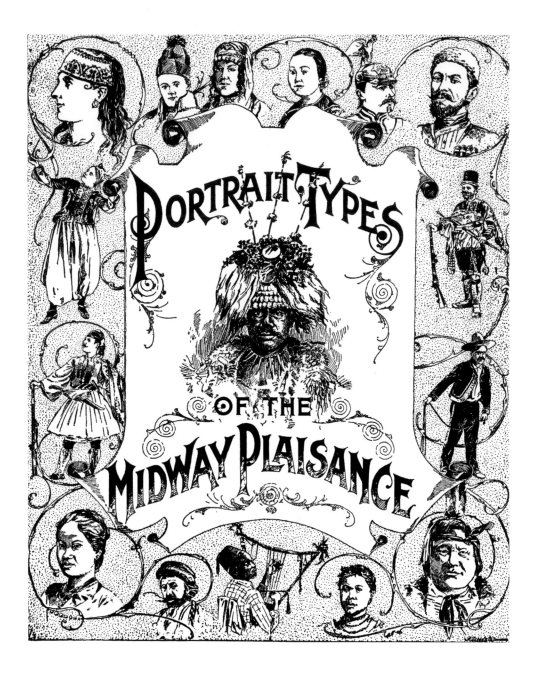

PORTRAIT TYPES

OF THE

MIDWAY PLAISANCE

Cover of *Portrait Types of the Midway Plaisance,* Portrait Types Art Series (St. Louis: N. D. Thompson, 1894). The portrait in the top left corner is identified within as "Rebecca Meise Alithensii. (Jewess.) Though the Jews are no longer a nation and properly claim citizenship in all countries, there is no racial type that has been so persistent through so many centuries and amid such varied environment. Whether in Palestine or America, in the Tenth Century before or the Nineteenth Century after Christ, the Jew shows the same physical characteristics, slightly modified by his surroundings, and the same intellectual acumen and business capacity that have made him the most successful financier in the world. This handsome oriental lady was born of Jewish parents in Constantinople twenty-seven years ago; and, while retaining evidence of her Jewish blood, she is in general appearance a fair type of Turkish beauty, and her dress gives an exact idea of the picturesque and gorgeous costume of that nation. Her husband, a merchant of her native city, was induced to come to the Fair by Mr. Levi and that quaint character, Far-Away Moses, whose portrait will be found on another page. She assisted her husband in disposing their beautiful stuffs, clothing, bric-a-brac, and many quaint curios; and the public was attracted by this beautiful woman as much as by the rare wares they sold. She speaks English quite well with a very fascinating accent, and is exceedingly polite."

Responding warmly to the idea of foreign villages, the board of directors made Adler commissioner of the World's Columbian Exposition to Turkey, Persia, Egypt, Tunis, and Morocco. Everywhere Adler went he visited the local Jewish community and activated a Jewish network. The result, in the case of Turkey, was that Adler gave the concession to Souhami, Sadhullah and Company, which he characterized as "the largest merchants in the Constantinople bazaar." Two of the partners in the company were American Jews. Robert Levy, whose wife, Adele (née Jackson), was one of the principals in the company, ran the Turkish Village and managed personnel in the Near East exhibits on the Midway.[30] Levy brought hundreds of people to live and work in the Turkish Village, which made it one of the largest villages on the Midway. Isidor Lewi's estimate that

four-fifths of the people in the Turkish Village were Jews would seem to be supported by complaints from visitors: "Some have said that all this does not represent Turkey, and that the Turkish village is purely a speculative enterprise of some Oriental Jews," though this observer did concede that "the originators, whoever they may be, are seeking to represent Turkey . . . and have given the village a distinctive Turkish meaning."[31] Levy supplemented his Turkish contingent with young Americans who worked at a variety of jobs, including the serving and selling of soft drinks. A controversy erupted when the women refused to wear so-called oriental costumes, particularly pantaloons. Their objection to "bifurcated garments," even in the interest of ethnographic theater, was part of a larger debate at the fair over dress reform.[32]

Accounts of the fair stressed that, like Constantinople itself, the population of the Turkish Village on the Midway was heterogeneous and included Jews. Furthermore, when he visited Turkey, Adler could not tell Jews apart: "When I first began to walk around Constantinople and the villages I could not distinguish the populations at all. . . . The Jews did not have any distinguishing characteristics."[33] Jews could therefore live and work in the Turkish Village at the Chicago fair *in their capacity as Turks.* Jews also appeared as Tunisians, Algerians, and other Mediterranean peoples, particularly in foreign villages and theaters at the Paris expositions before and after the Chicago fair. As early as the 1876 Centennial Exhibition in Philadelphia, reporters were remarking on the preponderance of Jews among exhibitors from the Levant.[34] Celebrated oriental dancers were billed as Moorish, Tunisian, or Egyptian and assumed to be Muslim, but many were actually Jewish and often from places other than those they represented—La Belle Fathma (Rachel Bent-Eny) in Paris is a celebrated example, as is Rahlo Jammele, who performed in the Moorish Palace on the Midway Plaisance.[35]

There was at least one point, however, where it was deemed important to distinguish Jews, and that was in the photographic portraits illustrating "individual types of various nations from all parts of the world who represented, in the Department of Ethnology, the manners, customs, dress, religions, music and other distinctive traits and peculiarities of their Race."[36] Here, in book form, Putnam finally succeeded in creating the

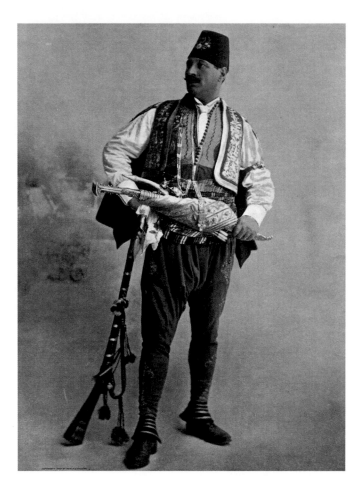

"Mr. R. J. Levi, a Jewish resident of Constantinople, and by profession a chef
and caterer, was the manager and chief proprietor of the Turkish Village and
Theatre. Many of the vendors of Oriental wares in this village were Jews and
personal friends of Mr. Levi; and all returned to the Orient at the close of the
Fair well paid for their enterprise in coming to Chicago. Mr. Levi, when at
home, ranks high in the city of the sublime Porte as a caterer; and it is one
of the curious and suggestive things in connection with the great Exposition
that a man whose training and education has been in distinctly different
channels should have organized and carried to a successful conclusion such
an enterprise as the Turkish Theatre. This is another illustration of the won-
derful fertility of the Jewish mind and the power of the Jew to adapt himself
to any environment, and to utilize every opportunity for pecuniary gain and
personal advancement. Mr. Levi is unusually tall and handsome, and he ap-
peared at the Fair in fanciful garb that gave him a striking appearance."

From *Portrait Types of the Midway Plaisance,* Portrait Types Art Series, vol. 2,
no. 8 (26 April 1894) (St. Louis: N. D. Thompson).

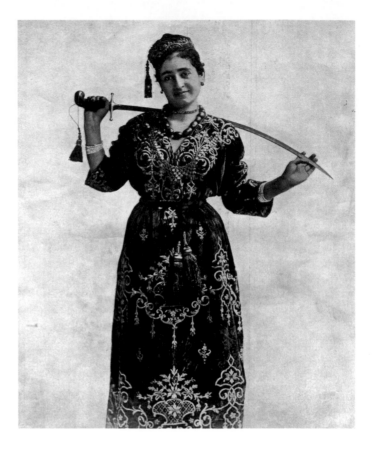

"Rahlo Jammele was another beautiful Jewish dancer who shared the honors with Nazha Kassik at the Moorish Palace. Larger in figure and more fully developed than her light-footed sister she was selected by Milhem Ouardy, the manager, on account of her remarkable cleverness in handling the sword during her dance. Her skill in this particular was one of the acknowledged sights of the Midway. She is a native of Jerusalem, where she early learned the dances of that country; and while still a child she was instructed in the ancient dances of the peculiar people. Her sword dance had in it much that was startling and not a little that was amusing, and never failed to win for the fair performer a generous round of applause. Her dress is of heavy rich material wonderfully embroidered and her shapely head is surmounted with a turban which has a suggestion of coquettishness about it. Like Nazha Kassik, she wears a great necklace of amber beads. Unlike the Egyptian, Persian or Turkish dancers, these Jewish girls moved with a willowy grace in dancing which to Western eyes, trained to the habit of admiring steps in which the feet and ankles play the prominent part, was most pleasing."

From *Portrait Types of the Midway Plaisance,* Portrait Types Art Series, vol. 2, no. 6 (12 April 1894) (St. Louis: N. D. Thompson).

"panorama of the world's races" that he had hoped to realize on the Midway. In this book Jews, and in particular Jews in the Turkish and Egyptian Villages, appear as racial types. The captions to the images address the tension between the individual portrait and the type that it is supposed to represent.

Perhaps the most interesting case is that of Far-Away Moses, who served as Mark Twain's guide in Constantinople. Twain immortalized him in *Innocents Abroad,* which included his portrait, and Murray's *Handbook for Travellers in Turkey in Asia* recommended him to visitors. So colorful a character was Far-Away Moses that after the Chicago fair, instructions for creating little Midways as "burlesque entertainments" recommended "some distinguished characters with leisure to wander around and be only ornamental. 'Far-Away Moses' must be one of these."[37] The caption to his portrait in the album of types of the Midway Plaisance includes the claim that "They [Jews] are very nearly, if not absolutely, a pure race in a sense in which no other race is pure."

Such dragomans (translators) and guides were ideal because they were experienced at explaining their region to strangers. Far-Away Moses was not the only such guide. Solomon Levi, an Egyptian Jew from Cairo and manager of the Soudanese warriors in Cairo Street, was also a professional dragoman and guide and, like Far-Away Moses, was experienced in guiding Americans. Far-Away Moses, according to John J. Wayne, who has explored his history, was actually one of the partners in the company that held the concession for the Turkish Village—he was none other than Harry R. Mandil, one of the two American partners. He was also, Wayne claims, the model for the Semite head in the ethnological series of thirty-three races that adorns the keystones above the windows on the first floor of the Library of Congress.

Why, since Jews were already on the Midway, did they not form their own foreign village? First, there were the logistical problems: given the Jewish dispersal, there could have been as many Jewish villages as there were foreign villages. Should the organizers have selected one Jewish community and re-created, say, a Yemenite Jewish Village, or should they have formed a composite village or a comprehensive series of villages to replicate the Diaspora itself? Second, there was the issue of sponsorship.

A foreign village required considerable financial backing, whether from a foreign government or from a private entrepreneur. Third, there was the pressing issue of how Jews were to be represented, particularly in the American context, where recently arrived Jewish immigrants from eastern Europe were already highly visible on inner-city streets.

Jews were cautious about how they would fare in so public a forum. The *Reform Advocate* struck a cautionary note with respect to the various Jewish congresses—the Jewish Women's Congress and Jewish Denominational Congress (Jews also participated in the Parliament of Religions) —at the Chicago fair: "We have no doubt, our congresses will be among the best attended by—non-Jews. For, there is no use denying it, for many thousands and thousands of non-Jews, we are a curiosity, a freak, an archeological specimen." This is one reason (indifference being another), the article continued, that "[o]ur own coreligionists will be less eager to assist," for each had an "aversion against being paraded as a 'dime museum freak.'"[38]

The mass immigration of eastern European Jews to America was at the forefront of the Jewish Women's Congress that convened at the Chicago world's fair. Social workers like Minnie D. Louis, who spoke at the congress, were more interested in transforming immigrants into Americans than in exploiting their exoticism in foreign villages on the Midway. Using the trope of the city as dark continent, its inhabitants as exotic savages, and the urban experience as "ethnographic sensation"—rhetorical devices well established in late nineteenth-century American and British journalism as well as in Jewish writing of the period—Louis proclaimed,

> See! the claims of the far-away savage heathen that, for so many centuries, monopolized the efforts of the zealous, are no longer paramount. "Borrioboola Gha" has been supplanted by "Whitechapel," "Mulberry Bend," and the nearest district tenements. Instead of the outward-bound ship with its cargo of beads and trinkets and gay calicoes and missals, unfurling the Constantine banner, see the "People's Palace," the "University Settlement," "Hull House," spread their buoyant pennons at our street corners; instead of the sacrament given to wondering, half-dressed, tawny natives in a distant land, see libraries, club-rooms, lecture halls, tradeshops, given to wondering, half-dressed, pale-skinned natives in our own towns.[39]

In other words, Jews could construct a Midway Plaisance of their own in which the attraction would be miserable eastern European immigrants struggling to survive in the crowded tenements of inner-city neighborhoods.

Of special interest is Louis's fear of immigrant solidarity, their tendency to settle in the same neighborhood and transplant their "foreign language and customs," and their political radicalism. At the same time, she criticized the "indiscretion of elevating the unenlightened Jews too suddenly into the unaccustomed atmosphere of culture," noting the ease with which they catch "the infection of culture from the grand dames." Such immigrants were more likely to disdain "plain, home labor" in favor of more glamorous stenographers' jobs. "We do not want so much to Americanize them," she went on, "as to Judaize them, or rather to help them to know their Judaism." She took issue with the tendency to "glorify the Jew, while we almost abandon Judaism," and in this one cryptic formulation captured the essence and ethos of Jewish participation and displays at the Chicago world's fair.[40] Judaism, commonalities among people, and the cause of religious liberty were the priorities for a German Jewish elite fearful that their exotic brethren from the "Orient"—and their visible Jewishness—would erode the inroads they had made in American society.

To be seen or not to be seen? Exhibition or exhibitionism? The Chicago fair could accommodate a wide range of strategies, from the "enthusiastic Americanism" of Jewish immigrants in the grand opening parade to the dignified Judaism in the religion congresses and U.S. National Museum's exhibition of religion.[41] The fair also rewarded impressarios and entrepreneurs, the Sol Blooms and Robert Levys of the Midway Plaisance, and professional culture brokers like Far-Away Moses. While Jews exemplified an ancient and immutable racial type in the portrait gallery, they were indistinguishable from the Turks or Algerians or Egyptians for whom they were proxies in the staging of place: for however strict the purities of a photographic or granite gallery of racial types, the foreign villages, like the places they represented, were heterogeneous. Taken together the diverse forms of Jewish participation at the Chicago fair illuminate the paradoxes of diaspora and the theatricality of race, which needed to be staged to be seen. That staging also offered a place to hide.

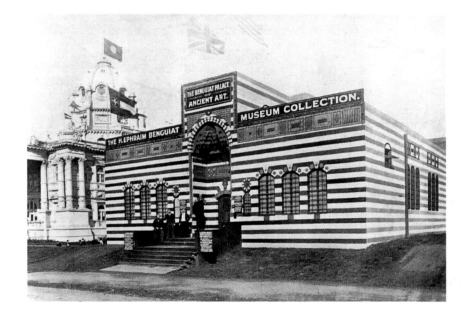

Louisiana Purchase Exposition, St. Louis, 1904

At the time the Louisiana Purchase Exposition was being planned, Adler was librarian of the Smithsonian Institution and no longer curating exhibitions. Ephraim Benguiat seized the opportunity to mount his own collection exactly as he saw fit—in a building that he had added to his collection, a reproduction of the Damascus Palace rooms. Fair visitors were enthralled by palatial rooms that Benguiat had fully furnished, as well as by the "museum," which consisted of collectanea in glass cases and on platforms and walls in galleries. This installation exemplified the very opposite of Adler's scientific approach. Where Adler saw representative ob-

"General Interior View of the Damascus Palace."

From *Fine Art Portfolio Illustrating Some of the Exhibits of the H. Ephraim Benguiat Museum Collection and the Historical Damascus Palace* (St. Louis: Louisiana Purchase Exposition, 1904), 11.

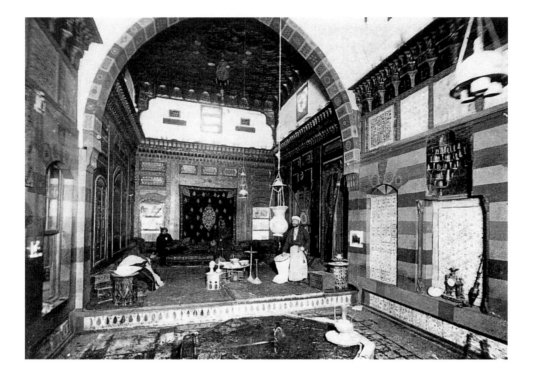

jects of cult that might communicate religious ideas in an exhibition, Benguiat saw singular instances of perfection: "Only the perfect of its kind is worth collecting" was Benguiat's motto. The H. Ephraim Benguiat Palace of Ancient Art won the Grand Prix at the Louisiana Purchase Exhibition.

By Benguiat's own account, he had long admired the Damascus Palace rooms, which were part of the ancient ruins in the Maidan in Damascus. Having tried without success to acquire a facsimile of them for a wealthy patron who knew his reputation for fully furnishing period rooms, Benguiat was astonished to discover that the Turkish government, with the

financial backing of four private citizens, had sent a copy of the Damascus Palace rooms to the Chicago world's fair in 1893.[42] At the end of the fair, Benguiat outbid Marshall Field for the rooms: he negotiated with the owner of the rooms, bought out the other shareholders, and "traded rugs for palace."[43] In the decade between the Chicago and St. Louis fairs, Benguiat stored the dismantled palace rooms. In 1904, he restored them on the grounds of the Louisiana Purchase Exposition to house his fabulous collection.

This privately owned building was situated on International Avenue on the Plateau of Foreign National Buildings and was filled with the former possessions of royalty and vanquished states—the plunder of the Spanish-American War of 1898, featuring "Philippine war loot," was a special attraction—as well as Jewish ceremonial objects. Everywhere the exhibit spoke to Benguiat's power to acquire, a power that was compared with that of monarchs and other heads of state. Not only was his Damascus Palace situated with other national pavilions on International Avenue, he had acquired the former possessions of monarchs, including a choice rug from the floor of the Alhambra. A special correspondent to the fairgrounds, Mark Bennett, wrote at the time, "The queen's jubilee gifts are tinsel in comparison with some of the works in the Benguiat collection. . . . Here is a Chinese bed of carved teak wood finer than anything in the Chinese government exhibit." Benguiat's acquisitions outshone the accumulations of treasures in the national buildings.

Entitled *Fine Art Portfolio, H. Ephraim Benguiat Fine Art Museum Collection and the Historical Damascus Palace,* the souvenir booklet featured endorsements from such luminaries as Frederick W. Putnam, director of the Peabody Museum ("A grand collection and one that should be kept in this country. As one looks about gems of art are everywhere"), W. J. McGee, chief of the Department of Anthropology, Louisiana Purchase Exposition ("A revelation; the rending of the veil over the olden time"), and S. C. Simms, Field Columbian Museum ("A jewel box of gems").

From the outset, Benguiat classified his entire collection as "fine art," and he and others referred to his possessions as gems and jewels. Though historical associations were not enough in themselves to make an object

worthy of acquisition, narratives of acquisition and the ironies of prov-
enance did add interest to choice items in his collection. The object be-
came the denouement of a story featuring the collector as protagonist. In
contrast, Adler's catalog entries for Judaica from Benguiat's collection in-
dicated where and when the object was made and used, if known; the di-
mensions, materials, and technique; translations of Hebrew inscriptions;
the lender or donor; and above all the customs and beliefs associated with
the object. They did not generally elaborate on the history of how the ar-
tifact had been acquired.

For his part, Benguiat had little patience with Adler's scientific
approach.

> I care not to collect curios and antiquities—mere curios and mere antiq-
> uities, mere articles of historical interest. That does not satisfy me. Where
> there are curios I see the pearl of curios. Where there are antiquities I seek
> the beautiful and perfect, the gem of its kind. Of historical objects my
> wish is for the beautiful, the valuable and the genuine—not merely those
> having historical associations. But that is for myself. All collectors are not
> so exacting.[44]

Even Benguiat became an object of attraction—as a newspaper headline
declared, "Hadji Ephraim Benguiat and His Red Fez and Black Beard
Have Made Themselves a Feature of Antiquarian Interest Here."[45] Sin-
gularity thus extended to the collector himself. He became, in a sense,
part of the collection: photographs of Benguiat at the St. Louis world's
fair showed him in "Oriental" dress, lounging in the palace rooms as if he
inhabited them. By integrating himself into the exhibition as one of the
attractions, Benguiat capitalized both on his own exoticism as a kind of
living ethnographic specimen and on his power as an astute collector and
businessman.

Arranged without apparent system or extensive labels (by professional
museum standards of the period), Benguiat displayed his treasures in
two ways: in completely furnished period rooms and as collectanea in
glass cases, arranged by type of object (costumes, arms, lace, etc.). In a
word, this was an arrangement that Adler and others would have viewed

"An Interior View of the Museum. . . . The lower part of the picture illustrates some objects of Jewish ceremonial, to be added to the H. Ephraim Benguiat Collection in the United States National Museum, at Washington, D.C."

From *Fine Art Portfolio Illustrating Some of the Exhibits of the H. Ephraim Benguiat Museum Collection and the Historical Damascus Palace* (St. Louis: Louisiana Purchase Exposition, 1904), 31.

as a cemetery of bric-a-brac. To characterize this installation as without order, however, is to miss its internal logic, which is predicated on enumeration, accumulation, and singularity, and its larger concern—the collector. Enumeration rather than taxonomy guided the display, for Benguiat was more interested in unique objects than in representative examples of a class of artifacts. Far from being shown like a heap of debris, the massive accumulation of objects focused the viewer's attention on the collector and on the wonder of acquisition. For Benguiat, the more singular and valuable the object, the more singular the collector who could acquire it. The objects' very profusion was intended to amaze visitors that an ordinary mortal could possess such things. Who among them could imagine owning a fully furnished palace or "collection of looted Greek textiles and embroideries brought to Smyrna by the Turkish soldiers during the Turko-Greek War, 1897"?

Both the display and the portfolio consistently told a story of prodigious value, aristocratic provenance, and wondrous acquisition through the aggrandizing ethos of spectacle.[46]

Exposition of the Jews of Many Lands, Cincinnati, 1913

Twenty years after Minnie D. Louis delivered her address at the World's Columbian Exposition in Chicago, the Exposition of the Jews of Many Lands celebrated "immigrant gifts" to America as a way of redirecting the entire project of Americanization. Inspired by the national pavilions and foreign villages so prominent at international expositions, the social worker Boris D. Bogen mounted a Jewish world's fair in miniature at the Jewish Settlement House in Cincinnati in 1913. On the eve of World War I, as pressure mounted to pass restrictive immigration legislation, social workers tried to foster appreciation of immigrant cultures in the hope that if immigrants were valued, they would be treated more fairly and would respond more warmly to Americanization efforts.

The historical context of Bogen's effort was not the Gilded Age of the Chicago world's fair but the Progressive Era, not the teeming immigrant quarters of Chicago and New York but Cincinnati, the center of the Reform Jewish movement in the United States. Restrictionists were agitating with increasing vigor for legislation to stem the tide of immigrants.

About a million immigrants were arriving annually, and revolution and war in Europe guaranteed a continuous flood of new refugees. The Treaty of Versailles, at the end of World War I, would redraw the European map and attempt to guarantee the rights of national minorities within newly created republics in central and eastern Europe. With American nationalism on the rise, "inassimilable aliens" on American soil saw their national aspirations fostered in Europe even as they faced increasing hostility in America: conservative intellectuals who envisioned a great melting pot or aimed to preserve Anglo-American superiority had little patience with the foreigners in their midst. In opposition to them, liberal intellectuals such as Horace Kallen, who coined the term "cultural pluralism," and Randolph Bourne, who proposed a "transnational America," condemned the position that immigrants should be stripped of their "ancestral endowment" and proposed instead that cultural differences be respected as part of "American civilization."[47] These views were to inform social work among immigrants, nowhere more clearly, perhaps, than in the many homelands exhibitions and festivals during the first three decades of the twentieth century.

From 18 to 26 January 1913, the entire building of the Jewish Settlement House in Cincinnati was "utilized for booths, each one representing the settlement of Jews in another land, and each presided over by men and women in the picturesque costume of that land."[48] In his textbook for training professional social workers, Bogen, who was superintendent of the United Jewish Charities of Cincinnati and director of the settlement house, described the exposition at length.[49] The event, scheduled to coincide with the convention of the Union of American Hebrew Congregations, featured the Jews of twenty-seven countries (including the United States and Abyssinia) and brought together four hundred volunteers, fifty-one local Jewish organizations, and twelve national, philanthropic, and educational organizations, which among them covered a wide spectrum of Jewish life in America, from labor unions to Zionist associations.

What did Bogen exhibit? First, there were "over four hundred charts and tables covering the entire history of the Jews of twenty-seven countries, with statistical data and describing present conditions," including the growth and achievements of Jews in the United States. Second, "there

were living demonstrations of the costumes worn by Jews of the different countries, and in the case of the United States, the uniform of the West Point cadet and the athletic attire of a Vassar maid were taken as characteristics."[50] A bearded Jew wearing a caftan represented the Balkans. Third, there were over five hundred objects, most of which, the program booklet explained, were "relics [that] have been brought over by the Jewish immigrants when seeking new homes . . . [or] brought back by tourists who have taken enough interest in their religion and their people to care to have curios around them."[51] From "rich and poor" alike came the loan

"Balkan Territories" booth at the Exposition of the Jews of Many Lands, Cincinnati, 1913.

From Boris Bogen, "Jews of Many Lands," *Jewish Charities* 3, no. 10 (May 1913): 8. Collection of the YIVO Institute for Jewish Research.

of ceremonial objects, "attributes of the foreign household," and examples of "women's handiwork" created with the needle and that "indicated the innate love of the beautiful."[52]

The list that appears in the program affords an unusual glimpse into the contents of Jewish immigrant homes in Cincinnati in 1913, but from a special perspective. Most of the items on the list are objects that immigrants valued enough to save and bring with them. These objects now represented the many lands from which they had come. Each lender was identified by name and address. There were tools and utensils: samovars, coffee grinders, a brass bowl for cooking jellies, soap, a shoe last, an old quart measure, a set of plates with the heads of the king and queen of Hungary, and a printing press "used for printing nihilist and anarchist notices." There were household textiles of all kinds: lace, towels, bedding, embroideries, and items from a trousseau. There were clothing and jewelry: a Russian sable fur coat, a handmade purse in the shape of a Russian soldier's cap, a watch fob engraved with the Ten Commandments, a nightgown, and a peasant blouse. There were ritual objects: the prayer shawl of the "original weaver killed in the Kishineff Progrow [*sic*]," an old Passover *kharosis* dish, Torah ornaments, and prayer books. And there were decorative objects, certificates, and miscellanea: Chinese gongs, beaded pictures of Holy Land scenes, items made by Bezalel craftsmen in Palestine, European money, and copies of sculpture by Ezekiel.

The program included a variety of performances, from a Russian "recital of continuous suffering and oppression" and pageants on the theme of Israel Zangwill's "Melting Pot" to tableaus, or "living pictures," on such subjects as the "Maidens of Many Lands," Samuel Hirszenberg's painting *Galut,* and Ezekiel's *Religious Liberty.* The Turkish Jews living in Cincinnati presented their songs and dances, a large chorus sang Jewish songs of various countries, and professional musicians performed during the Cantata Evening. The recently formed Young Women's Hebrew Association (YWHA) presented "national dances," and the Young Men's Hebrew Association (YMHA) offered an athletic exhibition. The Jewish Mothers' Club served Jewish specialties at a lunch counter.

The contrasts with earlier exhibitions and their organizers are striking. First, Bogen was an immigrant himself. He was a Russified Jewish intel-

lectual from Moscow who had learned Yiddish on the Lower East Side of New York City. Politically radical, he worked as a journalist and then as a social worker. Second, he served immigrants in a local Jewish settlement house, unlike the academics and private collectors who organized displays in museums and palaces of art. Third, Bogen mobilized broad community support and participation, instead of depending on the efforts or collections of a single person or organization. Perhaps most important, Bogen affirmed Jewish particularity and heterogeneity in cultural terms. Not fine art and not Judaism as an ancient religion, but the diversity of Jewish life as lived across the globe was on display. Also on view was the settlement house itself, the agency for helping immigrants adjust to American life.

The program booklet characterized this exposition as "a new and wholesome departure in the realm of settlement activity" because "it represents a return to Jewish ideals. . . . This past of the Jew has often been neglected by Jewish settlements in planning their work."[53] Bogen also noted the growing gap between immigrant parents and their American-born children as well as divisiveness among Jewish groups of differing religious, political, and cultural persuasions. Recognizing that immigrants tended to be wary of settlement workers, particularly those who viewed immigrant languages and cultures with disdain, Bogen was convinced that appreciation of the diversity of cultures represented by the Jews of Cincinnati was essential to the success of the Jewish Settlement House. The decision was made in 1912, after several false starts beginning in 1909, to "make Jewish culture the central idea of all activities" at the Jewish Settlement House.[54] The Exposition of the Jews of Many Lands offered "concrete proof" of the success of this initiative and put on display the settlement house as an agency and social work as a profession.

There is evidence to support the claim that the Exposition of the Jews of Many Lands was a new development in the history of Jewish settlements in America. Reformers of the 1890s, like Minnie D. Louis, for example, viewed the kinds of cultural particularities celebrated in Cincinnati as an impediment to Americanization and a mistaken emphasis upon Jews rather than Judaism. In contrast, Bogen characterized efforts to strip immigrants of their language and customs as a "policy of inflexible

Americanization," which he attributed to German Jewish philanthropy and which he viewed as a deprivation unique to Jews. He noted by way of contrast that second-generation German immigrants continued to speak German and to sing their songs and that "in the Civil War there had been several regiments of German immigrants to whom commands were given in the German language."[55]

Consistent with Bogen's concerns, *The Significance of Recent National Festivals in Chicago,* a report issued by the Playground Association of America in 1908, also expressed concern that foreign ceremonies were disappearing and attempted to elucidate under what conditions they thrive and decline. After noting that seventy thousand Norwegians in Chicago celebrate their national day, a tradition in the city for the last twenty years, and proceeding to the Swedes, Hungarians, and Irish, the author briefly mentioned the Sicilians, Chinese, Lithuanians, Slavs, Welsh, and Jews, who, she wrote, "walk the endless labyrinth of the Jewish market into which Passover turns the street and curbs of the Ghetto, when every household must be purified and burnished."[56] She concluded with praises for the Play Festival of Chicago, which brought together on one city green diverse national games and dances and developed "a higher variety of cosmopolitanism which may be claimed to be America's destiny."[57] It would be hard to imagine Passover purification as part of such an event.

Nor did Jews represent themselves through their "national" traditions at the Chicago World's Columbian Exposition, where they were conspicuous by their absence from programs organized along these lines. Friedrich S. Krauss, a distinguished Jewish folklorist and ethnographer specializing in the South Slavs, came to the Chicago fair from Vienna. He was indignant that Yiddish was not among the forty-seven languages represented in the folk song program at the International Folk-lore Congress that was held at the Chicago fair and wrote to a colleague in Warsaw, "It is a great pity that American Jews, for the most part from Russia and Poland, do not understand the importance of Yiddish folksongs. Unfortunately, Rabbi Jastrow [a colleague of Cyrus Adler] fails to see their importance as well. I will try to interest the German-Jewish press."[58] On his return to Vienna, Krauss wrote a letter to the *Journal of American Folklore* in which he appealed to scholars in America to collect Jewish folklore

before it was too late: "Even now, at the eleventh hour, it is possible to note and record for the purposes of science a folk-life which is in the process of rapid decay—I mean that of Jews."[59] By 1904, the Yiddish folklorist Y. L. Cahan had arrived in New York and was actively collecting folklore from eastern European Jewish immigrants in America. Bogen's efforts are all the more significant in this context.

"Homelands" exhibitions like the Exposition of the Jews of Many Lands were to proliferate over the next two decades.[60] They were built on the model of world's fairs but turned them upside down, for the participants were new Americans who were here to stay, not foreign governments or exotic visitors from distant lands. Cincinnati's Exposition of the Jews from Many Lands was a tour de force in the way that it integrated diverse aspects of a living Jewish community, deployed so many kinds of display, affirmed the Diaspora, and represented Jews in terms of the heterogeneity of Jewish culture rather than the unity and antiquity of normative Judaism.

Zionist Pageants and Pavilions: Wembley, Chicago, Paris, New York

Meyer Weisgal's Zionist pageant *The Romance of a People* at the 1933 Chicago fair and the Jewish Palestine Pavilion at the 1939 New York World's Fair were radical departures from the displays discussed thus far, though the Exposition of the Jews of Many Lands contained many of the elements that Weisgal was to exploit on a much larger scale. World War I had changed the European map, restrictive legislation had brought immigration to America to a trickle by 1924, and the period of mass migration was over. With the world depression and the rise of fascism in Europe and anti-Semitism in the United States, relief efforts and the pressures to form a Jewish state intensified. During the thirties in America, Zionism was on the rise across the Jewish spectrum. It is in this context that Weisgal organized his extravagant pageants and ambitious pavilion, ventures that were national and international in scope and explicit in their fundraising, relief, and political goals. They are extraordinary examples of the use of performance and exhibition for political mobilization.[61]

The history of Jewish Palestine pavilions is linked to Holy Land displays, to Palestine exhibits in British colonial expositions, and to fairs that were mounted in Palestine. World's fairs during the nineteenth century had featured displays dealing with the Holy Land—for example, Adler's exhibitions of biblical antiquities—and scale models of Jerusalem of the kind seen in Vienna in 1873. The Jerusalem Exhibit at the St. Louis fair in 1904 was to cover ten acres, feature five hundred natives, and cost $1,400,000, according to the prospectus. At their fund-raising bazaar and fair in New York City in 1916, the People's Relief Committee for the Jewish War Sufferers promoted a "Palestine exhibit" in the form of a Bedouin Village, with one hundred and fifty people in costume—"See and show your children how our ancestors lived in Biblical Times."[62] These displays focused on the distant past.

Zionist displays looked to the future. They used the past, understood as deep Jewish roots in the land of the Bible and a subsequent history of persecution, to add weight to the legitimacy of a future Jewish state in Palestine and its practical necessity. Exhibitions demonstrating the potential and success of agricultural and industrial development there attested to the feasibility of such a state. Palestine exhibits intended to spur trade and investment, as well as Jewish colonization, had been appearing since the 1890s, often in connection with Zionist congresses and with British imperial displays.

The Palestine Pavilion at the 1924 British Empire Exhibition in Wembley, for example, shared a building with Cyprus for economic reasons. It combined "government stalls" showing the accomplishments of the Palestine government under the British Mandate (railway, post office, schools, public health, natural resources and investment opportunities) with "Zionist stalls" devoted to Jewish efforts to build a Jewish homeland, including agriculture (Arab agriculture was exhibited by the government), manufacture and trade, industry and commerce, as well as arts and craft. The Bezalel School of Arts and Crafts had a stand and two Yemenite craftsmen demonstrated silver filigree work in an annex to the pavilion. A second annex featured "large models of the Tabernacle of the Exodus, the Temple, and the Dome of the Rock," courtesy of the Pro-Jerusalem Society. One reporter complained that the models were "somewhat

shoddy in appearance, and it is a pity that one of the lecturers on the Temple appears in Eastern costume with a very occidental collar and tie," his khakhi trousers and boots showing beneath his flowing burnoose.[63] Costumed lecturers gave tours of such models, as well as of dioramas and panoramas of Jerusalem or the Holy Land, a popular genre during the nineteenth century.

Though recognizing that Palestine under the mandate was not technically part of the British Empire and that the Palestine Pavilion itself left much to be desired, the *Jewish Chronicle* proclaimed that the pavilion's very existence exhibited a rapprochement of British and Jewish interests:

> The inclusion within the Exhibition of a Palestine Pavilion is . . . a token that, albeit embryonically, the Jewish nation has become part of the British Empire. . . . It were well for Great Britain to understand, and for the British Empire to appreciate, the immense moral gain they have acquired . . . in thus enfolding the Jewish nation within their bosom. With a proper understanding of the true position on both sides, there is room ample and to spare for the development to the fullest degree of Jewish National aspirations consistent with the very best interests of the British Empire. . . . Thus the great Exhibition, which has drawn together representation from every corner of the Empire upon which the sun never sets, by the inclusion within it of the Palestine exhibit makes manifest to all the new relation that now subsists between the British Empire and the Jewish people.[64]

Shortly after the British Empire Exhibition at Wembley, between 1926 and 1929, the British Mandatory Government organized several agricultural exhibitions in Palestine.

The quality of the exhibits themselves became more professional with the advent of the Levant Fairs in Tel Aviv in the twenties and their blossoming in the thirties. These fairs not only promoted trade and industry but also showcased the talents of the Levant Fair Studios in the design and fabrication of exhibits.[65] Recognizing the power of display to encourage economic development, this company circulated exhibitions promoting Palestine trade and industry through central and eastern Europe.

It also established a Museum of Palestine Home Products in Tel Aviv.

At the same time, the Bezalel National Museum was established in Jerusalem (1922) and a major exhibition of "Palestine Arts and Crafts" celebrating the twentieth anniversary of the founding of the Bezalel School of Arts and Crafts of Jerusalem opened in New York in 1926. As the epitome of a Jewish national art movement in Palestine, Bezalel became a regular feature of exhibitions devoted to Jewish Palestine at Zionist congresses, world's fairs, and elsewhere.

By the thirties, the Levant Fairs were occurring at regular intervals at a large permanent exhibition site on the outskirts of Tel Aviv, and the Levant Fair Studios were producing exhibits for Palestine pavilions at fairs in Paris (1931, 1937) and New York. These exhibits were to be about Palestine right down to their very fabrication, a point that was stressed both in official fair publications and by the exhibition of a glass model of the Levant Fair inside the Palestine Pavilion at the 1939 New York World's Fair.[66]

Zionist Pageants

During the early thirties, when he was looking for a powerful way to mobilize support for the Zionist cause, Meyer Weisgal rejected the idea of a building or exhibit. The child of eastern European Jewish parents—his father was a cantor and he described his mother as a revolutionary—and an ardent Zionist, Weisgal capitalized instead on the ability of pageants to mobilize vast numbers of people in a single spectacle, first with *Israel Reborn* at the 1932 Hanukkah Festival and again with *The Romance of a People* at the 1933 Century of Progress Exposition, both in Chicago. In his memoir, published in 1971, Weisgal described the situation he faced at the time.

> The Zionist field in Chicago was strewn with dry bones and a thousand speeches were not going to revive them. The leadership was confined to two or three men, and they were powerless against the inertia of the community. I realized at once that in these circumstances pedestrian Zionist

propaganda and routine education, however well intentioned, would produce no effect. There had to be, first, a reawakening, and I turned to the performing arts—music, drama, spectacle.[67]

The pageant would tell the story of the ancient struggle of the Jews, using the machinery and properties of the Chicago Opera House, which had recently produced *Aida*. According to Weisgal, "The highlight of the evening was to be: *no speeches!* The spectacle would deliver its own message. This was an unheard of proposal: a great Zionist affair at which the local Zionist orators would keep their mouths shut."[68]

The timing of the preparations for the Hanukkah Festival coincided with the organization of the 1933 Century of Progress Exposition. As Weisgal recalled, "The Jews of Chicago had been asked to participate, and negotiations and confused discussion went on for months as to whether the Jews were a race, a religion, or a nation, and whichever they were, could they appropriately be represented by a building." Weisgal called for "not a building, not an exhibit, but a spectacle, portraying four thousand years of Jewish history; it would have everything, religion, history, the longing for Zion, the return to Zion, and it would be called *The Romance of a People*. It would have something for everybody, Zionists, non-Zionists, the religious, the nationalists, everybody."[69]

Weisgal had three goals: to further the Zionist cause by gathering support and raising funds; to amplify the voice of protest against Hitler and raise money to help Jews leave Germany; and, at the same time and through these efforts, to stage a strong show of American Jewish solidarity. To galvanize Jewish interest on a national scale, Weisgal invited Chaim Weizmann to make an opening speech, promising him one hundred thousand dollars for his Zionist Central Refugee Fund. Weisgal made the proviso, however, "that he was to make *one* speech. If two, the fee would go down to fifty thousand dollars; if three, to twenty-five thousand dollars."[70] Weizmann at the time was specially concerned with raising money to help Jews fleeing Germany to settle in Palestine. By Weisgal's account, 131,000 people attended the pageant, thousands were turned away, and the pageant broke all attendance records at the fair.

A second opportunity to orchestrate Jewish participation at a world's fair arose when Henry Montor, chief fund-raiser for the United Palestine Appeal, approached Weisgal about Jewish participation in the New York World's Fair of 1939.[71] Again, Weisgal succeeded in attracting record-breaking crowds, this time to the Jewish Palestine Pavilion, which he claimed was "the first Palestine exhibit at an international exposition in the United States."[72] The presence of Albert Einstein at the opening helped produce the largest single day's attendance in the history of the fair, according to Weisgal. In all, more than 2 million people visited the pavilion.[73]

In a chapter of his autobiography entitled "A Jewish State in Flushing Meadows," Weisgal characterized the Palestine Pavilion as "showman-

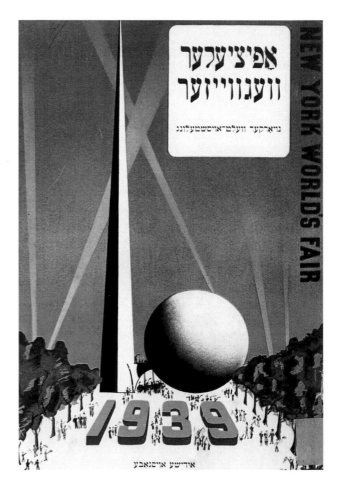

Cover of Yiddish edition of the *Official Guide to the New York World's Fair* (New York: Exposition Publications, 1939). Collection of the YIVO Institute for Jewish Research. Whereas the English edition included but one paragraph on "Palestine Exhibits, Inc.," the Yiddish edition devoted an entire chapter to the "Land of Israel Pavilion."

ship of another kind."[74] Its location on the Flushing Meadows fairground, however, became a major bone of contention. "One section had been set aside for the national pavilions, and that is where I wanted us to be. There was of course no Jewish State as yet, but I believed in its impending arrival on the scene of history, and I wanted the idea of Jewish sovereignty to be anticipated there, in Flushing Meadows."[75]

The design of the Jewish Palestine Pavilion and its contents was in accord with Weisgal's desires, which was "something authentically Palestinian" to show that "in 1938 Jewish Palestine was a reality; its towns, villages, schools, hospitals and cultural institutions had risen in a land that until our coming had been derelict and waste. . . . I wanted a miniature Palestine in Flushing Meadows."[76] Only after objections that the Palestine Pavilion did not represent Arabs in Palestine did Weisgal agree to change its name to Jewish Palestine Pavilion. Insisting—with no trace of irony—that the pavilion should steer clear of politics, Weisgal applied himself to the "construction of the Jewish State under the shadow of the Trylon and Perisphere, or, as the Jews were fond of calling it, the Lulav and Esrog."[77] Winning the battle over location at the fair was critical to the success of Weisgal's construction: "Located as we were on the borderline of the National Pavilions, there was always some question as to whether or not we really 'belonged.'"[78] The exhibits in the Jewish Palestine Pavilion, by following the model of national buildings, simulated the state before it was legally formed. Indeed, as Weisgal pointed out, "In one particular respect, The Palestine Pavilion is unique: It is a national exhibit not sponsored by a government."[79]

Interestingly, there was no room for ceremonial art created in the Diaspora, in striking contrast with the earlier exhibitions of biblical antiquities and religion organized by Cyrus Adler. During the late thirties, Benjamin and Rose Mintz, "ardent Zionists and devout Jews," attempted to leave Poland. They had applied for visas to visit America and had been refused. Benjamin was an antique dealer and collector who had amassed a fine collection of Judaica, which they hoped to sell in America. Max M. Korshak had the idea that if the collection could be exhibited at the New York World's Fair, the Mintzes might get temporary visas to accompany the objects. Their intention was to settle permanently in Palestine, using

money gained from the sale of the collection, a prospect they were not able to realize because the market was depressed at the time. Korshak proposed the inclusion of the Mintz collection in the Jewish Palestine Pavilion, which Weisgal rejected. According to Korshak, "Mr. Weisgal felt, for some reason that I never understood, that the collection was not suitable as a Palestinian Exhibit since the articles were not products of Palestine,

although he did admit that it was a product of the Jewish heritage."[80] The collection and the Mintzes were allowed out of Poland in anticipation of the exhibit, but the collection was never shown at the fair. The objects were stored in a warehouse and later purchased for the Jewish Museum.

Temples of Religion

The Jewish Palestine Pavilion was in keeping with the World of the Future theme of the New York World's Fair, a factor in its acceptance by the fair organizers.[81] At the same time, fixtures of earlier fairs were either eliminated or reconceived. Located right next to the Jewish Palestine Pavilion, the Temple of Religion was to embody the general theme of religion, rather than feature ongoing exhibitions of particular denominations.

In this way the Temple of Religion at the New York World's Fair distinguished itself from the Hall of Religion at the 1933 Century of Progress fair in Chicago and the Temple of Religion at the Golden Gate International Exposition in San Francisco in 1939, both of which featured exhibits of specific religions. San Francisco's Temple of Religion promoted an ecumenical and cooperative spirit that would celebrate what particular religions had in common: Rabbi Rudolph I. Coffee declared, "We were hoping to erect a building in which various religions would cooperate but would in no manner make manifest that they considered theirs to be THE religion. True, at the Century of Progress in Chicago there had been a Hall of Religion but unfortunately religious differences were stressed there. In Chicago, religious groups bought space and held individual exhibits, some groups distributing literature of their own churches."[82] Indeed, world's fairs were a prime arena for proselytizing and Jewish exhibitors and visitors a prime target.

In San Francisco's Temple of Religion, two exhibits were of Jewish interest. First, the archaeological exhibit prepared by the Palestine Institute of the Pacific School of Religion featured excavated materials, photographs of Arab life in modern Palestine, presumed to have changed little from ancient times, and models (including one of the Tower of Babel) to convey as best they could one hundred thousand years of Palestinean history as the historical background of Judaism and Chris-

tianity. Second, the Jewish exhibit focused on "the vital and eternal aspects of Judaism," as seen through ceremonial art organized according to the annual cycle of holidays and life cycle rituals in the context of family life. Books, maps, and charts delineated the history of the Jewish people and relationships between Judaism and Christianity.[83]

At the New York World's Fair, religious denominations were not the only ones without dedicated exhibition space. Women were also without their own section or building. The objective was to achieve here what women had failed to do elsewhere, namely, to integrate women into all the principal categories of the fair. It was thus in the Temple of Religion that the Women's League of the United Synagogue of America, a Conservative Jewish organization, presented a pageant entitled *The Jewish Home Beautiful*.

According to Betty Greenberg, "The pageant . . . is not presented as a museum piece, as something to admire and then to forget, or merely to recall in conversation. Its purpose is rather to urge every mother in Israel to assume her role as artist and on every festival, Sabbath, and holiday, to make her home a thing of beauty as precious and elevating as anything painted on canvas or chiseled in stone. . . . A little skill and love and understanding can transform the humblest surroundings into a sanctuary more holy and beautiful than the house decorated elaborately, but without love and intelligence and religious warmth."[84] The author went on to explain that women had been turning to Christmas and Valentine's Day features in women's magazines and department stores for holiday ideas. Encouraging them to search more deeply into "their own treasure house," the pageant presented mothers and daughters at a series of holiday tables.

In a fair that celebrated the World of Tomorrow in the streamlined terms of high technology, this pageant emphasized the aesthetics of ritual, the artistic creativity of the Jewish woman, and nostalgia for yesterday. It recast the "kitchen religion" valorized at the Jewish Women's Congress in Chicago in 1893. There, Mary Cohen had spoken to her audience about the influence of the Jewish religion in the home. Apologetic in tone, she explained that Christian readers of Israel Zangwill's *Children of the Ghetto* might come away with an unfavorable impression of the poor Jews described there, whereas a more enlightened reader will see the

"Hanukkah Table," one of a series of holiday tables in *The Jewish Home Beautiful,* a pageant by Althea O. Silverman presented at the Joint Sisterhood Assembly in the Temple of Religion at the New York World's Fair, September 1940. "The table is set for a dessert supper party for six or eight people. . . . The centerpiece is a very attractive Menorah. . . . Shining new pennies, dreidlach [spinning tops], a Jewish National Fund box [in support of Jewish Palestine] and some Women's League publications are also properly spaced on the table. Place cards, cut in the form of a hammer with the name on the handle, and individual small candy baskets in the shape of oil cruses filled with Palestinian candy, add a decorative touch. Two large platters of lotkes [pancakes], at least one of which should contain potato lotkes, a large Menorah fruit salad, a tray of heizen-blozen [pastry fried in oil and dusted with powdered sugar], a fancy cake, candy, etc., help to complete the festival requirements."

From Betty D. Greenberg and Althea O. Silverman, *The Jewish Home Beautiful* (New York: National Women's League of the United Synagogue of America, 1941), 25. Photo courtesy of Women's League for Conservative Judaism.

"wondrous loyalty to the God of the People." Affirming religious faith in the face of ugliness, Cohen defended traditional forms of piety before an audience of Reform Jewish women, who experienced ceremonial punctiliousness as aesthetically offensive. Faithfulness to her husband and children, hospitality, moral force, and character were the terms in which Cohen defined the Jewish woman.[85]

In 1940, *The Jewish Home Beautiful* suggested that Jewish life required more than "faith, knowledge or observance." It required art: "To live as a Jewess, a woman must have something of the artist in her. . . . The Jewish woman today, guided by the memories and traditions of yesterday, must herself create new glory and new beauty for the Jewish home."[86] Art in Jewish life became the charge of the Jewish woman, and her home became the place to exhibit her artistry. The world of tomorrow would include not only a Jewish homeland in Palestine, but also a Jewish home right in the heart of suburban America.

With such high stakes—freedom of religion, safe haven from persecution, social integration, group survival, statehood—some Jews seized the opportunity to be seen and heard, to be amplified by the international exposition, while others cautioned against such hypervisibility. Taking control of the discourse on Jews, the events and exhibitions discussed here reveal how display constitutes its subject. It does so by way of an exhibitionary logic that dictates the classification of objects, their arrangement in space, their status as art or artifact, their contextualization, their animation and mode of display. The agency of display, as analyzed here, is not to be folded into "the image of the Jew" or even representation, whether discursive or demographic. Display not only shows and speaks, it also *does*—with greater or lesser success. Clues to the agency of display lie in the social processes from which it emanates and in which it eventuates. Weisgal understood this perfectly well when he wrote that "the Palestine Pavilion is a potent instrument for the enlightenment of world public opinion."[87] Less than a decade later the state of Israel was formed. From then on, Jewish national exhibits at world's fairs were sponsored by the state of Israel.

A Second Life as Heritage

Destination Museum

When Gatwick Airport's theme park opens in 1998, visitors for whom the experience of actual travel is no longer enough will be taking "a tour through baggage, security and emergency facilities, a mock control tower where visitors can have a go at landing planes and a 'white knuckle' ride through a replica of a baggage handling system."[1] The very trials and tribulations of travel are becoming attractions in their own right through principles that have long connected tourism and museums.[2]

Whole countries market themselves as "the world's largest open air museum." Deep in this marketing ploy for Turkey is the unnerving insight that tourism may beat museums at their own game by enabling travelers to encounter "some of the most stunning, intact, works of art and architecture anywhere. Such as St. Sophia, the Blue Mosque and the sumptuous Topkapi Palace" and to experience them in situ, before they have been dismantled and shipped off to a museum.[3] The Bikini Islands is developing an atomic theme park in the areas devastated by nuclear testing. The U.S. National Park Service characterizes the ships and bombs at the bottom of a Bikini Island lagoon as an "unmodified museum of the dawn of the era of the atomic bomb."[4] Such promotions promise an experience that is more real, more immediate, or more complete, whether they deliver an actuality (Gatwick Airport) or a virtuality (Gatwick Airport theme park)—or both at the very same place.

Immersion in a world other than one's own is a form of transport, whether one travels twenty-six hours from Europe to New Zealand, strolls from Samoa to Fiji within the virtual space of the Polynesian Cultural Center in Hawaii, or crosses the road separating Chinatown from Little Italy in Manhattan. What is most ordinary in the context of the destination becomes a source of fascination for the visitor—cows being milked on a farm, the subway in Mexico City during rush hour, outdoor barbers in Nairobi, the etiquette of bathing in Japan. Once it is a sight to be seen, the life world becomes a museum of itself.

Tourism needs destinations, and museums are premier attractions. Museums are not only destinations on an itinerary: they are also nodes in a network of attractions that form the recreational geography of a region and, increasingly, the globe. Museums, by whatever name, are also an integral part of natural, historical, and cultural sites. Such facilities orient the visitor to Napier's art deco district, the Waitomo Caves, and the Waitakere rain forest, in New Zealand. Some businesses establish full-fledged museums devoted to their own history (Atlanta's World of Coca-Cola) or the history of their product (Toronto's Bata Shoe Museum).[5] Museums are also events on a calendar. Blockbuster exhibitions are known in the trade as event tourism.

Museums have long served as surrogates for travel, a particularly important role before the advent of mass tourism. They have from their inception preserved souvenirs of travel, as evidenced in their collections of plants, animals, minerals, and examples of the arts and industries of the world's cultures. While the museum collection itself is an undrawn map of all the places from which the materials have come, the floor plan, which determines where people walk, also delineates conceptual paths through what becomes a virtual space of travel.

Exhibiting artifacts from far and wide, museums have attempted from an early date to reconstruct the places from which these things were brought. The habitat group, period room, and re-created village bring a site otherwise removed in space or time to the visitor. During the nineteenth century, exhibitions delivered to one's door a world already made smaller by the railroad and steamship. Panoramas featured virtual grand tours and simulated the sound and motion of trains and ships and the at-

Sign pointing to the Auckland Museum.

New Zealand, 1994. Photo by Barbara Kirshenblatt-Gimblett.

mospheric effects of storms at sea. A guide lectured and otherwise entertained these would-be travelers. Such shows were celebrated in their own day as substitutes for travel that might be even better than actually going to the place depicted. As one commentator explained in *Blackwood's Magazine* (1824), panoramas were a painless form of travel:

> Panoramas are among the happiest contrivances for saving time and expense in this age of contrivances. What cost a couple of hundred pounds and half year a century ago, now costs a shilling and a summary manner. The affair is settled in a quarter of an hour. The mountain or the sea, the classic vale of the ancient city, is transported to us on the wings of the wind. . . . If we have not the waters of the Lake of Geneva, and the bricks and mortar of the little Greek town, tangible by our hands, we have them tangible by the eye—the fullest impression that could be purchased, by our being parched, passported, plundered, starved, and stenched, for 1,200

miles east and by south, could not be fuller than the work of Messrs
Parker's and Burford's brushes. The scene is absolutely alive, vivid, and
true; we feel all but the breeze, and hear all but the dashing of the wave.[6]

Viewers might prefer the panorama of Naples to Naples itself because it
is "even more pleasant to look upon in Leicester Square, than is the real-
ity with all its abominations of tyranny, licentiousness, poverty, and dirt."[7]

Furthermore, not everyone could travel, and for them panoramas and
dioramas were, in the words of Charles Dickens, a "mode of conveyance."
Mr. Booley's travel account in *Household Words* (1850) turns out to be
based on a panorama—"all my modes of conveyance have been pictor-
ial."[8] The panorama's value, in Booley's words, lay in its ability to convey

"the results of actual experience, to those who are unable to obtain such experiences for themselves."[9] In addition, the panorama might convey "aspects of soil and climate . . . with a completeness and truthfulness not always to be gained from a visit to the scene itself."[10] Displaced by cinema and amusement parks by the end of the century, this exhibition tradition can be found today in the atavism of museum dioramas, the futurism of IMAX projection, the special effects of rides like Back to the Future at Universal Studios, and hi-tech panoramas at the Museum of Sydney. Museums continue to enact transformations in perception linked to the technologies and practices of travel.

Museums now also serve as literal travel agents and organize exclusive tours to distant places. Travel With a Purpose tours, many of them led by curators from the Powerhouse Museum in Sydney, focus on ecotourism and the arts. These tours are intended to be "informative expeditions into other cultures for those of us not interested in poolside tourism experiences";[11] during the last months of 1994, groups went to Bhutan, France, Nepal, and India. The cost of the tour includes a donation to one of the sponsors—World Wide Fund for Nature—and to the Powerhouse Museum.

Instead of waiting for the tourists to come to them, museums are going to the tourists. Thanks to an exhibition program inaugurated in 1980 by the San Francisco Airport Commission, more than one person making a connecting flight in 1996 stepped off the motorized walkway to stroll through a display of kitchen equipment and tableware from the Ritz Collection at the California Academy of Sciences or slowed down for an exhibition of vintage ukeleles from the collection of Akira Tseumara in an otherwise bleak corridor.

Museums are even reproducing the protocols of travel. Visitors can purchase a Museums Passport to more than 190 museums in Queensland, Australia, get their documents stamped as they complete each visit, and save the passport as a souvenir.[12] The American Museum of Natural History in New York, to celebrate its 125th anniversary in 1995, thematized visits to its galleries as an expedition comparable to those the museum once sponsored to collect the specimens on display. *Expedition Passport*, available at two Base Camps in the building, welcomes the young visitor, the primary audience for this booklet:

Most explorers travel to far-off places, but your journey will take place right in the footsteps of those scientists who have travelled the world and who have brought back many of the treasures you will see today. On this expedition, you can move back in time to the Age of Dinosaurs. You can touch a meteorite as old as the solar system. You can see a young Chinese woman on the way to her wedding. You can visit the woodlands, savannahs, and mountain regions of Africa. You can even shrink to the size of an ant. A great adventure lies before you today. To begin, turn the page.[13]

At field stations in five galleries, visitors get their "passports" stamped.

Such tropes form an archive of historical understandings that go uncontested. Their playfulness insulates them from the very critiques that destabilized celebrations of the Columbus Quincentenary and that have brought museums themselves to task for their historic role in grand projects of discovery and conquest. Marketing a troubled history that glorifies colonial adventure and a repudiated anthropology of primitivism, tourism provides a safe haven for these ideas. A 1987 Iberia Airlines promotion began, "With 100 tours to choose from, Spain is once again open to invasion," and added tourists to a list that included Phoenicians, Greeks, Romans, and Visigoths—"Get ready for a vacation that's destined to go down in history."

Museums need visitors and the tourism industry, more than any sector of the economy, can deliver the hordes to museum doors. By one estimate, 7 billion tourists will be moving around the globe annually by the year

Expedition Passport, booklet accompanying the exhibition Expedition: Treasures from 125 years of Discovery, 1995.

Copyright 1995 American Museum of Natural History, New York.

2000.[14] Museums hope to draw many of them into their galleries. Because the number of visitors, not the number of visits, determines the total disposable income brought through a museum's doors, tourists generate more revenue for museums than "a relatively small core of repeat visitors."[15] The newly refurbished Louvre attracted more than 6 million visitors in 1994, most of them tourists.[16] Tourists make up two-thirds of the visitors to the Metropolitan Museum of Art at the present time.[17]

As the tourism industry moves from a product-driven approach to one that is market-led—and from creating an experience based on seeing to one based on doing—it positions museums in the rearguard of the industry. Travel itself has become almost effortless, compared with its arduousness in earlier periods, and tourists look for "action" elsewhere. They fly in comfort to endure the rigors of whitewater rafting and rappelling. Scenic tourism gives way to adventure tourism, which the industry classifies as active (doing). In this taxonomy of tourist amenities, cultural attractions, including museums, are passive (seeing).[18]

Museums have long epitomized a product-driven ethos, reserving for themselves the prerogative (in the public interest) to determine what they want to say and show. This prerogative is a legacy of the bifurcation of entertainment and edification during the last half of the nineteenth century, when the public museum and art gallery as we know them came into their own, as Tony Bennett has noted.[19] Until recently, a long history of public service, scientific research, education, social amelioration, cultural elevation, and local enthusiasms has insulated museums from the customer focus of the modern tourism industry.

Writing about twenty years ago, the art historian E. H. Gombrich complained that museums had become exhibition centers, which he attributed to tourism and the pressure to increase attendance figures. People who would not bother to visit the permanent collection would line up to see paintings that had been moved into the gallery from across the road. "Any windowdresser, if I may put it so bluntly, can place an isolated Greek vase under a spotlight in an empty room and force it upon our attention."[20] He bemoaned the price of accessibility. Lost was the "almost religious awe" with which visitors used to approach a museum and the possibility of "scanning and grouping" the collection on display according to one's perceptions and interests.[21]

Today some critics bemoan not just the spotlight, but also the displacement of the Greek vase itself by the ideas it is made to illustrate. Such critics note a decline in the "museum product," as museums "move away from object-based museum services to the contextual approach advocated by the New Museology."[22] This move, as they see it, does not just take objects out of the spotlight, but also removes them from the gallery. It emphasizes education and visitor services, at the expense of curatorial research based on museum collections.

This self-conscious shift in orientation away from the museum's artifacts and toward its visitors is signaled by the term "experience," which has become ubiquitous in both tourism and museum marketing—the term indexes an engagement of the senses, emotions, and imagination. Museums were once defined by their relationship to objects: curators were "keepers" and their greatest asset was their collections. Today, they are defined more than ever by their relationship to visitors. In its brochure, the Powerhouse Museum promises "good service" to what it now calls its "customers" and in this way is consistent with a shift within the tourism industry itself, where service has become more important than product. A focus on visitors is also why mounting exhibitions, which is how museums produce experience, has become their major activity.

The complaints signal a crisis in museum identity. With long histories sedimented in the very buildings many have occupied since their inception, museums must negotiate the competing expectations of diverse constituencies. And they must do so in contexts very different from those in which many of them were first established. What is today's museum?

A vault, in the tradition of the royal treasure room, the *Schatzkammer*

A cathedral of culture, where citizens enact civic rituals at shrines to art and civilization

A school dedicated to the creation of an informed citizenry, which serves organized school groups as well as adults embarked on a course of lifelong learning

A laboratory for creating new knowledge

A cultural center for the keeping and transmission of patrimony

A forum for public debate, where controversial topics can be subjected to informed discussion

A tribunal on the bombing of Hiroshima, Freud's theories, or Holocaust denial

A theater, a memory palace, a stage for the enactment of other times and places, a space of transport, fantasy, dreams

A party, where great achievements and historical moments can be celebrated

An advocate for preservation, conservation, repatriation, sovereignty, tolerance

A place to mourn

An artifact to be displayed in its own right, along with its history, operations, understandings, and practices

An attraction in a tourist economy, complete with cafes, shops, films, performances, and exhibitions

And, what is the fate of the "museum product," however it is defined, in today's tourism economy? The presumption in some quarters is that visitors are no longer interested in the quiet contemplation of objects in a cathedral of culture. They want to have an "experience." Museums worry that they will be bypassed as boring, dusty places, as spaces of death— dead animals, dead plants, defunct things. This is why Te Papa Tongarewa, The Museum of New Zealand, in its Wellington Visitors' Center, has made a preemptive strike, first anticipating the negative image of the museum as a solemn place, "somewhere you have to whisper like [in] a church" and are not allowed to touch old things in glass cases. Then it tells the visitor that "[w]e are re-imagining the term 'Museum,'" as a place alive, exciting, and unique—exactly what tourism markets. The flyer announcing Te Papa defines the museum experience as "an amazing adventure—one in which all New Zealanders are travellers," for "[t]he Museum is going to take us on a journey." The destination is collective self-understanding. Museums engaged in the task of imagining the nation must define its location, a responsibility that has repercussions beyond the journey within its walls.

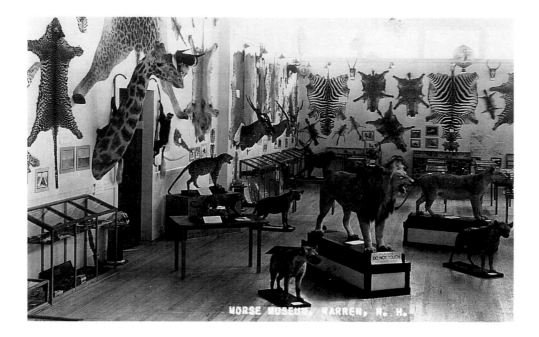

Even as museums model themselves on tourism—the promise of "experience" indexes the immediacy of travel—the industry in parts of the world like New Zealand and Australia has been slow to develop "cultural tourism." Most tourism in these relatively young states is based on nature and the rest on purpose-built tourist attractions. There are several reasons for this emphasis.

There is the problem of how to define the uniqueness of a destination the better to market it in a competitive industry. What makes *this* place different? Australia and New Zealand have tended to identify their uniqueness as tourist destinations with the indigenous and to identify culture with the places from which settlers came. Yet, despite a high rate of endemism, their difference from other places is not natural but cultural; that is, difference is produced, not found. For Anthony Trollope, writing in 1873, "the great drawback to New Zealand,—or I should more

properly say to travelling in New Zealand,—comes from the feeling that after crossing the world and journeying over so many miles, you have not at all succeeded in getting away from England. When you have arrived there you are, as it were, next door to your own house, and yet you have a two months barrier between yourself and your home."[23] Identifying New Zealand's specificity with unique aspects of its natural endowments is a cultural practice. Judging from Trollope's observation, it is not an obvious one. More than a century later, the information pamphlet in a Dunedin motel room keeps alive the idea that "[p]acked into this small country is seemingly a piece of every part of the world. England's countryside, Norway's fiords, Switzerland's alps, Canada's lakes, Oregon's coast, and Hawaiian beaches are but a few of the similarities one may find while travelling around this South Pacific gem."

Tourism can be taken as a barometer, and it operates as an instrument, of local and national self-understanding. As Christopher Wood, art historian and founder of Australians Studying Abroad, commented, "[I]n trying to package itself to attract a burgeoning new class of curious and sophisticated travellers, Australia is in a real sense having to invent itself. . . . What we're doing, if you like, is creating a whole new cultural geography based on things other people want to learn about; making Australia into a bounded place with a vast typology of things to see."[24] That process is museological.

New Zealand tourism projects an imagined landscape that segments the history of the country into three hermetic compartments. The nature story stops with the coming of people. The indigenous story stops with the coming of Europeans. And the Europeans (and later immigrants) have until recently not been convinced that their story is very interesting. The divided consciousness of settler societies, with one foot here and the other there, is registered in the very history of tourism. Where tourists once traveled all the way from Europe only to arrive in "Europe," today they disembark in "the world's oldest land," according to *Welcome to Australia*, the guest information book at the Brisbane Hilton.[25] The map of Australia found there features flora, fauna, sports, Uluru (aboriginal name for Ayers Rock), aborigines, and a few buildings—in other words, natural attractions, indigenous people, and sports.

"New Zealand's Got It All." The back of this postcard reads: "Tranquil lakes, snow-clad mountains, rolling pastures, native forest, magnificent seascapes—all combine to make New Zealand a land of unparalleled beauty and a joy to tourists."

Copyright Pictorial Publications, Ltd., Hastings, New Zealand.

The tourism industry is a business, and as far as the industry is concerned, culture is not. *Wellington Region Tourism Strategy* explains: "Tourist attractions within the industry are events and facilities oriented to experiential opportunities. Most attractions are in themselves outside the scope of the industry," including "free, inherent and natural resources" or "incidental resources from various industries."[26] Technically, then, museums are not within the tourism industry.

Because many museums in Australia and New Zealand still do not charge admission, they fall into the category of "free" resource. Nor, according to the industry, are they "experiential," at least not in the way

"Dragon's Mouth Geyser. Wairakei," New Zealand.

Real Photo Post Card, Frank Duncan and Co., Auckland,
New Zealand.

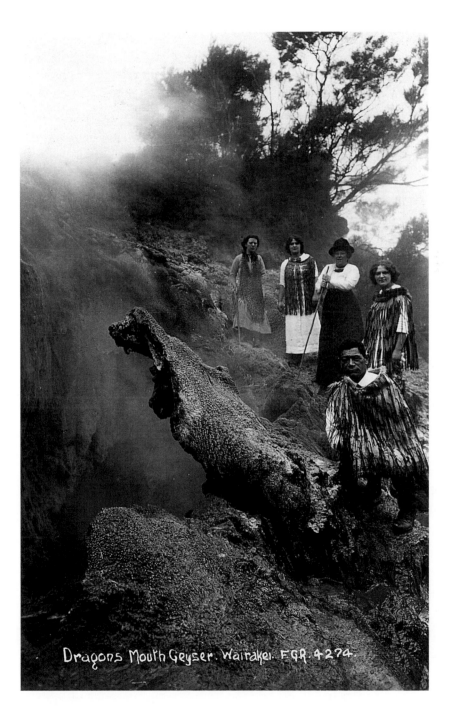

Dragons Mouth Geyser. Wairakei. F.G.R. 4274.

that climbing Ayers Rock (Uluru is not for climbing), scuba diving, eating, and shopping are "experiential." The introduction to *New Zealand's Tourist and Visitors' Guide* explains that "[t]ourist activities can be divided into two categories, passive and adventure. There are many activities for the older or less physically active tourist, including sightseeing, jet boating, arts and crafts, and enjoying the Maori culture and heritage which is unique to the country. Adventure tours are constantly being invented."[27] More sophisticated marketing speaks not of passive activities, but of soft adventure. ORCA, based in Wairarapa, features "Gentle Adventures—For family groups, the nervous, the less mobile, photographers. No heavy lifting or fitness required. Ages 5–90." Active is identified with physical exertion.

In Queensland, the Office of Arts and Cultural Development advocates cultural tourism to a tourism industry that needs to be persuaded of its profitability.[28] For their part, the art world and museums—what Hans Magnus Enzensberger called the "consciousness industry"—must be profitable to survive and so are looking to cultural tourism for income.[29]

Consider the Queensland Government Cultural Statement: "The Business of Culture" will promote "what makes Queensland culture distinctive—our social history and heritage, our Indigenous cultures and natural environment, our quality products, regions and many diverse cultures."[30] Or *Destination New Zealand*'s proposition: "while our cultural heritage can be presented as 'entertainment' in the hubs, it can be experienced as 'lifestyle' in the regions."[31] This formulation elides several notions of culture: culture as lived practice, culture as heritage, and the culture industry. It also raises several questions. How does a way of life become "heritage"? How does heritage become an industry? And what happens to the life world in the process?

There is a reciprocity, a recursiveness, between the exhibition of the world and the world as exhibition of itself. Museums, through their exhibitions, create "an effect *called* the real world."[32] That effect is one of tourism's most valuable assets. But, it is not enough, from the industry's perspective, to open the bus and release tourists into the lifespace of their destination—the "real world," available everywhere, always open, and free of charge.[33] The industry prefers the world as a picture of itself—the picture window, cultural precinct, and formal performance.

First, model villages and performing troupes are transportable. Maori cultural performances were exported to Australia and England during the 1860s and to the Festival of Empire Celebrations in England in 1911.[34] Tourists to Bali today can see performances related to those created for international expositions in the course of the last hundred years and specially during the thirties in Paris.[35] Second, designated precincts are more profitable than the lifespace because they "add value" to it. Controlled access to an area makes it possible to charge a fee. Third, model villages and cultural concerts are more manageable and less intrusive on the lifespace, hence less destructive of it.

The appeal of the lifespace is its high resolution, its vividness and immediacy. One problem with the lifespace is its low density, the dead space between attractions. A second problem is saturation: as they increase in number, tourists fill the space and displace what drew them to it in the

first place. To address the saturation issue, the industry markets exclusive sites to high-end tourists, thereby generating more revenue from fewer visitors. This is the promise of the empty beach. This is the message of photographs that show the site, but not the tourists.

To address the density issue, the industry develops linkages among sites in a region to form "heritage corridors" and itineraries that link sites in a region. *The International Express: A Guide to Ethnic Communities along the 7 Train* provides reasons to get off at *every* stop on the route:

> The #7 train passes above so many ethnic and immigrant communities on its seven-mile route through northwest Queens [New York City] that it has been dubbed The International Express. We invite you to experience it yourself. Get off in Sunnyside, spend an evening at a Spanish theater and a night at a Romanian disco; get off in Woodside, rent a Thai video and strike up a conversation at an Irish pub; get off in Jackson Heights, visit an Indian sari shop and dance at a Colombian night club. . . .[36]

Or, the industry designs cultural precincts like Brisbane's riverside district, which will provide "a showcase for the finest performers, artworkers and the State's cultural heritage, integrated with food, shopping, and other exciting lifestyle experiences," a convention and exhibition center and a casino: "It will be a model cultural tourism concept that will promote an integrated lifestyle and local cultural experience."[37] In this way the district brings "free, inherent and natural resources" or "incidental resources from various industries" within the scope of the tourism industry proper.

Purpose-built tourist attractions like the Polynesian Cultural Center in Hawaii, where you can experience the Cook Islands, the Marquesas, Samoa, and Fiji all in one spot, are not only dense, they also insulate from tourists the lifespace represented there, while controlling its representation and bringing it firmly within the industry. Guides to the site are Pacific people who have converted to Mormonism, many of them students at Brigham Young University. Through their performance of a way of life they no longer live, made safe for display by that very fact, they also exhibit their conversion.

Theme parks achieve the highest density of all—the whole world

within a few acres, often in places that have nothing else to draw tourists. The parks generally stand in an arbitrary relation to the sites where they are built, since fantasy has no fixed geographic location. Nor do recreations. New Yorkers who visit the New York–New York resort in Las Vegas may wonder why they left home. In Central Florida, orange groves and swamps have been displaced by highways, motels, and restaurants that serve the 34 million tourists who "visit Orlando each year to see the world," or rather the "world's showcases"—including, soon, a representation of Key West, a rival destination nearby. Key West World "will distill the essence of the tiny island into a land-locked five-acre theme village" at Sea World, just seven hours away from Key West itself. The park is to offer charm without crime and "introduce guests to the island's 'fascinating inhabitants' as well as to its subtropical ecosystem." Is the theme park competition or free advertising for Key West itself? One pundit has proposed that Key West create an "Orlando World," in which visitors would "park in gigantic parking lots, ride trams to the main gate, purchase tickets and spend the remainder of the day standing in an enormous, nonmoving line," after which "they would buy ugly T-shirts, get back on the trams, spend an hour or so trying to find their cars, then spend the rest of the evening driving around trying to decide which one of 317 Sizzler restaurants to eat dinner in."[38] In a word, a theme park of a theme park—all infrastructure, low density, dead space.

When these same tourists return home, they may well discover that the places they left have themselves become destinations. Small towns in Britain have become so popular that they are turning visitors away. *The Age* reported in 1994 that "'Town Full' is a sign of the times."[39] Three million guests visit 30,000 hosts at Windsor, where the ratio is one hundred to one and even higher in the peak season. So resentful are the locals in areas such as Bath that residents have been known to turn hoses on open-top buses. Tourists, it is said, are spoiling the towns for each other and making them uninhabitable for residents, who are fed up with congestion, pollution, and erosion of the sites themselves. Some towns, conceding that they cannot keep tourists away, are drafting "visitor management plans." Others, like Cambridge, are refusing to promote themselves at all.

The only way to keep visitors away from sites that they are "loving to

Kudzu, a comic strip by Doug Marlette.

Reprinted with permission from Creators Syndicate.

death" is to hide them.[40] Visitors to the Native American ruins at Hoven-
weep National Monument, which straddles the border of Utah and Col-
orado, have doubled in five years to 30,000. Some sleep in them. Others
loot them. The locations of Native American ruins have been removed
from maps so they cannot be found.

Density levels are specially high at Gettysburg. This Pennsylvania town
of 8,000 serviced an influx of 1,748,000 tourists in 1995, a decline from
the peak of more than 2 million visitors in 1963, the centennial of the
Battle of Gettysburg.[41] The vast battlefield is the main attraction. The
town's economy depends on tourists, most of them day trippers, for the in-
come they generate.

Roratonga, capital of the Cook Islands, projects a doubling of the local
tourism industry and a ratio of ten tourists for every local. The Uluru Na-
tional Park Cultural Center is to be jointly managed by the Mutitjulu
Community and the Australian National Parks and Wildlife Service. About
2,000 visitors a day are expected to visit the center during peak periods, not
only to shop for aboriginal art and souvenirs and see exhibits but also to
meet aboriginal people.[42] Despite great sensitivity in the design of this site,
one can only imagine what it will be like for the Mutitjulu community to
welcome 2,000 guests a day, day in and day out in peak periods. "Tell the
tourist where to go" has been heard in at least one part of Australia.

In 1990 the local population of Cairns, the jewel in the crown of Australia's Gold Coast, was 70,000. Five years later it was 120,000, with tourists visiting at the rate of 500,000 a year. Longtime residents mourn the loss of the "real Cairns," which is the first step in converting a way of life into heritage.

Heritage, in this context, is the transvaluation of the obsolete, the mistaken, the outmoded, the dead, and the defunct. Heritage is created through a process of exhibition (as knowledge, as performance, as museum display). Exhibition endows heritage thus conceived with a second life. This process reveals the political economy of display in museums and in cultural tourism more generally. The following argument proceeds from seven propositions:

Heritage is a new mode of cultural production in the present that has recourse to the past.[43]

Heritage is a "value-added" industry.

Heritage produces the local for export.

A hallmark of heritage is the problematic relationship of its objects to the instruments of their display.[44]

Heritage is produced through a process that forecloses what is shown.[45]

Heritage tests the alienability of inalienable possessions.[46]

A key to heritage productions is their virtuality, whether in the presence or the absence of actualities.

Heritage Is a New Mode of Cultural Production in the Present That Has Recourse to the Past

Heritage is not lost and found, stolen and reclaimed. Despite a discourse of conservation, preservation, restoration, reclamation, recovery, re-creation, recuperation, revitalization, and regeneration, heritage produces something new in the present that has recourse to the past. Such language suggests that heritage is there prior to its identification, evaluation, conservation, and celebration: "Pieces of history are yours to find. . . . [T]he

past is waiting for you to explore in The Central West Coast" of the South Island of New Zealand, the flyer beckons. By production, I do not mean that the result is not "authentic" or that it is wholly invented. Rather, I wish to underscore that heritage is not lost and found, stolen and reclaimed. It is a mode of cultural production in the present that has recourse to the past.

Heritage not only gives buildings, precincts, and ways of life that are no longer viable for one reason or another a second life as exhibits of themselves. It also produces something new. If a colonial past, a past of missionaries and forced acculturation, threatened to produce "de-culturation," the heritage industry does not so much reverse that process, even though its discourse of reclamation and preservation makes such claims. Rather, the heritage industry is a new mode of cultural production and it produces something new. There is no turning back. If heritage as we know it from the industry were sustainable, it would not require protection. The process of protection, of "adding value," speaks in and to the present, even if it does so in terms of the past.

Heritage Is a "Value Added" Industry

Heritage adds value to existing assets that have either ceased to be viable (subsistence lifestyles, obsolete technologies, abandoned mines, the evidence of past disasters) or that never were economically productive because an area is too hot, too cold, too wet, or too remote or that operate outside the realm of profit because they are "free, inherent and natural resources" or inalienable possessions. Heritage organizations ensure that places and practices in danger of disappearing because they are no longer occupied or functioning or valued will survive. It does this by adding the value of pastness, exhibition, difference, and, where possible, indigeneity.

The Value of the Past

"The past is a foreign country" thanks to the heritage industry.[47] The notion of time travel is explicit in invitations to "[t]ake a trip through history" (Taranaki Heritage Trail) or "walk down memory lane" (Howick

Historical Village), both in New Zealand. The very term "historic" can be taken as an indication of obsolescence: no calls can be placed from the "Historic Telephone Box" on the Heritage Trail in Palmerston North. It is enshrined by the City Corporation with the words, "This is a protected building," but its windows now display real estate listings for Harcourts, a business older than the box. Harcourts, which has been operating since 1888, is not on the Heritage Trail.

The Value of Exhibition

Heritage and tourism are collaborative industries, heritage converting locations into destinations and tourism making them economically viable as exhibits of themselves. Locations become museums of themselves within a tourism economy. Once sites, buildings, objects, technologies, or ways of life can no longer sustain themselves as they formerly did, they "survive"—they are made economically viable—as representations of themselves. Heritage projects in Pennsylvania address the massive deindustrialization of the state—by one estimate, "65 percent of land zoned for industrial use lies abandoned"—by providing new uses for derelict buildings and jobs for unemployed industrial workers, who serve as guides to their former lives as miners and steelworkers, to what has become industrial heritage.[48]

Dying economies stage their own rebirth as displays of what they once were, sometimes before the body is cold. In the former East Germany, tourism is stepping in where the heavy industry encouraged by the Communist regime is in decline. Thuringa is selling the good old days of Luther and Goethe by featuring its medieval castles, Renaissance town hall, and churches.[49] Just north of Berlin, on a former army base, "the bad old days" are the subject of a museum and theme park.[50] The museum will present the political and social history of East Germany; the theme park will re-create Communist life there. "Clerks and shopkeepers will be surly and unhelpful. The only products for sale will be those that were available in East Germany."

The fall of communism and end of the cold war have created a large zone of ambivalence, if not repudiation, which prompts uneasy nostalgia,

irony, or historical reassessment. With the shift from making nuclear weapons to dismantling them—and the end of government contracts— Los Alamos is turning to tourism to boost its declining economy. Scotland has transformed "an underground bunker, once a nuclear shelter for British Government Ministers," into a "national museum to the Cold War." Golfers putt on the lawn, while thirty-three meters beneath them "[v]isitors can explore the nuclear command, computer and communications rooms, dormitories and broadcast studios, all equipped with original artifacts."[51] Tourism thrives on such startling juxtapositions, on what might be called the tourist surreal—the foreignness of what is presented to its context of presentation.

The Value of Difference

To compete for tourists, a location must become a destination. To compete with each other, destinations must be distinguishable, which is why the tourism industry requires the production of difference. It is not in the interest of remote destinations that one arrive in a place indistinguishable from the place one left or from any of a thousand other destinations competing for market share. The Queensland Government Cultural Statement recognizes this all too well when, under the heading "The Business of Culture," it states that "[t]he Government will expect the subsidized arts sector to ensure the cost effective delivery of distinctive Queensland cultural products and services to the State's audiences."[52] It is about "profiting from difference," as the report put it, and benefiting from the "spillover effect" of "a positive Queensland image."[53]

"Sameness" is a problem the industry faces. Standardization is part and parcel of the economies of scale that high-volume tourism requires. First, vertical integration in the tourism system places much of the infrastructure in the hands of a few national and multinational corporations: the biggest earners are international airlines, followed by hotels. Airlines often own interests in hotels. Not surprisingly, tourists spend much of their time in the grips of the industry, in the planes, hotels, buses, and restaurants. Second, the industry requires a reliable product that meets universal standards, despite the dispersal of that product across many widely separated locations. Third, the very interchangeability of

generic products suits the industry, which can quickly shift destinations if one paradise or another is booked solid or hit by a typhoon, political unrest, or currency fluctuations. For this and other reasons, the discourse of tourism marketing is so consistent that only the insertion of place names tells you which getaway or which natural wonder you are being sold. "It took over 5000 years to build the perfect resort." Where? "Israel, on a TWA Getaway vacation."[54] Once there, you send home a "generic postcard" or check off the boxes on a "lazy letter."

Getting away is different from going somewhere. Because escapes are defined as departures rather than arrivals, the actual destination is somewhat arbitrary. The very term "getaway" or "escape" suggests that the push away from home is stronger than the pull toward a particular place. "No crowds. No hassles." But where? Only for those who choose to "[g]et lost at Capricorn" in Queensland. Being generic (sand, sun, sea, sex), paradise can be found as easily in the Bahamas as in Bali. Noting that the "undifferentiated beach market becomes more and more competitive," the Queensland Government Cultural Statement proposes a cultural tourism strategy that will "encourage visitors to stay longer, spend more and make return visits"—and "broaden [and increase] the tourism base."[55]

Heritage Produces the Local for Export

Tourism is an export industry and one of the world's largest. Unlike other export industries, however, tourism does not export goods for consumption elsewhere. Rather, it imports visitors to consume goods and services locally. In many countries, for example Egypt, tourism is one of the largest earners of foreign revenue; it is the largest industry in places like Utah. In the Virgin Islands, tourism sustains 70 percent of the economy.

Heritage is one of the ways locations become a destination. Heritage is a way of producing "hereness." However many tourists arrive in Auckland, Wellington, Christchurch, or Dunedin, these cities complain that they are only gateways. Tourists pass through them on their way to tourist regions on their outskirts, rather than stay for several days. While it would be a boon to those promoting recreational fishing in Auckland reservoirs, Ben Wilson's dream of "the day when Auckland will have fishing guides

"Generic Post Card. "

Published by Fagan Color Cards, Inc., Virginia Beach, Virginia 23464.

GENERIC POST CARD

0 51060 025 8

When you don't know or care what to send!

Dear _____ :
- ☐ You asked for a card . . . Here it is!
- ☐ Having a wonderful time.
- ☐ Having a terrible time.
- ☐ Wish you were here.
- ☐ Wish I were there.
- ☐ The picture I wanted to send is not on a card.
- ☐ I'll be home soon because:
 - ☐ I'm out of money.
 - ☐ I'm out of time.
 - ☐ I'm worn out.
 - ☐ I'm lonesome for you.
 - ☐ None of the above.

I rate the following things about this place on a scale of 1 to 10.

People	_____	Entertainment	_____	
Drink	_____	Restaurants	_____	
Accent	_____	Traffic	_____	
Hotels	_____	Night Life	_____	
Sex	_____	Colleges	_____	
Music	_____	Weather	_____	
History	_____	Sight Seeing	_____	

Signed _____

Published by Fagan Publishing Company, Madison, Wisconsin 53705
98853-D

MWM DEXTER
AURORA, MISSOURI
U.S.A.

post card

AUSTRALIAN BALLOT POST CARD	Date	190
Am feeling fine	It is very lonely here	Received no letter
Am not feeling well	I wish you were here	Smile, don't worry
Slept well last night	If you were only here	You are in my thoughts always
Did not sleep well last night	Pleased that you are well	Remember me to my friends
This hotel is excellent	I leave here	Do not forget me
Hotel is very poor	Expect to return soon	With love and kisses
The town is beautiful	Will remain several days	With best regards
This is a regular jay town	Business is good	Hope you are well
Weather is fine	Business is poor	Don't do a thing until you see me
Weather is disgusting	Think I will do well here	Good bye for the present
Raining here	Not much business in sight	Keep a corner in your heart for me
Very hot today	Very little doing	Remember me to
Very cold today	Let me hear from you	My love to
Will not come here again	Send me all the news	My love to the kids
Am enjoying myself	Received your letter	Signed

LINES CROSSED BEAR MY SENTIMENTS

based in the city to whisk international travelers straight from their plane or hotel by helicopter to the dams to chase rainbows" is the urban tourism industry's nightmare.[56] A visitor information leaflet tries to entice the tourist to the desolate west coast of New Zealand's South Island: "Hokitika, 'A Place to Stay for More than a Day.'"

Protected by legislation and supported through tourism, heritage becomes an instrument of urban redevelopment. Salem, Massachusetts, has attempted "[f]or almost a decade . . . to augment its declining industrial and regional retail economy with a more vibrant tourism industry." Two hundred million dollars are being infused into this small town of thirty-eight thousand to capitalize on its six hundred buildings dating from the 1600s. Kevin J. Foster, chief of the National Maritime Initiative of the Park Service, projects that "Salem—which in the late 18th and early 19th centuries was an important mercantile center—could become an even greater tourist attraction."[57] Similarly, more tourists will pass through the Ellis Island Immigration Museum, located on a small island

off the tip of Manhattan, than did immigrants through Ellis Island, a processing center, in its peak at the turn of the century.

A Hallmark of Heritage Is the Problematic Relationship of Its Objects to the Instruments of Their Display

The heritage industry produces something new. A key to this process is its instruments. Dance teams, heritage performers, craft cooperatives, cultural centers, arts festivals, museums, exhibitions, recordings, archives, indigenous media, and cultural curricula are not only evidence of heritage, its continuity, and its vitality in the present, they are also instruments for adding value to the cultural forms they perform, teach, exhibit, circulate, and market. Much is made of the traditions themselves, as if the instruments for presenting them were invisible or inconsequential. This point is not missed by those who oppose the placing of Maori weaving on New Zealand's National Qualifications Framework on the grounds that this would "tamper with the traditional methods of transfer of knowledge," and therefore have negative effects on community cohesion.[58]

Landmarking, historic re-creation, and cultural conservation are instruments with a history. They leave their own traces on the sites they mark as heritage. When one site is landmarked repeatedly, each time for a different reason, and used for different purposes, even at one point in time, the result is a heritage palimpsest. The George Gustav Heye Center of the National Museum of the American Indian, Smithsonian Institution, at the Alexander Hamilton U.S. Custom House in Lower Manhattan is a case in point, as the very name suggests. The Beaux-Arts architecture and its iconography, dating from the turn of the century, stand in an equivocal relationship with the Reginald Marsh murals gracing the grand rotunda, which were executed during the Great Depression as part of a government work scheme. Visitors today choose at the entrance to follow the sign into the museum or the one to U.S. Bankruptcy Court occupying the same building. The Museum's Resource Center is located in the cashier's office, its signage still intact.

Commemorative language now identifies the site on which the museum stands with "the southern end of the Wiechquaekeck Trail, an old Algonquin trade route."[59] A plaque mounted in 1890 by the Holland Society

memorializes Fort Amsterdam, which occupied the site from 1626 to 1790. A plaque mounted in 1991 honors Alexander Hamilton, for whom the custom house was originally named. The Museum neither eradicates the layers of historical landmarking, nor attempts to create a closer fit between the history of the heritage for which it is responsible and that represented by the building and the site. The ironies play out willy-nilly, eluding any easy resolution between the mode of exchange symbolized by the custom house, the "inalienable possessions" on display, the market past and present for Native American artifacts, and the public trust represented by the museum itself.

In these ways, instruments such as landmarking connect heritage productions to the present even as they keep alive claims to the past. It is therefore important to examine not only what the instruments produce but also how. How is value added or lost when *taonga*, Maori treasure, are exhibited in an art gallery or museum of natural history or used on a *marae*, Maori meeting place? Or when Maori weaving is taught in school? When the Pintubi paint on canvas, rather than on their own bodies, and circulate their work within an international art market?[60] When "traditional Irish dancers" are featured in a "Mediaeval Tour of Shannon Free Airport?" When farmers gather for a World Ploughing Championship in Dunedin? When sheep line up on a stage? When their shearers "demonstrate" their work?

Heritage productions tend to conflate their effects with the instruments for producing them. But, a hallmark of heritage productions—perhaps their defining feature—is precisely the foreignness of the "tradition" to its context of presentation. This estrangement produces an effect more Brechtian, more alienating, than mimetic and makes the interface a critical site for the production of meanings other than the "heritage" message. The interface—folk festivals, museum exhibitions, historical villages, concert parties, postcards—are cultural forms in their own right and powerful engines of meaning. Messages of reconciliation, of multiculturalism or biculturalism, or of development—messages other than heritage—are likely to be encoded in the interface.

This in part explains why exhibitions at the National Museum of the American Indian take the form that they do—and disappoint many visitors expecting to learn more than they do about the history of the objects

on display and the way of life they represent. Many splendid objects from the prodigious Heye collection are indeed on display. But they are not all that is exhibited.

First, the museum's own infrastructure is visible, including what is now a largely Native American staff and their control over what is shown and how. Labels are signed, and in several cases there is more than one label for each object. Those who wrote the labels are identified by name, profession, and tribe (in the case of Native Americans). Photographs are rarely if ever identified, a comment in itself about their status in the exhibition—they are about, but not by, those they represent.

Second, the exhibition *All Roads Are Good* presents the selections of twenty-two Native Americans invited to explore the collection and choose objects for exhibition. Their choices did not necessarily conform to their "identity." Rather, the guest curators ranged freely across the collection and made connections that were at once intensely personal and contemporary.

The advertisement for the museum that declares "Meet the Real Native New Yorkers" exemplifies the statement by Jonathan Mane-Wheoki at the 1995 Museums Australia conference in Brisbane that museums are about people not things.[61] What is on display above all is the presence, the vitality, the survival of Native Americans themselves. What visitors discover in these galleries is what the objects on display mean to Native Americans today. This is how this museum addresses the historic foreclosures of ethnographic exhibitions that the collection itself exemplifies.

Heritage Is Produced through a Process
That Forecloses What Is Shown

Exhibition is instrumental in the foreclosing of what is shown. The destruction of cultural forms under the pretext of preservation has precedents in the Protestant Reformation, the French Revolution, the formation of colonial empires, the emergence of nation-states, and the reform of Judaism in the nineteenth century, to mention but a few cases. Utopian longings notwithstanding, the world imagined under the banner of heritage is a battlefield. Which is not to say that all combat waged there is equally bloody, or that the terms of the conflict are the same.

Paradoxically, remembering is a prelude to forgetting, and the collecting of error an overture to its eradication. During the royal entry of Henry II into Rouen in 1550, Brazilian villages stocked with natives for the occasion and supplemented with Frenchmen appropriately attired for battle were the scene of a mock siege and French triumph. Steven Mullaney's analysis of this event focuses not so much on its re-creation as on its erasure: "The ethnographic attention and knowledge displayed at Rouen was genuine, amazingly thorough, and richly detailed; the object, however, was not to understand Brazilian culture but to perform it, in a paradoxically self-consuming fashion."[62] He argues further that the interest in Brazilian culture displayed at Rouen served "ritual rather than

ethnological ends, and the rite involved is one ultimately organized around the elimination of its own pretext." Such performances, he continues, are rehearsals, in the legal sense of the term, and are to be understood within a dramaturgy of power that first exhibits what it "consigns to oblivion."[63]

Long processes of "cultural evolution," violent revolutions, systematic programs of reform, and processes of absorption leave behind what they have rejected. Zones of repudiation, where the outtakes of a cultural editing process are to be found, form a geniza of sorts. In this way, Catholic Europe became a source of fascination for Protestants eager to see what the Reformation had repudiated.

Similarly, the attempt to reform Jewish life by repudiating customary practices created a large domain of cultural trash, which was to return as "folklore."[64] During the early nineteenth century, *Sulamit*, a popular little magazine in German for Jewish readers, ran a column entitled "Gallery of Obnoxious Abuses, Shocking Customs, and Absurd Ceremonies of the Jews." Writing in what might be called the ethnographic burlesque—what Mona Ozouf calls "shameful ethnology"—the author first contrasts the simplicity and naturalness of life in the Bible with the bizarre ceremonialism introduced by the rabbis.[65] He then urges readers to adopt the aesthetic and refined manner of cosmopolitan Jews. In an account of wedding customs, for example, the author objects to matchmaking because it seems to ignore the desires of the young couple and focus on crass financial transactions. The author questions the use of an incomprehensible language, Hebrew-Aramaic, for something as important as the marriage ceremony. He is offended by the public spectacle of outdoor processions accompanied by music, because the bridal couple is put on public display in a filthy courtyard. How much preferable are the refined practices of the Jews in Leipzig who hold their wedding ceremonies discretely in the nicest room in the city.[66]

Reform is here promulgated not at gunpoint but through a process illuminated by Norbert Elias's notion of "[w]hat may be described as an advance of the threshold of embarrassment and shame, as 'refinement,' or as 'civilization.'"[67] The ethnographic burlesque induces shame at thresh-

olds of its own making. This art of rhetorically induced estrangement mobilizes the will of the reader to abandon established custom and internalize new forms of sensibility and conduct.

By narrowing the domain of what could be considered normative, critics of traditional ceremonies and customs simultaneously expanded the field of the nonnormative. What one was too ashamed to do, one could study, collect, and display. Fifty years later, the vituperation we see in *Sulamit* would give way to nostalgia and the very wedding customs that had been burlesqued would be offered as a critique of Jewish respectability:

> The marriages of Jews of quite recent times have only this one peculiarity that need engage attention, that instead of the old tone of natural and religious joy which sprang from the heart, we now too often see the stiff etiquette of the salon, and it is only in a few localities that the old forms, artless and happy as they were, have held their ground against the general tendency to sublimate and refine away what antiquity handed down.
>
> Particularly interesting in this connection is the account from the pen of a French tourist, of a Jewish marriage celebrated not long ago in Alsatia. Here we see the "Marshaliks," who have so long disappeared from our weddings, still amusing the guests with their improvised discourses abounding in surprising twists of thought; the costumes, so singular and of such venerable antiquity, defy the universal supremacy of French fashion, and the man of the world from Paris who witnesses and reports the scene, tells us that he could not help fancying that he sat at a table with hosts that had risen straight out of the grave of the preceding century.[68]

The tourist stands at the edge of an open grave, not with spade in hand to bury old traditions but with a pen to record them.

The process of negating cultural practices reverses itself once it has succeeded in archaizing the "errors"; indeed, through a process of archaizing, which is a mode of cultural production, the repudiated is transvalued as heritage. The very term "folklore" marks a transformation of errors into archaisms and their transvaluation once they are safe for collection, preservation, exhibition, study, and even nostalgia and revival.[69] How

safe is another matter. In the words of John Comaroff, "[F]olklore . . . is one of the most dangerous words in the English language" because it often obscures "a highly unreflective populism," or worse, in the case of Splendid China theme park in Florida.[70]

Documentation and exhibition are implicated in the disappearance of what they show, whether intended to induce disgust in those still internalizing the new norms; justify genocide, as the Nazis intended their planned exhibition of an extinct race to do; or demonstrate improvement, in the case of a sanitized Maori model village. These rehearsals of culture, which Mullaney likens to the rehearsal of evidence and presentation of exhibits in a court of law, entail "the exhibition of what is to be effaced, repressed, or subjected to new and more rigorous methods of control."[71] This principle guides the exhibition on drugs at the Justice and Police Museum in Sydney, where a text panel reads: "For legal and ethical reasons the layout of this [drug] laboratory is not detailed or complete. Its purpose is only to suggest the chemistry and equipment used at different stages in the production of amphetamines." After answering a boy's questions about the drug paraphernalia on view, a mother murmured her concern to me: "If you tell them too much, it raises their interest." Show just enough to foreclose the subject.

A recent effort of Burmese authorities to relocate "long-necked" minority women from their homes in eastern Burma to Rangoon to live in a model-village tourist attraction implicates exhibition in the disappearance of what it shows. A Burmese opposition group protested the forced removal of "ethnic minority people from more than two hundred villages in Thandaung township in the hills of northern Karen state," including "members of the Padaung ethnic group whose women put metal rings around their necks giving them a 'long-necked' look." Some of them "will be forced to live in a model village, which is being built near Rangoon in time for next year's 'Visit Myanmar Year'" and is described by the dissidents as an "ethnic human zoo." This is not the first time that "Padaung people have been promoted as tourist attractions," nor is it the first time that human exhibits have been featured in zoos.[72]

According to a plan for the "New Luxor," "the 100,000 residents of Qurna, currently living above and among ancient tombs, will ultimately be relocated from this archeological zone to Al-Taref." To encourage

tourists to stay longer—if not for a thousand and one nights, then for "Six Egyptian Nights"—developers plan a golf course and "a model village that portrays aspects of Egyptian life—Pharaonic, Bedouin, Nubian and rural cultures."[73]

Bushmen, "routed almost out of existence" by early settlers and now few in number, were expelled from Kalahari Gemsbok Park in 1970, because "management decided that tourists did not like seeing hungry-looking Bushmen. The tribesmen's lack of materialism made them unreliable, many employers say, and they were eating too many animals." Twenty years later forty Bushmen have been brought from a shantytown to the Kagga Kamma Game Park north of Cape Town, where tourists can view them for $7.00 ($1.50 of the fee goes to the Bushmen). Bushman activists hope to reclaim ancestral land, some of it in the Kalahari Gemsbok Park, which they consider essential to their survival and way of life.[74]

Cultural precincts have a long history. Model villages, open-air museums, and theme parks are the legacy of foreign villages at international expositions in the nineteenth century. Likely inspired by these examples, a model Maori village was proposed by the Department of Tourism and Health Resorts in 1902 and conceived from the outset in museological terms:

> As an additional attraction to the Rotorua district, I recommend that a model Maori pa [fort] or kainga should be established in the Whakarewarewa Reserve between the water supply setting basins, and the Native school. There is ample land of a substantial nature available there, also some very interesting thermal action and fresh water lagoons. My proposals provide for the erection of a *runanga* (meeting house), *pataka* (food store-house)—these to be carved in the old Maori style—and several comfortable *whares* [houses]; a shed to be built near the schoolhouse, in which the young Native boys should be taught carving and the girls matmaking, the whole to be fenced in the Maori manner. Later on a model fighting pa could be added. Selected native families to be given residence at this pa, and sanitation be a salient feature of it. The villagers could make carvings and mats for sale, thereby earning sustenance. Thus, two important object-lessons would be provided for the Maoris generally, and visitors would have an opportunity of seeing a replica of old Maori life. The total cost need not exceed £500.[75]

"Guide Tina, Whakarewarewa, Rotorua, N.Z."

Maoriland Photographic Series. Published by Tanner Bros. Ltd., Wellington, New Zealand.

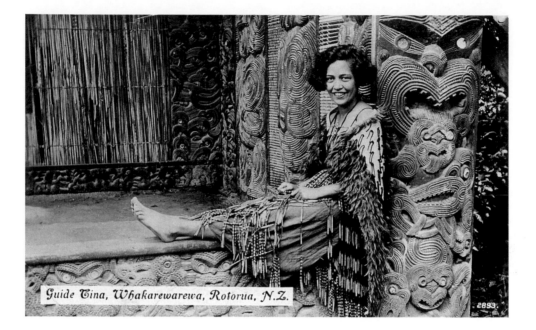

Guide Tina, Whakarewarewa, Rotorua, N.Z.

The village materialized, but it was not inhabited. However, the long history of Maori involvement in tourism became part of the site. Celebrated guides and performers are immortalized in the form of carved figures at the tops of *totara* posts along a path to the thermal valley. And, "cultural performances" developed for tourists have themselves coalesced into such notions as the "classic old style programme." They also serve new roles within Maori communities. Some even credit tourism with stimulating the continued vitality and creative transformation of Maori performance, carving, and weaving, though certain practices (carving and weaving) and performance forms (*wero, haka, poi*) have become icons, while many other areas of Maori history and contemporary culture are not presented to tourists.[76] Almost a century later and at considerably greater expense, an "interactive Maori living village" is planned for Rotorua as part of "a $10 million redevelopment programme which will in-

clude a modern gallery area for contemporary Maori artists [and] a geothermal interpretation centre."[77]

Efforts are now being made to increase Maori participation in the tourism industry, in its planning and policy and as entrepreneurs. *Marae* tourism, which has been operating on a small scale since the seventies, is coming into sharper focus and debate. There is concern that in committing much of daily life to displaying Maori culture to tourists, actual *marae* life would confine itself to designated occasions.[78]

Heritage Tests the Alienability of Inalienable Possessions

Native peoples are taking charge of the disposition, handling, access, ownership, and interpretation of their patrimony—whether artifacts or performances—the spaces in which they live, and their ways of life. A new generation of museum professionals is proactively addressing the stewardship of cultural property, its presentation and interpretation in museums. These changes have important implications for the tourism industry, which often defines the uniqueness of its product in terms of indigeneity, both natural and cultural.

In the words of Raymond Williams, "[A] culture can never be reduced to its artifacts while it is being lived," though this is what museums have tended to do.[79] Promising to bring its dead specimens "to life" through the theater of installation, museums produce the lifelike, the work of the undertaker, which is not to be confused with life force, the work of survival. For *taonga* the issue is not a second life as an exhibit. What is at stake is the restoration of living links to *taonga* that never died. They were removed from circulation. They were withheld. Some will forever remain orphans, their provenance unknown, which is a point brought home by the permanent installation of *taonga* at the Manawatu Museum in Palmerston North, New Zealand. The vibrant relationship of particular objects in the collection to actual people and communities is dramatically displayed in the opening gallery. Nearby, artifacts about which little is known are exhibited separately. Severed links, these isolated objects are a poignant reminder of the circumstances of their acquisition, of their alienation.

The life force of *taonga* depends not on techniques of animation but on the living transmission of cultural knowledge and values. What matters is not the vividness of a museum experience but the vitality, the survival, of those for whom these objects are *taonga*. That survival depends on intangible cultural property, which lives in performance. It must be performed to be transmitted. This is the source of its life. This is the source of its vividness.

Folklorist Barre Toelken remembers the consternation of students at the University of Oregon who signed up to learn how to make baskets from Mrs. Matt, a Native American from a Northern California tribe. The class met daily for several weeks during which she taught them songs and they kept asking when she would start to teach them to weave baskets. "That's what we're doing," she responded. They sang songs when they gathered plants. They hummed songs and were to think of the words as they softened the materials in their mouths, because the words are "addressed to the materials themselves." When, finally, by the end of the course, they "began" actually assembling a basket, she explained, "After all, you people are missing something here. You're missing the point. A basket is a song made visible."[80]

A Key to Heritage Productions Is Their Virtuality, Whether in the Presence or the Absence of Actualities

Claims to the contrary notwithstanding, heritage and tourism show what cannot be seen—except through them—which is what gives such urgency to the question of "actuality" and the role of "experience" as its test. The atavism of something genuine or real, even if it never materializes, can be seen in cases where the question of authenticity is either irrelevant or fails to illuminate the matter at hand. Consider pilgrimage itineraries. The most ambitious pilgrim can trace a circuit through the entire Indian subcontinent. Alternatively, she can walk a circuit within a region, or within a town, or in a temple, or on a miniature map of India, or even, contemplatively, in her own mind. One can trace Christ's last steps anywhere, which accounts for the Stations of the Cross processions on Good Friday all over the world. And, more to the point, no one asks if the

locations of the stations are authentic. I prefer to think in terms of actualities and virtualities—to posit a collaborative hallucination in an equivocal relationship with actualities.[81]

Both heritage and tourism deal in the intangible, absent, inaccessible, fragmentary, and dislocated. These are features of the life world itself, which is one reason for the appeal and impossibility of the wholeness promised by the various worlds and lands of exhibitions, whether in museums or theme parks. Museums hope that re-creations of natural habitats are not just clever simulations of something somewhere else, not just surrogates for travel to inaccessible places. They must reveal something about the nature of what is shown that a visitor would not be able to discover at the site itself. They must show more than can otherwise be seen. Guides routinely refer to what cannot be seen—the people and events and places of years ago. They animate a phantom landscape on the back of the one toward which attention is directed.

The *AA Book of New Zealand Historic Places* depends entirely on the power of information to create interest in places, specially those lacking noteworthy visual attributes: "Some buildings or sites included in this book may at first glance look uninteresting" or "may initially disappoint those who make an effort to visit them." The organizing metaphor for the experience of these sites is discursive, centered in language and the process of reading: "For the informed traveller, the landscape is an open history book. It is not difficult to learn how to decipher its blurred and indistinct pages, so that one is able to 'read' the human landscape in a way that adds interest and enjoyment to journeys around New Zealand."[82]

But, the guide insists, information is not enough. Imagination is what animates sites:

> Many of the historic places . . . will only come to life if visitors use their imaginations. This is especially true of the "prehistoric" sites from which we can learn much about Maori life in New Zealand before the arrival of Europeans. It is not always easy to visualize people living, working—or fighting—on a site hundreds of years ago when all that can be seen today is a grassed-over ditch and bank, a faint terrace or a heap of old sea-shells. But it is important to make an effort of imagination to see such sites as they were when peopled by past generations.[83]

In this scheme, purpose-built tourist attractions can prepare visitors to use their imaginations when visiting actual sites: "No West Coast gold-mining town ever looked like Shantytown, but a visit there can help to fire the imaginations of those who later visit abandoned, overgrown gold-mining township sites."[84]

The reassurance of hypervisibility—close encounters with the actual or the virtual—is fragile. Not everything that is to be known or understood is so directly available to the senses. While the marketing of heritage promises experience, and specifically to engage not only sight and sound but also touch, smell, and taste, heritage interpreters often locate truth in what cannot be seen, in the invisible heart and soul of the site. Their expressed desire to make sites real and vivid indicates that sites cannot do this for themselves. The inability of sites to tell their own story authorizes the interpretation project itself.[85] Nor is sensory involvement and intellectual understanding enough. *Getting Started: How to Succeed in Heritage Tourism*, issued by the National Trust for Historic Preservation and underwritten by American Express, stresses the importance of making "heritage resources emotionally accessible," or "[a]s the salesmen say, sell the sizzle as well as the steak."[86]

Rather than thematize what is not there and re-create Government House, built in 1788 by Governor Phillip, Australia's Museum of Sydney takes as its subject not only the site on which it is located but also the nature of itself as a museum.[87] The Museum of Sydney exhibits itself—its methods, fragments of evidence unearthed from the site, the process of coming to terms with the place and its history. At Hyde Park Barracks, which is associated with it, a large vitrine with live rats is located next to the cash register. Rats are honored at this site as the minions of history, for it was in their nests between the joists that much evidence survived. Not the nests of these very rats, of course, but much is to be learned by watching how they create their nests and tuck things away there.

These two museums exploit the limitations of the actual sites to reveal what they are about. As the *AA Book of New Zealand Historic Places* explains, "Throughout our history, people have left very different marks on the New Zealand landscape, some faint and some clear. In some cases there is no mark at all, but the place is still historic because we know some important event occurred there."[88] This is precisely why both museums

and tourism are largely in the business of virtuality but claim to be in the business of actualities—of real places, real things, and real experiences. "Hereness," as the *AA Book of New Zealand Historic Places* understands all too well, is not given but produced.

The production of hereness in the absence of actualities depends increasingly on virtualities. Consider the case of the Abbey Church of Saint Peter and Saint Paul (1088–1804) in Cluny, France, a church the size of two football fields. The church outlived its usefulness with the decline of the vast Benedictine monastic order for which it had been the center. Shortly after the French Revolution, the Burgundian village in which it was found allowed the massive church to be dynamited and the stone sold. Not until protective legislation halted the process in the late nineteenth century did the village realize the value of what had been destroyed. Robb Walsh, a travel writer, recently reported that "Last year 700,000 tourists came to see Cluny and the church that isn't there." As he explains, "[T]he only thing larger than the empty space where a church once stood is the legacy of its destruction. . . . Like an amputee who still feels sensations in his phantom limb, the ancient village of Cluny is still haunted by its phantom church." What do visitors find there? "Towers of the transept, and bases of the interior pillar, the great church's foundations exposed and left vacant." They also find a virtual church:

> A museum dedicated to the church stands a few feet away from the excavation. Inside, I look at an animated, three-dimensional computer recreation on videotape that shows views of the structure from all angles while a Gregorian chant fills the background. Back outside, I stare again at the void. The computer model is still so fresh in my mind that an image of the enormous edifice seems to appear before me. I'm not alone in this optical illusion: Everyone leaving the museum seems to do the same double take outside. It's as if we're having a mass hallucination of a building that no longer exists.[89]

The museum is an integral part of the site. The museum does for the site what it cannot do for itself. It is not a substitute for the site but part of it, for the interpretive interface shows what cannot otherwise be seen. It offers virtualities in the absence of actualities. It produces hallucinatory

effects. On the basis of excavation and historical reconstruction and in collaboration with visitors, the museum openly imagines the site into being—in the very spot where it should be still standing but is no more. This is also the beauty of the Museum of Sydney, a museum that finds the truth of the site as much in the poetics of the documents as in the "facts."

Like museums, tourism is predicated on dislocation—on moving people and, for that matter, sites from one place to another. Take Luxor—Luxor Las Vegas that is:

> Luxor Las Vegas, which opened on October 15, [1993], is a 30-story pyramid encased in 11 acres of glass. The hotel's Egyptian theme is reflected in the decor of its 2,526 rooms and 100,000 square foot casino. Guests travel by boat along the River Nile from the registration desk to the elevators, which climb the pyramid at a 39-degree angle. Other features include an obelisk that projects a laser light show in the pyramid's central atrium; seven themed restaurants, and an entertainment complex offering high tech interactive "adventures" into the past, present, and future. Double rooms at the Luxor, 3900 Las Vegas Boulevard South, are $59 to $99.[90]

Is getting to and from the registration desk to the elevators by boat along the river Nile any stranger than squeezing the Temple of Dendur into the Metropolitan Museum of Art in New York? Any stranger than traveling to Luxor, Egypt, itself? Travel Plans International promises a cruise up "the legendary Nile in a craft that surpasses even Cleopatra's barge of burnished gold. . . . It is a yacht-like 44-passenger vessel carefully chosen for its luxuriously intimate appointments. Each cabin provides panoramic views through picture windows as well as the convenience and comforts of private showers, individual climate control, and television." What *Travel Plans International* (1988) does not tell you is that several years later "[t]ourism in Luxor has all but ended because of violence."[91] Islamic militants were planting bombs in Pharaonic monuments, both to drive out tourists and to wipe out traces of idolatry.

Go to Las Vegas, experience Egypt. Go to Stockholm, experience all of Sweden—at the Skansen open-air museum. Go to Elancourt, outside Paris, and experience the glories of France-Miniature—including scale

models of the Arc de Triomphe, the Cathedral of Notre Dame, and the Alps. Stay in the Acapulco Motel in Auckland or the Sahara Guesthouse and Motel in Dunedin or the fully generic Heritage Motor Inn, in faux Tudor, in Rotorua. In Christchurch, at Orana Park, where African cheetahs, rhino, and giraffes roam, "The Serengeti Restaurant offers brilliant views over the African Plains," just twenty-five minutes from the heart of the city. The International Antarctic Center invites you to "Experience Antarctica Right Here"—"It's better than being there."

Increasingly, we travel to actual destinations to experience virtual places. This is one of several principles that free tourism to invent an infinitude of new products. As the recent textbook *The Business of Tourism* states, "The beauty of tourism is that the number of products that can be devised to interest the tourist is virtually unlimited."[92] The market is king. In New Zealand, you can scale the wall of your hotel or "spend the night in jail for a farm stay with a difference," at Old Te Whaiti Jail, as it advertises itself. Refashioned as a living accommodation, this historic jail wears with pride and humor the irony of its second life as heritage. The Cowshed Cafe markets itself as "New Zealand's only restaurant in a once operating dairy shed (no shit)."[93] The Elephant Hotel in Atlantic City is "the only elephant in the world you can go through and come out of alive."

To the degree that they operate in the public interest and with public funds, museums have a responsibility to their "product" that distinguishes them from market-driven amusement, whose primary responsibility is profitability. They are responsible for giving form and space to concerns animating public life in the communities they serve.[94] This difference is enough to stop even Disney in its tracks. Those most likely to benefit economically from the locating of the proposed new theme park, Disney's America, near Haymarket, Virginia, were bitterly disappointed by the announcement that Disney had abandoned the site. Disney's decision was prompted not only by the vehement protests of organizations and families in the region who were concerned about congestion and smog, but also by the objections of historians that "the project would desecrate nearby Civil War battle sites like Bull Run."[95]

The campaign waged by Protect Historic America "argued that the

"Absolute Adrenalin Adventures, Rap Jumping, N.Z.'s Newest Off the Wall Craze!" Text inside this brochure continues: "Imagine looking down a 155 ft vertical wall and jumping off face first!!! Woa, what a rush. . . . Rapping is even more unnatural than a bungy jump. . . . Run, jump, crawl or be even more daring and aerial spin down the face of the Novotel Hotel, Ye Haa!"

Urban Adventure Specialist Company, now Adrenalin Adventures, Ltd., Auckland, New Zealand, 1994.

Elephant Hotel, Margate City, Atlantic City, New Jersey. "The only elephant in the world you can go through and come out alive." According to the back of the postcard, "This famous building erected in 1885 was one of what was to be a menagerie of such hotels. The elephant contains ten rooms and while not used as a hotel, it is visited by thousands who inspect its interior."

Genuine Curteich-Chicago "C.T. Art-Colortone" Post Card, Jersey Supply Company, Atlantic City, circa 1946.

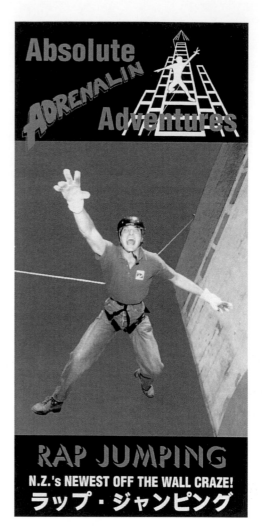

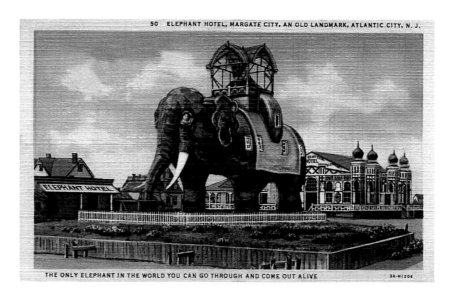

50 ELEPHANT HOTEL, MARGATE CITY, AN OLD LANDMARK, ATLANTIC CITY, N. J.

THE ONLY ELEPHANT IN THE WORLD YOU CAN GO THROUGH AND COME OUT ALIVE

project, which was to include virtual reality battles and a Lewis-and-Clark white water raft ride, would not only destroy important Civil War sites but would also trivialize and sanitize American history."[96] Disney history—Distory or Mickey Mouse History, as some call it—has a poor track record.[97] Not even the willingness of some of America's most distinguished historians to help the company get the story right could inspire sufficient confidence to allow Disney to work the magic of virtuality so close to the actual sites. Manassas National Battlefield, with its "somber hills and statues and authentic stone houses" and its "brief movie and booklets about the Civil War and . . . a walking tour," has been attracting as many visitors in a year (about one hundred and thirty thousand) as Disney had hoped to reach in four days. "There's not much exciting there for a child," complained the head of the Haymarket Historical Commission and supporter of the Disney project.[98] The problem lies deeper than getting the facts right or making the site more exciting. As critics hastened to point out, attendance is down at Disney's theme parks, largely because fewer foreign visitors are going to them.

Nearby, at Colonial Williamsburg, controversy raged over the reenactment of a slave auction. Ostensibly on surer ground, a respected historic site tested the threshold of virtuality. Its aim was not to cash in on the glamour of battle or the excitement of rafting, but to mobilize moral outrage and stimulate critical reflection on a shameful aspect of national history. But there was fear that "education could be trivialized into entertainment" or that "the re-creation might be inaccurate or sensationalized for entertainment." Christy S. Coleman, who supervised the department responsible for the reenacted slavery auction, "contended that only by open display and discussion could people understand the degradation and humiliation that blacks felt as chattel. She compared the pain of the slave auctions for blacks to that of the Holocaust for Jews and said that if museums were built to illustrate the horrors of one, why should not efforts be made to illustrate the other."[99]

The term "illustration" suggests that display techniques are neutral, which they are not. It is inconceivable that the U.S. Holocaust Memorial Museum in Washington, D.C., would reenact mass murder. That the Museum of Tolerance in Los Angeles re-creates a gas chamber, which func-

Berlin Cafe Street Scene. "This street scene brings you to 1932 Berlin, on the eve of Hitler's rise to power. Eavesdrop on conversations at this elegant café, then flash forward as the narrator reveals the characters' futures. Some play important roles in the Nazi regime, while others fall victim to Nazi persecution."

From Simon Wiesenthal Center, *Beit Hashoah Museum of Tolerance,* ed. Anne Du Bois (Los Angeles: Albion Publishing Group for Simon Wiesenthal Center, 1993), 28. Photo copyright Jim Mendenhall / Simon Wiesenthal Center, 1992.

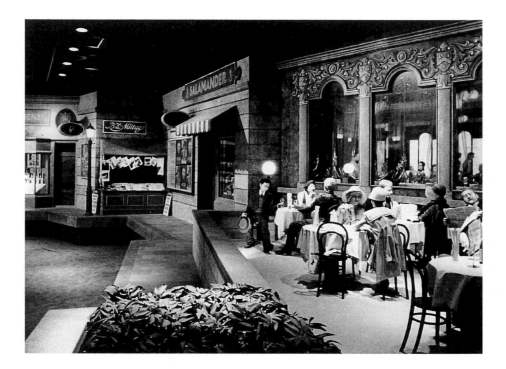

tions as a gallery for videos, reflects its more theatrical (rather than evidentiary) approach to display. Controversies have erupted over the propriety of exhibiting hair shaved from the heads of those who perished at the hands of the Nazis; this question is part of a larger problem of displaying human remains. Religious Jews question the ethics of showing photographs of naked victims, humiliated and terrified—particularly in relation to those today who recognize their own relatives in these images. Such disputes suggest the limits of what can be shown, even when the ob-

Hall of Testimony. This hall "attempts to give visitors a sense of both the despair and hope that the Jews and other victims experienced during the Holocaust. As you stand beneath steel girders in a dark, concrete hall, you listen to the first-person testimony of victims, perpetrators, and witnesses. A series of video-photo montages accompanies the stories."

From Simon Wiesenthal Center, *Beit Hashoah Museum of Tolerance,* ed. Anne Du Bois (Los Angeles: Albion Publishing Group for Simon Wiesenthal Center, 1993), 40. Photo copyright Jim Mendenhall/ Simon Wiesenthal Center.

jectives are worthy. They also point to culturally specific sensitivities—and insensitivities—to exhibition, as does the Nazi theme park at Wolf's Lair, in Poland.[100]

Distory, at least to date, is about history as it should have happened—the best, only the best, nothing but the best. To the degree that the tourism product is "the concrete expression" of the "most attractive images possible," it too is in the Distory business.[101] But the perfect world projected through the virtualities of tourism may well be at odds with the

actuality of corporate policies and the infrastructure of the site. The Walt Disney World Hotel was recently taken to task for what employees characterize as its "English only" policy.[102]

The dependence of tourism on unlimited entitlement in a hedonocracy of dreams come true is fundamentally at odds with what counts as "action" in the cultural sector, though this sector is by no means immune to Distory. If the market has no conscience, what then is the role—and fate—of the consciousness industry? *Welcome to Australia*, the Brisbane Hilton's guest information book, devotes a page to "History at a Glance." It starts with 1606 and Australia's first written record, kept by the Dutch ship *Duyfken*, and proceeds through a series of fleets, discoveries, foundings, and wars. There is no indication in this chronology of aboriginal presence before the Mabo Decision ("Mabo v. The State of Queensland [No. 2]," 1992), which mandated a process of reconciliation. We have here an exhibition of understandings sloughed off by the consciousness industry.

Where do old ideas go to die? Tourism, a museum of the consciousness industry.

Ellis Island

How does a federal office become a shrine? From 1892 until 1924, millions of steerage passengers passed through Ellis Island as quickly as possible, without looking back. Today, even more recreational immigrants will board *Miss Freedom* and other official Ellis Island boats provided by "America's Favorite Boatride," the Circle Line. They will participate in the founding myth of our time, "America's great immigrant heritage," through the trope of retracing the steps of those who came to the "promised land" before them.

Never an icon like the Statue of Liberty, Ellis Island was an aperture, not a place. It was a gauntlet controlled by the U.S. Department of Immigration and Naturalization Services (INS). Since 1965, the onset of a new period of mass immigration, it has been under the jurisdiction of the National Park Service. Ellis Island, now a repository of patriotic sentiment, has been incorporated into a recreational geography of national parks and monuments, alongside Colonial Williamsburg, Plymouth Rock, and the Grand Canyon. Tourists entering the newly restored main building are informed that "[r]angers will welcome visitors at an orientation desk in the Baggage Room." This is not the reception immigrants got.

Quietly sinking into the landfill on which they were built, abandoned buildings on Ellis Island are a tangible reminder of restrictive legislation enacted in 1921 and 1924 (and during the 1950s cold war) that reduced the

Postcard from Ellis Island. "Yesterday: In lines anxiously awaiting an unknown future. Today: On tour eager to retrace the immigrants' footsteps." As noted on the back of the postcard: "A panoramic view of historic Ellis Island nestled in New York Harbor. Ferries carry visitors to the Ellis Island Immigration Museum from the Battery in NYC, Liberty Statue Park in New Jersey the Statue of Liberty. This museum honors all immigrants to the United States."

Photo of Ellis Island today by Klaus A. Schnitzer.

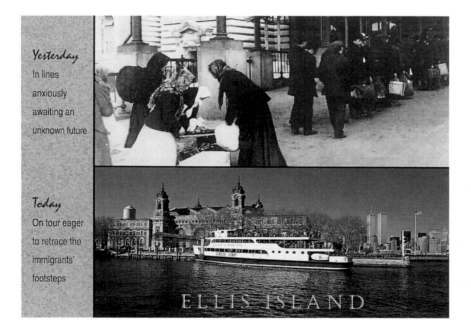

torrent of immigration to a trickle for four decades and changed Ellis Island from a major immigration center to a small detention and deportation facility. According to Stephen Briganti, president of the Statue of Liberty–Ellis Island Foundation, Ellis Island was abandoned in 1954, not because of any "lack of pride in its heritage," but because the site had outlived its usefulness. Such formulations obscure how the death of the site resulted from the stranglehold of restrictive immigration policy, a heritage unworthy of shameless pride.

Restored, Ellis Island rises like the Phoenix out of the ashes of American immigration history. In the wake of the 1986 Immigration Reform

and Control Act, the AIDS testing of gays trying to enter the country, and the movement to make English our official language and the square dance our national dance, the restoration of Ellis Island attracted some $158 million from the private sector for what is billed as the largest restoration project in American history. A golden handshake between President Ronald Reagan and the Chrysler Corporation's chief executive officer, Lee Iacocca, in 1982 brought forth from the pockets of corporate sponsors and underwriters representing the alcohol, tobacco, soft drink, and infant formula interests—as well as from some two hundred thousand private citizens—enough dollars to enshrine a government office in 1990. Meanwhile, millions of would-be immigrants, many of them casualties of American foreign policy, languish in refugee camps in Thailand, wait for visas in El Salvador and Haiti, are rounded up along the Mexican border, pay exorbitant sums to lawyers to help them get green cards, or live as illegal aliens, uncounted by the census and unprotected in the workplace. Souvenirs in the Ellis Island gift shop in 1995 update the site by billing the island as the "front door" to America.

In 1900, ten years after the first immigration station was constructed on Ellis Island, the main building that is the centerpiece of the restoration was completed. Designed by the architects Boring & Tilton in Beaux-Arts style, this building was refurbished after World War I and has been restored to the period when, in 1918, the intimidating Registry Room acquired its vaulted ceiling of Guastavino tile. The restoration of the building was thus determined by the dictates of architectural, not immigrant, history. Most immigrants who passed through Ellis Island had done so by 1918 and never saw the building in this state. The Registry Room has been left practically empty so that visitors may fill it with their own images and feelings. Given past and present discourse about the site, we might well ask whose images and feelings they really are. Iacocca experienced "ghosts of the immigrants who once huddled under the arching dome of the Great Hall, clutching their few worldly possessions." He continued, "I could almost sense the steamships, the crowds, the mixture of hope and fear on their faces. My own mother and father, I thought, must have stood right where I was standing"—a Hollywood film epic in the making.

The building is frozen in a narrow band of time, while the two decades of mass immigration during which Ellis Island processed more than half the immigrants entering the United States expand to encompass four centuries of American history. The Ellis Island restoration thus subsumes prior and subsequent historical moments—from the *Mayflower* to Fort Chafee to the Los Angeles International Airport—while the immigrants who passed through the facility become prototypes for all arrivals to America no matter what their point of origin, port of entry, time of arrival, or circumstances. When Vice President Dan Quayle declared, "What we celebrate in Ellis Island is nothing less than the triumph of the American spirit" and American Express proclaimed that "Ellis Island speaks for everyone who's shared in the American dream," they drew a circle around all Americans present, past, and future and incorporated them into the master narrative of immigration. All of them are "pilgrims of freedom." This designation obscures important differences, for example, how political expediency determines who is a refugee. Those fleeing Communist regimes can enter the United States more easily than those escaping right-wing dictatorships supported by the U.S. government.

In the production of Ellis Island as a national park, the Main Building begins as a metonym. It is one structure in an architectural complex where steerage passengers arriving in New York were processed during the period of mass immigration. Using the principle of synecdoche, the restoration makes Ellis Island the master paradigm for all ports of immigrant entry in all historical periods. This approach to classifying immigrants would be unthinkable in the halls of the INS, because it offers little basis for excluding anyone. So powerful is this master category that it includes not only the living American descendants of immigrants processed at Ellis Island, estimated at about 100 million people, but also Mickey Mouse, who appears with cap and bag in front of Ellis Island on a T-shirt in the gift shop. Like Mickey, tourists also become honorary Ellis Islanders, their visits authenticated by the "Official Ellis Island Visitor's Medal" or the certificate that serves as an "official document that will take its place alongside your family's most precious heirlooms," just like the visa, green card, and passport. At the Ellis Island restoration, even memories are produced and authenticated.

Though the Ellis Island Immigration Museum attempts to correct the exclusions of the past by finding a place for those who were never allowed to pass through its doors when the island was still in the immigration business, the stories of most Americans bypass the island. Some arrived under duress, as part of the slave trade, or found themselves in the United States because the territories in which they lived were annexed or simply taken away. Others had the money to avoid steerage class and, therefore, Ellis Island. Still others were deported for any one of dozens of reasons that fly in the face of professed ideals of liberty. Many from Asia, Africa, and Latin America were allowed to enter in substantial numbers only after 1965, when U.S. immigration legislation was significantly liberalized. What does it mean, then, to absorb their stories into the master narrative of Ellis Island as the golden gateway to America? Can the perfection of the restoration mitigate the imperfections of history?

In an extraordinary example of purchasing history on credit, American Express invites its cardholders to honor an ancestor by inscribing the person's name on the American Immigrant Wall of Honor, a copper ribbon covering the upper surface of the seawall ringing the island. Not death on the battlefield of war or disease, but only cardholder status and a minimum of one hundred dollars charged to Amex is required. Those whose names are inscribed on the wall are the Ellis Islanders, proxies for those who paid to honor them, a point not lost on the casual visitor. Overheard: "These are the names of the people who spent a hundred dollars." However cynical the younger generation may be about the Amex invitation, their older relatives may expect, even pressure, them to honor the family in this way. Almost two hundred thousand names had been inscribed by the time the restoration opened its doors, raising more than $20 million for what is billed as the longest wall of names in the world. And extensions to the wall have since been completed. The ease with which one can sign on to the American Immigrant Wall of Honor, however, obscures the very real obstacles to obtaining a visa and green card. Those obstacles become a game in the *Ellis Island Coloring Book*. Literally faceless, the new immigrants stand at the entrance to a maze, awaiting only a playful pencil to guide them through processing.

Visitors are also encouraged to trace their family genealogies with the

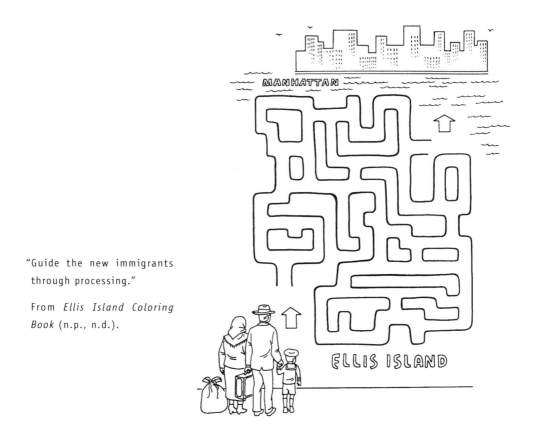

"Guide the new immigrants through processing."

From *Ellis Island Coloring Book* (n.p., n.d.).

assistance of computers (only those whose names appear on the wall are included in the computer registry) and videodiscs. We are told repeatedly that over 40 percent of living Americans are descendants of immigrants who passed through Ellis Island. This formulation embeds federal bureaucracy into family histories, creates genealogies that are defined by the presence of Ellis Island in them, and makes a federal procedure the "symbol of this nation's immigrant heritage." The elite project of genealogy is enlisted to elevate immigrant history, which depends for its prestige on the ancestor who passed through the federal bureaucracy of Ellis Island. As heritage is reduced to genealogy and port of entry, records that controlled America's borders are subjected to adaptive reuse and the apparatus of the state becomes the custodian of family history.

Who authorizes Ellis Island to speak for all Americans? Lee Iacocca? Corporate sponsors and underwriters? The National Park Service? Pro-

"Draw in the faces of these immigrants to the 'New World.'"

From *Ellis Island Coloring Book.*

fessional historians? The National Society of the Daughters of the American Revolution? How does Ellis Island speak, and what does the restoration say? Consider for a moment the role of the list and the grid. Each name has its own line on the Immigrant Wall of Honor, arranged in the arbitrary order of the alphabet, just like ship manifests and naturalization records. Each immigrant's face has its own quadrant on a corrugated surface so arranged that the faces we see from one viewing angle dissolve into the American flag when viewed from the other. Unhuddled, each name and face distinct, the tired and the poor of "The Great Colossus" are here disciplined by the orderly list and grid, instruments of perceptual control that appear to treat all citizens equally. "We want to have visitors leave with the feeling that they know the people who came to this country and the emotions felt at Ellis Island," according to Briganti. But the list and the grid also neutralize significant differences by virtue of their

arbitrary and repetitive structures—and they have their analogues in the gift shop and restaurant.

Unrestrained by the discipline of professional historians or the dictates of tastefulness that tempered the "selling" of Ellis Island to corporate philanthropy, the gift shop and fast-food restaurant offer popular conceptions of the site. Consistent with the hushed and elevated tone that suffuses the site more generally, the gift shop features "products that reflect the heritage of the people from all over the world who passed through Ellis Island, the Gateway to America." Visitors are encouraged to "enjoy them with pride and remember those who came this way." What exactly is the heritage that this "exclusive Ellis Island Gift Collection" reflects? Using a gallery-of-nations approach, the gift shop features the national colors, flags, costumes, and other attributes of passport identities associated with the imagined communities of nation-states and the traditions they have invented—limited edition porcelain eagles from the American Signature Collection, a Connemara green marble worry stone from Ireland, German steins, Russian nested dolls, Bentley's of London Old Master's Collection of Fruit Bonbons, and an "adopt a Norfin troll" from Denmark. Thanks to a shelving error, the Dala horse key ring from Sweden becomes a Dutch souvenir, a suggestive metaphor for the arbitrariness of immigration classifications. Indeed, the plethora of mementos from Holland says more about who makes good souvenirs than which country sent the most immigrants to America.

The limits of the historical categories of immigration classification— "racial ancestry" and passport identities—as a repository for "heritage" are specially clear in the gap between how immigrants were differentiated during the acme of Ellis Island and the categories relevant to today's tourists. Is a visitor whose Jewish grandmother came from Vilna in 1920—immigration officials would have classified her as "Hebrew race"—expected to purchase a souvenir mug bearing the image of a Polish man or a plaque emblazoned with the Israeli flag? Visitors whose eight grandparents came from as many different places might drift toward ready-to-wear world maps in the form of jackets, umbrellas, and bags. Which souvenirs are appropriate for Palestinians, Ukrainians, Armenians, Basques, Gypsies, Quebecois, and African Americans? Marketing

niches that would be too small if split into separate countries are consolidated under the pan-national umbrellas of Scandinavia or Africa. At the very least, the generic Ellis Island commemoratives—plaques, medals, plates, mugs, steins, desk pen sets, clocks, money clips, key chains, refrigerator magnets, ashtrays, trivets, thimbles, china bells, trays, paperweights, shot glasses, rings, spoons, bags, letter openers, pennants, ranger badges, toy jewelry, and the T-shirt in a cup—can immortalize their recreational visit to the restored site, if nothing else. This is Ellis Island logocentrism run amok, for these objects are the historical equivalent of a designer label applied to a ubiquitous repertoire of neutral shapes whose sole purpose is to codify memory, even in the absence of appropriate memories. This is a cartography drawn with souvenirs from countries on today's map, from independent states that did not exist at the turn of the century when they were part of the Austro-Hungarian or Russian or Ottoman Empire. Even today's map won't hold still long enough for the gift shop to clear its inventory. Decals and key chains bearing the symbols of the U.S.S.R. and Yugoslavia sit next to ones announcing the new states of the New Europe. These hyphenless identities mark an apparently easy passage from one citizenship to another, encapsulated by the name of a country and a national symbol on a platter or mug.

Following the logic of corporate capitalism, the gift shop, like the corporate sponsors, converts historical subjects into markets. AT&T, which underwrote the "Treasures from Home" exhibition, celebrated the opening of Ellis Island by offering discounts on long-distance telephone calls ("Let us help you go home"). NYNEX, which sponsored the Videowall (sixteen screens and a cast of millions), invites visitors to "[e]xperience the spirit of our ancestors through the technology of today." American Express, in a direct mailing to its cardholders, urges them to use their credit cards to inscribe names on the copper ribbon so that "your family's heritage will still be recognized for the contributions it has made to making America the greatest nation on earth."

Perhaps the most labile expressions of the Ellis Island story are to be found in "All America Worlds Fare" [*sic*] at the time the museum opened in 1990. Past a photomural of immigrants at long tables with their bowls of stew and crusts of bread are the lines of tourists ordering from a fast-

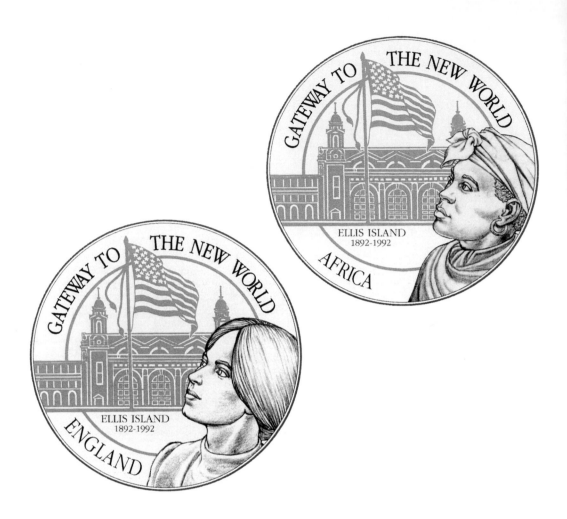

"A greeting from Ellis Island" cards, each with souvenir medal commemorating immigrants from a particular country—or continent, in the case of Africa. Each card reads: "In one record day this month, 21,000 immigrants came into the port of New York alone; in one week over 50,000. This year the total will be 1,200,000 souls, pouring in, finding work at once, producing no fall in wages. They start digging and building and making. Just think of the dimensions of it! H. G. Wells, 1906." Lower left: souvenir medal commemorating immigrants from England. "Between 1899 and 1931, 1,313,716 English immigrants passed through Ellis Island, the gateway to the New World." Upper right: souvenir medal commemorating immigrants from Africa. "Between 1899 and 1931, 142,559 African immigrants passed through Ellis Island, the gateway to the New World."

food menu that is an intestinal metaphor for the amalgamation of those who passed through Ellis Island—as if to say, "Would that the absorption of immigrants were as easy as eating a Greek salad." The French breakfast (egg, ham, and cheese on a croissant) and the English breakfast (egg, ham, and cheese on an English muffin) are the culinary corollaries of the national dolls, with their identical, mass-produced plastic bodies in "ethnic" dress, for sale in the gift shop. Pizza, hamburgers, hot dogs, chili dogs, and "french" fries, those mainstays of American junk food, have had their "national" origins restored; in this context they are ethnic foods. The menu specifies "Italian" meatball submarine, corned beef on "Jewish" rye, and the mysterious Parisienne tuna salad. When I inquired what was Parisienne about two scoops of tuna salad, lettuce, and a hard-boiled egg, the cashier replied, "It must have been made in Parisia." Ethnic blurs abound. Overheard: "Where's the pierogi sandwich?"

"Treasures from Home," sponsored by AT&T, takes its own liberties with what counts as a treasure from home. Ostensibly, everything on display was brought from the old country by an immigrant to the United States. But, several objects that stand in for Jewish treasures from home were donated to the Ellis Island Immigration Museum by the Jewish Museum in New York. Their provenance is identified as the Benjamin and Rose Mintz collection. Nothing could be further from the story of Ellis Island than the history of how these objects came to the United States. As discussed in chapter 2, the Mintzes were headed for Palestine from Poland during the late thirties. Denied visas to visit America, they sent their Judaica collection to the United States in the hope that the objects would be shown at the New York World's Fair and the Mintzes might receive temporary visas to accompany their collection. In this case, the objects saved their owners, not the other way around.

However exquisite the restoration of Ellis Island and however seductive the rhetoric that surrounds it, memory is not reclaimed. It is produced. The attribution of authorship to those who subscribe to the Immigrant Wall of Honor obscures the hands that really control what will be remembered and how, for ultimately the intermittently visible producers of the restoration are the authors of institutionalized memory.

Plimoth Plantation

Plimoth Plantation is a beautifully faceted jewel, or perhaps a Chinese puzzle. Its meaning cannot be exhausted, nor can its paradoxes be resolved. Living history at Plimoth Plantation goes beyond re-creation and simulation. It is an extraordinary experiment in virtuality. An unscripted ensemble performance that is environmental and improvisational, the Pilgrim Village aligns itself more with experimental performance modes than with conventional theater, understood as European drama constructed on Aristotelian principles for a proscenium stage.

As Steven Eddy Snow, in his book on the site, vividly demonstrates, the legacy of the Pilgrims' antipathy to theater is encoded in the history of how their arrival has been commemorated, represented, and animated.[1] Ceremonies, banquets, orations, processions, festivals, tableaus, pageants, and exhibitions have celebrated the Pilgrims for almost two centuries, blurring the boundaries of ritual, theater, and museum. During the early nineteenth century, performances that would have been objectionable to conservative Protestants if staged in a theater were acceptable when presented in a museum (or as civic ceremony), even if there was little else to distinguish them. Reframing performances in terms of nature, science, history, education, and commemoration made them respectable.[2] In the town of Plymouth today, the history of the heritage production is even

more fully visible than the Pilgrim history these productions commemorate. There are historic buildings, landmark plaques, walking tours, museums of artifacts, wax museums, archaeological sites, commemorative events, souvenir shops, thematized restaurants, and the re-created village—in sum, the town and its environs are a museum of heritage performance practices.

Plimoth Plantation is but the most recent interpretative treatment of a site whose primary touchstone is literally a rock: Plymouth Rock, thought to mark the place where the Pilgrims first set foot. What's to be done with a rock? Standing at that spot, with little more than a plaque to distinguish this rock from any other, visitors look out over the ocean and are left to themselves to visualize the historical events the site is meant to commemorate. A little portico has been added to protect the rock from those inclined to chip off souvenirs. This attraction is mute: it is a very plain, very big rock. It is incapable of conveying anything about "the pilgrim experience," which is the sine qua non of the re-created Pilgrim Village. Nor does the neoclassical portico, whose role is to enshrine and protect a relic, help in this regard. Other than reverence and quiet contemplation, no protocols guide the tourist. The assumption in years past was that any visitors attracted to the site already knew the story through its frequent retelling as part of the national founding myth in history books and by tourist guides. The minimalism of this approach—its patently untheatrical character, the absence of mimesis or illusion, the literalism of the rock—is consistent with a Puritan sensibility.

If earlier types of heritage performance were responses to the rock, the re-created village is a response to a hole—the hole that was left after archaeologists excavated the pilgrim settlement. At Plimoth Plantation, archaeological actualities, the excavated fragments, are staged in the museum, while the virtual pilgrim world is re-created in the village. Both the museum and the village are optimistic statements about what can be found, known, shown, and experienced. Both involve theatrical mediations, the museum operating in the tradition of object theatre, the village in the mode of environmental and improvisatory performance.

Today's Plimoth Plantation is both museum and theater, literally. The Pilgrim Village, the living historical museum, has not displaced the ex-

"Seeing Plymouth: Home of the Pilgrims."

Copyright Mike Roberts Color Productions, Oakland, California. Published by Bromley & Co., Inc., Boston.

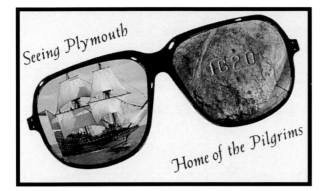

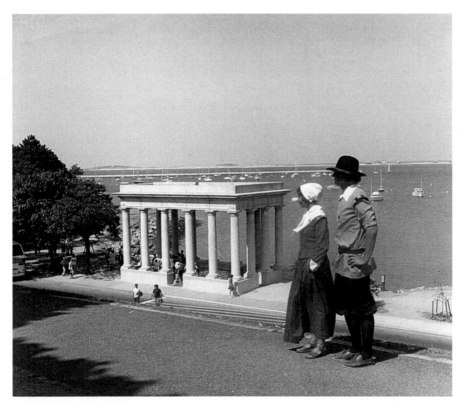

Portico over Plymouth Rock.

Pana-Vue Slide. Published by Bromley & Co., Inc., Boston.

hibit gallery, where archaeological actualities are labeled and displayed in vitrines. Rather, "experience theater" stands in a strategic relationship to the "theater of objects."[3] There is a drama in objects—in the processes by which they are made and used. Consider the visual narratives of Denis Diderot's plates in the *Encyclopédie,* which show the object, its parts, how it is made, and how it is used.[4] Or consider the work displays so central to agricultural fairs. Otis T. Mason, an anthropologist at the Smithsonian Institution, addressed the theatricality of objects in 1891 when he defined "the important elements of the specimen" as "the dramatis personae and incidents."[5] Archaeologists understand this when they try out tools, whether replicas or present-day versions, as a way to better understand them and the processes of which they are part. More recently, Elaine Scarry reimagined the object as "a projection of the human body" that "deprives the external world of the privilege of being inanimate."[6] That privilege is fully forfeited in the Pilgrim Village.

The Pilgrim Village is a homunculus of history, fashioned not from clay but from the living tissue of twentieth-century actors. More than an embodiment of history, the village is an imaginary space into which the visitor enters. Gone is the fourth wall. Immersed in a total environment, the visitor negotiates a path through the site, both physically and conceptually. A brochure invites the visitor to interact with the Pilgrims, to "talk with them, ask them about their lives, and listen as they tell you, in the seventeen regional dialects heard throughout the Village, what it was like to come to this foreign place and build their future." In contrast to the exhibit gallery, which is silent as a tomb, the Pilgrim Village is full of "the sounds of life, laughter, songs, and voices. Although the days of the pilgrims and Native People are filled with chores, there's always time to include you in the lively discussions, storytelling and games that balance their lives." The visitor inhabits the icon.

Two trajectories—the history of archaeology and the history of theatrical commemoration—converge at Plimoth Plantation. Digging painstakingly in the dirt, meticulously sifting and recording every scrap of evidence from the garbage heap of history, the archaeologist infers a totality that is utterly virtual. Living history takes the archaeological imagination—reconstituting wholes from parts—the extra mile. If the ar-

Plimoth Plantation, 1627/1985. View from the entrance to the village.

Photo by Barbara Kirshenblatt-Gimblett.

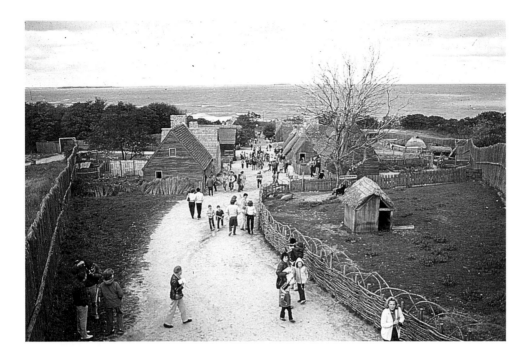

chaeologist cannot excavate the whole pot intact, or all of the fragments, then he can fill in the gaps, inferring from a few shards what the whole might have been. Having reconstituted the pot, why not the potter? Why not his studio, home, and marketplace? And why limit the reconstruction, let alone the exhibition, to drawings and words? The curator is a dramaturge of the metonyms of history, fashioning a mimetic re-creation of the totality of Pilgrim daily life from archaeological fragments, some of them on display in the exhibit gallery. The Pilgrim Village is a consummate performance of connoisseurship. Authenticated by the actualities in the museum, the virtual village completes the picture. The more fragmentary the archaeological evidence, the more virtuosic the recreation.

Several display traditions are at work here. First, living history muse-

ums are an extreme example of the passion to imagine the past in the most literal detail, a passion perhaps most familiar in meticulous reconstructions of what is described in the Bible. The making of architectural drawings and scale models of the Tabernacle, the Temple, Noah's Ark, the Tower of Babel, and the entire city of Jerusalem has a long history, stimulated in part by the Protestant Reformation and the fascination with the literal truth of scripture. In this respect, it is perhaps less ironic that the Pilgrims, who so detested theater, should be represented so literally at Plimoth Plantation. Second, the habitat group became popular during the nineteenth century as a way to display natural and cultural specimens. Rather than arrange them in a decorative pattern or according to some purely formal taxonomy, curators staged objects within their "habitat." The legacy of this approach may be seen today in the re-created environments of animals in zoos, period rooms, and theme parks. Such exhibitions are surrogates for the sites near and far that they represent. Third, even when tourists travel to distant destinations, what they encounter is often an exhibition of where they are or of somewhere else, as discussed in chapter 3.

Even as historic re-creations in our own day model themselves on the tourist experience, tourism itself recodes space as time. Travelers are routinely promised idyllic escapes from their harried lives to destinations where time "stands still" or the past lives on, untouched by modernity. Time does indeed stand still at the Pilgrim Village. It is always 1627 in the virtual world that emanates from the deep hole of archaeology. Traces once fixed in layered sediments of time can be seen in the exhibit gallery.

There is at work here, in both the archaeological and the curatorial imagination, a performance epistemology that places a premium on experience—visceral, kinesthetic, haptic, intimate—and a performance pedadogy more akin to the nascent medium of virtual reality than to older models of learning. Forfeiting third-person omniscience for the partiality of the first person seems a small price to pay, for what is lost in historical comprehensiveness is gained in immediacy and detail, in the completeness and penetrability of a small virtual world. Immersed in an experiential situation, the visitor uses all her senses to plot her own path, at her own pace, through an imagined world. She is never told what questions to ask or given definitive answers. Learning here is all process and

discovery. It is partial, negotiable, polyvocal. More like hypermedia than a play, the site is truly interactive. Visitors do not "passively" watch a performance on a stage, look at displays in a museum, or take "rides" through installations in a theme park. They actively engage the site and those in it. The virtual world they are exploring pushes back.

We can see in the display history of the site a shift from ceremonial to virtual, from commemorative to exploratory, from discrete moments, objects, and scenes to the waking dream of a virtual Pilgrim world. But Plimoth Plantation keeps alive the tension between actualities and virtualities. Denigrated by some as Disney World history, as ersatz, the Pilgrim Village should be seen in relation to the history of exhibiting copies. In many ways, American museums of the nineteenth century were virtual museums, consisting in large measure of copies of the great works of Western civilization. Copies were commissioned or collected and exhibited by museums with pride. Whether created in wax, plaster, marble, or some other reproductive medium, copies were subject to their own distinctive aesthetic values. Copies might even be preferred to originals because their very presence indicated that education was the primary objective of the exhibition.

Modeling is a way of knowing, whether it projects back to a past that must be imagined into completeness or forward to what has not yet been experienced. Even the older notion of copy, while submissive to its source, is more than a surrogate for a missing original. Why else keep alive the relationship between archaeological artifacts displayed in the exhibit gallery and the "full-sense fantasy" of the Pilgrim Village? The brochure invites the visitor to compare them: "Many of the originals upon which the copies have been based may be viewed in the museum's Exhibit Gallery." The pleasure of the Pilgrim Village derives in part from the tour de force of its staging, which is all the more amazing given the fragmentary nature of the archaeological remains. But realness, or the fidelity of the virtual world of the village, is not enough. The "actual" must be exhibited alongside the "virtual" in a show of truth.

The result is a shifting locus of authenticity, a trade-off between the aura of actuality, that is, the archaeological remains, and the virtuality of a re-created Pilgrim world. The mediating term is process. Visitors are urged, "Browse through the museum's renowned gift shop, where many

items created using authentic 17th-century methods are available for your own private collection." Authenticity is located not in the artifacts per se or in the models on which they are based but in the *methods* by which they were made—in a way of doing, which is a way of knowing, in a performance. The village as a whole is based on this principle, which is taken to an extreme in the technique of first-person interpretation. It is as if the tool animated not only a hand but also a total sensibility—and so fully that using an adze to understand how it works extends from the hand to the body to the mind to the inner state and way of being in the world that constitutes the person who might have used the tool in 1627. The mementos in the gift shop acquire their authenticity from this chain of effects.

What are the implications of Plimoth Plantation for the historical con-

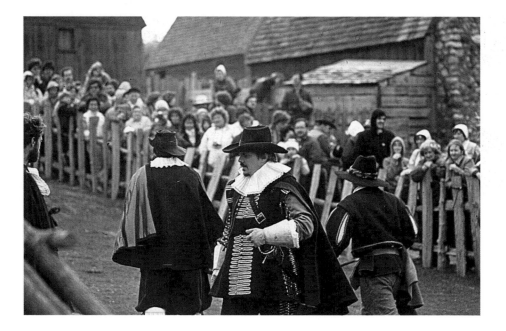

Plimoth Plantation, 1627/1985. A crowd gathers to watch a pilgrim dispute.

Photo by Barbara Kirshenblatt-Gimblett.

sciousness of actors and visitors alike? Historical re-creations like Plimoth Plantation activate three different clocks. The effects are unexpected, difficult to control, and possible sources of delight in their own right. First, there is the stopped clock of the historical moment chosen for re-creation. The Pilgrims in the re-created village live in a narrow strip of time, punctuated by particular moments in 1627 and repeated annually, even though they work hard to create a deeper and richer "memory" of the preceding years. At the same time, they must actively forget what came after the very moment they are reenacting, whether within the year 1627 or in the centuries between then and now.

Second, there is the heritage clock. While heritage sites stop the historical clock, the heritage clock keeps ticking; that is one reason why is it difficult to synchronize these two clocks. The historical moment, the desig-

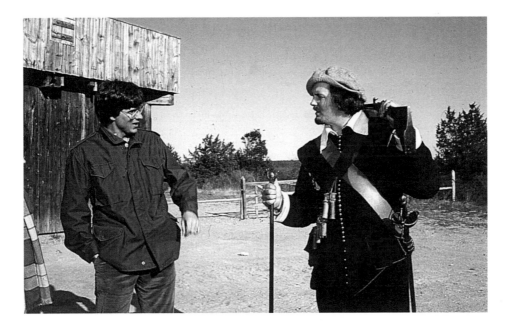

Plimoth Plantation, 1627/1985. Visitor and pilgrim talk across time.

Photo by Barbara Kirshenblatt-Gimblett.

nated year, is sustained through repetition, whereas heritage is sustained through reversal. The older the heritage installation, the less historically accurate. For this reason, it is necessary to arrest its movement, to turn the clock back, not once but perpetually.

Just how this works became apparent to me when I asked permission to reproduce in this volume a photograph I had taken of Plimoth Plantation about fifteen years ago. The person responding to my request told me that my photograph was wrong. How could my photograph be wrong? She explained that the chimneys were from the wrong period. I explained that those chimneys were there when I took the picture. Yes, she responded, but they have been removed. What's more, she continued, Plimoth was seven years old in 1627, whereas Plimoth Plantation is now more than twenty-five years old. As a result, when the site closes for the winter, the staff tears buildings down, schedules house-raisings during the tourist season, and prematurely ages the buildings so they will look seven years old, just as they were in the year 1627. At this site, history stands still while heritage continues to age. What looks like a logistical problem is a more profound question of synchronizing the site's clocks.

The third clock is one that visitors bring to the site—the time of their lives, the "time-out" of a vacation. The term *time machine* and the discourse of time travel are misleading. The imperatives of marketing promise a seamless experience, but the success of such sites lies precisely in their failure as the perfect time machine. Enter the world of 1627, encounter the Pilgrims, be carried away and forget that you ever lived in any other place or time. Have a "pilgrim experience." While there may be instants when the time machine—the museological interface—recedes from awareness and visitors lose themselves in a pilgrim world, what actually happens most of the time is more interesting than what is intended.

This can be seen in the way actors and visitors collaborate in a historical imaginary that denies and jumbles time by sustaining one small slice of it indefinitely, even while abutting it with the present moment. Visitors try to tempt the historical reenactors to break frame. At Plimoth Plantation, the Pilgrims express consternation at the strange machines that visitors bring with them—their cameras and cellular phones—and respond with disbelief, attributions of magic or sorcery, or accusations of

consorting with the devil. They struggle to stay in character all the time. Visitors watch to see if the Pilgrims will tear the fabric of time and emerge as 1998 persons, even if only for a flash. This little game is a way to touch and test the historical membrane so carefully fashioned by the re-creation.

The third clock also operates as a challenge to forgetting. To re-create 1627, the actors have to "forget" everything that happened thereafter. It is the enabling fiction of forgetting that creates the necessary gap between actors and visitors. In that gap visitors become seers into the future. Converting their own past into the Pilgrims' future, visitors become prophets. They see the three centuries that followed, while the actors are supposed to know nothing beyond the year in which they live in perpetuity. In this way, visitors reverse the direction of the time machine, unsettle the perpetuity of the re-created moment, and give to memory a prospective trajectory. This complex engagement of times past and present holds even more possibilities for understanding the theatre of afterlife called heritage.

It is in the nature of tourist productions to create just such effects. However persuasive the representation, finally what you experience is the site itself. The juxtaposition of virtual pilgrim world and actual tourist amenities, the intercalation of quotidians (theirs and ours), and the breaking of frames are deliberately engineered and a source of pleasure in their own right. The brochure instructs the visitor: "Upon your return from the Village and Homesite, take a break from the arduousness of Pilgrim living conditions before travelling to *Mayflower II*. Have a bite to eat in the Courtyard, Gainsborough Room or Picnic Pavilion." This is always a *double* experience, an experience of then and now, which enhances its role as historiographic corrective: "At the waterfront a double treat awaits you. After your visit to the Ship, enjoy authentic 17th-Century baked goods— not at all the bland taste so often imagined—at the J. Barnes Bake Shop." History at Plimoth is so real you can taste it.

Freeze-frame, by making time stand still, also interrupts the inexorable narrative of origins in its tracks and displaces the unbroken line of its exclusive genealogy. Pilgrim displays past and present are in conflict, not only in relation to each other but also internally. The refusal of the

Wampanoag to pretend to be themselves, their refusal to give up their Native American actuality for a more complete Pilgrim virtuality, is but one indication. Snow's account of difficulties that arose when an African American became part of the virtual village is another. Such tensions give the Pilgrim quotidian and its virtuality their ideological charge. The Pilgrim Village, billed as the "Living Museum of Everyman's History," is supposed to be more democratic because "[t]otal history gives rhyme and reason to everyone in a historical community, the nobodies not less than the somebodies."[7] Everyone is offered a chance to (re)live Pilgrim daily life in all its detail and elusiveness—or at least to walk among the living dead.

But can the "democratizing effect" of Plimoth Plantation really remedy the exclusions and inequities of history? The recent Ellis Island restoration faces the same problem (see chapter 4), as did the Columbus Quincentenary. We are witnessing an era of historical identification by consent (and dissent), rather than descent. Sites long associated with a discrete historical experience and an exclusive set of participants, whether Pilgrims landing at Plymouth Rock or immigrants coming through Ellis Island, compete for the status of definitive master narrative. How shall the founding of the nation be told? Which site can be more inclusive, which is to say, more "democratic"? At the Ellis Island Immigration Museum, virtually anyone, no matter when he arrived in the United States or through which port, can pay one hundred dollars to have his name or the name of an ancestor inscribed on the American Immigrant Wall of Honor that rings the island—and that includes the Pilgrims and their descendants! Ellis Island, in a slick taxonomic move, has absorbed Plimoth. The rock is just another port of entry for just another group of immigrants.

Undoing the Ethnographic

People [at the Los Angeles Festival of the Arts] had to look at stuff they did not know how to react to. That began to be an authentic experience. They simply had to react as human beings. They did not know [how to react]. They simply had to look.

Peter Sellars (1991)

Confusing Pleasures

What are the preconditions for creating interest in what audiences do not understand? Or, more specifically, how has the avant-garde prepared us for watching and valuing what we don't know how to react to? The definition of authentic experience as one in which audiences confront the incomprehensible is at the core of the 1990 Los Angeles Festival of the Arts, which I see as a cultural form driven by an avant-garde sensibility. It might even be said that this festival restaged the loci classici of avant-garde performance, among them those encounters with Chinese opera and Balinese performance in Moscow and Paris during the thirties that gave us Bertolt Brecht's *Verfremdungseffekt,* or defamiliarization, and Antonin Artaud's pure theatricality.[1] This essay explores how the 1990 Los Angeles Festival, in staging work unfamiliar to its audiences, avoided "ethnographic" and "entertainment" approaches. The location of authenticity in a moment of aesthetic reception—rather than in the objects presented—gives to the Los Angeles Festival its special character.

After describing the 1990 Los Angeles Festival, I explore the process by which it developed out of the Olympic Arts Festival held in Los Angeles in 1984. The essay then examines the elaborate planning process and administrative structure of the 1990 festival in some detail, because the organizers themselves accord it such importance. First, their experimental

approach to the festival—they attempt to reinvent the festival form itself—requires a particularly extensive planning process. Second, they recognize that the infrastructure of the festival is itself a critical site for the production of meaning and pay special attention to it.

I then place the Los Angeles Festival within two historical contexts— international arts festivals and avant-garde performance. Despite its departure from many conventions of international arts festivals, the 1990 event is deeply connected to their history. International art exhibitions have been an essential feature of world's fairs since the latter's inception in 1851. Olympic games, which were appended to world's fairs in the 1890s, became an independent venture during the early years of the twentieth century.[2] By attaching art exhibitions to world's fairs and Olympic games, organizers elevated the status and enlarged the scope of such events, which were otherwise dedicated only to industry, commerce, or physical skill. By the 1890s, massive international art exhibitions also became independent events. Some, like the Venice Biennale, which was established in 1895, took place at the same location on a regular basis. But even when an international event occurred only once in a given location, it could have lasting effects on the place that hosted it. As suggested in chapter 2, many museums were formed on the basis of collections and buildings featured at world's fairs. As is the case here, an arts festival created on the occasion of the Olympic games could become an independent, if not permanent, institution.

The 1990 festival is also informed by the history of the avant-garde's relationship to that which lies outside accepted notions of art and culture. Key figures in the history of avant-garde performance have long used the performance traditions of Asia and other parts of the world, which they may have encountered only briefly in Europe, to mount their attack on the status quo. Artaud's exposure to Balinese theater was limited to what he saw in the Dutch Pavilion at the Paris Colonial Exposition in 1931, and Brecht's encounter with Chinese opera took place in 1935 when Mei-Lan-Fang toured Russia.[3] That such limited exposure could have such enormous impact offers an important key to the 1990 festival's optimistic belief in the value of brief encounters with work not necessarily understood.

Explorations of the relationship of the avant-garde to anthropology

have tended to pay more attention to literature and the visual arts and their repositories, namely, museums, than to the performing arts and their venues, which is the focus of this essay. The performing arts present particular challenges and possibilities, first among them the live presence of performers and the ephemerality of their activity, topics also addressed in chapter 1.

If the 1990 festival rejected two approaches outright—what the organizers characterized as ethnographic and mainstream entertainment—what approach did the festival use to stage work that was unfamiliar to its audience? After looking at the history of approaches rejected by Peter Sellars, the festival's artistic director, I explore why he found it "thrilling beyond all expectations" to see "the genuine surprise of people who didn't understand what they were looking at and had no way of figuring it out. All they could do was look."[4] Audiences who have learned the pleasures of confusion from their experience with avant-garde performance are prepared to receive performance forms from other social and cultural worlds as if they had emanated from the avant-garde itself.

This examination of performance at the interface of cultural encounter in an avant-garde mode concludes by identifying some of the unintended consequences of a kind of aesthetic reception that resists conventional understanding, if not actually assaulting it.

From Olympic Arts Festival to Los Angeles Festival

The 1990 Los Angeles Festival, which took place September 1 through 16, was an ambitious undertaking, given the number of events mounted in so compressed a period of time over so vast a space. In all, about twenty-nine hundred artists appeared in 550 events in seventy venues. They included, within the curated program of 150 events, some fourteen hundred artists—five hundred of them brought to Los Angeles from twenty-one Pacific Rim countries and various parts of the United States and nine hundred of them based in Southern California. Another fifteen hundred artists, also based in Southern California, presented their independently produced work in 400 events within the Open Festival that accompanied the curated program. This activity was spread across Greater Los Angeles,

primarily the downtown and mid-Wilshire areas, Hollywood, and Westwood, but also East Los Angeles, Santa Monica, Pasadena, Long Beach, Van Nuys, Hawthorne, San Pedro, and Huntington Park, among others. The venues included parks and gardens; museums, art galleries, and art centers; theaters, cinemas, and amphitheaters; community and cultural centers, temples, and churches; historic districts and ordinary streets, shop windows, and storefronts; buses, a train station, and a pier; an outdoor marketplace; and city hall. Festival events included not only formal performances (theater, dance, music) and performance events that fit no easy categorization but also literature programs, films and videos, and exhibitions. The budget was about $6 million.

The festival's grand opening ceremonies took place on Labor Day weekend at Angel's Gate and Point Fermin Park overlooking the Pacific. Centered on a great Korean Peace Bell, itself a marker of the 1976 Bicentennial, the proceedings were described in the program and ticket information booklet as follows:

> In the morning, the artists will gather at the Korean Bell for a blessing beginning with Native American prayer. After a procession down the hill joined by Chinese, Hawaiian, Tongan, Japanese, Samoan and gospel musicians, all the groups will arrive at Port Fermin Park for an afternoon-long gift exchange of song, dance and invocation—a gesture of welcome and respect traditional to many cultures. This is not really a sneak preview of performances in the Festival, but a spiritual jam session. In the evening, there will be social dancing to a hot local group, Rudy Regalado and Chevere Band, playing straight-ahead salsa. . . .
>
> Got the idea? Take a deep breath. Inhale the world.[5]

That Sunday, Los Angelenos visiting the African Marketplace at the Rancho Cienega Park would find four stages featuring music (jazz, blues, rock, salsa, reggae, rhythm and blues, and gospel), parades of floats as well as costumed groups of dancers and drummers, and performances by the Woomera Mornington Island Culture Team (aborigines from Queensland, Australia), performers from the Polynesian islands of Wallis and Fatuna, and Japanese American *taiko* drummers. Those who went to

Grand opening of the Los Angeles Festival, 1990.

Courtesy Los Angeles Festival.

Grand opening of the Los Angeles Festival, 1990.

Courtesy Los Angeles Festival.

Olvera Street and Union Station could see the Ikooc, indigenous musicians from Oaxaca, and the Jemez Pueblo Matachines from New Mexico perform near the oldest church in the city, Iglesia Nuestra de Los Angeles. They were joined by the Bread and Puppet Theater. On the next day, the Moon Festival in Chinatown was incorporated into the festival, which seems to have revived it after a ten-year hiatus. That afternoon shamans from the Chindo Island in Korea performed "their euphoric, electrifying dances in the courtyard of Pasadena's Pacific Asia Museum." They were accompanied by an ensemble of musicians and were to "offer a special blessing to Los Angeles—an event sure to startle and amaze."[6]

In the days that followed, an extraordinary lineup of artists appeared in locations far and wide, from the Children of Bali (twenty-two musicians and dancers aged nine to fifteen) and the Court Performers from the Yogyakarta Palace of Java to the Los Angeles Poverty Department (LAPD;

a performance group developed from a workshop for homeless people, directed by John Malpede) and the mixed-media installation *Living with AIDS*. Rather than adopt the modular approach of so many international festivals, with formal national representation in dedicated pavilions or through official national performing troupes, the 1990 festival sited itself in a city that Mayor Tom Bradley declared was home to more Koreans and Cambodians than anywhere except Korea and Cambodia. The world had already arrived and the task of the festival was "to open up Los Angeles' neighborhoods to one another as never before, to introduce us to ourselves."[7] As constructed by the festival, immigration was the international made local. Artists from abroad were "guests," rather than official state representatives.

In a recent interview, Claire Peeps, who has been with the Los Angeles Festival since 1988 and who became its associate artistic director, shed

Children of Bali. "To watch a group of 22 young Balinese—ages nine to fifteen—execute the complex rhythms of the *gamelan* music and the breath-taking beauty of the dance with astonishing precision is to watch a kind of magic. This, the direct product of a society which wholly integrates art into daily life." From *Los Angeles Festival, September 1 thru 16, 1990, Program and Ticketing Information,* 15.

Photo courtesy Los Angeles Festival.

light on its history. The festival was founded as the successor to the 1984 Olympic Arts Festival that accompanied the Olympic Games in Los Angeles. Incorporated in 1985 as a nonprofit organization, the Los Angeles Festival mounted its first event in 1987. Though a new and different organization, the Los Angeles Festival drew several of its board members, including Maureen A. Kindel, who became the chair of its board, and Robert Fitzpatrick, who became its first director, from the Olympic Arts Festival's board and staff. It also retained some of the same patrons.

Both the 1984 Olympic Arts Festival and the 1987 Los Angeles Festival featured internationally recognized theater, music, and dance groups, most of them touring companies that worked within established Western genres on a proscenium stage. They performed at a few established venues in Los Angeles, with the exception of Peter Brook, whose *Mahabharata* was staged in the Raleigh Studios in Hollywood, which were specially prepared for it. Whereas the Olympic Arts Festival was more international, that is, more countries participated, the 1987 Los Angeles Festival concentrated on European artists.

During the 1987 festival, Robert Fitzpatrick announced his resignation as director and his new role as president of Euro Disneyland Corporation, though he continued to serve on the 1990 festival's board of directors.[8] During both festivals, he had been president of the California Arts Institute, which was founded as a training ground for Disney animation but had eventually broadened its mandate. Several other key people also left the festival for jobs with Disney. The board initiated a search to fill the directorship. It invited Peter Sellars to direct the organization and announced his appointment on the last day of the 1987 festival.

Sellars became both the director of the festival and the president of the board of directors. Sellars, who had established an international reputation as a brilliant theater artist, perhaps best known for his experimental staging of opera, first thought he would bring his own work and that of his colleagues to Los Angeles to form the core of the next Los Angeles Festival. He had been directing Mozart operas at PepsiCo SummerFare, near New York City, at the time. As he became familiar with the city and made contacts at the University of California at Los Angeles (UCLA), particularly with Judith Mitoma, director of the World Arts and Cultures

Program (now a department), he realized that this plan "did not fit the Los Angeles landscape, literally or figuratively," in Peeps's words. Colleagues at UCLA had been thinking in terms of a Pacific Rim festival. The Los Angeles Festival picked up this theme and developed it in partnership with UCLA colleagues.

The first issue was to determine whether the Pacific Rim theme was more than a political expedient serving international trade, now that Los Angeles was the center of a new global economy based in the Pacific and the home of a burgeoning immigrant population from this region. Peeps recalls several questions that needed to be addressed: Was there a cultural theme here? Could this theme be "made real" in arts terms? What was the role of the arts in cultural survival?

Under Sellars's direction, the Los Angeles Festival as an institution changed its organizational structure, curatorial process, and artistic vision, experimented with the international arts festival as a form in its own right, and redefined the festival's relationship to the city. Peeps explained that the Los Angeles Festival prior to Sellars's arrival had been more traditionally structured. Like many other presenting organizations for the performing arts, it had had a single artistic director whose taste defined the programming, an associate artistic director, a general manager, a business manager, production staff, and marketing staff. When Sellars became director, the impresario model was abandoned for a more collaborative one that involved a director (Sellars), an executive director (Judith Luther), an associate director (Norman Frisch), a program director (Claire Peeps), and a curator (Judith Mitoma). By the 1993 festival, Sellars was director, Allison Samuels was executive director, and Peeps and Frisch were associate artistic directors.[9]

This arrangement expressly divided and shared responsibilities between executive and artistic directors. It was tailored to having a working artist as a director. The reason was as much pragmatic as ideological, because Sellars could not be there full time to deal with the day-to-day operations and because he needed to focus on artistic issues. The organization also needed a director who had skills in public and community relations to operate not only in governmental, civic, and business spheres but also within local communities, and to make a case for the arts and en-

list support and cooperation. This structure produced neither the unified artistic vision of one person nor the consensus of a committee, but rather what Peeps characterizes as something between a democratic discussion and individual visions that are clearly discernible within the larger project. What the team shared was a concern for the role of the arts in everyday life and cultural survival. They were open to any work from anywhere that dealt with such issues.

The organization has continued to be deeply committed to an intensive curatorial process. For the 1990 festival, an interdisciplinary and intercultural advisory committee participated in preliminary planning meetings. Several other curators and curatorial committees addressed particular communities and events. For example, Paul Apodaca orchestrated Native American participation in the opening ceremonies, while others prepared local Los Angeles communities over a six-month period for the arrival of Japanese and Balinese performers. The 1993 festival, which followed the Rodney King verdict and ensuing uprising in Los Angeles, would engage local communities to a much greater degree. Both the 1990 and the 1993 festivals were followed by evaluation conferences attended by scholars, artists, arts professionals, funders, educators, and community representatives. Proceedings of the 1990 festival evaluation conference were issued.

This process is more labor intensive than conventional programming. It requires more staff, which makes the organization administratively heavy. It demands more time, which is why there were several years between festivals. And it consumes more resources, about half the organization's budget—$6 million for the 1990 event, which lasted sixteen days, and $4 million for the 1993 event. The budget for the 1993 festival was considerably less than the $11 million for the 1984 Olympic Arts Festival, which ran ten weeks, and the $5.8 million for the 1987 festival, which lasted three and a half weeks. The planning and evaluation process is as important to the organization as the outcome or product and reflects a mission that is larger than the festival as an event. The recording, transcription, and circulation of the proceedings of such meetings is itself a major undertaking. The Los Angeles Festival allocates its costs accordingly. It will put more money into the planning process or into preparing an outdoor

venue, while saying no to big-ticket items like a symphony orchestra from abroad, whose costs can approach five hundred thousand dollars. But this approach is hard to sustain in tough financial times. Even under the best of circumstances, it is easier to raise money for events than for process. And it is easier to raise money for international stars and genres familiar to Los Angeles patrons and established audiences for the performing arts than it is for emerging experimental artists or accomplished, if less known, performers from the Pacific Rim and the United States.

The 1993 festival made some significant changes in response to both artistic and financial considerations. While most of the events were still free, many more were sited indoors. Reeling from a statewide economic crisis and attempting to rebuild itself after the uprising, the city could no longer provide the pro bono services needed for large events in outdoor public spaces—police, security, sanitation, and traffic control for several miles around the area, including the closing off of streets, parking, and a free shuttle from parking to the event. Even with a city subsidy, the organization would have needed two hundred and fifty thousand dollars per park site to outfit it with a stage, sound system, electricity, and toilets. Instead, the 1993 festival featured master musicians and soloists whose work was perfectly matched in terms of scale, audience, and acoustics to such indoor venues as churches and temples. This was still not ticketed theater. Indeed, as Peeps explained, the organizations that hosted performances and exhibitions were progressive institutions that had broken the ground locally for precisely the kind of dialogue the festival hoped to encourage. They had already been tackling hate crimes, advocating for immigrants, dealing with housing issues, and otherwise building bridges across communities. A major benefactor of the 1993 Los Angeles Festival was the Community Redevelopment Agency of the city of Los Angeles.

In the wake of the 1994 earthquake, plans for future activity were open and the organization, stripped to its bare bones, was again rethinking the "festival" as a form and how to experiment with the event, the process, and the institution. Since then plans for a future festival have been placed on hold. When he took on the 1990 festival, Sellars made a commitment to the Los Angeles Festival as a "10-year project to introduce Los Angeles to itself and to reintroduce the world to Los Angeles."[10] Increasingly, the

organization became committed to the arts in advocacy terms and sought to define their role in a civic agenda, not only for the intense weeks of the festival proper but throughout the year. It served both as a presenting organization and as a catalyst and broker within the arts community of Los Angeles more generally. Other organizations, such as the Los Angeles Philharmonic, are encouraged to work more closely and effectively with local communities, not only on the model of the Los Angeles Festival, but with the help of Sellars in his capacity as their creative consultant.

This essay is based on remarks that I delivered at the 1990 festival evaluation conference, "New Geographies of Performance: Cultural Representation and Intercultural Exchange on the Edge of the Twenty-First Century." The conference took place on 10–13 January 1991. It was cosponsored by the Getty Center for the History of Art and the Humanities, the Los Angeles Festival, and the World Arts and Cultures Program at the University of California at Los Angeles and funded by the Rockefeller Foundation, the Ford Foundation, AT&T, and the Getty Center for the History of Art and the Humanities, among others. Sellars and his colleagues have consistently sought serious engagement with their work. It was in this spirit that they received my remarks, which took issue with several aspects of the event, and then invited me to join the Program Steering Committee for the 1993 festival. I attended one of several national 1993 Los Angeles Festival Planning Conferences, entitled "Frontiers of a New Global Society: Los Angeles, Africa and the Middle East," on 17–19 January 1992, at the Hsi Lai Temple in Hacienda Heights. This temple, as described in the letter of invitation (18 November 1991) from Sellars and Peeps, "is the largest Buddhist temple in the western hemisphere. . . . [It is] a vital gathering spot in the community and an extraordinary piece of architecture." I also participated in Program Steering Committee meetings during the 1991–1992 academic year. Though I was not at the 1990 Los Angeles Festival, I did attend the 1993 event, which addressed many of the issues raised at the evaluation conference. My discussion of the 1990 festival, which is the focus of this essay, draws on interviews, internal documents, press coverage, video documentation, and the evaluation conference in which I participated.

Not Ethnographic

When the organizers of the 1990 Los Angeles Festival distanced them-selves from the ethnographic—as they understood it—they were reject-ing "labels" (primitive, ethnic, folk) and academic claims to authoritative knowledge. For Sellars, the will to explain and understand such perfor-mances as Bedhaya Court dance or Kogi-eso was misguided because futile, as were attempts to demystify Kun Chinese Opera or Wayang Wong dance theater—to make these forms accessible and familiar. The trade-off—mystery for information—was suspect, for Sellars envisioned an aesthetic experience predicated on an unmediated encounter. By ensuring that the strange would stay that way, the 1990 Los Angeles Festival resisted efforts to reduce or otherwise dissipate the force of performances by explaining them away.

It was in this context that Sellars spoke disparagingly of "cultural bag-gage." As he spoke those words, I saw excess luggage. But the "cultural baggage" that he considered an impediment is precisely what ethnogra-phers produce through the labors of fieldwork and bring into the festival and exhibition: ethnographic insight is a prerequisite, if not a require-ment, for the deeper understanding that ethnographers propose. While incomprehensibility may be a necessary way to begin a cultural en-counter, intelligibility is the ethnographer's destination. "Cultural bag-gage," from an ethnographic perspective, is not a nuisance, but an open-ing. It can be a corrective for the unacknowledged and unexamined stereotypes that "humans" bring to cultural encounters. It can be even more.

A further clue to Sellars's objections may be found in the ways that an-thropologists value shock and understanding. From an ethnographic per-spective, culture shock, while an expected part of fieldwork, appeals to the prurient interest of general audiences if it is not mitigated by empa-thetic understanding. This is the challenge posed by the brief intercul-tural encounters that museums, festivals, and tourism afford, even when produced by professional students of culture. But culture shock is more than an occupational hazard. It has historically been a defining experience in the making of anthropologists and, to some degree, folklorists and

ethnomusicologists—though perhaps less so, as we study ourselves. Making a virtue of necessity, we have learned to transvalue our lack of prior knowledge as a relative absence of preconception or bias. We attempt to avoid ethnocentrism, or seeing the world in our own image. Trained to become virtual clean slates on which to write cultural logics beyond our own experience and imagination, we have often studied societies about which little has been published. Initial confusion, while valued, is not an end in itself. Rather, it anticipates a deeper and more empathetic understanding that requires extended immersion in the lives of those we study. Where hope of cracking the cultural code still prevails, fluency in that code is the objective: Come as a blank, leave as a native.

Shock, from this perspective, is a powerful prelude to intimate knowing. What at first seems odd, becomes just another way of being human. The strange is normalized. Eventually, I can imagine living the way of life that I am studying. At one extreme, then, empathetic knowing eventuates in "going native" or the desire to do so, whether temporarily through initiation and apprenticeship or permanently. The dramatic structure of many fieldwork accounts arises from the process by which intimate knowing happens. When this process precipitates an epistemological crisis—when language and reason fail—the fieldworker may surrender to what Michael Jackson calls the embodied character of lived experience, a surrender that requires kinesthetic, practical, and bodily engagement.[11] Epistemological crisis is also a source of what James Clifford has characterized as "the surrealist moment in ethnography"—namely, "that moment in which the possibility of comparison exists in unmediated tension with sheer incongruity."[12]

At the other extreme, *not knowing* is an ethnographic subject in its own right. Indeed, the desire to render oneself blank—and the impossibility of ever really doing so—has given to the fieldwork account special importance as a genre of ethnographic writing. The dramatic structure of much of this writing arises precisely from the author's struggle to transform herself from novice fieldworker at the beginning of the research to cultural connoisseur at the end of the project—and the incompleteness of that venture. Here the convulsions of culture shock intensify reflexivity by offering dramatic access to the ethnographer's own assumptions, not so

as to empty herself out, but so she becomes visible to herself. As the ethnographer becomes a native of what she is studying, she becomes a stranger to herself. The double itinerary of culture shock thus leads simultaneously into and out of the ethnographer. To the degree that shock intensifies reflexivity, it also offers the possibility of critique. Ethnographic knowledge arises from an interpersonal encounter, and accounts of that encounter, whether written or filmed, are often attentive to the process of coming to know.

We not only publish and teach in academic settings but also produce public displays of our knowledge in museum exhibitions, films, and festivals directed to general audiences. We have developed our own ways of determining what to bring to festivals of art and culture, how to site performances, and how to shape encounters. Our distinctive display genres and performance values range from elaborate mimetic re-creations reminiscent of the ethnographic villages at world's fairs during the late nineteenth century and dioramas of natural history museums to extremely spare presentations of a singer and his songs on a clear stage.[13]

Using what might be called an ascetic approach to staging, the Smithsonian Institution's Festival of American Folklife, as discussed in chapter 1, often presents performers without costumes or sets on a bare platform in a tent on the Mall in Washington, D.C. Audiences sit on backless bleachers in a setting that is at once informal and respectful, reminiscent perhaps of county fairs and other rural and small town gatherings. Scholars "present" performers using a "talk show" format in order to prepare audiences for what they will see. State-of-the-art sound and recording equipment is prominent, for the performances are fully documented and the recordings archived. This plain style of presentation—the very absence of the theatricality we associate with folkloric troupes—is an "ethnographic" way of marking the authenticity of what appears on the stage. Many of the "performances" at folklife festivals are nothing more than the arts of everyday life—conversational storytelling, ballad singing, cooking, and work skills. The very act of bracketing them for public presentation makes them "performances" of a special kind. They depend for their "reality effect" on a presentational mode low in theatricality and high in information. To avoid degenerating into casual exoticism, events

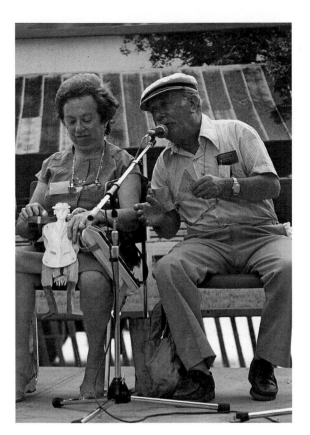

Doris Kirshenblatt and Mayer Kirshenblatt demonstrate how to make toys, remembered from Mayer's childhood in Poland, at the Grand Generation program at the Festival of American Folklife, Smithsonian Institution, 1984.

Photo by Barbara Kirshenblatt-Gimblett.

like the Festival of American Folklife place a premium on intelligibility and on reflecting the perspective of those who are performing. This festival has its own ways of mediating the encounter consistent with its own ethos—what has been termed cultural equity and cultural conservation—and style.[14]

In his 1977 appeal for "cultural equity," Alan Lomax condemned the devastating effects on local music and culture of aesthetic imperialism and "centralized music industries, exploiting the star system and controlling the communication system."[15] As this statement suggests, ethnographic approaches to the display of performances from outside the official art world also carry a political load, one that both advocates forms whose survival is precarious and criticizes the forces that undermine them. This is a position underpinned by a sense of social responsibility,

expressed politically (as it was by the Federal Writers Project during the New Deal in the thirties), practically (as in the settlement houses and playground and pageant movements during the first half of this century), or intellectually within academic disciplines. We might situate this approach within a tradition of "ethnographic humanism," whose reigning values are cosmopolitan, progressive, and democratic, though its effects may not necessarily be consonant with its aims.[16]

Not Mainstream

Sellars made it clear that he consciously avoided not only the didacticism of an ethnographic approach but also the conservatism of "mainstream entertainment," what he characterized as "your typical Labor Day band / parade / barbeque fare."[17] He alerted audiences that the Los Angeles Festival would not be "the Festival of Fun Foods at your nearest mall."[18] Nor would it be Edinburgh or Spoleto. In other words, the festival would avoid the kitsch of low and high culture. It would skirt painfully bad and painfully good taste. The Los Angeles Festival was to be neither a series of illustrated lectures nor yet another celebration of the accessible arts, whether classical or "ethnic."

The avant-garde understands well the artistic possibilities of bad taste and the transgressive potential of popular culture, with its love of anomaly and panoply of genres for presenting the strange—the old anatomy and medical museum, zoological garden, the sideshow, Ripley's Believe It or Not, Barnum's dime museum, the Guinness World Records Exhibit Hall, the *National Enquirer,* tourism (which also replicates older forms of ethnography), and world's fairs, among others. These too are loci classici of avant-garde performance and continue to inspire contemporary artistic practice: for example, the installation performances of ethnographic captivity that were part of *The Year of the White Bear,* a collaborative arts project created by Guillermo Gómez-Peña and Coco Fusco in opposition to uncritical celebrations of the Columbus Quincentenary; David Wilson's Museum of Jurassic Technology; recent exhibitions in art galleries of historical displays of human pathologies from the Mütter Museum of the

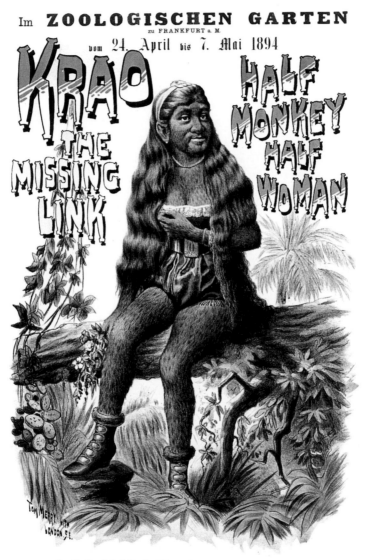

College of Physicians of Philadelphia; and Luke Roberts's "Wunderkammer/Kunstkamera."[19] But enthrallment with anomaly verges on prurient interest, because it quickly attaches itself to the monstrous and grotesque for their own sakes. Anomaly in popular entertainment, as Robert Bogdan notes, appeals to a fascination with that which defies explanation, with "'curiosities,' 'freaks of nature,' 'rarities,' 'oddities,' 'eccentrics,' 'marvels,' 'nature's mistakes,' 'strange people,' 'prodigies,' 'mon-

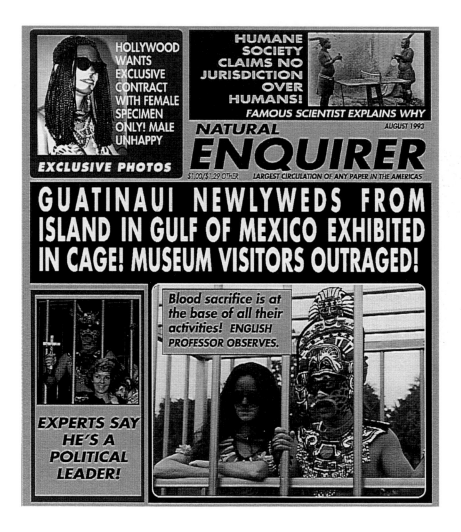

Announcement for the video *The Couple in the Cage: A Guatinaui Odyssey,* by Coco Fusco and Paula Heredia, 1992.

sters,'" and even ethnographic objects, to the extent that they are "exotic," "primitive," or "oriental."[20] What such objects and acts might lack in fame, they make up for in strangeness, or so it would seem from the way they are produced and promoted as popular entertainment in restaurants, nightclubs, theme parks, cruise ships, and amusement parks. Events like the Smithsonian's Festival of American Folklife and the Los Angeles Festival try to achieve the exuberance and wide appeal of popular entertainment without exoticizing performances unfamiliar to their audiences.

Sellars explained to the press how he tried to reach a wide audience: "It's about trying to remove as much of the starch as possible from a cultural experience. It's not a formal thing where you have to sit in row 36J for an entire evening and behave." What made the event so special, in his view, was siting "the greatest artists in the world in a completely alfresco environment where it's not a big deal, it's just living."[21] Maureen A.

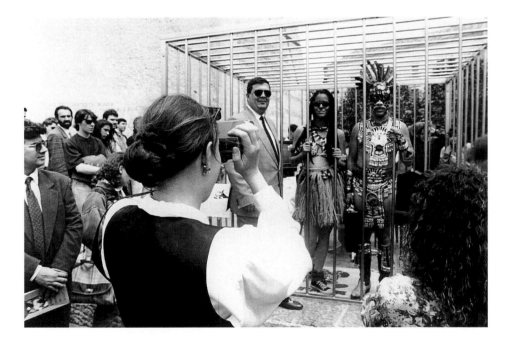

The Year of the White Bear, "Two Amerindians on display for three days at Columbus Plaza," Madrid, 1992, a performance by Coco Fusco and Guillermo Gómez-Peña.

Photo by Peter Barker.

Kindel, chair of the Los Angeles Festival, reassured audiences that this festival was "casual, personal, intimate, and accessible. It is for everyone."[22] These statements are somewhat disingenuous because they are reassuring about experiences whose power, in many cases, lies precisely in their potential to disconcert: associate director Norman Frisch made just this point when he wrote in the program, "I can promise you that the cumulative experience will be disturbing, challenging, even at moments offensive: a slap in the face, a bucket of water, a stain on the sheets. It has been for me."[23] Whether reassuring or warning their audiences, the festival organizers clearly signaled a rejection of the stiff discipline of the opera house, Broadway theater, symphony hall, and ballet and the elitism expressed by their price of admission, clear separation of audience and performer, audience decorum, and highbrow status.[24] Instead, the Los Angeles Festival used a wide variety of venues, many of them outdoors in parks and other open public spaces, where environmental, multifocus, multisensory, interactive events combined the casual accessibility of popular entertainment with the seriousness of "art."

The embrace of popular entertainment offered yet another position from which to attack the status quo, for the 1990 Los Angeles Festival seemed to say that art takes forms you have never seen before in places you would least expect them, and that you are not required to undergo an onerous regimen of preparation to enjoy them. Quite the contrary. The organizers took as a measure of success such statements as "I didn't understand it, but I had fun." They depended not on the didacticism of ethnography to normalize the strange, not on popular entertainment's appeal to a prurient interest in the irreducibly weird, but on the power of art, as they conceived it, to create fascinating confusion. If audiences at the Los Angeles Festival could enjoy what they did not understand, they might become more receptive to contemporary art more generally—one of the long-range objectives of the festival. Their very naïveté was a virtue, for if properly approached, the uninitiated audience might prove even more open to a broader range of artistic expression than the institutionalized publics cultivated by the cultural establishment.

Given the fact that usually only celebrity performers draw big audiences, one of the 1990 festival's biggest challenges was to attract audiences to performers who were not superstars here, however famous they might

be at home. Indeed, according to Sellars, "many of the performers in the Festival are not professional entertainers," though this did not make them amateurs either.[25] While the distinction was irrelevant, it presented a serious marketing problem because the media were less likely to pick up on the events. The organizers had to convince audiences who expected the assurance of star performers and familiar art forms that performances at the Los Angeles Festival from throughout the Pacific were, in the words of Rudy Garza, the festival's public relations director, "every bit as much sophisticated and legitimate as European culture. [They're] just *different*."[26] Festival organizers had to bring their audiences from fear of the unfamiliar to a love of the "just different," while preventing the just different from becoming really weird, on the one hand, or the Disney pap of "It's a Small World," on the other. The very audiences who until this point had resisted experimental art forms were a prime target for the Los Angeles Festival.

Toward a Genealogy of the Los Angeles Festival

Values derived from the historical avant-garde before World War II and from experimental performance during the postwar period drive this festival. They offer keys to the special pleasures afforded by the incomprehensible and, beyond pleasure, to the importance of making audiences experience, rather than interpret, what they see. The historical avant-garde, by exposing the arbitrariness of the autonomous art object and the institutions that police the domain of art, challenged the status quo, the academy, bourgeois cultural institutions, and the culture industry.[27] So too did the Los Angeles Festival. It was surely no accident that the festival did not shy away from controversy when it featured Rachel Rosenthal, the LAPD, the Wooster Group, and David Wojnarowicz, one of several artists at the heart of a recent controversy regarding the public funding of art and the role of the National Endowment for the Arts.

Radical artistic movements during the first half of this century dethroned the notion that the aesthetic is a hermetic realm set apart from daily life and attempted to restore to art its social consequentiality.[28] Without intending to collapse important differences among the various movements and their proponents, I would single out the following tactics.

Avant-gardists subverted the high seriousness, compartmentalization, and purity of bourgeois art forms. They questioned the illusionistic naturalism of proscenium drama, the primacy of literature, and the subordination of the other arts to it. Some insisted on the sensuous presence of the object, its materials and formal properties, rather than on "content" located elsewhere. Others celebrated the trivial and banal, the obvious and commonplace, the low and vulgar—in a word, that which lay outside received notions of art. Some rejected the notion of artistic genius and masterpiece. Some tried to recover the immediacy, physicality, and hybrid force of such popular forms as circus, the fairground booth, variety theater, magic shows, puppet theater, folk plays, and street performance. Others were entranced by the pure theatricality of Asian forms, their quality of total performance—that is, their success as *Gesamtkunstwerk.* Some aspired to the ecstatic, spiritual, and marvelous qualities of ritual and festival and saw here the possibilities for a physical theater, rather than one centered in language. Others alienated the audience from identification with the action to produce a critical reflexivity that might serve the cause of radical social change. Consistent with these values, the Los Angeles Festival is a *festival,* "a moment," in Sellars's words, "in which the world is turned upside down and we can rethink which end is up"; that is, the festival acquires special significance in the history of avant-garde performance as a model for what theater, if not life itself, might be.[29]

A history remains to be written of the sources to which the historical avant-garde, midcentury experimentalists, and more recent postmodern performance artists have turned for their critique of the very art world within which they worked and against which they rebelled—the European peasantry, rural America, the tribal, the industrial, the quotidian, and, in the case of the Los Angeles Festival, "multicultural artists" and "international performers." The following discussion places the 1990 festival within a brief history of avant-garde encounters with such sources to better understand both the display traditions within which it is working and the distinctiveness of its approach.

The Arts and Crafts Movement in late nineteenth-century Europe and the United States turned for its antimodernist critique of the excesses of civilization and ills of industrialization to the European peasantry, to rural

and urban America, and to earlier periods of European art history, notably to the Gothic and the Renaissance. Using these sources, and others farther afield, the movement, led by William Morris, affirmed joy in labor, organic community, and the collapse of distinctions between art and craft. Repercussions of this movement can be seen in the Bauhaus, the work of architects such as Frank Lloyd Wright and other proponents of the concepts of form following function and truth to materials, as well as in folk festivals.[30] In their search for a preindustrial past that might save European and American society from itself, followers of the movement found the "folk" at two social margins, the countryside and inner-city neighborhoods with immigrants. As discussed in chapters 1 and 2, by the end of World War I, as the gates to immigration were closing, settlement houses and sister organizations were staging exhibitions and folk festivals of the "homelands," an urban counterpart to their celebrations of rural life in such areas as Appalachia.[31]

Immigration during the last thirty years is not the first case of mass immigration that the United States has experienced, though recent immigration differs from the influx between 1880 and 1924 in important ways. The predominance of southern Europeans and eastern Europeans at the turn of the century was new in relation to the Irish and German immigration of the mid-nineteenth century. Southern Italians and eastern Europeans, many of them Jews, so exotic at that time, can now celebrate their passage at Ellis Island, the *Mayflower* of mass immigration, while those who have arrived since 1965 from Asia, Latin America, the Caribbean, and Africa are the newest new immigrants. These two periods of mass immigration have yielded their own displays of diversity, their own ideologies of pluralism, their own ethos, and their own theorists.[32] Today's displays should be seen in relation to the efflorescence of holidays in America after the Civil War, the rise of world's fairs, with their national pavilions, foreign villages, and "exotic" dancers, the pageant movement, immigrant homelands exhibitions and festivals, folk festivals, and international arts festivals. Many of these events, prototypes for the "multicultural" events of our own day, offered a cosmopolitanized notion of the common man, made the quotidian a site of utopian intervention, and gave to the arts (which included craft) a redemptive role.

Czech father teaching his son to dance at the
Buffalo, New York, homelands exhibition, 1919.

"A Nautch in the Café de Maroc" at the *Exposition Universelle* in Paris, 1878. "The Exposition has drawn to Paris representatives from almost every part of the world. . . . There is, however, this drawback. Just as at our Centennial Exhibition a bright red fez sometimes magically transformed a son of Erin into a native of Turkey, the Parisian skill in making up is brought into such requisition that one never knows if he is looking at genuine Turks, Arabs, Russians, or only Frenchmen ingeniously disguised. It will not do to make particular inquiries; and here, as in many other cases,

"Where ignorance is bliss,
'Tis folly to be wise."

From *Harper's Weekly* (21 September 1878): 757.

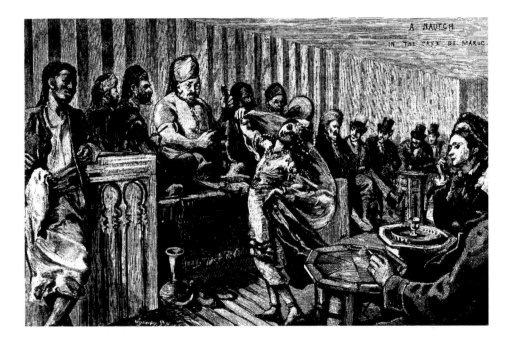

Just how widely the historical avant-garde was prepared to cast its net for fresh sources can be seen from Jindřid Honzl's account in 1940 of theatrical experimentation in interwar Czechoslovakia.

Cubo-futuristic theatrical experiments turned our attention to stages and theaters other than those built for the tsarist ballet, the box displays of high society, or for the cultural activity of the small-town amateurs. Through these experiments we discovered the theater of the street, we became fascinated by the theatricality of the sports field and admired the

theatrical effects created by the movements of harbor cranes, and so on. Simultaneously, we discovered the stage of the primitive theater, the performances of a barker, children's games, circus pantomimes, the tavern theater of strolling players, the theater of masked, celebrating villagers. The stage could arise anywhere—any place could lend itself to theatrical fantasy.[33]

From at least the romantic period, the study of these forms in their own right by folklorists and ethnographers has long proceeded in relation to contemporary artistic interest in them. This has produced in many cases a shared sensibility, to mention only the preoccupation of eighteenth-century British literati with the ballad and French surrealists' fascination with primitive art.[34] Sellars's attempt to distance the Los Angeles Festival from ethnography obscures the role of an "ethnographic attitude" in the formation of avant-garde sensibility and vice versa. As Clifford notes, "Surrealist procedures are always present in ethnographic works, though seldom explicitly acknowledged."[35]

New categories create new subjects out of old materials. Nowhere is this clearer than in the role of curators of modern art in constituting "folk art" as a subject.[36] According to Holger Cahill, "Contemporary interest in it [American folk sculpture] began with the modern artists who found in this folk expression a kinship with their own work."[37] That kinship is at the heart of the relationship between artistic movements and academic disciplines. During the thirties, the Newark Museum and New York's Museum of Modern Art showed "folk" and "popular" art "without apology or condescension," in the words of Alfred H. Barr.[38] "Primitive paintings" and "folk sculpture" were valued precisely because these curators believed them to be "unschooled," unpretentious, and for these very reasons a "truer and more indigenous expression of the American artistic sense"—that is, for the curators of these shows they had little to do with "the fashionable art" of their time and were "never the product of art movements."[39] Thanks to a curatorial category, "folk" painting and sculpture became a "natural" resource for challenging the status quo, while affirming a uniquely "American" artistic sense.[40]

"Primitivism" in Twentieth-Century Art (1984) at the Museum of Modern Art in New York is a sequel to a series of exhibitions in the 1930s that

had featured "folk art," "popular painting," and "modern primitives." Informed by the curatorial interests of Cahill, MoMA mounted *American Folk Art: The Art of the Common Man* (1932) and *Masters of Popular Painting: Modern Primitives of Europe and America* (1938), which was the last in a trio of exhibitions that included *Cubism and Abstract Art* and *Fantastic Art, Dada and Surrealism,* both in 1936.

Five decades later, *"Primitivism" in Twentieth-Century Art* would document a similar conjuncture in the various European avant-garde movements of the early twentieth century, this time in the form of "affinities" between the "tribal" and the modern—Picasso's *Guitar* and a Grebo mask, for example. More recently, MoMA's *High & Low: Modern Art, Popular Culture* (1990) explored how "high" artists—from Braque and Leger to Warhol and Holzer—appropriated the mass culture of industrialized cities, which the curators identified with such "low" sources as newspapers, advertising, billboards, comics, and graffiti. In a sense, the MoMA exhibitions of the thirties are closer in spirit to the Los Angeles Festival because they go beyond assertions of "kinship" between modern art and folk and popular forms—indeed, they exhibit the latter in their own right. In contrast, the two recent MoMA exhibitions are firmly wedded to "affinities," an approach that makes into a curatorial principle and exhibition strategy the primacy of "sources" in the study of art history. This principle is fully literalized in the installation of *High & Low,* where the walls were plastered with copies of the actual newspapers from which the cubists clipped pieces for their collages. The "sources" have no independent life in this approach to exhibition. Rather, they serve to reinforce the division between high and low that legitimates MoMA's corner on the high market.

In what seems like a global resurgence of interest in such juxtapositions, *Les Magiciens de la Terre,* organized in 1989 by Jean-Hubert Martin at the Centre Pompidou and La Grande Halle de la Villette, used the rubric magical-spiritual to exhibit together artists as diverse as Barbara Kruger, members of the Yuendumu community of Alice Springs, Anselm Kiefer, Tibetan monks, and Nam June Paik: "From the great Canadian North to the Australian desert, from Arizona to China and Japan, from Africa to Central and Latin America, a small team set forth to seek out the art of today, visiting studios set up in disused factories as well as villages which

have scarcely discovered electricity. The first worldwide exhibition of contemporary art." Authenticity here was located in the "genuine outsider," which according to Roger Cardinal was in short supply.[41]

The contemporaneous, that which is *in* the present, was elevated to the truly contemporary, that which is *of* the present.[42] Temporal elevation moved objects from the status of artifacts to that of (modern) art. The result is a disjuncture between the history of the category and the history of objects. When presented in an art museum, the mandala made by three Tibetan monks using multicolored mineral powders—or the work of "outsider artists"—does not trace its history back to French impressionism or Russian formalism. The Tibetan mandala becomes contemporary by sharing the space of display, not by way of a common history of production. Despite elevation from the contemporaneous to the contemporary, it is the lack of a shared history that produces authenticity. The less history shared, the more genuine the outsider. This is how I read Cardinal, when he writes that the "genuine outsider" was in short supply. Paradoxically, however, *Les Magiciens de la Terre* and the 1990 Los Angeles Festival attribute to the "genuine outsider" closer contact with the mythic origins of art itself. These are the terms in which a shared history for insiders and outsiders is formulated and a critique of the European art world mounted.

Postmodern choreographers such as Merce Cunningham (working with John Cage), Trisha Brown, and Yvonne Rainer and performance artists such as Linda Montano turn not to an earlier historical period or distant place or low cultural form but to the quotidian, the life world, ordinary movement, everyday talk—to the habitual and the mundane. Their embrace of the everyday is a refusal of such accepted performance values as spectacle, virtuosity, illusion, and glamour, as well as some of the more radical practices of experimental performance that with repetition had become somewhat predictable.

The Pleasures of Confusion

To what did the Los Angeles Festival turn? To performers from the "Pacific Rim," which the festival organizers juxtaposed with artists from

various parts of the United States, mainly Los Angeles. The result was an anthology of Cambodian court dance, gospel choirs, Sellars's *Nixon in China,* Javanese shadow puppets, China's Kun Opera, Trash Lizards, Pacific Island Kava Ceremony, mariachi bands, and Eugene O'Neill's *Hughie* in English and Chinese. In this respect, the Los Angeles Festival restaged the world as seen from an experimental performance perspective. This is not quite the synthesis and hybridity of a Peter Brook, Jerzy Grotowski, or Eugenio Barba—what Richard Schechner would call interculturalism or what counted as ethnosyncrétisme in *Les Magiciens de la Terre.* It is rather a restaging of their sources, so to speak, within a new masterwork, the FESTIVAL.

On display at the Los Angeles Festival are many values that derive from the historical avant-garde, prominent among them resistance to commodification and the status quo, in both artistic and social terms. Many of those who worked on the festival did so with a deep commitment to the project as something worth doing in its own right. Some gave up their salaries. Many gave of themselves far beyond the call of duty. Seventy percent of the festival, according to Sellars, was free of charge. Commercial gain was not the primary consideration in determining what would be presented, and art forms that had resisted commercial exploitation, a quality that Sellars attributed to "much of non-Western culture," were accorded very high value, particularly since this was one of the reasons, in his view, that they had remained invisible to us. Or it could be said that their invisibility is what had saved them from us until now. Festival organizers challenged audiences to encounter work they might otherwise ignore or reject, to rethink the boundaries of "art," to step outside the art world, to actively participate rather than passively spectate, and to venture into parts of Los Angeles they had never before visited.

These concerns bear on the central theme of these remarks, the pleasure of the unfamiliar and the incomprehensible. Consistent with avant-garde values, there is in the Los Angeles Festival a refusal to reduce art to something that can be explained. The test of a work's resonance is precisely its irreducibility, its resistance to interpretation. Aficionados of avant-garde and experimental performance can sit and watch something

they do not "understand" because of what they have *unlearned*—namely, the expectations, attitudes, values, and sensibility associated with establishment art forms. This unlearning entails holding interpretation and judgment in abeyance. Such audiences know how to yield to "experience," to sensuous immediacy, to presence, energy, and actuality. They value abstraction, pure form, pure theatricality, pure performance. They are open to chance operations, indeterminacy, and improvisation. They enjoy the blurred boundaries between art and life and between performer and audience. A century of Dada cabarets, futurist *serata* (theatrical evenings), surrealist ballets, epic theater, agitprop, Bauhaus puppetry, theater of the absurd, happenings, environmental performance, postmodern dance, and performance art has cleared a space not only for radical artistic experimentation but also for performance forms from other social and cultural worlds. Most important, these audiences have been trained to receive the latter *as if they had emanated from the avant-garde itself.*

Though the history of avant-garde and experimental performance has prepared its specialized audiences for this festival, the problem is not the boundaries, clear or blurred, between high culture and low culture or between Western and non-Western art forms, *but the split between the art academy and the avant-garde.* Here the gate opens through which the rest of the world can enter, for once the avant-garde says that what counts as art is not for the academy to decide, everyone—well, almost everyone—can come in. This is not quite what Lincoln Center did when its president, Nathan Leventhal, told the *New York Times,* "'I had the same prejudices about jazz that opera lovers or ballet lovers might have. . . . But I've learned a lot, and now I am a convert. There is as much richness and as much variety in Duke Ellington as there is in Mozart.'" Mozart was the standard jazz had to meet if it was to be accepted by the artistic academy.[43] In allowing jazz to squeeze through the narrow aperture that opened for a moment, Lincoln Center reaffirmed the values of the academy. When Sellars asserted, "We have opened a door that can't be closed again," not only was the door opened wider and permanently—at least in principle—but the conditions for admission had changed, for the Los Angeles Festival challenged the academy itself. This was the avowed "hidden

agenda" of the festival, according to Norman Frisch: "the possibility of a deep and extensive re-examination of the role of the arts in our most public and most private lives."[44]

Many of the values of avant-garde and experimental performance were mapped directly onto the arts featured at the Los Angeles Festival: first and foremost, a reclassification of activities as "art," however they were understood in their home settings, and second, an affirmation that in many of the societies represented at the festival "the working definitions of 'traditional' and 'contemporary' are not mutually exclusive."[45] According to the literature distributed to the press and the public, the performers came from communities that do not think of what the performers do as art; in these communities art and life are one, everyone's an artist, and people do not distinguish between high and low art. These are vital and spiritual communities; they are in tune with nature. Their arts illustrate the spiritual origin of art; they are about survival, not decoration; they heal. These arts are egalitarian, collective, and communally produced; they are participatory; they resist commodification. They're spontaneous and improvisatory; they are synthetic, combining music, dance, theater, and oratory; they are all form. They range from the loftiest spirituality to the bawdiest humor; they meld the old and the new. They are repositories of ancient wisdom passed down through the generations. They celebrate the kinship of all people. As Judith Mitoma, curator of the 1990 Los Angeles Festival, explained, "Performance in these cultures occurs in the streets, in the temple, in the public square—contexts that democratize the arts to a great extent since access is assured for all levels of the community."[46] The credibility of these claims does not concern me here. What matters is that they inform the ethos of the Los Angeles Festival.

Indeed, they tell us much more about the festival organizers than they do about the performances, for embedded in these affirmations of arts brought from afar—not only from other countries but also from the margins of the American art world—is a critique of American commercial theater, academic art forms, and the culture industry. Read back on themselves, these affirmations are a plea for the arts to regain their emancipatory power in American life. Sellars saw the festival as an answer to the

decorativeness of European high culture and the vacuousness of mass culture: "Western civilization has produced a neurotic, afflicted, hyperextended society where psychoanalysis has replaced culture and Big Entertainment has replaced everything."[47] The festival was an antidote to "mall culture," to the cult of the superstar and the blockbuster, to the safety of conventional theater, though the festival publications made these points on pages facing advertisements for Hollywood films, cosmetics, alcohol, banks, luxury hotels, cars, airlines, tourism, realtors, and television. Someone had to pay for the festival.

The Pacific Rim, broadly conceived, offered the producers of the Los Angeles Festival yet another area for staging an attack on the status quo and for affirming the oppositional values of the avant-garde, values that they attached to the King Island Inupiat Singers and Dancers, Wallis and Fatuna, Children of Bali, and so many others. As Mitoma stated, "We are also being challenged to recognize the value of their perspective on the world, to ask ourselves if their insights might enhance the quality of our lives."[48] Hints of New Age spirituality may also be detected, as well as affinities with the antimodernism of the Arts and Crafts Movement of the earlier part of this century. Sellars expressed the utopianism of the Los Angeles Festival thus: "Interculturalism is the basis for the survival of the species." In his view, the place to start is with visibility, with looking at each other, for "[w]e live in a culture of exile," defined both by the massive immigration of the last three decades and by "an unnamed internal exile from our own selves. . . . [O]ur effort and our need to recover the lives of others is a need and a possibility to recover the missing pieces of our own lives."[49] Looking would, it was hoped, lead to talking, listening, and action.

With all these good intentions, the festival organizers still had to deal with audiences unprepared for much of what they would see. What was to be done with audiences who were as yet neither inoculated with ethnographic information that might make performances from afar more accessible nor initiated into the experimental art world and its values? Sellars's comment at the conference—"Nothing happens for hours and that's the beauty of it"—is of the essence, for it suggests how experimental per-

formance trains audiences to watch almost anything. After hours of Philip Glass or Lucinda Childs or other postmodern performers, where "nothing happens for hours and that's the beauty of it," audiences are in a sense primed for Inuit drumming, Woomera Mornington Island dance, and Philippine *kulintang.* Los Angeles audiences had to be told that "[m]any of our presentations do not 'reach a climax' in the second act," an indication that they were still in training, so to speak.[50]

Sellars's refusal to supply Roland Barthes's missing term, a practice honed by avant-garde protocols, takes on special significance here. [51] It is one thing if the missing term is missing by design, if the signifier has been evacuated so it can float free. Much experimental performance works in this way. In the Los Angeles Festival, it might be said that "ethnographic" performances offered a shortcut to this effect, substituting inaccessibility for evacuation. That is, performances that are semantically dense for their home audiences acquire the desirable quality of free-floating signifiers when produced for avant-garde reception. Barthes's discussion of obtuse meaning may be helpful here.

Discussing the work of Sergei Eisenstein, Barthes locates the filmic—and by extension, the performative—in "that which cannot be described," that is, where "language and metalanguage end."[52] That place is also a site of obtuse meaning. Techniques of defamiliarization override what Barthes calls gratuitous meaning, whether by severing the expected relations between signifieds and signifiers, refusing the logic of narrative, or emptying the sign of obvious meaning. The Los Angeles Festival took a shortcut to Barthes's obtuse meaning: to the extent that performances were presented as quotations, found objects, or readymades, they were instantly obtuse by virtue of their foreignness to many Los Angeles audiences. This is not to suggest that for their home audiences such performances are totally intelligible or without Barthes's "third meaning," but only that signifiers need not be evacuated for obtuse meaning to emerge. A mismatch of performance and audience will suffice. The *unfamiliar,* rather than defamiliarization, becomes the route to obtuse meaning. Signifiers float free, not because something familiar has been made strange by virtue of formal operations in the work itself, but because a disjunction between a performance and its audience has been created

Woomera Mornington Island Culture Team. "Family-based teams of body-painted dancers and *dijeridoo* players such as *Woomera Mornington Island Culture Team* pass along the legacy of the Australian Aborigines. And like the Alaskan peoples, the Mornington Islanders live highly integrated lives, in which art and musical expression represent a natural dialogue with the seaside environment—its fish, its birds, its spirits. A 14-member group (including four children) will bring to the Festival a repertoire ranging from a spiritual 'meeting between the unseen people' to 'shake-a-leg' fun dances. 'Our culture is not just something fading from the past, but we are contemporary people in a real world,' the Mornington Islanders remind us. 'We are showing something of our culture as it is felt and practiced today, the 'Dreaming,' not just of the past, but also the present.'"

From *Los Angeles Festival, September 1 thru 16, 1990, Program and Ticketing Information,* 13. Photo courtesy Los Angeles Festival.

and preserved. The organizers of the Los Angeles Festival "quoted" from Japanese or Hawaiian culture, but in theory, if not in practice, withheld "translation" for the many people in the Los Angeles audience who were not speakers of those "languages." To some extent, this approach could be seen as a way of circumventing "hollow" meaning—explanations of what the performance is "about" or what it "means"—and maximizing the potential for obtuse meaning, which by definition starts where language ends. The greater the absence of gratuitous meaning in unfamiliar performances, the greater the temptation to supply it. The organizers of the Los Angeles Festival studiously avoided this temptation.

By short-circuiting gratuitous meaning, the festival gave audiences who have cut their teeth on experimental performance a passport to all the performance traditions of the world: in principle, they need neither plot nor climax, neither special training nor explanation, to enjoy what they see. Other cultures become their performance art and even a measure of what is missing in their own lives. Would that our theater was as vital as theirs! Would that our lives were as meaningful! Ethnographic expertise was just not up to the task, for all it could do, from the festival organizers' perspective, was come between audience and performer with "information" that, even at best, offered little chance of conveying all that audiences back home could be expected to know. As Sellars remarked at the conference, "You're not Samoan. You can't know." A few factoids delivered by experts cannot close the gap. Nor should "information" create the illusion of instant communication. As Sellars suggested, "People in those societies don't sit around explaining everything. . . . What about societies where the highest point is in the performance, in the dance, not in talking about it afterwards?" If so, then his audiences should simply deal with the performances themselves. Who is to say that everyone back home understands what these performers are doing? Or that everyone can or should have access to everything? There is in these remarks a convergence between practical limitations on what audiences can be expected to know or learn and avant-garde principles of reception that, at least theoretically, require no preparation or expert foreknowledge and may even benefit from their absence.

Consistent with this position, 1990 festival organizers were skittish about "experts" telling audiences what to think. Phyllis Chang, educa-

tional coordinator for the festival, told the press, "We've eliminated the third person . . . or the specialist who gets up there and says: 'I have studied Latino culture, and here are my findings.' It is not academic at all."[53] The Los Angeles Festival was not infotainment. But the very casting of expert knowledge in these terms—a bespectacled egghead comes to mind—suggests a missed opportunity and a somewhat naive view of ethnographic expertise, for there are many convergences in sensibility between the festival's avant-garde approach and ethnography in its more experimental mode. These convergences could have served the festival well, for ethnographers also destabilize the locus of "understanding" and they do so on the very ground on which we stand.

Sellars stated at the conference, "One of the aims of the Festival was to remove forever the concept of ethnomusicology and ethnic studies, which at its core is offensive, and to move to another level where we didn't have to have special parentheses around things. These were not 'primitive' artists or 'folk' artists. These were *artists.*"[54] It could be said that the labels, and the categories associated with them, posed a challenge to the festival's working concept of art and that the festival organizers transformed this challenge into a provocation by *restaging the "ethnographic" as "art."* The Los Angeles Festival began precisely at the point where the ethnographic and the avant-garde converged, and it forged its own path by undoing the ethnographic.

How was this undoing achieved? Festival organizers systematically removed ethnographic labels, withheld explanation, asserted the primacy of experience over hermeneutics, demanded attention to form as content, and affirmed the power of art to transcend difference by constituting difference as "just different" and asking audiences to respond as just "humans." In the absence of "ethnographic labels," performances chanced upon in unfamiliar places became objets trouvés—an artistic operation celebrated by the historical avant-garde. Gathered together from the far reaches of the Pacific, performances of seemingly infinite number were dispersed across a sprawling megalopolis at the end of the second millennium in a maze-cum-menu of possibilities to be sampled, not grasped, in a decentered entirety. The compositional principle of the festival, in Frisch's words, was "blend and clash," the component parts retaining

their identities.[55] The "art" of such a festival arises from dislocation and juxtaposition, procedures that give to ethnography its surreal quality and to surrealism its ethnographic character. In both cases—and this is of the essence—we see how the elements in question *"continually proclaim their foreignness to the context of presentation,"* be that context the printed book, museum display case, record album, film, or festival stage.[56]

I have colleagues who turn the sound off when watching film, who prefer to watch dance without the music. They refuse to read program notes, reviews, or synopses. They won't go to a preperformance lecture. They don't want anyone to explain to them what's going on. They prefer performances in a foreign language because they don't understand the words. Not "understanding" is precisely what makes it possible for them to ignore language, to attend to the purely performative. Not "understanding" is precisely what keeps them open to something entirely new. If anything, language gets in the way. As Sellars said at the conference, "Communication reaches the most satisfying level when we don't have to talk," a statement more likely to come from an avant-garde director than a conventional playwright. Language is the enemy because of its power to "assimilate Art into Thought, or (worse yet) Art into Culture," as Susan Sontag wrote in 1964.[57]

This approach to performance, which informed many aspects of the Los Angeles Festival, is encapsulated in a distinctive conceptualization of authenticity. I have in mind the comment that the most authentic moment occurs when the audience confronts what it does not understand, a notion rooted in an avant-garde sensibility (I cannot imagine this formulation coming from the Cahuilla Bird Singers or Halau O'Kekuhi). "Understanding" Chindo Sitkim-Kut or The Wooster Group's *Temptation of St. Anthony*, or requiring that they be "explained," interferes with the purity of the aesthetic experience, because from an avant-garde perspective, explanation mediates what should be a direct encounter. Audiences should come to performances open. They should be willing to experience what is immediately before them and make up their own minds about what they see. Artistic intention and curatorial guidance—not to mention what the critics have to say—are finally irrelevant. Nor does it matter what the performers think of this approach to their work, though clearly the festival

organizers were respectful to the performers and wanted them to be comfortable. What matters is the total event as the organizers produced it. Understanding was to be deferred: according to Sellars, "We hope that after looking, there will be talk, and that after listening, there will be action."[58]

When Frisch stated that "[o]urs is an 'appropriated' festival," he meant that many of the performances at the Los Angeles Festival were cultural quotations. Extrapolating from Barthes on the postmodern text, he characterized the festival as a "tissue of quotations" that "blend and clash"

"In Frank Dell's *The Temptation of St. Anthony,* a conflation of Lenny Bruce's final days with Flaubert's epic poetic drama, a mysterious figure overdubs all the voices on an all-nude cable TV talk show."

Performed by The Wooster Group. From *Los Angeles Festival, September 1 thru 16, 1990, Program and Ticketing Information,* 32. Shown here, Ron Vawter and Kate Valk. Photo by Paula Court. Courtesy The Wooster Group.

without forming a neat totality.[59] Consider for a moment the difference between works designed from the outset as theatrical events, however experimental and iconoclastic, and "heritage" performances excised from occasions and settings that have not been transplanted with them, an absence that the press and even the program booklet attempted to redress by re-creating in words what had been left at home. Hardja Susilo, professor of ethnomusicology at the University of Hawaii, explained in the program booklet, "Today . . . wayang kulit is performed in the context of weddings, celebrations of thanksgiving, national holidays, etc., in cities and villages everywhere. Such performances begin about 8:30 P.M. and end around 5:00 A.M. the following morning."[60]

Such accounts point up with special clarity the partiality of strict quotation and what a larger bite might afford. I am reminded of Petr Bogatyrev's account of peasant reception of folk plays in Czechoslovakia during the first half of this century. The same plays were performed year after year. Far from demanding a change of fare, audiences knew the old plays almost by heart and watched them with great interest. Rather than novelty of plot, "the focal point of a folk theatre performance lies in the treatment of detail."[61] Other cases could be cited. But as long as we repeat the mode of reception taught to us by avant-garde practice, as long as we turn our cheek toward the slap, we will not know what it is like to revel in the "detail" of performance worlds new to us but familiar to their local audiences, who find the new in the repetition. A narrower opening, the detail requires a different grasp on the event, a different mode of reception. We need an orientation not to the performance as a self-contained artifact but to the performance as a ramified event in which reception (not to be confused with interpretation) is integral. Such an approach would reveal to what degree the assumptions of an avant-garde approach to reception are culturally specific rather than a master key to art as a transcendent category.

Fearful Asymmetries

Cultural quotation is not ethnographic vivisection. It is not a cultural kidney on ice that is rushed to the festival body, readied for transplant, with the hope that the foreign organ will take. We are not dealing with a

kind of ethnographic *théâtre libre,* which instead of slicing life quotes cultures. Nor, in the case of the many Los Angeles neighborhoods featured at the festival—"Every two blocks it's a new world"—are we dealing with a bell jar dropped over an ethnographic region of the city. The festival does not bring a vitrine to the site, suddenly making the neighborhood itself an exhibit. The organizers were well aware that the Los Angeles Festival was the determining context for everything it presented. Indeed, the arts festival is in some cases the primary—if not the only—one for performance forms that have lost whatever other settings and contexts they once had. Even as some of these performances evoke an originary setting of the old days, they may in fact only be performed at festivals of the arts. One of the festival organizers commented that a performer who had immigrated to Los Angeles from Thailand worked at Federal Express during the day—but surely not in the elaborate costume he wore for the Los Angeles Festival. Were audiences to assume that performers wore their "costumes" all the time? Or just for this occasion?

The arts festival may have become the safe and appropriate place to be different, to be "ethnic." As such, these festivals have long been the repository of imagined communities and invented traditions.[62] "Heritage" is not simply inherited.[63] This is a claim that draws on a rhetoric of legitimation. Rather, "heritage" is constantly constituted and renewed. When Sellars aimed for a festival without labels, when he refused to identify the performers as ethnic, folk, or primitive, he was taking the ethnomusicologists, ethnographers, and folklorists to task, for these are in his view anthropological labels. But the Los Angeles Festival did use labels: "the Maoris," "the Koreans," "the Balinese," and so on. Why were those labels benign? I am not arguing for the other labels. I want only to shatter the illusion that there were no labels, that designations geopolitical or ethnic or cultural are unproblematic, and to draw attention to the implications of these labels, their singularity, as if those who performed could be defined in their entirety by a geopolitical designation. The ease with which such labels were used suggests that the only way that American "minorities" and Pacific peoples can appear is in their essential "ethnic" or "national" mode, that people are best known in the festival genre, that culture divides while art transcends, and that the only safe differences are aesthetic

ones. The dizzying array of diversity, while motivated by an exuberant spirit of inclusiveness, also risked the danger of banalizing difference by rendering it inconsequential, particularly in the humanizing face of art, the master category.

Indeed, the ethnographic survived as the hidden term in the festival equation, where disavowal helped to create a lexical minefield. Having stripped the performances of ethnographic labels—it's all just art—the terminology dance began anew, only this time the preferred terms were "tradition," "heritage," and "multicultural." These terms were offered by Susan Auerbach, former folk arts coordinator for the Los Angeles Cultural Affairs Department and a thoughtful writer on her subject. Still, they are indicative of the dilemma, as is her statement in the program booklet: "Tradition encompasses change, and heritage-related arts range along a continuum from purist roots to hybrid and avant-garde offshoots, as the Festival amply shows."[64] Roots are pure—folk arts programs "encourage cultural preservation"—and presumably they are purest at their putative source, whether removed in time or space or saved by immigration. Terms like "fusion," "blend," "hybrid," "evolving," and "dynamism" define the other end of the continuum.

When both ends meet at the Los Angeles Festival, the result is a "cross-cultural arts venture" that makes Los Angeles itself a "multicultural mecca." The delicacy of these terminological maneuvers is particularly clear when the Cambodian musician Chim Reap, an immigrant, is "multicultural" (a euphemism for not white), but a group like the Gujo Hachiman Bon Odori, brought from Japan, is "international" (a euphemism for not American). As surrogates for "foreign," both euphemisms occlude difference—and the asymmetries of power—by pluralizing (and otherwise splitting and reconstituting) the Other. Why is Chim Reap multicultural? Who, by implication, is (mono) cultural? If the Friendly Islanders of Tonga are international, who is by implication national? Whether "multi," "cross," or "inter," the entities so designated stand in a special relationship to those who are not, for, it would seem, "they" are plural, "we" are one. Euphemisms take us only so far, particularly when the categories and assumptions they seem to challenge are still very much alive. After all, just who counts as different or as different enough or as

different in the ways that matter? And who does not? Is the Bread and Puppet Theater, which is neither multicultural nor international, technically speaking, also "just different"? And if so, just different from what? The categories seem to be structurally intransigent and lexically fluid. Though the shifts in terminology do suggest some taxonomical give, they promise more than they deliver.

For another spin on the problem, consider Arlene Croce's dismay when Mark Morris was dropped from the Los Angeles Festival for financial reasons. In her *New Yorker* piece entitled "Multicultural Theatre," Croce champions Morris as "a genuine expression of world dance" and "a multicultural microcosm"—his dancers are of "every color and physical description" and his choreography is "a blend of East and West." Opining on multiculturalism, "the latest buzzword" created by the university, Croce celebrates the ecumenicism of dance and bashes the political correctness of academics. "Multiculturalism exists and has always existed in American dance; there is scarcely an American choreographer of note who has not been influenced both by the pluralism of our society and the way that dance just naturally soaks it up. Pinning a label on a simple phenomenon like that is something only an academic would want to do. And only political academics would want to isolate the elements of pluralism in such a way as to aggrandize some and stigmatize others."[65] To at once trivialize the issues signaled by the term "multiculturalism" as a "simple phenomenon" that only academics would gussy up with a buzzword and then celebrate Morris as "a multicultural microcosm" only dramatizes the extent to which Croce herself has jumped on the bandwagon, but without having paid the price of admission.

What is so insidious about Croce's position? She equates appropriation with pluralism, an equation that naturalizes the process by which "the West" separates forms from their performers, converts those forms into "influences," brings the influences into the center, leaves the living sources on the margins, and pats itself on the back for being so cosmopolitan. "There may be a need to promote the accessibility of Asian, Hispanic, and African dance companies, many of which lead a marginal life. But the dance forms themselves are hardly inaccessible—they're part of every dance tradition the West knows. At their purest (assuming

that one can find village and street festivals that are uninfected by television and tourism), they still speak a rhythmic language intelligible to all."[66] To think otherwise is "divisive." Croce's affirmations of the purities of difference and her identification of the "'other' (it's another buzzword)" with rhythm bear the traces of racist thinking.

Multiculturalism, in Croce's view—and she is not alone—is an invention of the academy and the enemy of the arts, for it presumes that ballet and modern dance are in decline and that "these other styles," kept outside by "mainstream prejudice," are the only hope for rejuvenation. On the contrary, she argues, "Morris speaks so many [dance] languages that it comes as a surprise when from time to time, he creates a work that has no trace of an accent—that is just 'pure' movement." In other words, Babel is the path to the transcendent purity of artistic form, and even more important, to greatness as a dance company, for Morris's work exemplifies "a vision of the universe and the individual's place in it."[67] Enlightenment values reassert themselves and political realities are obscured in the elision of anything—multiculturalism?—that might stand between the smallest unit (individual) and the largest (universe).

Yo! "After all, what is 'yo'? Only 'oy' spelled backward," a *New Yorker* cartoon at the time quipped. Step back a moment. What about "art"? Is that not a label? Who decided what to present at the Los Angeles Festival? The choices were not random. If, as Sellars stated, anthropological labels imply the superiority of Western art forms, then the label "art" is a way to elevate forms that have been so labeled. We dignify such forms by reclassifying them, by using categories we value, whether or not our categories bear any relation to those the performers use. As Mitoma noted, "Most of the international participants invited to the Festival do not consider themselves 'artists' in the general Western sense of the word."[68]

I want to dispel the notion that when art mediates, it makes us all just human. I want to challenge the idea that art does not mediate. That it speaks directly. Or, that when art speaks it does so in a universal "nonlanguage." Phyllis Chang's assertion that "[w]e've eliminated the third person" when we have eliminated the academic specialist fosters the illusion that the festival organizers did not mediate what they presented, that they simply let "art" speak for itself. Yet it is precisely the theatrical

mediation effected by the Los Angeles Festival that distanced so many of the events from the ethnographic and bracketed them as art.

Consider Croce's comment at the end of her review of Mark Morris: "In dance, high art has always needed to be nourished by folk art, and folk art has always needed the mediation of the theatre. Without the theatre, dance isn't a medium; it's the preserve of anthropologists, not of artists."[69] The diction is suggestive: in its role as nourishment, is "folk art" only food for the master, who "mediates" by digesting it? This reading exposes the *illusion* of reciprocity in Croce's statement, which promotes the fiction of a quid pro quo that equates nourishment with mediation. Though Croce's sensibility is very different from that of Sellars, her pronouncement points again to the power of theatrical mediation to remove "folk art" from the "preserve of anthropologists"—and, inter alia, to the tensions between artists and what Croce calls anthropologists. The Los Angeles Festival is a spectacular case of theatrical mediation.

The mediation of theater, however well intended and successful, skirts the apologetics of inclusion. As noted earlier, Lincoln Center was un-abashed on this score when it declared its plan "to elevate jazz to the same level as opera, ballet and symphony." Nathan Leventhal, president of Lincoln Center, predicted that "people will be very pleased about the fact that we're giving recognition to jazz, and that jazz has a place at Lincoln Center," an assessment that would meet its true test when Lincoln Center went after funding.[70] Money speaks loudly, even at the 1990 Los Angeles Festival, whose budget was considerably lower than those of its two predecessors. Were 70 percent of the events free of charge because they were hard to sell? Is "multicultural" a code word for low budget? If money talks, what is it saying? It certainly speaks to asymmetries of power in the relationships that made the Los Angeles Festival possible and that have kept jazz out of Lincoln Center until now.

The press was often at a loss. Were the critics to review performances or to report on them? Some articles reverted to the encyclopedia entry, offering a somewhat ethnographic or historical treatise on a particular art form assumed to be unfamiliar to the reader. Others fell back on the human interest story and wrote about the performers. Some followed the conventions of travel writing to describe their encounters with those who

had come from afar. Others observed Sontag's dictum to "supply a really accurate, sharp, loving description of a work of art."[71] Some wrote about the Los Angeles Festival as a total phenomenon. At bottom, reviewers seemed too unsure of themselves to write about performances from Asia and other parts of the Pacific the way they normally reviewed theater and dance in Los Angeles. Value judgments did not seem "politically correct" under the circumstances. While revealing a double standard—criticize art, describe the multicultural—their quandary also suggests how limited are the ways the performing arts are usually reported in the press and the need to experiment not only with performance and festivals but also with the ways we write about them. The "consumer report" quality of much performance criticism could do with a healthy dose of attentive description and critical analysis.

Like the press, what audiences experienced was the Los Angeles Festival itself—notwithstanding Sellars's comment that the festival was a huge maze, everyone made their own festival, no one saw everything, and one cannot really speak of a "shared" experience. Indeed, the maze, like the alphabetical list of events and the calendric grid of their occurrence, was a way to avoid hierarchy by using disorientation, arbitrariness, and parataxis to advantage. If anything, the Los Angeles Festival, a product of the contemporary art world, the university, civic institutions, corporate philanthropy, city government, and big business, could use an ethnomusicologist, a folklorist, or an anthropologist if it is to be understood as a cultural phenomenon in its own right.

When a brochure titled *The Los Angeles Festival Guide, 1991,* issued by the Cultural Affairs Department, was captioned "Celebrating America's City of Festivals," the message was that Los Angeles is party time. It is a happy place. The brochure stated further that these festivals "tell a story of a City that is culturally alive." Read the newspaper for the unstated story of urban decay, gangs, and all the other fixtures of American cities. At the Los Angeles Festival, the city of Los Angeles was the hero and the script, the stage and the producer, whatever else the event might have been about. The 1990 Los Angeles Festival, like the guide to all the festivals occurring in Los Angeles throughout the year, signified that Los Angeles is civilized, that Los Angeles has a civic and public sphere. People

work for the common good. Los Angeles has the arts. Los Angeles is in the vanguard. Los Angeles will lead the future. Los Angeles is multicultural. Diverse people can work together. The city is vibrant, a center, a magnet. We can beat the sprawl. We can get off the freeway. We can park our cars. We can visit each others' neighborhoods. There is a there there. Thanks to the last twenty-five years of new immigration—and the airplane that brings performers from around the Pacific—we can really prove it. Just look at Little Tokyo, Chinatown, Olvera Street, Philippine Town, Koreatown, and other distinctive parts of the city. The Los Angeles Festival helped the city define itself in terms of those who have come to it from somewhere else and who assert hereness through thereness.

A key to the Los Angeles Festival lies in its location of authenticity in a moment of aesthetic reception, rather than in the objects presented. This move is informed by an avant-garde sensibility that, having challenged the category of art and admitted what the art academy excludes, gives to reception a constitutive role. While this sounds emancipatory, there are unexplored asymmetries here between performances that are coherent in their home contexts and the planned anarchy of their reception by Los Angeles audiences. Driving a wedge between ethnographic and artistic practice obscures the extent to which the two enterprises share procedures and values and the ways that theatrical mediation "undoes" the ethnographic. The organizers of the Los Angeles Festival incorporated critiques such as this into their planning discussions for the 1993 festival and ongoing experimentation with the festival as a form.

Secrets of Encounter

The Museum for African Art inaugurated its new name and location with *Secrecy: African Art That Conceals and Reveals,* which opened on 12 February 1993. The Broadway storefront space, redesigned by the architect Maya Lin, marks a dramatic change of venue from the Upper East Side brownstone of the former Center for African Art. Situated now in Soho's lively art district, on the same block as the New Museum of Contemporary Art and the Guggenheim's downtown branch, the Museum for African Art attracted more visitors on its first Saturday than in an entire week uptown.

Under the inspired direction of Susan Vogel, the Museum for African Art has established a singular track record for mounting reflexive exhibitions and provoking the visitor to consider display as a subject in its own right.[1] Starting with two premises—little that we see in museums was made to be seen there and African "artifacts" are art—the museum's exhibitions have challenged viewers to question curatorial authority (*Perspectives: Angles on African Art*) and to think about how the installation itself produces meaning (*Art / Artifact*). In this spirit, the stated aim of *Secrecy* is "not to reveal secrets, but rather to show how certain works of art serve to protect and maintain secret knowledge." By exploring the logic and procedures of concealment, the exhibition stresses cognitive processes and epistemological implications, rather than the mystery of the dark

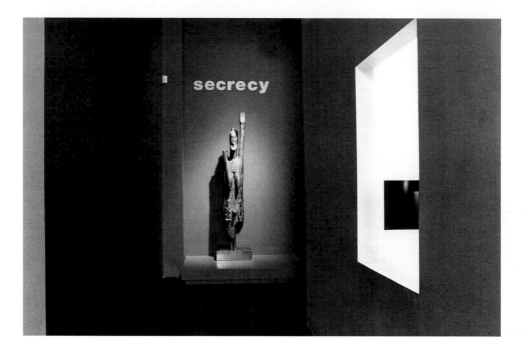

continent and related tropes of African otherness. Respect for what must
not be revealed and humility in the face of what cannot be known guide
the interpretation of objects. Here again, the curators play at the inter-
section of art and anthropology, where converging interests have helped
propel African objects far beyond contexts for which they were made.

Visually compelling masks, figures, textiles, and architectural elements
created in sub-Saharan Africa in the nineteenth and twentieth centuries
and borrowed from private and public collections (the museum does not
have its own collection) are organized into six sections, each of which ex-
plores a question:

How does art conceal and reveal secret knowledge?

How does art mark physical and social boundaries?

How does art express the secrets held by each gender?

How does art identify owners of secret knowledge?

How does art transmit secret knowledge?

Can we ever really understand another culture's secrets?

Satisfied by the tactile pleasure and elegant geometry of a raffia pile cloth (Kuba, Zaire), the visitor is drawn into the theme of secrecy by the way this object answers the first question: its woven pattern conceals and reveals secret knowledge by means of visual coding. The religious altars, figures, and masks in this section use other devices. The result? A display of the *repertoire of principles* for signaling the presence of something withheld, principles that attract the museum visitor to the object and keep her at a distance. An already compelling visual experience becomes even more elusive.

The choice to exhibit the objects as art, by themselves in dramatically lit vitrines, is a strategic one and achieves several objectives. It satisfies an uptown crowd whose primary interest is in the objects as art and who may not be entirely comfortable in the new location. And it establishes parity with what counts as art down the road. But the exhibition also demonstrates that to exhibit objects as art does not mean leaving them to stand entirely on their own. Lucid text panels and labels, none of them obtrusive, develop the exhibition themes in ways that direct the viewer's gaze back to the object, to look again, to inspect more closely. As the exhibition unfolds, one comes to understand better the workings of secrets, if not the secrets themselves, until in the last gallery the tables are turned and the Dogon of Mali become an exemplar of how secrecy has shaped Western perceptions of African art and by extension the very exhibition the visitor has just seen.

By way of summation at the symposium that coincided with the opening of the exhibition, I was asked to address the themes of "research,

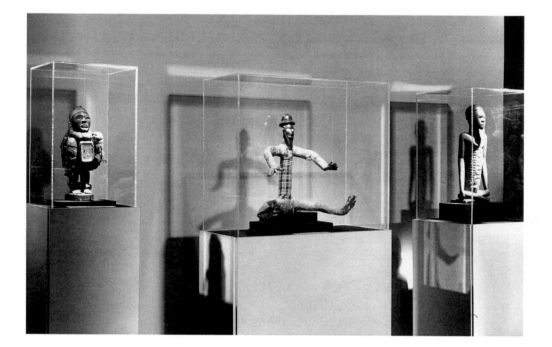

ethnography, and writing secrecy." Though these themes are signaled in the final gallery, the rest of the exhibition deals exclusively with secrecy in traditional African societies. Most of the objects, however, were made and used during the colonial period. As the late J. Ndukaku Amankulor protested during the symposium, characterization of African associations as "secret societies" is a colonial invention, part of a strategy to weaken them, the better to administer the colony. Although the exhibition is sharply focused and sets out complex issues clearly, greater attention to secrets of encounter would have made the exhibition even more reflexive and provocative. Catalog essays dealing with secret resistance in wall paintings by Sotho-Tswana women or Dogon tourist art suggest the richness of these themes.

As it is, the show's primary concern is the secrets that members of any given traditional African society keep from each other, not those they keep from ethnographers, art historians, colonial administrators, or tourists. Nor those that "we" keep from "them" by using languages that are not shared, writing that they may not read, and specialized discourses, whether art historical, ethnographic, semiotic, poststructuralist, or whatever else. And then there are the secrets we keep from each other, secrets about the transnational circulation of objects and the information about them that increases their value in global markets—the secrets of dealers, auction houses, collectors, curators, ethnographers, art historians, critics, and last but not least the anonymous lenders to the exhibition, to say nothing of the trade secrets protecting all the technologies in the building.

So we may well ask, just who is so preoccupied with secrecy? Enlightenment values—the very word *enlightenment*—place a premium on illumination, on full disclosure, on open access to knowledge and truth. The logical extension of these values is the information-glut society and the sinister notion that the most valuable fact about you is your telephone number, because of the access it provides to so much other information already stored in vast databases—the nightmare of no secrets.

Three questions guided my deliberations: How is our preoccupation with secrecy played out in the exhibition, catalog, and symposium? How are secrets displayed and discussed without being revealed? And how is that process enabled by the status of these objects as art? As discussed in the previous chapter, convergences between the avant-garde and twentieth-century ethnography have altered the relationship of art museum audiences to Roland Barthes's third, or obtuse, meaning, the result of signifiers whose signified is inaccessible or evacuated, if it ever existed.[2] The avant-garde, which opened the way for these objects from Africa to be accepted and shown as art, also gave us art that does not need to be "understood" to be enjoyed. "Understanding" might even be an impediment. The absence of a bottom line makes irrelevant such questions as "What does it mean?" or "What is it about?" or even "Is it art?" The point is the experience, the play of signifiers, the challenge. Remember, the New Museum and the Guggenheim are just down the road.

By making secrecy a semiotic problem, the exhibition at the Museum for African Art shifts our attention to how secrets work and away from what they mean. This strategy has several effects. First, by treating secrecy as a type of communication rather than as a source of esoteric information, the exhibition universalizes its message. Second, with reference to the specific objects on display, those who know their secrets do not have to reveal them, and those who do not know their secrets can get away with incomplete knowledge. The exhibition's interpretive strategy is itself a secret of encounter, one that is structured by the status of secrecy as a double sign, a split sign, and an asymmetrical sign.

Each secret announces itself twice, first to state "this is a secret" and then to relate the stated term to the hidden term. The first signification is a metasign, a sign of a sign. As a sign of Secrecy, rather than as a secret, the exhibition is itself a metasign—it takes upon itself the role of announcing that the objects on display are secrets. The second announcement establishes the character of secrecy as a split sign that exposes the signifier and defers the signified. By exhibiting only half the sign—the arts and techniques of concealment, the masks, marks, wrappings, bundles, codes, camouflage, distractions, ambiguities, accumulations, understatements, and containers—the exhibition keeps the secret. It says, half a sign is better than no sign, and for the purposes of writing and exhibiting secrecy, half a sign is all you need.

But there are troubling corollaries of the split sign, and they have to do with the issue of encounter. In the effort to keep our attention on the metasign, we are told in various contexts that information is less important than the idea of withholding it, that the content of secrets is often trivial. But trivial to whom? To those who keep the secrets? Or to ethnographers and art historians—and museum visitors? The claim of triviality is important as a distraction that enables the display, for whether or not the secret is knowable, the claim of triviality establishes that it is not *worth* the effort to find out. Ethnographic etiquette requires that we be satisfied with this state of affairs. One could say that playing with the metasign of secrecy is a consolation prize. Focusing on the metasign also deflects us from what we do not have a right to know, what is not our business. Hence the trope of disappointment when, after great effort, the secret turns out to be a tempest in a teacup.

The split also creates asymmetry, for the signifier may be overcoded or undercoded, spectacular in its elaboration or barely discernible if at all apparent, an undecipherable code in full view or object that gives little if any indication that anything is hidden. The signified may indeed turn out to be trivial, or it may take a lifetime to fully discover and understand what the hidden term means. Given the priority of visual interest in the display of objects and our own preoccupation with concealment, it follows that this exhibition should focus on elaborated signifiers, on objects that make a show of hiding. When coupled with the triviality claim, these objects hyperbolize the asymmetry of the sign of secrecy and keep our attention from wandering to what is not shown.

In the theater of secrecy, hiding and showing are mutually constitutive, as the exhibition, catalog, and symposium make clear. One is necessary for the other, even though they may not be equally elaborated. This peekaboo writ large creates critical discontinuities in a field of awareness, thereby giving shape not only to social life but also to knowing and to aesthetic experience. Little dramas of hiding and showing structure our perception and attention. They create channels and pathways for transmission. They regulate the rhythm, pace, range, and distribution of value.

The riddle, like secrecy, is a little drama of the split sign, whose completion is transacted in an encounter of concealing and revealing. But learning riddles is also one of the ways that children learn proverbs, many of which are also riddles. One is easily converted into the other. What is better than no loaf? Half a loaf. It is in the conversion that we can see how the location of the sign's split shifts—from inside the form of the proverb (which is where the riddle is created) to the structure of proverb performance as a social art of metaphor and indirection. Proverbs, like secrets, state only the signifier. The other half of the sign must be inferred, not stated. Catalog contributors and symposium participants made thoughtful links between the theme of secrecy guiding the exhibition of objects and enigma, dilemma tales, arithmetic puzzles, and divination.[3]

Other dramas in the theater of secrecy are confessions, and revelations that produce new secrets. Theater itself requires, for performative effect, that a line be drawn between what is shown and what is not and that revelations be carefully timed. Magic depends for the success of its illusion on hiding its methods and confuses the relations of causes and effects to

that end. Bunraku, the art of Japanese puppet theater, reveals and conceals the manipulators. They are hooded and clad in black but manipulate the puppets in full view.

In a word, secrecy is inherently performative. The Museum for African Art performs a secret of encounter by deferring the meaning of particular secrets indefinitely. That visitors should find that deferral pleasurable, rather than frustrating, is enabled by the history of how these objects have come to be exhibited as art. For visitors who have come to enjoy the undecipherability—the obtuse meanings—of much contemporary art, objects from other worlds are gold mines of obtuse meaning. These are the conditions in this exhibition that enable the paradox of showing secrets without revealing them.

Circulating Value

Disputing Taste

What do aerosol cheese, Liberace, tattoos, Chihuahuas, and feminine hygiene spray have in common? Those who consider them examples of bad taste. The diverse social locations from which such instances of "bad taste" come make Spam, ant farms, facelifts, low riders, and Lawrence Welk incommensurable as a set.[1] They have nothing in common but their relationship to the canon of good taste. Bad taste is one of the ways in which good taste announces itself—the finger that points to the breach points to the rule. The connoisseurship of bad taste must therefore be read back on itself, for it reveals more about the arbiter than the offender. As Meyer Shapiro is said to have said, "Kitsch is chic spelled backwards."[2]

In the museum of the life world, everyone is a curator of sorts. This excursus on the social location and circulation of value in everyday life explores vernacular practices of connoisseurship. Though taste presents itself as inherent to things and persons, distinctions attributed to good and bad taste are unstable. The same objects can be assigned to either category, even at the same point in time, and can move from one to the other over time. Bad taste is associated with the ephemeral, good taste with endurance, but before objects find a final resting place—will it be the garbage dump or the museum?—they pass through many circuits of exchange. Their value fluctuates with each transaction. What was once dis-

carded may recover its value, not only in the organized heritage productions discussed in chapter 3 but also in everyday life, which is not only where the process of converting life into heritage begins but where an ongoing process of distinction makes and remakes social hierarchy.

Like Velcro, the capsule histories of commodities and celebrities in *The Encyclopedia of Bad Taste* attach leisure suits and accordions to different constituencies at different times. Artificial pink flamingos move up and down the cultural escalator, as rampant recoding transforms their meanings; far from homogenizing all those who consume them, leisure suits and happy-face decals redraw the terrain of taste at every turn.[3] Taken as a set, Hummel dolls and heavy metal are unified only by the guardians of the precincts of good taste—the high priests of Milan Kundera's "theodicy of shit."[4] Tupperware and Frederick's of Hollywood are both perfectly atrocious according to *The Encyclopedia of Bad Taste* and the perfect commodities according to *Quintessence: The Quality of Having It*, the *Encyclopedia*'s mirror twin, a good-taste catalog.[5]

Taste distinguishes those who make the distinctions. This is what makes bad taste so coherent as a category. Indeed, it is a mark of good taste—part of its mystification—that, according to the etiquette books, it never calls attention to itself except in the breach, which is what gives "bad taste" its constitutive power. So much so that Miss Manners must warn her readers: "To keep a house in which every object, down to the smallest bibelot, is in perfect taste, is in shocking taste." A few "household atrocities"—whether "hideous presents" or tacky souvenirs—will demonstrate that the discriminating person is not completely devoid of "tradition and sentiment."[6]

Nuance and detail articulate the narrow range of good taste into an elaborate code of fine distinctions that governs everything from writing paper to greater and lesser works of art.[7] Much of this code is arbitrary, its sole purpose to signal difference—black tie as the marker of formal attire. As distinctions exhaust their power to distinguish, new ones must be employed: Emily Post counseled her readers in 1940 that since the term "'lady,' which once denoted elegance and cultivation," had descended to mean respectability and then to "no meaning at all," "a real lady . . . speaks of herself and her friends as women."[8] The tendency is toward

"Semiotic Guerrilla Warfare," a citation from Umberto Eco on a wall on Prince Street, near the Bowery, New York City, 1983.

Graffiti by artist Kenny Scharf and others. Photo by Barbara Kirshenblatt-Gimblett.

finer and finer discrimination and increasing attention to detail, to the point of decadence—twenty-plus pieces of crystal, silverware, and china of different shapes and sizes for each person at a formal dinner.

The civilizing process is directed toward self-restraint, as Norbert Elias so vividly shows.[9] The ways in which this restraint is marked—the specific forms, details, and nuances—give class culture its peculiar tenor at each point in history. Habituated and internalized, the emotional economy of social niceties creates thresholds of embarrassment that shift; practices once perfectly acceptable—wiping the hands on the tablecloth—are perceived as disgusting. As late as 1941, *The* New *American Etiquette* advised its readers on the disposal of chewing gum: better to

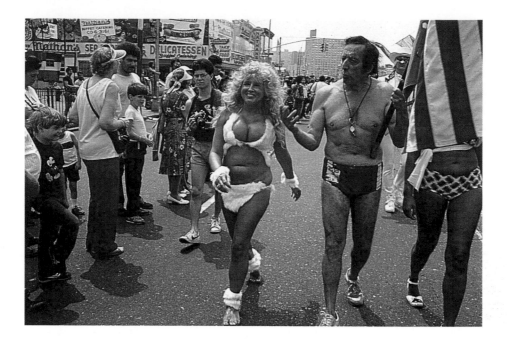

swallow it than to "eject" the gum from the mouth, wrap it in paper, and throw it away. Readers were also instructed in "Invisible Eating. . . . It is a matter of disguising the process."[10]

Nowhere is taste so vividly inscribed as on the body, which good manners systematically deny. The body in good taste is complete as given (or so discreetly altered as to appear so) and resplendent in its "self-sufficient individuality."[11] It derives from Enlightenment values—reason, moderation, classical formality, individual autonomy—transmitted in no small measure through the northern European austerities of Protestantism.[12] Blue is the color of blood in the chilly latitudes. But there is also a grotesque body, which, according to Mikhail Bakhtin in his study of Rabelais, is

not a closed, completed unit; it is unfinished, outgrows itself, transgresses its own limits. The stress is laid on those parts of the body that are open to the outside world, that is, the parts through which the world enters the body or emerges from it, or through which the body goes out to meet the world. This means an emphasis on the apertures or the convexities, or on the various ramifications and offshoots: the open mouth, the genital organs, the breasts, the phallus, the potbelly, the nose.[13]

The Encyclopedia of Bad Taste offers a kind of shopping list of parts for assembling the grotesque body. Its prostheses are provided by cosmetology (ornamental nails, hair, lashes), medicine (facelifts, nose jobs, breast implants), as well as body-building (to bulk up the physique from within) and tattooing on the epidermal canvas. These arts apply the finishing touches to the ever unfinished body in its state of becoming hypergendered (or androgynous), displaying its markers like a calling card. There are sartorial enhancements, the fetishes of erotic arousal—the animal lust of leopard skin; spike heels to cast the calves into a bulge and shift the body's weight; elevator platform shoes to extend the body upward; brassieres to raise, point, plump, and otherwise extend the breasts; hot pants to sheath the thighs, buttocks, and crotch so they form a single, sinuous plastic unit. We have here Bakhtin's two bodies in one—the dying and the being born—not in a uterine mode, not through a kind of hatching, but by painting over an existing canvas and reworking the living sculptural material. This is not the "unfinished and open body" of Rabelais, which proceeds from an egg, through a cycle of birth and death, but canvas and putty for the hands to rework.[14]

The grotesque body comes to a head, so to speak, in professional wrestling, where the forces of good and evil thump flesh to the mat. Athletes use their bulky bodies to simulate physical violence, the art of which is to inflict no physical damage, even as frenzied fans cry out for death and destruction. In novelty wrestling—often used to raise money for charity—the ring is filled with food: pudding, Jell-O, or spaghetti marinara, as if the entire body were a mouth awash in food; or with mud, as if the body might drown in its own waste. Bakhtin traces the historical process by which images of fundamental bodily processes like "eating, drinking,

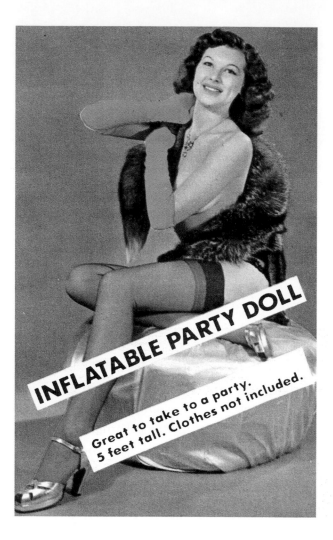

INFLATABLE PARTY DOLL

Great to take to a party.
5 feet tall. Clothes not included.

"Carrie Carlton (AKA Carioca),
Party Doll."

Copyright 1980 Carioca Novelty
Co., San Francisco.

copulation, defecation almost entirely lost their regenerating power and were turned into 'vulgarities'"—the gags and novelties of our own day, the rubber vomit, fart cushions, and plastic turds that bring the lower body, "the bodily grave," into focus.[15] An index to the differences is the quality of laughter each elicits—ribald belly laughs, mild amusement, sardonic smile. It might therefore be useful to think in terms not of good and bad taste but of classic and grotesque, which would signal the madeness of all categories. The "real" and the "natural" are no less made than the "artificial."

The grotesque is about paradox, ambivalence, mixture. During classical antiquity, it was expelled "from the sphere of official art to live and develop in certain 'low' nonclassic areas." By internalizing the grotesque as a subjective state and infusing it with fear, eighteenth-century aesthetics of the sublime and nineteenth-century romanticism attempted to restore to the grotesque a measure of artistic respectability that had been overshadowed by the "domination of the classic canon" and its values. In our own period, we can see something of "carnival spirit" and "grotesque imagery" in the marketplace, where it has always been at home.[16]

More than an embarrassment, bad taste is a crime. Look no farther than neighborhoods where residents are certain property values will plummet with the appearance of clotheslines, satellite dishes, storage sheds, birdbaths, or recreational vehicles or the wrong types of lawn grass, mailboxes, awnings, or siding material. Restrictive covenants legislate good taste by ensuring that "your neighbor isn't going to paint his house chartreuse."[17] Mary Douglas defines dirt as matter out of place.[18] Bad taste is social dirt. Zoning maintains social hygiene by ensuring the correct disposition of social matter. Restrictive covenants define the terms of that disposition. Propriety is also proprietary.

Good taste speaks in the moral language of honest lines, truth to material, form following function. Explaining why the Oreo cookie and Stetson hat are perfect, *Quintessence* describes such durable commodities as "faithful." The Spalding rubber ball is "sincere": it offers the "promise of a true and noble bounce." Ivory soap is "cheerful," "innocent," "clean." Tupperware is "pure" and "forthright." But "taste" is a language too anemic, the *Encyclopedia* at once too clinical and too tongue-in-cheek, to contain its less amusing "offenses"—Holocaust video games, Andres Serrano's *Piss Christ* (Rabelais immersed pilgrims in urine), Guillermo Gómez-Peña's *San Pocho Aztlaneca*, televised executions (let alone the principle of capital punishment itself), media coverage of the Ethiopian famine (to say nothing of famine itself as a weapon in civil war and feel-good mega-events like Hands across America), or the gulag, defined by Kundera as "a septic tank used by totalitarian kitsch to dispose of its refuse."[19]

The Temple of Confessions.
Guillermo Gómez-Peña as living saint "San Antonio Aztlaneca," a hyper-exoticized curio shop shaman for spiritual tourists.

Ex-Teresa Arte Alternativo, Mexico City, 1995. Photo by Monica Naranjo.

In what emerges as a recycling of postmodern sensibility for the masses, retro catalogs offer "fun" without judgment. What they know, they have learned from Las Vegas rather than from the trenchant critiques of kitsch by Hermann Broch and Clement Greenberg in the thirties—during the rise of fascism in Europe—or the irreverence of Puerto Rican *chuchería* and Chicano *rasquachismo*, punk, camp, cool, hip, and hip-hop (before they too were brought into the fashion mainstream and codified in their own manuals).[20] Is imagination, in its "inherent, incontrovertible tendency toward excess, amplitude, and abundance," at war with taste?[21] What is the nature of the imagination at work in the creation of the Mince-O-Matic chopper and its hypertrophy of mechanical wit or the

plastic honey bear—"poetry in plastic, . . . a bear filled to the eyebrows with his favorite food"—or aerosol cheese, the apotheosis of processed food, or, most recently, molds that grow vegetables in the shape of celebrities like Elvis?

Who is the homunculus—the *golem*—configured by the entries in the *Encyclopedia?* When not consuming junk food (jerky sticks, maraschino cherries, Hamburger Helper), the person of bad taste likes Hellenic diners and Polynesian restaurants (Trader Vic's), surf 'n' turf, and places where the waiter brings a giant peppermill to the table.

The body of the woman of bad taste is subjected to extravagant grooming—sculpted nails, bouffants, white lipstick. When not parading in the buff at nudist colonies, her male counterpart is outfitted in bell-bottoms, Hawaiian shirts, Nehru jackets, jogging suits, zoot suits, loud ties, and mood rings.

The disciples of bad taste drive Cadillacs, limousines, monster trucks, and muscle cars—accessorized with vanity plates, bumper stickers, and fuzzy dice—and Harley Davidsons. Destined for Las Vegas, the Smoky Mountains, Weeki Wachee, where mermaids perform under water, and, ultimately, Forest Lawn Cemetery, retired couples set out in motor homes, while families with kids hit the trail in campers. Muzak and heavy metal are their favorite types of music, along with that of Wayne Newton, Dolly Parton, Liberace, and Charo. The bad-taste crowd loves celebrities like Tammy Bakker and has a penchant for perky nuns, both singing and flying. Their children—Ashanti, Jason, Babette, Jamal, Ryan, Tiffany, and Jennifer—play with Barbies and trolls. Their poodle wears clothes. They shop at malls or order from the Home Shopping Network, and their favorite pastimes are bowling, miniature golf, roller derby, game shows, and charity telethons.

Their mobile homes are furnished with shag rugs, water beds, reclining chairs, and lava lamps. They cover toilet paper rolls and Kleenex boxes with crocheted cosies and slap Rickie-Tickie stickers to floors and walls. In the kitchen, Mom slices and dices with the Chop-O-Matic and seals the leftovers in Tupperware, while Dad and the boys hook dinner with Ronco's Pocket Fisherman, the all-in-one fishing rod and tacklebox (in

"All Dressed up and No Place to Go." Noted on the back of this post-card: "The Pekingese was known for centuries as the little Lion Dog of Peking. It became a sacred symbol of the Chinese in the first century and was surrounded by royal restrictions with breeding strictly confined to the environs of the Court. After British looting of the Imperial Palace in 1860, the first was introduced to the western world as a gift to Queen Victoria who appropriately named it 'Looty.'"

Dexter Press, West Nyack, New York, circa 1980. Photo by Camara Clix.

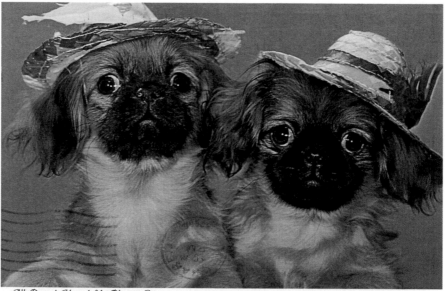

All Dressed Up and No Place to Go

the handle). On the living room walls hang original velvet paintings and reproductions of the works of Morris Katz, Leroy Neiman, and Margaret and Walter Keane. The family has a penchant for animated objects (nodding-head dolls and pictures with winking eyes) and collectibles (cedar souvenirs, and ashtrays in the shape of a toilet). They like to make things from "nothing" either by salvaging nature (driftwood furniture, taxidermy) or by transforming the most manmade of made things (recycling pop-tops, pantyhose, and household garbage). Their yards are fitted out with artificial grass and lawn ornaments—holy family groups and lawn balls.

"The Milk-Bone Dog Biscuit."

From Betty Cornfeld and Owen Edwards, *Quintessence: The Quality of Having It* (New York: Crown, 1983). Photo by Dan Kozan.

The homunculus of *Quintessence,* on the other hand, consumes the things in "our claptrap age" that have "the rare and mysterious capacity to be just exactly what they ought to be"—the "good news shining through the bad."[22] In his Lacoste polo shirt, Levis, Bass Weejun loafers, and Ray-Ban sunglasses, the *Quintessence golem* pauses for a moment— shall he wear the Cartier Santos watch or the Timex Mercury 20521, neither of them digital? He tosses Jockey briefs and Pro-Ked high-top sneakers into his Ghurka Express Bag No. 2 and is ready for the weekend. Checking his wallet for his American Express card, he makes a quick

stop for Bayer aspirin and Kleenex tissues, which he carries away in the classic unmarked brown paper bag.

The days of Checker cabs long gone (though fondly remembered), he zips in his Volkswagen Beetle to the shore. There he'll tool around on his Harley Davidson ElectroGlide—when he's not entertaining on his Cigarette Hawk speedboat. Frosty Budweisers and Coca-Cola on deck, Nathan's Famous hot dogs on shore, with Heinz's ketchup, of course, and junk food classics for the kids—M&M's and Hershey's chocolate kisses.

Back at the beach house, he whips up egg creams, with Fox's U-Bet chocolate syrup, in his Hamilton Beach Model 936 Drink Mixer. The kids enjoy their Oreo cookies and Barnum's Animal Crackers, the English bull terrier his Milk-Bone dog biscuits, and the adults their martinis. For a quick supper, he opens a can of Campbell's tomato soup with his Swiss Army knife, lights the gas stove with Ohio Blue Tip kitchen matches, serves the soup in Wedgewood plain white bone china, and stores the leftovers in Tupperware. The peanut butter (Skippy smooth) and jelly (Welch's grape) sandwiches are reliable standbys.

Supper is followed by a game of Monopoly. The adults light up Camel cigarettes with Zippo lighters, while the kids smoke their El Bubble bubblegum cigars. The little kids play with their Crayola crayons, Silly Putty, and Slinkies. The big kids throw Frisbees and hit Spaldings with Louisville Sluggers. The toddlers cuddle their Steiff teddy bears. Back at the New York apartment is the Märklin Electric HO Gauge model train.

Mom, in her Frederick's of Hollywood lingerie, stands by the Steinway piano ready to pour the Dom Perignon champagne. Brown as a nut, thanks to his Coppertone suntan lotion, the *Quintessence golem* scrubs down with Ivory soap, slicks his hair with an Ace comb, and dusts himself with Johnson's baby powder. The kids show Mom snaps of the Goodyear blimp captured with the Polaroid SX-70 camera before they settle in to watch reruns of Fred Astaire, Mickey Mouse, and Johnny Carson.

The authors of *Quintessence* mystify taste by lodging it first in the instinct of the well-bred—"You know it because you know it. To the receptive soul, quintessence reveals itself. Our instincts react to quintessence whether or not our intellects understand it." Second, they identify it in the objects themselves, which are said to have a "magical rightness."[23] The classic markers of good taste (universality, singularity, and

timelessness) are then read into the history of selected commodities. With pedigrees that extend back almost a century, the Coca-Cola bottle and Camel cigarette have stood the test of time. Because it is perfect, the quintessential object is not subject to revision—and vice versa. Moreover, good taste obviates excessive consumption. One is enough if it is perfect. Choose right the first time and there will be no need to choose endlessly.

"Abiding objects" come as close as mass-produced commodities can get to the older aristocratic value of patina—the quality that attests to the continuity and continuing power of an object to confer status on its owner—and to the aura associated with original works of art.[24] Nothing specially new or trendy here, no carnie "flash"—just the commodity classics, as good today as the day they were invented and even better if they have been owned for a long time. This tepid refusal of the fad is a high-minded elevation of the low: "Milk-Bone dog biscuits may seem something for dog owners only, but they'll hold their own on any shelf of pre-Columbian art."[25]

Objects in these two *golem* scenarios are anchored not in the social space of their purported consumers but in the conceptual space of the inventory. Inventories of abuses such as *The Encyclopedia of Bad Taste* do coalesce, not as style, but as sensibility. The alphabetical arrangement of entries, because it is arbitrary, refers each item in the inventory not to other items in the list, but to the master category of bad taste. Even items that would otherwise travel together (Spam, Wonder Bread, fish sticks, Twinkies) are first dispersed and then interspersed with water beds, Cadillacs, and dinosaur parks. Lined up in the neutral space of the alphabet, all contiguities of the items in the anthology are severed, a process that readies them for genetic tracing for continuities of another kind.

While lists create the fiction of disinterest and authority, the little histories that accompany each entry attach signatures to objects so habituated at the height of their acceptance as to seem given, just there. The job of the historical vignettes is to highlight the made-ness of ordinary things. They do this by converting objects from "made-real" to "made-up."

In that they are said to have the "rare and mysterious capacity to be just exactly what they ought to be," the "abiding objects" in *Quintessence* are perfect examples of what Elaine Scarry calls the made-real. So much so that even the moral language of Spalding's "true and noble bounce" is turned up a notch. At their most perfect, commodities are endowed with souls, "magical rightness," and a "numinous nature"—language that suggests they were created not by humans but by God, and which enshrines them for worship.[26] Historical snapshots expose such commodities as the inventions of named persons by attaching signatures to things that normally have none.[27] The moment a historical portrait makes its human inventor "real," an object previously experienced as "made-real" and inevitable is apprehended as "made-up."

Most of the objects in *The Encyclopedia of Bad Taste,* however, are precisely those that are so "unreal as to be immediately recognizable as 'made.'"[28] It is their madeness that is fascinating. This is accounted for by a certain consistency in the selection that favors the patently artificial, synthetic, plastic, simulated, fake, recycled, animated, ingenious, fantastic—in a word, the flagrantly made up. Lest their patent madeness recede as these objects establish themselves as given in the lived world, lest they become "real," they need only be experienced as out of joint with the moment—in advance or in arrears—to recover their quality of madeness. Without their pedigrees such objects bear only the general signature of human manufacture. To emerge fully as made up, they require the specificity of attribution that genealogies provide. That we do not generally know who invented aerosol cheese or artificial Christmas trees is what helps them to "function as 'real' or self-substantiating."[29] Historical factoids, by affixing specific signatures to them ("Day Glo colors did not always exist. . . . [They] were first synthesized in the thirties by the brothers Bob and Joe Switzer of Cleveland") intensify their "unreal" nature, their made-up-ness, and help to transform them from tools to artifacts.[30]

Unlike the plates in Diderot's encyclopedia, which, as Barthes suggests, favor a visual narrative that variously shows the object, its parts, how it is made, and how it is used, the illustrations in the *Encyclopedia of Bad Taste* show only the finished product.[31] There are virtually no images of

manufacture. Instead of the tools and machines that signaled the artisanal era of Diderot's objects, there are photographs and drawings taken from commercial packaging, catalogs, and other forms of advertising. Such images illustrate what are actually little histories of marketing, a fact that is itself a sign that the bad taste of the *Encyclopedia* resides somewhere in the unhealthy relationship between an unbridled commercial imagination and an undiscriminating consumer. The technology that produces these commodities remains mysterious. So inventive are these synthetic novelties—Astroturf, Cheez Whiz, Naugahyde—that the precise details of their manufacture are trade secrets.

Bad taste could be said to be bad timing. While the icons of good taste stand the test of time, the emblems of bad taste come and go. Subject to the wild fluctuations of fad and fashion, the will (or suggestibility) of the herd, bad taste spreads rapidly and almost as quickly ends up as a mountain of discards, thus suffering the double stigma of mindless acceptance and massive rejection. These most debased of commodities are also the most fertile for recoding, because they constitute such abundant trash.

How can objects that seemed so alive at the height of their popularity come to seem so dead? Rapid spatial saturation succeeded by rapid evanescence, a deliberate case of hit-and-run—the effect is stunning. Among the most valuable items in the retro business, perhaps because they epitomize this convergence, are commodity oxymorons—old stuff that is brand-new, complete with original price tag and packaging. This is not about patina, for these objects were never "owned." Rather, this is fashion cryonics. The mint-condition, still-in-the-box Barbie doll has been removed from circulation and frozen in time only to reappear thirty years later as if born yesterday—the legacy of forgotten overstock, an abandoned warehouse, inventory recovered in bankruptcy, or some other vagary of the market.

Having achieved saturation in space, the commodity runs out of time. It is the precision of its entrance and exit, the sharpness of its discontinuity, that makes the temporal location of a fad so clear. Commodities give shape to time—not the slow curves of archaeological time delineated

by George Kubler, but the abrupt swings between the pageboy and duck-tail.[32] There is more than one test of time: evanescence is as important as durability.

Sharp discontinuities in fashion cycles are engineered by a fashion clock set too fast for objects to wear out before they are replaced, so exhaustion of novelty fatigues the object even as the physical substance refuses to degrade. Planned obsolescence must be made perceptible in design: the *look* of the commodity signals that one version is different from another. Technologies arcane to the user are housed in forms that do not—that cannot—reveal function.[33] Indeed, the less visible the inner workings of its technology, the more intelligent the "smart house" and all the computerized appliances within it.

With product cycles ever shorter, and with constant repetitions (recycling, reissues, reprints, knock-offs, clones, sampling), recursiveness prevails. Whereas the mark of time was once the kiss of death, fads and fashions no longer fade permanently from view: vintage cars return, Frisbees escape the cycle to hover in the nirvana of quintessence.

Think of time as harboring a lengthy process of semiotic saturation so powerful as to destabilize an artifact like denim jeans.[34] Such saturations are so overdetermined, they become underdetermined: as they lose their semantic center, rawness—the plenitude of potentiality—is restored. (No one can have a firm, authoritative grip on the meaning of jeans.) The more elaborate and variegated the object's history, the more destabilized is the object's location in space and time. But what is raw has yet to be coded. Better to say, then, that the richness of what has happened to the object becomes part of its raw material. This is the richness that commonness can produce. As commodities go in and out, up and down, hot and cool, they show the power of semiosis to make and remake meaning and value. The commonplace, it turns out on closer examination, is not so general. The low is not common. The surface is not depthless.[35]

How is it that objects that attracted slaves to fashion in their first life can be tokens of rebellion in their afterlives? Walter Benjamin noted that the outmoded is a source of revolutionary energy, precisely because to pick it up again, after it has been discarded, is a potentially radical gesture. What

Smileys.

Reminiscence, a shop in Lower Manhattan,
New York City, 1996. Photo by Erin Mee.

some fads lacked in exclusivity during their first life they gain the next time round through the recoding operations that consumers (low riders, punks) produce—through what Umberto Eco calls semiological guerilla warfare. The smiley is a case in point. There are many forms of refusal. Timing is a way to set refusals in motion—to get out of step, to strike a kind of syncopation of the cultural clock, to establish stylistic arrhythmia.[36]

"Cool" does just this. What's out for the mainstream is cool for the subculture, except that some rejects are cooler than others. In and out, sub and counter. Artful dodgers of the fashionable. There are many ways of being out. Countercoding is not strictly reciprocal. Cool may recode bad taste, but what is uncool is not necessarily good taste. What is uncool is a failed attempt at coolness—the perpetrations of squares, puppetheads,

chowderheads, nerds, dorks, and drongos. *The aesthetic of cool cannot be predicted from that which it rejects,* an indication that taste as a category has been decoupled from culture and style.

"Subculture," as conceived by the cultural critic Dick Hebdige, is more than the marketing niche targeted by the image of a woman wearing mink and denim in a Revlon campaign. It is produced by style. Has style replaced taste, or so relativized it that it loses its power? As the meaning of "style" shifts from "stylish" to "lifestyle," from "fashion" to "culture," style comes to signify the choices people make in constituting a total way of life. No domain is too humble. While taste tends to be invoked most explicitly where the stakes are highest, that is, in the realm of the "legitimate" arts, no medium is impervious to the distinguishing process—not dog biscuits, matches, water, or plain white T-shirts (Lower Manhattan chic dictates extralarge, 100 percent cotton, thick weave, very white, no pocket).[37] The codes are arcane to the uninitiated up and down the cultural escalator.

Unintelligibility, however it is induced, whether through the understatement of good taste or the recodings of its subversions, is a gatekeeping operation, signaling at once to the inside and the outside, rattling the bars in both directions.

The relations among taste, culture, and style are reconfigured. First, taste is disentangled from Culture (in the sense of cultivation and civilization), with which it has long been associated. Second, taste is teased apart from style. Freed from their old moorings, culture and style (in the sense of way of life) are recoupled.

The detachment of art, beauty, and pleasure also destabilizes the very category of taste. In a programmatically de-aestheticized world, what's bad taste? Since the historical avant-garde narrowed the terrain of the unacceptable—opened up *la nostalgie de la boue* (dirt)—the curating of kitsch has become the supreme act of connoisseurship. The problem is no longer bad taste but good, which is conservative, boring, acquiescent.

Kitsch is to taste what superstition is to religion—somebody else's mistake. Built into modernist notions of kitsch is a theory of reception that posits either the autonomous individual of civilization or the uncritical

Solid milk chocolate cross.

Purchased from Woolworth's, New York City, Easter, 1991.

herd of mass culture, seen as a staging area for fascism—but not the possibility of sub- / countercultures other than the avant-garde. Kitsch requires the abdication of critical judgment because it tells us what to think and feel; Theodor Adorno characterizes kitsch as a "parody of catharsis."[38] As a postmodern concept, the aesthetics of kitsch subsumes the reception of kitsch as well as the object, the commodity and its consumers, the programmed response and its subversion. To the extent that kitsch is understood as all effect, all surface, depthless, it is the aesthetics par excellence of postmodernism.

Greenberg's classic formulation of 1939 signaled a crisis in the reception of both modern art—the public was basically unreceptive—and historical works as their uniqueness and value were compromised by reproduction. The condemnation of kitsch was a way the legitimate arts defended themselves as their tokens were degraded. Drawing the line around kitsch was one way that an embattled art world could defend itself against a public that refused modern art and misread historical art—liking it for the wrong reasons.[39] The problem is one of art and its publics—the avant-garde delivering the slap, kitsch the caress—and the ambivalent relationship of intellectuals to popular culture.[40] Do not assume, however, that the slap directed at the bourgeoisie comes only from disaffected artists and intellectuals. It comes also from the side, from below, from over there.

Good taste is cultural capital masquerading as the natural attribute of an elite. Even the terms designating good taste must be discrete: Emily Post alerted her readers in 1940 that "not long ago 'elegant' was turned from a word denoting the essence of refinement and beauty, into gaudy trumpery. 'Refined' and 'dainty' are both affected. But the pariah of the language is 'culture,' a word rarely used by those who truly possess it, but so constantly misused by those who understand nothing of its meaning, that it is becoming a synonym for vulgarity and imitation."[41] She particularly objected to calling someone who used a fingerbowl cultured.

Greenberg argued for the necessity of class as a precondition of Culture—wealth as necessary for cultivation, the rear guard of kitsch as the corollary of the avant-garde, and the lower classes as necessary for providing the economic base for the entire scheme.[42] (For the rich to exercise their leisure to cultivate themselves, someone had to work.) Whether

they divided the terrain of culture into two parts, high and mass, the latter a degradation of the former, or into three parts—two forms of high culture (academic and avant-garde) and a rear guard of kitsch—cultural critics since before World War II have argued for the necessity of an elite with the wealth and time to produce civilization. The crisis as they envisioned it, each in his own historical moment, was the blurring of boundaries between "the sublime and the paltry," as Kundera was to put it.[43] The domain of high culture was eroding as the working masses consumed poor imitations of it, and high-tone magazines like the *New Yorker* became a "stuffed shirt 'front' for kitsch."[44]

This basic view of culture is exceedingly durable, reappearing in debates about the canon, the core curriculum, the preeminence of Western civilization, Afrocentrism, multiculturalism, pluralism, affirmative action, political correctness, the "chilling effect." We are replaying the cultural debates of the century. This time the "low" talks back, but just how far have we really come in the debate? Consider Greenberg's 1939 statement: "There has always been on the one side the minority of the powerful—and therefore the cultivated—and on the other the great mass of the exploited and poor—and therefore the ignorant. Formal culture has always belonged to the first, while the last have had to content themselves with folk or rudimentary culture, or kitsch."[45] *The Encyclopedia of Bad Taste* reinforces the idea of a Greenbergian "great mass," one as diverse as the thesaurus entry for *churl* will allow: it is made up of rubes, bumpkins, cheapskates, vulgarians, potbellied sexagenarians, bimbos, parvenus, the gauche, flamboyant, and ostentatious. But these generic labels obscure the specific social categories to which so many of the objects in their bad taste phase are attributed: ethnics of all colors, white trash, retirees, working-class Catholics, blue-collar workers, and youth subcultures. "Cultural subversives" are an undifferentiated lot mentioned in passing in the entry on pink flamingos, where John Waters and Divine make a brief appearance.

The notion of taste as the privilege of wealth, leisure, and cultivation (and implicitly "breeding"—from which its racist flavor stems) is a corollary of Greenberg's notion of culture. Though cold war mass culture theorists like Dwight McDonald would concede the value of folk art, before it was allegedly displaced by mass culture, Greenberg views even "folk

Easter parade.

Fifth Avenue, New York City, 1985. Photo
by Barbara Kirshenblatt-Gimblett.

Woodlawn Cemetery, Las Vegas.

Photo by Carol Edison, 1982.

art" as a survival of aristocratic forms that trickled down to peasants after their masters had abandoned them.[46] What makes such views of culture so insidious—they are most clearly formulated when most embattled—is their denial of the *possibility* of cultural production of any significant value anywhere but at the top. The payoff for class difference, they tell us, is civilization. How else could Machu Picchu and the Pyramids of Giza have been built? Well-intentioned attempts to disseminate the cultural profits of this social arrangement are doomed, for the descent they entail is an inherently kitschifying process. That leaves the top its preeminent role as custodian of civilization.

Is the upshot of eroding differences between "angel and fly" a world of kitsch—"the absolute denial of shit"?[47] Or is it a liberating pluralism, an affirmation of the possibility of creative expression in all quarters?

Notes

Introduction

1. See Susan Buck-Morss, *The Dialectics of Seeing: Walter Benjamin and the Arcades Project* (Cambridge, Mass.: MIT Press, 1987), 331.

2. I have had the opportunity to curate exhibitions for the YIVO Institute for Jewish Research (for example, *Image before My Eyes: A Photographic History of Jewish Life in Poland, 1864–1939*), the Jewish Museum of the Jewish Theological Seminary in New York (*Fabric of Jewish Life: Textiles from the Jewish Museum Collection*), and the Smithsonian Institution (Festival of American Folklife), and to participate in the planning and evaluation of many exhibitions and festivals over the last twenty years. Most recently, they include the U. S. Holocaust Memorial Museum, Te Papa Tongerewa, The Museum of New Zealand, Israel Museum, Beth Hatefutsoth, Los Angeles Festival, Museum for African Art, and the Gene Autry Western Heritage Museum.

3. See Buck-Morss, *The Dialectics of Seeing*, 225. See also Theodor Adorno, "Valéry Proust Museum," in *Prisms*, trans. Samuel and Shierry Weber (Cambridge, Mass.: MIT Press, 1981), 175–185.

4. On the history of such spaces of abstraction, see Michel Foucault, *The Birth of the Clinic: An Archaeology of Medical Perception*, trans. A. M. Sheridan Smith (New York: Pantheon Books, 1973); and *The Order of Things: An Archaeology of the Human Sciences* (New York, Pantheon Books, 1970).

5. Timothy Mitchell, "The World as Exhibition," *Comparative Studies in Society and History* 31, no. 2 (1989): 225, which draws on Martin Heidegger, "The Age of the World Picture," in *The Question Concerning Technology and Other Essays*, trans. William Lovitt (New York: Harper and Row, 1977), 115–54.

6. See Edward M. Bruner and Barbara Kirshenblatt-Gimblett, "Maasai on the Lawn: Tourist Realism in East Africa," *Cultural Anthropology* 9 (1994): 435–470.

7. See "Citizens Against Communist Chinese Propaganda," http://www.afn.org/~afn20372/. Updated 8/25/97.

8. See "The World-Folklore Theme Park," <http://www.chinapages.com/guangdong/guangzhou/gz_wftpl.htm>. Dated 1996.

Chapter One. Objects of Ethnography

I thank my colleagues in the Department of Performance Studies at New York University's Tisch School of the Arts, particularly Sally Charnow and Naomi Jackson, for their able research assistance; Michael Taussig, who convened a stimulating faculty colloquium, "Mimesis and Alterity," during the 1988–1989 academic year; and Edward M. Bruner, Allen Feldman, Brooks McNamara, and Richard Schechner. I am also grateful to William Taylor, William Leach, and Peter Buckley, who convened the Commercial Culture Seminar at the New York Institute for the Humanities, to Diana Fane, Stephen Jay Greenblatt, and Charles Musser for bibliographic leads, and to Amy Horowitz and the Center for Folklife Programs and Cultural Studies, Smithsonian Institution, for locating photographs.

1. According to Richard D. Altick, *The Shows of London* (Cambridge, Mass.: Harvard University Press, Belknap Press, 1978), 6, Virgin's milk is listed in inventories of the reliquaries of medieval French cathedrals. This essay is deeply indebted to the pioneering work of Altick. See the following publications, each of which accompanied an exhibition of an object listed here: Carolyn Gilman and Mary Jane Schneider, *The Way to Independence: Memories of a Hidatsa Indian Family, 1840–1920* (St. Paul: Minnesota Historical Society Press, 1987); Amanda Dargan and Steven Zeitlin, *City Play* (New Brunswick, N.J.: Rutgers University Press, 1990); Cyrus Adler and I. M. Casanowicz, *Biblical Antiquities: A Description of the Exhibit at the Cotton States International Exposition, Atlanta, 1895* (Washington, D.C.: Smithsonian Institution, 1898); Charles Coleman Sellers, *Mr. Peale's Museum: Charles Willson Peale and the First Popular Museum of Natural Science and Art* (New York: W. W. Norton, 1980), 42. Pieces of the Berlin Wall were frantically collected at the time the wall came down. Entrepreneurs sold pieces, charging more for those fragments "with color" than for those without a vestige of graffiti.

2. In the wake of the historical avant-garde and the challenges it posed to "the autonomy of art . . . [as] a category of bourgeois society," the problem of visual interest, a term I take from Svetlana Alpers's provocative essay, "The Museum as a Way of Seeing," in *Exhibiting Cultures: The Poetics and Politics of Museum Display*, ed. Ivan Karp and Steven D. Lavine (Washington, D.C.: Smith-

sonian Institution Press, 1991), 25–32, is refigured—Duchamp's readymades, his urinal, were offered not primarily for their visual interest but as provocations. See Peter Bürger, *Theory of the Avant-Garde,* trans. Michael Shaw, vol. 4, *Theory and History of Literature* (Minneapolis: University of Minnesota Press, 1984), 46, 51–52. Such provocations, which have the potential to make anything interesting, also challenge our assumptions about visual interest.

3. As William Insley, an artist working in New York City, commented on reading this essay, "What was absent from the ruin is often less marvelous than we imagine it to have been. The abstract power of suggestion [the fragment] is greater than the literal power of the initial fact. Myth elevates" (pers. comm., 16 November 1989). Insley makes architectural drawings of a future city of the imagination.

4. See M. W. Thompson, *Ruins: Their Preservation and Display* (London: British Museum Publications, 1981); and Barbara Maria Stafford, *Voyage into Substance: Art, Science, Nature, and the Illustrated Travel Account, 1760–1840* (Cambridge, Mass.: MIT Press, 1984).

5. See, for example, Oliver Impey and Arthur MacGregor, eds., *The Origins of Museums: The Cabinet of Curiosities in Sixteenth- and Seventeenth-Century Europe* (Oxford: Clarendon Press, 1985), on the Mannerist fondness for the fragment and quotation and the uses to which body parts were put after anatomical dissections. See also Lawrence D. Kritzman, ed., *Fragments: Incompletion and Discontinuity* (New York: Literary Forum, 1981).

6. On cultural and national wholes, see Benedict Anderson, *Imagined Communities: Reflections on the Origin and Spread of Nationalism,* rev. ed. (London: Verso, 1991); Richard Handler, *Nationalism and the Politics of Culture in Quebec* (Madison: University of Wisconsin Press, 1988); and Johannes Fabian, *Time and the Other: How Anthropology Makes Its Object* (New York: Columbia University Press, 1983).

7. On the representational conventions informing the nature dioramas at the American Museum of Natural History, see Donna Haraway, "Teddy Bear Patriarchy: Taxidermy in the Garden of Eden, New York City, 1908–1936," *Social Text* 11 (winter 1984): 20–64. On the period room, see Stephen Bann, "Poetics of the Museum: Lenoir and Du Sommerard," in *The Clothing of Clio: A Study of the Representation of History in Nineteenth-Century Britain and France* (Cambridge: Cambridge University Press, 1984), 77–92. On the re-creation of historical sites, see Michael Wallace, "Visiting the Past: History Museums in the United States," *Radical History Review* 25 (1981): 63–96.

8. Henry C. Shelley, *The British Museum: Its History and Treasures* (Boston: L. C. Page, 1911), 301.

9. See William Ryan Chapman, "Arranging Ethnology: A. H. L. F. Pitt Rivers and the Typological Tradition," in *Objects and Others: Essays on Museums and*

Material Culture, ed. George W. Stocking Jr., vol. 3, *History of Anthropology* (Madison: University of Wisconsin Press, 1985), 15–48; and Sellers, *Mr. Peale's Museum.*

10. Shelley, *The British Museum,* 304.

11. Ibid., 299.

12. Oleg Grabar, "An Art of the Object," *Artforum* 14, no. 7 (March 1976): 39; and George Kubler, *The Shape of Time: Remarks on the History of Things* (New Haven: Yale University Press, 1962).

13. Joseph Alsop, *The Rare Art Traditions: The History of Art Collecting and Its Linked Phenomena* (New York: Harper and Row, 1982), 74.

14. Alsop, *Rare Art Traditions,* 99, offers the example of a twelfth-century *armilla,* which the Nuremberg Museum bought for $2,034,450: "the *armilla* looks like what it has become—a tremendous collectors' prize of the utmost rarity. But neither to the eye nor in almost any other way does the *armilla* look in the museum as it formerly looked, when it served as an epauletlike ornament of the hieratically grand ceremonial robes of Frederick Barbarossa—the purpose the *armilla* was originally made to serve."

15. Detachment and circulation are by no means a unique feature of ethnographic objects. It is the manner of detachment that makes an object ethnographic, historical, or artistic, a point underscored by E. H. Gombrich: "Nearly all the objects in our collections were once intended to serve a social purpose from which they were alienated by collectors. . . . The image was pried loose from the practical context for which it was conceived and [was] admired and enjoyed for its beauty and fame, that is, quite simply within the context of art" (quoted by Alsop, *Rare Art Traditions,* 99).

16. Francis Bacon referred to "the shuffle of things" in 1594. See Oliver Impey and Arthur MacGregor, "Introduction," and Rudolf Distelberger, "The Hapsburg Collections in Vienna during the Seventeenth Century," in Impey and MacGregor, *Origins of Museums,* 1, 34–35. See also Krzysztof Pomian, *Collectors and Curiosities: Paris and Venice, 1500–1800,* trans. Elizabeth Wiles-Portier (Cambridge: Polity Press, 1990).

17. Th. H. Lunsingh Scheuleer, "Early Dutch Cabinets of Curiosities," in Impey and MacGregor, *Origins of Museums,* 34–35.

18. See M. H. Dunlop, "Curiosities Too Numerous to Mention: Early Regionalism and Cincinnati's Western Museum," *American Quarterly* 36, no. 4 (1984): 524–548.

19. Sellers, *Mr. Peale's Museum,* 202.

20. Committee on Publication (Harry F. Perkins et al.), "Part II. The Exhibit," in *A Decade of Progress in Eugenics: Scientific Papers of the Third International Congress of Eugenics held at the American Museum of Natural History, August 21–23, 1932* (Baltimore: Williams and Wilkins, 1934), 486–510 and 28 plates.

21. On things, their collection, classification, exchange, transvaluation, and "social life," see Arjun Appadurai, ed., *The Social Life of Things: Commodities in Cultural Perspective* (Cambridge: Cambridge University Press, 1986); Jean Baudrillard, *For a Critique of the Political Economy of the Sign,* trans. Charles Levin (St. Louis: Telos Press, 1981); Pierre Bourdieu, *Distinction: A Social Critique of the Judgment of Taste,* trans. Richard Nice (Cambridge, Mass.: Harvard University Press, 1984); James Clifford, "On Collecting Art and Culture," in *The Predicament of Culture: Twentieth-Century Ethnography, Literature, and Art* (Cambridge, Mass.: Harvard University Press, 1988), 215–251; and Mihaly Csikszentmihalyi and Eugene Rochberg-Halton, *The Meaning of Things: Domestic Symbols and the Self* (Cambridge: Cambridge University Press, 1981).

22. Eric Cochrane, *Historians and Historiography in the Italian Renaissance* (Chicago: University of Chicago Press, 1981), 426.

23. Cyrus Adler, *I Have Considered the Days* (Philadelphia: Jewish Publication Society of America, 1941), 69.

24. George Brown Goode, "The Museums of the Future," *Annual Report of the Board of Regents of the Smithsonian Institution . . . for the Year Ending June 30, 1889: Report of the National Museum* (Washington, D.C.: Government Printing Office, 1891), 433. Goode delivered this lecture before the Brooklyn Institute on 28 February 1889.

25. Ibid., 427.

26. Cyrus Adler, "Museum Collections to Illustrate Religious History and Ceremonials," in U.S. Cong., House of Representatives, *Miscellaneous Documents,* 53d Cong., 2d sess., 1893–1894, vol. 30: 759. This paper was read at the International Congress of Anthropology at the World's Columbian Exposition in Chicago in 1893.

27. Goode, "Museums of the Future," 427.

28. Ibid., 434. Thomas Henry Huxley (1825–1895) wrote on scientific education.

29. The quotation is from Adler, *I Have Considered the Days,* 67; see also Goode, "Museums of the Future," 435.

30. Luke Wilson, "William Harvey's *Prelictiones:* The Performance of the Body in the Renaissance Theatre of Anatomy," *Representations* 17 (winter 1987): 62–95.

31. Philippe Ariès, *The Hour of Our Death,* trans. Helen Weaver (New York: Knopf, 1981), 366.

32. Trevor Fawcett, "Visual Facts and the Nineteenth-Century Art Lecture," *Art History* 6, no. 4 (1983): 442, contrasts the pedagogic mode of the illustrated medical and scientific demonstration lecture with the literary and rhetorical approach used by Sir Joshua Reynolds in his discourses on art to the Royal Academy, which were "purely verbal statements read aloud with a minimum of gesture or 'performance'" and without illustrations.

33. Sellers, *Mr. Peale's Museum*, 100–101. Coleman notes the allusion here to Rousseau's *Emilius*.

34. Fawcett, "Visual Facts," 458. For a well-documented eighteenth-century example of the illustrated lecture as a theatrical form, see Gerald Kahan, *George Alexander Stevens and "The Lecture on Heads"* (Athens: University of Georgia Press, 1984).

35. Goode, "Museums of the Future," 433. On the rise and decline of lecturing as a profession, see Donald M. Scott, "The Profession That Vanished: Public Lecturing in Mid-Nineteenth-Century America," in *Professions and Professional Ideologies in America*, ed. Gerald D. Geison (Chapel Hill: University of North Carolina Press, 1983), 12–28.

36. Washington Matthews, "Sacred Objects of the Navajo Rites," in *The International Folk-Lore Congress of the World's Columbian Exposition*, ed. Helen Wheeler Bassett and Frederick Starr (Chicago: Charles H. Sergel, 1898), 227–247.

37. Anthropologists frequently "played Indian" as a way of demonstrating what was difficult to describe verbally: see, for example, Curtis Hinsley Jr., *Savages and Scientists: The Smithsonian Institution and the Development of American Anthropology, 1846–1910* (Washington, D.C.: Smithsonian Institution Press, 1981), 105.

38. Neil Harris, *Humbug: The Art of P. T. Barnum* (Boston: Little, Brown, 1973), 79. According to Harris, "In place of intensive spiritual absorption, Barnum's exhibitions [which exemplify the operational aesthetic] concentrated on information and the problem of deception. Onlookers were relieved from the burden of coping with more abstract problems. Beauty, significance, spiritual values, could be bypassed in favor of seeing what was odd, or what worked, or was genuine."

39. Otis T. Mason, "The Natural History of Folklore," *Journal of American Folklore* 4, no. 13 (1891): 99.

40. See David Kunzle, "The Art of Pulling Teeth in the Seventeenth and Eighteenth Centuries: From Public Martyrdom to Private Nightmare and Political Struggle?" in *Fragments for a History of the Human Body*, part 3, ed. Michael Feher et al. (New York: ZONE, 1989), 28–89; Wilson, "William Harvey's *Prelictiones*."

41. The remains of criminals had long been displayed, whether as a deterrent to those who might contemplate similar actions, as punishment to an adulterer's surviving lover or as ghoulish attraction. See, for example, Joseph Dorfeuille's display of a criminal's head, heart, and right hand during the 1830s in Cincinnati, which is discussed by Dunlop, "Curiosities Too Numerous to Mention," 543.

42. David Hancocks, *Animals and Architecture* (London: Hugh Evelyn, 1971), 108.

43. Saartjie Baartman, who was exhibited in London in 1810 as the "Hotten-tot Venus," is a case in point. See Sander L. Gilman, "Black Bodies, White Bodies: Toward an Iconography of Female Sexuality in Late Nineteenth-Century Art, Medicine, and Literature," *Critical Inquiry* 12, no. 1 (1985): 204–242.

44. See Scheuleer, "Early Dutch Cabinets of Curiosities," in Impey and Mac-Gregor, *Origins of Museums*, 115–120.

45. Altick, *Shows of London*, 55.

46. Ibid., 340–341.

47. Ibid., 285, 341.

48. The *Kleiderkammer*, which featured costumes from around the world, appeared in Germany as early as the sixteenth century. See Franz Adrian Dreier, "The *Kunstkammer* of the Hessian Landgraves in Kassel," in Impey and Mac-Gregor, *Origins of Museums*, 104–106.

49. Quoted by Sellers, *Mr. Peale's Museum*, 280–281.

50. See Mary C. Cowling, "The Artist as Anthropologist in Mid-Victorian England: Frith's *Derby Day*, the *Railway Station* and the New Science of Mankind," *Art History* 6, no. 4 (1983): 461–477.

51. Sellers, *Mr. Peale's Museum*, 192–193.

52. Quoted by Altick, *Shows of London*, 496.

53. Quoted by Ira Jacknis, "Franz Boas and Exhibits: On the Limitations of the Museum Method of Anthropology," in Stocking, *Objects and Others*, 102.

54. See Edward P. Alexander, "Artur Hazelius and Skansen: The Open Air Museum," in *Museum Masters, Their Museums, and Their Influence* (Nashville, Tenn.: American Association for State and Local History, 1983), 239–275; and Mats Rehnberg, *The Nordiska Museet and Skansen: An Introduction to the History and Activities of a Famous Swedish Museum* (Stockholm: Nordiska Museet, 1957).

55. Steven Mullaney, "Strange Things, Gross Terms, Curious Customs: The Rehearsal of Cultures in the Late Renaissance," *Representations* 3 (1983): 45–48.

56. D. B. Quinn, "Virginians on the Thames," *Terra Incognita* 2 (1978): 7–14.

57. See Altick, *Shows of London*; Carl Hagenbeck, *Von Tieren und Menschen: Erlebnisse und Erfahrungen* (Berlin: Vita Deutsches Verlagshaus, 1909); and Stefan Goldmann, "Zur Rezeption der Völkerausstellungen um 1900," in *Exotische Welten, Europäische Phantasien*, ed. Hermann Pollig et al. (Stuttgart: Edition Cantz, 1987), 88–93.

58. See Altick, *Shows of London*, 280.

59. See Stafford, *Voyage into Substance*.

60. Quoted by Altick, *Shows of London*, 248.

61. I take the notion of cultural performance from Milton Singer, "Search for a Great Tradition in Cultural Performances," in *When a Great Tradition Mod-*

ernizes: An Anthropological Approach to Indian Civilization (New York: Praeger, 1972), 71.

62. Altick, *Shows of London,* 282.

63. Ibid., 273–275.

64. In his *Address to the Ethnological Society of London, delivered at the Annual Meeting on the 25th of May, 1855* (London: Ethnological Society of London, [1855]), 4, John Conolly noted

> the benefits that might be expected from the immediate direction of the observation of the Fellows of the Ethnological Society to any such [new importations of natives of other regions to this metropolis] that may be brought to our shores; and particularly to those brought to this country for exhibition. These benefits would partly consist of the counteraction of fraud; and would be partly derived from the additional illustration of the science we cultivate; as well as from the attention that could scarcely fail to be given to such efforts in favour of defenceless and ignorant natives of uncivilized nations, as ought to be forgotten by the happier inhabitants of Christian countries.

65. Altick, *Shows of London,* 281.

66. Ibid.

67. Shelley, *The British Museum,* 299–300.

68. The discussion of spectacle is indebted to John J. MacAloon, "Olympic Games and the Theory of Spectacle in Modern Societies," in *Rite, Drama, Festival, Spectacle: Rehearsals toward a Theory of Cultural Performance,* ed. John J. MacAloon (Philadelphia: ISHI, 1984), 241–280.

69. Dean MacCannell, *The Tourist: A New Theory of the Leisure Class* (New York: Schocken, 1976), 91–107. Following Erving Goffman's dramaturgical analyses of social interaction, MacCannell discusses these phenomena in terms of front and back regions.

70. See Alice Kaplan and Kristin Ross, eds., *Everyday Life,* Special issue, *Yale French Studies,* no. 73 (1987).

71. MacAloon, *Rite, Drama, Festival, Spectacle,* 244.

72. Brochure for *Christian Boltanski, Lost: New York Projects,* A Citywide Project of the Public Art Fund, 1995. The historical avant-garde and more recent experimental performance, performance art, and installation art explore the boundaries between life and art. See "Confusing Pleasures" in this volume.

73. Quoted by Altick, *Shows of London,* 281.

74. Ibid., 278.

75. Conolly, *Address,* 4.

76. Quoted by Altick, *Shows of London,* 286.

77. Ibid., 33.

78. Ralph W. Dexter, "Putnam's Problems Popularizing Anthropology,"

American Scientist 54, no. 3 (1966): 325. These dancers may well have been adept at European social dances, contrary to Putnam's assumption.

79. Minnie D. Louis, "Mission-Work among the Unenlightened Jews," in *Papers of the Jewish Women's Congress Held at Chicago, September 4, 5, 6 and 7, 1893* (Philadelphia: Jewish Publication Society of America, 1894), 171–172. I would like to thank Shalom Goldman for making his copy of this volume available to me. Borrioboola-Gha appears in *Bleak House* as the faraway place where misguided philanthropists such as Mrs. Jellyby devote their energies to caring for the "natives," meanwhile neglecting the welfare of their own families and the poor in their midst.

80. See Christopher Herbert, "Rat Worship and Taboo in Mayhew's London," *Representations* 23 (1988): 1–24.

81. E. S. Martin, "East Side Considerations," *Harper's New Monthly Magazine* 96 (May 1898): 855.

82. See Altick, *Shows of London*, 44–45; Henri F. Ellenberger, "The Mental Hospital and the Zoological Garden," in *Animals and Man in Historical Perspective*, ed. Joseph Klaits and Barrie Klaits (New York: Harper and Row, 1974), 59–92; and Michel Foucault, *Madness and Civilization: A History of Insanity in the Age of Reason*, trans. Richard Howard (New York: Random House, 1965).

83. See, for example, William Brown Meloney, "Slumming in New York's Chinatown, A Glimpse into the Sordid Underworld of the Mott Street Quarter, where Elsie Sigel Formed Her Fatal Associations," *Munsey's Magazine* 41, no. 6 (September 1909): 818–830.

84. On the prospect, see Stafford, *Voyage into Substance*, 431–435. On the panorama as a discursive convention, see Mary Louise Pratt, "Conventions of Representation: Where Discourse and Ideology Meet," in *Contemporary Perceptions of Language: Interdisciplinary Dimensions*, ed. Heidi Byrnes, Georgetown University Round Table on Languages and Linguistics 1982 (Washington, D.C.: Georgetown University Press, 1982), 139–155.

85. On the panoptic, see Michel Foucault, *Discipline and Punish: Birth of the Prison*, trans. Alan Sheridan (New York: Pantheon, 1977).

86. Nancy L. Evans, *"By Our Houses You Will Know Us": A Tour of Homes at the Field Museum* (Chicago: David Adler Cultural Center, 1989), 3.

87. John Conolly, *The Ethnological Exhibitions of London, Read at a Meeting of the Ethnological Society* (London: J. Churchill, 1855).

88. See Robert O'Brien, *Hands across the Water: The Story of the Polynesian Cultural Center* (Laie, Hawaii: Polynesian Cultural Center, 1983). The Polynesian Cultural Center is an outgrowth of the earlier Mormon mission settlement and the Hawaii campus of Brigham Young University. The center features Mormon Polynesians and serves as "a showcase for what the Mormon Church stands for." Here, in our own time, ethnographic performance serves "a Christian mis-

sionary effort of major magnitude" (89). See Andrew Ross, "Cultural Preservation in the Polynesia of the Latter-Day Saints," in *The Chicago Gangster Theory of Life* (New York: Verso, 1994), 21–98.

89. Robert Meyer Jr., *Festivals Europe* (New York: Ives Washburn, 1954), ix–x.

90. I discuss these tropes more fully in "Authenticity and Authority in the Representation of Culture: The Poetics and Politics of Tourist Production," in *Kulturkontakt/Kulturkonflikt: Zur Erfahrung des Fremden*, 26. Deutscher Volkskundekongress in Frankfurt vom 28. September bis 2. Oktober 1987, ed. Ina-Maria Greverus, Konrad Köstlin, and Heinz Schilling. *Notizen* 28, Teil 1 (October 1988): 59–69.

91. See Haraway, "Teddy Bear Patriarchy," 25.

92. See, for example, Allen H. Eaton, *Immigrant Gifts to American Life: Some Experiments in Appreciation of the Contributions of Our Foreign-Born Citizens to American Culture* (New York: Russell Sage Foundation, 1932).

93. "Festival of American Folklife: Presentation-Oriented Guidelines" (Washington, D.C.: Office of Folklife Programs, Smithsonian Institution, 1975), 20.

94. The festival is in its way a corollary to the habitat group, only here an event structure guides a performance, where in the habitat group a mise-en-scène and arrested moment in an implied narrative structures a physical installation.

95. Richard Kurin, "Mela! An Indian Fair," in *1985 Festival of American Folklife* (Washington, D.C.: Smithsonian Institution and National Park Service, 1985), 70.

96. My impression of the *mela* exhibition was very different from that of Richard Kurin, one of the exhibition's organizers. I was struck by the relative absence of the activities associated with selling that one would encounter at an Indian *mela*, while Kurin, who had to deal with the Smithsonian's rules and regulations, feels selling was in fact a notable feature of the Smithsonian *mela*. See his essay, "Cultural Conservation through Representation: Festival of India Folklife Exhibitions at the Smithsonian Institution," in *Exhibiting Cultures: The Poetics and Politics of Museum Display*, ed. Ivan Karp and Steven D. Lavine (Washington, D.C.: Smithsonian Institution Press, 1991), 315–343.

97. See "Plimoth Plantation," in this volume; Steven Eddy Snow, *Performing the Pilgrims: A Study in Ethnohistorical Role-Playing at Plimoth Plantation* (Jackson: University Press of Mississippi, 1993); and Richard Schechner, "Restoration of Behavior," in *Between Theatre and Anthropology* (Philadelphia: University of Pennsylvania Press, 1985), 35–116.

98. These problems arose in homelands exhibitions too, but for different reasons, namely, the preoccupation with citizenship. Diasporas were anomalous,

though the Exposition of the Jews of Many Lands in Cincinnati in 1913 addressed the issue by representing the Jewish Diaspora as a little world's fair of its own. I analyze this case in greater detail in "Exhibiting Jews," in this volume.

99. See Kirshenblatt-Gimblett, "Authenticity and Authority in the Representation of Culture."

100. "Festival of American Folklife," 22.

101. I have in mind sociolinguistics and the ethnography of communication, particularly the pioneering work of Dell Hymes and William Labov, and performance approaches to expressive behavior more generally—verbal art, ritual, and music—as seen in the work of Richard Bauman, Steven Feld, Richard Schechner, and others.

102. See Singer, "Search for a Great Tradition in Cultural Performances."

103. I have in mind the work of Max Gluckman and Victor Turner, among others.

104. See, for example, David Whisnant, *All That Is Native and Fine: The Politics of Culture in an American Region* (Chapel Hill: University of North Carolina Press, 1983).

105. See Barbara Kirshenblatt-Gimblett, "Mistaken Dichotomies," *Journal of American Folklore* 101, no. 400 (1988): 140–155, an earlier discussion of the issues raised here; and Werner Sollors, *Beyond Ethnicity: Consent and Descent in American Culture* (New York: Oxford University Press, 1986).

106. Stuart Hall, "Notes on Deconstructing 'the Popular,'" in *People's History and Socialist Theory*, ed. Raphael Samuel (London: Routledge and Kegan Paul, 1981), 234.

107. Ibid., 237.

108. Ibid., 230.

109. Ibid., 234. See also, "Destination Culture," in this volume.

110. See Barbara Kirshenblatt- Gimblett, "Making Difference: Mapping the Discursive Terrain of Multiculturalism," *Writings on Dance* (Sydney) 13 (1995): 55–61, and "Confusing Pleasures," this volume.

111. See David Glassberg, *American Historical Pageantry: The Uses of Tradition in the Early Twentieth Century* (Chapel Hill: University of North Carolina Press, 1990).

Chapter Two. Exhibiting Jews

I am grateful for grants from the American Council of Learned Societies and the Memorial Foundation for Jewish Culture to support the writing of an intellectual history of Jewish folklore and ethnology, of which this essay is part. I thank Grace Cohen Grossman for sharing her unpublished essays on the Smithsonian collections of Judaica; Vivian Mann and the Judaica staff of the Jewish

Museum for access to their library and archives; Atay Citron, Hasia Diner, Eve Jochnowitz, Jenna Weissman Joselit, Shanny Peer, Norman Kleeblatt, and Jesse T. Todd for bringing valuable material to my attention; Frances Terpak, curator of rare photographs, the Getty Center for the History of Art and the Humanities; Zachary M. Baker, head librarian at the YIVO Institute for Jewish Research, for locating the Yiddish guide to the 1939 New York World's Fair and other material; Kevin Profitt, archivist at the Archives of American Jewish History in Cincinnati, for making the program for the Exposition of the Jews of Many Lands available to me; Andrew Davis for the gift of *Portrait Types of the Midway Plaisance;* Peter Cherches, Shawna Silver, and Lesley Wright for their able assistance in gathering research materials; and David Hollinger and Alan Trachtenberg for helpful suggestions.

1. See Benedict Anderson, *Imagined Communities: Reflections on the Origin and Spread of Nationalism,* rev. ed. (London: Verso, 1991); and Eric Hobsbawm and Terence Ranger, eds., *The Invention of Tradition* (Cambridge: Cambridge University Press, 1983). On ethnographic displays at world's fairs, see Robert W. Rydell, *All the World's a Fair: Visions of Empire at American International Expositions, 1876–1916* (Chicago: University of Chicago Press, 1984); and Burton Benedict, *The Anthropology of World's Fairs: San Francisco's Panama Pacific International Exposition of 1915* (London and Berkeley: Lowie Museum of Anthropology and Scolar Press, 1983).

2. [Georges Stenne, pseud.], *Collection de M. Strauss. Description des objets d'art religieux hébraïques exposés dans les galeries du Trocadéro, à l'Exposition universelle de 1878* (Paris: Poissy, 1878), i. Stenne is the pseudonym for David Schorstein (1826–1879). On the significance of this exhibition, see Richard I. Cohen, "Nostalgia and 'Return to the Ghetto': A Cultural Phenomenon in Western and Central Europe," in *Assimilation and Community: The Jew in Nineteenth-Century Europe,* ed. Jonathan Frankel and Steven J. Zipperstein (Cambridge: Cambridge University Press, 1992), 130–155; and Jeffrey David Feldman, "Die Welt in der Vitrine und die Welt ausserhalb; die soziale Konstruktion jüdischer Museums exponate," in *Weiner Jahrbuch für jüdische Geschichte, Kultur, und Museumswesen,* Band 1 (1994–1995), *Jüdishes Kultur in Museen und Ausstellungen bis 1938,* ed. Bernard Purin (Vienna: Verlag Christian Brandstätter), 39–54.

3. Claude Lévi-Strauss, avant-propos to *Catalogue raisonné de la collection juive du musée de Cluny,* by Victor Klagsbald (Paris: Éditions de la Réunion des musées nationaux, 1981), 5–6. Claude's paternal grandmother was the youngest of Isaac's five daughters. Isaac Strauss (1806–1888) died twenty years before Claude was born. At Isaac's death, the Judaica in his collection were withheld from sale. The Baroness Nathaniel de Rothschild later charged M. Charles Mannheim to serve as her intermediary in arranging to purchase the Judaica

collection on condition that the state accept it. The objects were installed at the Cluny Museum in a room bearing her name in 1890. See Alain Erlande-Brandenburg, "Les collections d'objets de culte juif du Musée de Cluny," in *Catalogue raisonné*, 7–11.

4. *l'Univers israélite* (August 1855, June 1867, June 1878).

5. Supplement to *The Jewish Chronicle*, 8 April 1887.

6. Joseph Jacobs and Lucien Wolf, comps., *Catalogue of the Anglo-Jewish Historical Exhibition, Royal Albert Hall, 1887*, Publications of the Exhibition Committee, no. 4 (London: F. Haes, 1888), 207.

7. Ibid., 83.

8. Ibid., 84.

9. Ibid., 96.

10. Supplement to *The Jewish Chronicle*, 8 April 1887.

11. See Deborah Dash Moore, *B'nai B'rith and the Challenge of Ethnic Leadership* (Albany: SUNY Press, 1981); and Naomi Cohen, *Encounter with Emancipation: The German Jews in the United States, 1830–1914* (Philadelphia: Jewish Publication Society of America, 1984), 48–51.

12. Sir Moses Ezekiel, *Memoirs from the Baths of Diocletian*, ed. Joseph Gutmann and Stanley F. Chyet (Detroit: Wayne State University Press), 21.

13. John Maass, *The Glorious Enterprise: The Centennial Exhibition of 1876 and H. J. Schwarzmann, Architect-in-Chief* (Watkins Glen, N.Y.: American Life Foundation, for the Institute for the Study of Universal History through Arts and Artifacts, 1973), 81.

14. See Cohen, *Encounter with Emancipation*, 245–298.

15. The definitive study of Adler and his work at the Smithsonian is Grace Cohen Grossman with Richard Eighme Ahlborn, *Judaica at the Smithsonian: Cultural Politics as Cultural Model*, Smithsonian Studies in History and Technology, no. 52 (Washington, D.C.: Smithsonian Institution Press, 1997).

16. Cyrus Adler, "Report on the Section of Oriental Antiquities in the U.S. National Museum, 1888," *U.S. National Museum Annual Report for* 1888 (Washington, D.C.: Government Printing Office, 1890), 94; and R. Edward Earll, "Appendix A. Report upon the Exhibit of the Smithsonian Institution, Including the U.S. National Museum, at the Centennial Exposition of the Ohio Valley and Central States, Held at Cincinnati, Ohio, in 1888," in G. B. Goode, Report of the Assistant Secretary, *Annual Report of the Board of Regents of the Smithsonian Institution...Report of the National Museum* (Washington, D.C.: Government Printing Office, 1891), 165.

17. Cyrus Adler and I. M. Casanowicz, *Biblical Antiquities: A Description of the Exhibit at the Cotton States International Exposition, Atlanta, 1895*. From the Report of the U.S. National Museum for 1896 (Washington, D.C.: Government Printing Office, 1898), 989–999.

18. Adler and Casanowicz, *Biblical Antiquities*, 994–997.

19. For a recent example of how exhibition classifications constitute some groups and erase others, see the Hall of Asian Peoples at the American Museum of Natural History in New York City, specifically, the Jews of Asia section. I discuss this installation in *Jewish Folklore and Ethnology Review* 10, no. 2 (1988): 25–27.

20. Adler and Casanowicz, *Biblical Antiquities*, 953. Similar positioning strategies have been noted in the history of Greek folkloristics. See Michael Herzfeld, *Ours Once More: Folklore, Ideology, and the Making of Modern Greece* (Austin: University of Texas Press, 1982).

21. Cyrus Adler and I. M. Casanowicz, *Descriptive Catalogue of a Collection of Objects of Jewish Ceremonial Deposited in the U.S. National Museum by Hadji Ephraim Benguiat.* From the Report of the U.S. National Museum for 1899, 539–561, with 36 plates (Washington, D.C.: Government Printing Office, 1901), 547.

22. Cyrus Adler and I. M. Casanowicz, *The Collection of Jewish Ceremonial Objects in the United States National Museum.* From the Proceedings of the United States National Museum, vol. 35 (Washington, D.C.: Government Printing Office, 1908), 701.

23. Cyrus Adler, "Museum Collections to Illustrate Religious History and Ceremonials," in U.S. Congress, House of Representatives, *Miscellaneous Documents,* 53d Cong., 2d sess., 1893–1894, vol. 30 (Washington, D.C.: Government Printing Office, 1895), 761.

24. Adler cited the work of W. Robertson Smith on the "religion of the Semites" as exemplary, particularly his essay on sacrifice.

25. Adler and Casanowicz, *Collection of Jewish Ceremonial Objects,* 701.

26. Mordecai Benguiat, "A Jewish Museum in America," typescript, 1931, in Benguiat File, Jewish Museum, New York.

27. Isidor Lewi, "Yom Kippur on the Midway," *Report of the Committee on Awards of the World's Columbian Commission,* Special Reports upon Special Subjects or Groups, vol. 2 (Washington, D.C., 1901), 1693.

28. Cyrus Adler, *I Have Considered the Days* (Philadelphia: Jewish Publication Society of America, 1941), 72.

29. See Sol Bloom, *The Autobiography of Sol Bloom* (New York: G. P. Putnam's Sons, [1948]), 105–140. Imre Kiralfy, also Jewish, played an important role in popularizing "native villages" in the decades following the 1893 Chicago fair, especially in Britain. See Paul Greenhalgh, *Ephemeral Vistas: The Expositions Universelles, Great Exhibitions and World's Fairs, 1851–1939* (Manchester: Manchester University Press, 1988), 90–97.

30. For details regarding the history and ownership of Souhami, Sadhullah

and Company, see John J. Wayne, "Constantinople to Chicago: In the Footsteps of Far-Away Moses," *Library of Congress Information Bulletin* 51, no. 1 (13 January 1992): 15–16.

31. Denton J. Snider, *World's Fair Studies* (Chicago: Sigma Publishing, 1895), 373.

32. "Object to Bloomers," *Chicago Daily Tribune*, 5 May, 1893, 1. See Jeanne Madeline Weimann, *The Fair Women* (Chicago: Academy Chicago, 1981), 532–536.

33. Adler, *I Have Considered the Days*, 136.

34. *Reform Advocate*, 22 July 1893, 441–442. On the preponderance of Jews among Levantine exhibitors, see "Centennial Notes: Israel in the Exhibition," *Jewish Messenger*, 8 September 1876, 4.

35. *Oriental and Occidental Northern and Southern Portrait Types of the Midway Plaisance* (St. Louis: N. D. Thompson, 1894), with an introduction by F. W. Putnam, an American anthropologist. In this volume, see portraits of Rahlo Jammele, "Jewish Dancing Girl" and native of Jerusalem, who performed in the Moorish Palace with Nazha Kassik, similarly identified but a native of Beyrouth, Syria; and Jamelee, "Syrian Dancer," who performed in the Turkish cafe. On La Belle Fathma, see Zeynep Çelik and Leila Kinney, "Ethnography and Exhibitionism at the Expositions Universelles," *Assemblage* 13 (December 1990): 43–44.

36. *Oriental and Occidental Northern and Southern Portrait Types on the Midway Plaisance*, unpaginated.

37. *The Midway: A Burlesque Entertainment* (Chicago: Dramatic Publishing, 1894), 13.

38. *Reform Advocate*, 22 July 1893, 441–442.

39. Minnie D. Louis, "Mission-Work among the Unenlightened Jews," in *Papers of the Jewish Women's Congress. Held at Chicago, September 4, 5, 6 and 7, 1893* (Philadelphia: Jewish Publication Society of America, 1894), 171–172.

40. Ibid., 180, 183, 184.

41. Hyman L. Meites, ed., *History of the Jews of Chicago* (Chicago: Jewish Historical Society of Illinois, 1924), 175–179, documents Jewish participation in the Chicago fair, noting that Jews were "among the earliest and heaviest purchasers of capital stock" and prominent in a grand parade the day the grounds were dedicated.

42. See Zeynep Çelik, *Displaying the Orient: Architecture of Islam at Nineteenth-Century World's Fairs* (Berkeley and Los Angeles: University of California Press, 1992), 87–88.

43. *Fine Art Portfolio Illustrating Some of the Exhibits of the H. Ephraim Benguiat Fine Art Museum Collection and the Historical Damascus Palace* (St. Louis: Louisiana Purchase Exposition, 1904), 8.

44. Helen Dare, "King of Collectors, Chief of Connoisseurs, Crank of Cranks," *Sunday Examiner Magazine* (undated clipping in the Benguiat File, Jewish Museum, New York).

45. Ibid.

46. On spectacle, see John J. MacAloon, "Olympic Games and the Theory of Spectacle in Modern Societies," in *Rite, Drama, Festival, and Spectacle: Rehearsals Toward a Theory of Cultural Performance*, ed. John J. MacAloon (Philadelphia: ISHI, 1984), 241–280.

47. Horace Kallen, "Democracy versus the Melting Pot," *Nation* (18 and 25 February 1915): 190–194, 217–220; Randolph Bourne, "Trans-National America," *Atlantic Monthly* 118 (July 1916): 86–97. See also Philip Gleason, "The Melting Pot: Symbol of Fusion or Confusion," *American Quarterly* 16, no. 1 (1964): 20–46; and David A. Hollinger, "Ethnic Diversity, Cosmopolitanism, and the Emergence of the American Liberal Intelligentsia," in *In the American Province: Studies in the History and Historiography of Ideas* (Bloomington: Indiana University Press, 1985), 56–73.

48. Boris D. Bogen, *Born a Jew* (New York: Macmillan, 1930), 79.

49. Boris D. Bogen, *Jewish Philanthropy: An Exposition of Principles and Methods of Jewish Social Service* (New York: Macmillan, 1917), 252–257.

50. Ibid., 254.

51. "List of Exhibits," in *Jews of Many Lands: Exposition Arranged by the Jewish Settlement, January 18–26, 1913, Cincinnati, Ohio* (Cincinnati: Jewish Settlement, 1904), 18.

52. Bogen, *Jewish Philanthropy*, 253.

53. George Zepin, "Introductory Words," in *Jews of Many Lands*, 3.

54. Bogen, "History of the Exhibit," in *Jews of Many Lands*, 6.

55. Bogen, *Born a Jew*, 57, 59.

56. Amalie Hofer, *The Significance of Recent National Festivals in Chicago*. Reprinted from *Proceedings of the Second Annual Playground Congress for the Playground Association of America and the Playground Extension Committee of the Russell Sage Foundation* (New York: n.p. [1908]), 12.

57. Ibid., 12–13.

58. Quoted in Jacob Shatzky, "Perets-shtudyes," *YIVO-bleter* 27, no. 1 (1946): 51. Translation from the Yiddish is mine.

59. Friederich [*sic*] S. Krauss, "Jewish Folk-Life in America," *Journal of American Folklore* 7 (1894): 72–75.

60. See, for example, Allen H. Eaton, *Immigrant Gifts to American Life: Some Experiments in Appreciation of the Contributions of Our Foreign-Born Citizens to American Culture* (New York: Russell Sage Foundation, 1932).

61. See Atay Citron, "Pageantry and Theatre in the Service of Jewish Nationalism, 1933–1946" (Ph.D. diss., New York University, 1990).

62. *The Book of the Exile*, Souvenir of the Bazaar and Fair held under the auspices of the People's Relief Committee for the Jewish War Sufferers (New York City, 1916), 21.

63. *The Jewish Chronicle*, 30 May 1924, 27 June 1924.

64. Ibid., 25 April 1924.

65. See American Near East Corporation, *Levant Fair, Tel-Aviv, 1936* (New York: [1936]) and *Palestine and Near East Economic Magazine*. See also, Susan Miller, "The Selling of Zion: Mischar W"Taasia and the Levant Fair" (unpublished paper, 1995).

66. Meyer W. Weisgal, ed., *Palestine Book*, 1939 (New York: Pavilion Publications for the American Committee for Jewish Palestine Participation at the New York World's Fair [1939]), 44, 108. I thank Robert Rothstein for making his copy of this book available to me.

67. Meyer W. Weisgal, *Meyer Weisgal, . . . So Far: An Autobiography* (New York: Random House, 1971), 106–107.

68. Ibid., 107.

69. Ibid., 109.

70. Ibid.

71. Ibid., 147.

72. Weisgal, *Palestine Book*, 41.

73. Ibid., 148. Weisgal was not the only one to mount a Palestine pavilion at this time. See, for example, the Pavillon d'Israël en Palestine at the 1937 Exposition Internationale in Paris.

74. Ibid., 142.

75. Ibid., 149.

76. Ibid., 150.

77. Ibid., 158, 161. The Trylon, a tall spire with three sides, and Perisphere, a huge globe, were emblems of the New York World's Fair. The *esrog* and *lulav* refer to the citron and palm branches, respectively, which, together with branches of myrtle and willow, are blessed on the Jewish festival of Succoth, or Feast of Tabernacles.

78. Ibid., 161.

79. Weisgal, *Palestine Book*, 41. This was not the first time a national exhibition was organized by a group seeking sovereignty. For example, the Finnish Pavilion at the 1900 Exposition Universelle in Paris made the case for Finnish independence from Russia. See Ann Thorson Walton, "The Swedish and Finnish Pavilions in the Exposition Universelle in Paris, 1900" (Ph.D. diss., University of Minnesota, 2 vols., 1986).

80. Letter from Max M. Korshak to Dr. Stephen Kayser, 21 February 1950, Mintz File, Jewish Museum, New York.

81. Equally interesting are the proposals that were rejected. See Susan Miller,

"The Selling of Zion: Eretz Israel at the 1939 New York World's Fair (unpublished paper, 1994).

82. Rabbi Rudolph I. Coffee, foreword to *Temple of Religion and Tower of Peace at the 1939 Golden Gate International Exposition*, by Stanley Armstrong Hunter (San Francisco: Temple of Religion and Tower of Peace, 1940), xxiii. See also, Jesse T. Todd, "Goodwill in the World of Tomorrow: Imagining the Future of American Religion at the New York World's Fair, 1939–1940" (Ph.D. diss., Columbia University, 1996).

83. Coffee, foreword, 26–41.

84. Betty D. Greenberg and Althea O. Silverman, *The Jewish Home Beautiful* (New York: National Women's League of the United Synagogue of America, 1941), 13–14.

85. Mary M. Cohen, "The Influence of the Jewish Religion in the Home," in *Papers of the Jewish Women's Congress. Held at Chicago, September 4, 5, 6 and 7, 1893* (Philadelphia: Jewish Publication Society of America, 1894), 115–121.

86. Greenberg and Silverman, *Jewish Home Beautiful*, 13. A second pageant, *The Lamp of Liberty*, was performed in the Temple of Religion on July 31, 1940 and sponsored by the New York Metropolitan Section of the Jewish Welfare Board.

87. Weisgal, *Palestine Book*, 41.

Chapter Three. Destination Museum

I thank Suzi Jones, Natasha Staller, Sonja Spear, Noreen Tomassi, and Amy Underhill for their insights and tips.

1. Deborah Holden, "When All the Fun Is Getting There," *New Zealand Herald*, 30 August 1994, section 3, p. 6. Dedicated to the history and future of air travel, this themed attraction outside London will occupy a four-story building specially constructed for it on the northern end of the South Terminal. The project remains in the planning permission stage because of objections to the additional traffic it will generate. My thanks to Vince Horan and Adam Hayward for this information.

2. The Mitchell Gallery of Flight, an aviation museum at Milwaukee's General Mitchell International Airport, claims to be the first airport museum in the world.

3. This advertisement appeared repeatedly in various magazines and newspapers, including *New York Times*, 26 February 1995, Travel section, p. 16.

4. Jeffrey Davis, "Bikini's Silver Lining: You Wouldn't Want to Live There, But It Could Be a Great Place to Visit with a Face Mask," *New York Times Magazine* (1 May 1994): 48.

5. See Doug Gelbert, *Company Museums, Industry Museums and Industrial*

Tours: A Guidebook of Sites in the United States That Are Open to the Public (Jefferson, N.C.: McFarland, 1994).

6. Quoted by Ralph Hyde, *Panoramania!: The Art and Entertainment of the "All-Embracing" View* (London: Trefoil, with Barbican Art Gallery, 1988), 38.

7. Ibid.

8. Ibid., 39.

9. Ibid.

10. Ibid., 38.

11. "Travel with a Purpose," *The Australian Way* (June 1994): 9.

12. Museums Passport is an initiative of the Museums Australia (Queensland Branch) and the Queensland Museum.

13. Christine Economos, *Expedition Passport* (New York: American Museum of Natural History, [1995]), 1.

14. Allan M. Williams and Gareth Shaw, "Tourism Research: A Perspective," *American Behavioral Scientist* 36, no. 2 (1992): 133. This figure includes both international and domestic tourists.

15. "Editorial," *Museum Management and Curatorship* 12 (1993): 122–123.

16. Visitation to the Louvre has more than doubled since 1988, when the visitation figure was 2,773,000. Attendance peaked (up more than 55 percent from the previous year) after the opening of the Richelieu wing at the end of 1993. It has since leveled off, resulting in an average increase of 25.3 percent for 1994. I would like to thank Marijke Naber of the Louvre Communications Department for "La fréquentation du Musée du Louvre en 1994," a fact sheet.

17. Office of Research and Evaluation, *The Economic Impact of The Metropolitan Museum of Art* (New York: Metropolitan Museum of Art, 1994).

18. Ambivalence about seeing is a more general problem. See Martin Jay, *Downcast Eyes: The Denigration of Vision in Twentieth-Century French Thought* (Berkeley and Los Angeles: University of California Press, 1993).

19. Tony Bennett, *The Birth of the Museum* (London: Routledge, 1995).

20. E. H. Gombrich, "The Museum: Past, Present and Future," in *The Idea of the Museum*, ed. Lars Aagaard-Mogensen, vol. 6, *Problems in Contemporary Philosophy* (Lewiston, N.Y.: Edwin Mellen Press, 1988), 124.

21. Ibid., 120.

22. "Editorial," *Museum Management and Curatorship*, 124.

23. Anthony Trollope quoted by Peter Yap, ed., *The Travellers' Dictionary of Quotation: Who Said What about Where?* (London: Routledge & Kegan Paul, 1983), 663.

24. "Creaming Off the Big Spenders," *The Independent Monthly* (Sydney) 5, no. 5 (November 1993): 80.

25. *Welcome to Australia* (Melbourne: Waiviata International 1995–1996), 46.

26. *Wellington Region Tourism Strategy* (Wellington, New Zealand, 1991), 2–3.

27. *New Zealand's Tourist and Visitors' Guide* (Kumeu: Link Publications, winter 1994), 3.

28. See *Building Local, Going Global* (Queensland Government Cultural Statement, June 1995); and Jane Lennon, *Hidden Heritage: A Development Plan for Museums in Queensland 1995–2001* (Brisbane: Queensland Office of Arts and Cultural Development, 1995).

29. Cited by Hans Haacke, "Museums, Managers of Consciousness," *Art in America* 72, no. 2 (February 1984): 9.

30. *Building Local, Going Global,* 1.

31. *Destination New Zealand: A Growth Strategy for New Zealand Tourism* ([Wellington: Tourism Strategic Marketing Group, 1990]), 23.

32. Timothy Mitchell, "The World as Exhibition," *Comparative Studies in Society and History* 31, no. 2 (1989): 225, citing Martin Heidegger, "The Age of the World Picture," in *The Question Concerning Technology and Other Essays,* trans. William Lovitt (New York: Harper and Row, 1977), 115–154.

33. David Ives, "Welcome to World World," *New York Times Magazine* (17 December 1995): 100.

34. Ngahuia Te Awekotuku, *The Sociocultural Impact of Tourism on the Te Arawa People of Rotorua, New Zealand* (Ph.D. diss., University of Waikato, 1981), 157–158, 164.

35. See Kathy Foley, "Trading Art(s): Artaud, Spies, and Current Indonesian /American Artistic Exchange and Collaboration," *Modern Drama* 35, no. 1 (1991): 10–19.

36. Ilana Harlow, *The International Express: A Guide to Ethnic Communities along the 7 Train* (New York: Queens Council on the Arts, 1995), [1].

37. *Building Local, Going Global,* 24.

38. "Theme Park to Portray Key West," *New York Times,* 19 November 1995, p. A29. Since the opening of Walt Disney World in 1970, a proliferation of theme parks has transformed the landscape of central Florida.

39. David Nicholson-Lord, "'Town Full' Is a Sign of the Times," *The Age,* 2 July 1994, 4.

40. Barry Meier, "U.S. Tries to Hide Indian Ruins from Intruders, *New York Times,* 19 May 1994, p. A22.

41. Reported in *Gettysburg Times,* 27 January 1996. Clipping courtesy Carey Moore.

42. Uluru National Park Cultural Center, Project Brief and Concept Design, prepared for Mutitjulu Community and Australian National Parks and Wildlife Service, by Gregory Burgess Pty. Ltd. Architects, Sonja Peter, Environmental Designers et al. (October 1990). Courtesy Tim Webster.

43. For the notion of folklore as a mode of cultural production, see Johannes Fabian, *Power and Performance: Ethnographic Explorations through Proverbial*

Wisdom and Theater in Shaba, Zaire (Madison: University of Wisconsin Press, 1990), 270–275.

44. See James Clifford, "Ethnographic Surrealism," *Comparative Studies in Society and History* 23 (1981): 539–564.

45. See Steven Mullaney, "Strange Things, Gross Terms, Curious Customs: The Rehearsal of Cultures in the Late Renaissance," *Representations* 3 (1983): 40–67.

46. See Annette B. Weiner, *Inalienable Possessions: The Paradox of Keeping-While-Giving* (Berkeley and Los Angeles: University of California Press, 1992); and Nicholas Thomas, *Entangled Objects: Exchange, Material Culture, and Colonialism in the Pacific* (Cambridge, Mass.: Harvard University Press, 1991).

47. The phrase comes from L. P. Hartley, *The Go-Between* (London: H. Hamilton, 1953).

48. James Dickinson, letter to the editor, *New York Times,* 17 December 1995, p. A12.

49. Stephen Kinzer, "Luther and Goethe Breathe Life into a Dead Land," *New York Times,* 20 May 1993, p. A4.

50. Stephen Kinzer, "For East German Theme Park, the Bad Old Days," *New York Times,* 9 November 1993, p. A4.

51. Holden, "When All the Fun Is Getting There." The defunct East German Kessler Bunker in Harnekop was opened to tourists after German reunification.

52. *Building Local, Going Global,* 9.

53. Ibid., 17.

54. Advertisement, *New York Times,* 22 November 1987.

55. *Building Local, Going Global,* 23.

56. Bob South, "Water Low, Trout High," *Southern Skies* (Ansett, New Zealand) (August 1994): 44.

57. Susan Diesenhouse, "$200 Million in Projects to Build Tourism," *New York Times,* 1 August 1993, Real Estate section, p. 5.

58. Wynn Te Kani, letter, *Kia Hiwa Ra National Maori Newspaper,* August 1994, p. 4.

59. See, for example, the pamphlet *The George Heye Center of the National Museum of the American Indian, Smithsonian Institution, at the Alexander Hamilton U.S. Custom House* ([New York: National Museum of the American Indian, 1994]).

60. See Fred R. Myers, "Representing Culture: The Production of Discourse(s) for Aboriginal Acrylic Paintings," in *The Traffic in Culture: Refiguring Art and Anthropology,* ed. George E. Marcus and Fred R. Myers (Berkeley and Los Angeles: University of California Press, 1995), 55–95.

61. Advertisement, *New York Times,* 27 October 1995, p. A26.

62. Mullaney, "Strange Things, Gross Terms," 48.

63. Ibid., 48, 49, 52.

64. The following discussion is drawn from Barbara Kirshenblatt-Gimblett, "Problems in the Early History of Jewish Folkloristics," in *Proceedings of the Tenth World Congress of Jewish Studies, Jerusalem, August 16–24, 1989,* division D, vol. 2, *Art, Folklore, and Music,* ed. David Assaf (Jerusalem: World Union of Jewish Studies, 1990), 21–31.

65. In her landmark book, *Festivals and the French Revolution,* trans. Alan Sheridan (Cambridge, Mass.: Harvard University Press, 1988), Mona Ozouf argues that the revolution entailed not only the rejection of the old cultural order, but also the systematic creation of a regime of social experience in which new forms of festivity were to play a central role in educating and transforming the citizenry. This process produced what she calls a "shameful ethnology," which served as an instrument of the revolution's "repressive militantism" (218, 223). Negative accounts of traditional practices measured the success of the revolution in eradicating what it repudiated and the rebellious potential of what persisted.

66. David Fränkel, "Gallerie schädlicher Misbrauche, unanständige Convenienzen und absurder Ceremonien under der Juden—1) Ueber die jüdischen Heurathsstiffungen und Hochzeitsfeste," *Sulamit* 1, no. 1 (1806): 222–245.

67. Norbert Elias, *The History of Manners,* vol. 1, *The Civilizing Process,* trans. Edmund Jephcott (New York: Pantheon, 1982), 101.

68. Joseph Perles, "Jewish Marriage in Post-Biblical Times: A Study in Archeology," in *Hebrew Characteristics: Miscellaneous Papers from the German* (New York: American Jewish Publication Society, 1875), 68. This essay was first published in 1860.

69. In England, where the term *folklore* was coined in 1846, it referred to "survivals" in a civilized society of behaviors that had their origins in earlier stages of cultural evolution. On the continent, the term *folklore* or its rough equivalents (*Volkskunde, traditions populaires*) referred to the purity of national culture preserved in rural backwaters outside the cosmopolitanizing reach of the metropole.

70. Quoted by Judith Gray and David Taylor, "Cite Unseen," *American Folklore Society Newsletter* 21, no. 4 (1992): 2. Those protesting Splendid China theme park in Florida characterize it as "a propaganda campaign by the Communist Chinese government to eliminate the cultural identity of the non-Chinese peoples," including Uighurs, Tibetans, Mongolians, and Miao. Splendid China features idyllic scenes of "charming folkways," temples, and monasteries, while the Communist Chinese government is actually suppressing if not obliterating the culture and religion of its ethnic minorities. See "Citizens Against Chinese Propaganda," http://www.afn.org//~afn20372.

71. Mullaney, "Strange Things, Gross Terms," 52–53.

72. Quoted in a human interest brief from Reuters (September 1995) that was circulated on the Internet.

73. Rehab Saad, "'New Luxor' Nights," *Al-Ahram Weekly* (7–13 March 1996): 14.

74. Suzanne Daley, "Endangered Bushmen Find Refuge in a Game Park," *New York Times*, 18 January 1996, p. A4.

75. Quoted by Awekotuku, *Sociocultural Impact of Tourism*, 107–108.

76. Ibid., 22. See also Leonard Bell, *Colonial Constructs: European Images of Maori 1840–1914* (Auckland: Auckland University Press, 1992). In Bali, tourists who pay to attend cremations make possible more frequent and lavish cremations than would otherwise be possible. In Neah Bay, Washington, Makah Indians are turning to the museum, a tourist attraction on their reservation, in an effort to revive whaling skills.

77. New Zealand Tourism Board, *New Zealand Tourism Investment and Development Opportunities* (April 1994), 5.

78. Awekotuku, *Sociocultural Impact of Tourism*, 186–187, discusses three rural *marae* that became tourist venues in 1978–1979 and Maori concern with this development.

79. Raymond Williams, *Culture and Society, 1790–1950* (New York: Anchor Books, 1960), 343.

80. Barre Toelken, "Seeing with Both Eyes," *Native Arts Issues* 81 to 82 (1982): 10.

81. On authenticity, invention, and simulation, see Eric Hobsbawm and Terence Ranger, eds., *The Invention of Tradition* (Cambridge: Cambridge University Press, 1983); Jean Baudrillard, *Simulations*, trans. Paul Foss, Paul Patton, and Philip Beitchman (New York: Semiotext [e], 1983); and Umberto Eco, *Travels in Hyperreality: Essays*, trans. William Weaver (San Francisco: Harcourt Brace Jovanovich, 1986).

82. John Wilson, comp., *AA Book of New Zealand Historic Places* (Auckland: Landsdowne Press, for New Zealand Historic Places Trust, 1984), 6. Still in print, this book offers a useful benchmark for defining the present moment. The text was drafted by the publications officer of the New Zealand Historic Places Trust.

83. Ibid., 7.

84. Ibid., 10.

85. See Freeman Tilden, *Interpreting Our Heritage*, 3d ed. (Chapel Hill: University of North Carolina Press, 1977), which continues to serve as a handbook for training interpreters of America's heritage sites.

86. Joslyn Green, *Getting Started: How to Succeed in Heritage Tourism* (Washington, D.C.: National Trust for Historic Preservation, 1993), step 3, unpaginated.

87. Artists such as Marcel Duchamps, Marcel Broodthaers, David Ireland, Hans Haacke, Joseph Kosuth, Fred Wilson, David Wilson, and the anonymous

creators of the Salon de Fleurus—as well as institutions such as the Karl Ernst Osthaus Museum in Hagen, Germany—have been making the museum, its history and practices, the focus of their work for some time. See for example *The Label Show: Contemporary Art and the Museum*, at the Museum of Fine Arts, Boston, in 1994; and A. A. Bronson and Peggy Gale, eds., *Museums by Artists* (Toronto: Art Metropole, 1983). It is only recently however that museums themselves (and institutions other than public art galleries) have begun creating exhibitions that critically examine their own conventions. In the process, new approaches to exhibition and to the museum as an institution are emerging.

88. Wilson, *AA Book of New Zealand Historic Places*, 7.

89. Robb Walsh, "Phantom Church of Cluny," *American Way*, 27, no. 19 (October 1994): 15.

90. *New York Times*, 7 November 1993, Travel section, p. 3.

91. Chris Hedges, "The Muslim's Wrath Doesn't Spare the Mummies," *New York Times*, 23 July 1993, p. A4.

92. J. Christopher Holloway, *The Business of Tourism*, 4th ed. (London: Pitman Publishing, 1994), 147.

93. Advertisement, *West of the Alps* 7 (1994): 2.

94. The issue of the museum's public is a complicated one. See Ivan Karp, Christine Mullen Kreamer, and Steven D. Lavine, eds., *Museums and Communities: The Politics of Public Culture* (Washington, D.C.: Smithsonian Institution Press, 1992). On the relationship of art galleries to their constituencies, see the work of Vera Zolberg, Paul DiMaggio, and Howard Becker.

95. Michael Janofsky, "Town 'Devastated' by Loss of Project," *New York Times*, 30 September 1994, p. A12.

96. Sally Hofmeister, "Disney Vows to Seek Another Park Site But Analysts Ask Whether Company Should Go On with Project," *New York Times*, 30 September 1994, p. A12.

97. See Eric Smoodin, ed., *Disney Discourse: Producing the Magic Kingdom* (New York: Routledge, 1995); Project on Disney, *Inside the Mouse: Work and Play at Disney World* (Durham: Duke University Press, 1995); Michael Sorkin, "See You in Disneyland," in *Variations on a Theme Park: The New American City and the End of Public Space*, ed. Michael Sorkin (New York: Noonday Press, 1992), 205–232; Stephen M. Fjellman, *Vinyl Leaves: Walt Disney World and America* (Boulder, Colo.: Westview Press, 1992); Michael Wallace, "Mickey Mouse History: Portraying the Past at Disney World," in *History Museums in the United States: A Critical Assessment*, ed. Warren Leon and Roy Rosenzweig (Urbana: University of Illinois Press, 1989), 158–180.

98. Michael Wines, "A Disneyland of History Next to the Real Thing," *New York Times*, 12 November 1993, p. A14.

99. Michael Janofsky, "Mock Auction of Slaves: Education or Outrage?" *New York Times,* 8 October 1994, p. 7.

100. Gary Krist, "Tragedyland," *New York Times,* 27 November 1993, p. A19.

101. Jean Hodson, *Tourism Potential of the Manawatu—Prospects for Agricultural Tourism* (Palmerston North, New Zealand: City Planning Department, Palmerston North City Council, 1983), 3.

102. Tamar Lewin, "Suit Accuses Hotel at Disney World of 'English Only' Policies," *New York Times,* 13 October 1994, p. A23.

Chapter Five. Plimoth Plantation

1. Turning and examining the site from every angle, Steven Eddy Snow's *Performing the Pilgrims: A Study in Ethnohistorical Role-Playing* (Jackson: University Press of Mississippi, 1993) demonstrates brilliantly just how good Plimoth Plantation is to think with. Snow, our expert guide, is a pilgrim thrice over: He is descended from Pilgrims, and he played Pilgrim roles for two seasons at the Pilgrim Village. His vivid analysis of this experience is itself the result of an intellectual pilgrimage.

2. For an extended discussion of these and related topics, see "Objects of Ethnography," this volume.

3. The discussion here of virtual reality is indebted to Brenda Laurel, *Computers as Theatre* (Reading, Mass.: Addison-Wesley, 1991).

4. See Roland Barthes, "The Plates of the Encyclopedia," in *New Critical Essays,* trans. Richard Howard (New York: Hill and Wang, 1980), 23–40.

5. Otis T. Mason, "The Natural History of Folklore," *Journal of American Folklore* 4, no. 13 (1891): 99.

6. Elaine Scarry, *The Body in Pain: The Making and Unmaking of the World* (New York: Oxford University Press, 1985), 281, 285.

7. Snow, *Performing the Pilgrims,* 203, quoting Cary Carson.

Chapter Six. Confusing Pleasures

I would like to thank Norman Frisch, Judith Mitoma, Claire Peeps, and Peter Sellars for the opportunity to participate in the Los Angeles Festival and their openness in discussing it with me; Judith Burns; Michelle Kiskliuk for her thoughtful reading of an earlier draft of this essay; and Karl Signell, editor of ERD (Ethnomusicology Research Digest), for posting an electronic draft of this essay in 1992 and for the discussion that followed.

1. Antonin Artaud, *Antonin Artaud: Selected Writings,* ed. Susan Sontag, trans. Helen Weaver (New York: Farrar, Straus, and Giroux, 1976); id., *The Theatre and Its Double,* trans. Mary Caroline Richards (New York: Grove Press, 1958); Bertolt

Brecht, *Brecht on Theatre,* ed. and trans. John Willett (New York: Hill and Wang, 1964).

2. See John J. MacAloon, *This Great Symbol: Pierre de Coubertin and the Origins of the Modern Olympic Games* (Chicago: University of Chicago Press, 1984).

3. Artaud, *Antonin Artaud: Selected Writings* and *Theatre and Its Double;* Brecht, *Brecht on Theatre.*

4. Greg Braxton, "The L.A. Festival: Thumbs Up or Down?" *Los Angeles Times,* 20 September 1990, Calendar section, pp. F1, 10.

5. Los Angeles Festival, *Los Angeles Festival, September 1 thru 16, 1990, Program and Ticketing Information* (Los Angeles: Los Angeles Festival, 1990), 8.

6. Ibid.

7. Tom Bradley, "Official Invitation," in *Los Angeles Festival Program Book,* ed. Barbara Allen (Los Angeles: McTaggart-Wolk), 2.

8. He has since left Euro Disneyland Corporation.

9. Frisch has since moved on.

10. Peter Sellars, "Welcome," in *Los Angeles Festival Program Book,* 15.

11. Michael Jackson, "Knowledge of the Body," *Man* 18 (1983): 327–345.

12. James Clifford, "On Ethnographic Surrealism," *Comparative Studies in Society and History* 23, no. 4 (1981): 563.

13. See Robert Cantwell, *Ethnomimesis: Folklife and the Representation of Culture* (Chapel Hill: University of North Carolina Press, 1993); and "Objects of Ethnography," in this volume.

14. Burt Feintuch, ed., *The Conservation of Culture: Folklorists and the Public Sector* (Lexington: University Press of Kentucky, 1988); Robert Baron and Nicholas Spitzer, eds., *Public Folklore* (Washington D.C.: Smithsonian Institution Press, 1992); Richard Bauman, Patricia Sawin, and Inta Gale Carpenter with Richard Anderson et al., *Reflections on the Folklife Festival: An Ethnography of Participant Experience,* Series Publications of the Folklore Institute, no. 2 (Bloomington: Folklore Institute, Indiana University, 1992); Richard and Sally Price, *On the Mall: Presenting Maroon Tradition-Bearers at the 1992 Festival of American Folklife,* Series Publications of the Folklore Institute, no. 4 (Bloomington: Folklore Institute, Indiana University, 1994).

15. Alan Lomax, "Appeal for Cultural Equity," *The World of Music* 14 (1972): 3.

16. Clifford, "On Ethnographic Surrealism," 558.

17. Beth Kleid, "Family Adventures," *Los Angeles Times,* 26 August 1990, Calendar section, part 2, p. 16.

18. Sellars, "Welcome," 14.

19. *The Couple in the Cage: A Guatinaui Odyssey,* a documentary video-recording of installation performances of ethnographic captivity by Guillermo Gómez-Peña and Coco Fusco, directed and produced by Coco Fusco and Paula Heredia (Chicago: Authentic Documentary Productions and Video Data Bank,

1993); Guillermo Gómez-Peña, *Warrior for Gringostroika: Essays, Performance Texts, and Poetry* (St. Paul, Minn.: Graywolf Press, 1993); and Coco Fusco, *English Is Broken Here: Notes on Cultural Fusion in the Americas* (New York: New Press, 1995); Lawrence Wechlser, *Mr. Wilson's Cabinet of Wonders* (New York: Pantheon, 1995); Denise Carbone, *A Visit to the Mütter Museum: Terror in the Halls of Medicine* (Philadelphia: The Mütter Museum, 1991) and *Beyond Ars Medica: Treasures from the Mütter Museum* (New York: Thread Waxing Space, 1995); and Donna McAlear, "Show Me, Where the Mystery Has Left," in a pamphlet accompanying Luke Roberts's *Wunderkammer/Kunstkamera* exhibition at the Queensland Art Gallery in Brisbane, Australia, 17 December 1994 to 26 February 1995.

20. Robert Bogdan, *Freak Show: Presenting Human Oddities for Amusement and Profit* (Chicago: University of Chicago Press, 1988), 6.

21. Kleid, "Family Adventures," in *Los Angeles Festival Program Book*, 16.

22. Maureen A. Kindel, "Chair's Letter," in *Los Angeles Festival Program Book*, 2.

23. Norman Frisch, "The Hidden Agenda," in *Los Angeles Festival Program Book*, 21.

24. See Laurence W. Levine, *Highbrow/Lowbrow: The Emergence of Cultural Hierarchy in America* (Cambridge, Mass.: Harvard University Press, 1988).

25. Judith Mitoma, "Art and Spirit in Los Angeles," in *Los Angeles Festival Program Book*, 16; Sellars, "Welcome," 15.

26. Shauna Snow, "3 Out of 4 Unaware of L.A. Festival, Informal Survey Finds," *Los Angeles Times*, 1 August 1990, Calendar section, p. F4.

27. See Peter Bürger, *Theory of the Avant-Garde*, trans. Michael Shaw (Minneapolis: University of Minnesota Press, 1984).

28. See Jochen Schulte-Sasse, "Foreword: Theory of Modernism versus Theory of the Avant-Garde," in Bürger, *Theory of the Avant-Garde*, vii–xlvii.

29. Sellars, "Welcome," 14.

30. See Jane S. Becker and Barbara Franco, eds., *Folk Roots, New Roots: Folklore in American Life* (Lexington, Mass.: Museum of Our National Heritage, 1988).

31. See Allen H. Eaton, *Immigrant Gifts to American Life: Some Experiments in Appreciation of the Contributions of Our Foreign-Born Citizens to American Culture* (New York: Russell Sage Foundation, 1932); David Whisnant, *All That Is Native and Fine: The Politics of Culture in an Appalachian Region* (Chapel Hill: University of North Carolina Press, 1983).

32. See Steven Eddy Snow, *Performing the Pilgrims: A Study in Ethnohistorical Role-Playing at Plimoth Plantation* (Jackson: University Press of Mississippi, 1993); and "Ellis Island," in this volume.

33. Jindřich Honzl, "Dynamics of the Sign in the Theater," in *Semiotics of*

Art: Prague School Contributions, ed. Ladislav Matejka, and Irwin R. Titunik (Cambridge, Mass.: MIT Press, 1976), 76.

34. See Clifford, "On Ethnographic Surrealism," 539–564; Susan Stewart, *Crimes of Writing: Problems in the Containment of Representation* (New York: Oxford University Press, 1991).

35. Clifford, "On Ethnographic Surrealism," 563.

36. See Eugene W. Metcalf Jr. and Claudine Weatherford, "Modernism, Edith Halpert, Holger Cahill, and the Fine Art Meaning of American Folk Art," in *Folk Roots, New Roots,* 141–166.

37. Holger Cahill, *American Folk Sculpture: The Work of Eighteenth and Nineteenth Century Craftsmen, Exhibited October 20, 1931 to January 31, 1932* (Newark, N.J.: Newark Museum, 1931), 18.

38. Alfred H. Barr Jr, preface to *Masters of Popular Painting: Modern Primitives of Europe and America,* ed. Holger Cahill, Maximilien Gauthier, Jean Cassou, and Dorothy C. Miller et al. (1938; reprint, New York: Museum of Modern Art, 1966), 9.

39. Cahill, *American Folk Sculpture,* 5.

40. See John M. Vlach, "Holger Cahill as Folklorist," *Journal of American Folklore* 98, no. 388 (1985): 148–162.

41. R[oger] C[ardinal], "But Where Was the Magic?" *Raw Vision: Outsider Art, Art Brut, Grassroots Art, Contemporary Folk Art, Visionary Art* 2 (winter 1989): 55.

42. See Johannes Fabian, *Time and the Other: How Anthropology Makes Its Objects* (New York: Columbia University Press, 1983).

43. Jon Pareles, "Lincoln Center Is Adding Jazz to Its Repertory," *New York Times,* 10 January 1991, p. A1.

44. Frisch, "The Hidden Agenda," 21.

45. Sellars, "Welcome," 15.

46. Mitoma, "Art and Spirit in Los Angeles," 18.

47. Peter Sellars, "Beginning to Notice What We Are," *Los Angeles Times,* 5 February 1990, Calendar section, p. 3.

48. Mitoma, "Art and Spirit in Los Angeles," 18.

49. Sellars, "Artistic and Aesthetic Agendas," 15.

50. Sellars, "Welcome," 15.

51. Roland Barthes, "The Third Meaning: Research Notes on Some Eisenstein Stills," in *Image—Music—Text,* comp. and trans. Stephen Heath (New York: Hill and Wang, 1977), 52–68.

52. Ibid., 64.

53. Diane Haithman, "UCLA Course on the L.A. Festival Takes to the Streets," *Los Angeles Times,* 3 August 1990, p. F6.

54. Sellars, "Artistic and Aesthetic Agendas," 13.

55. Frisch, "The Hidden Agenda," 23.

56. Clifford, "On Ethnographic Surrealism," 563.

57. Susan Sontag, "Against Interpretation," in *Against Interpretation* (New York: Dell, 1966), 13.

58. Sellars, "Welcome," 15.

59. Frisch, "The Hidden Agenda," 23.

60. Hardja Susilo, "The Royal Court of Yogyakarta Java," in *Los Angeles Festival Program Book*, 80.

61. Cited by Honzl, "Dynamics of the Sign in the Theater," 80. See also Petr Bogatyrev, "Semiotics in the Folk Theater," in *Semiotics of Art*, 33–50.

62. See Eric Hobsbawm and Terence Ranger, eds., *The Invention of Tradition* (Cambridge: Cambridge University Press, 1983); and Benedict Anderson, *Imagined Communities: Reflections on the Origin and Spread of Nationalism*, rev. ed. (London: Verso, 1993).

63. See "Destination Museum," in this volume.

64. Susan Auerbach, "Against the Odds: Sustaining Traditional Arts in Los Angeles," in *Los Angeles Festival Program Book*, 36.

65. Arlene Croce, "Dancing: Multicultural Theatre," *The New Yorker* (23 July 1990): 84.

66. Ibid.

67. Ibid., 84, 87.

68. Mitoma, "Art and Spirit in Los Angeles," 16.

69. Croce, "Dancing: Multicultural Theatre," 87.

70. Pareles, "Lincoln Center Is Adding Jazz to Its Repertory."

71. Sontag, "Against Interpretation," 13.

Chapter Seven. Secrets of Encounter

1. See Mary Nooter Roberts and Susan Vogel et al., *Exhibition-ism: Museums and African Art* (New York: Museum for African Art, 1994).

2. Roland Barthes, "The Third Meaning: Research Notes on Some Eisenstein Stills," in *Image—Music—Text*, comp. and trans. Steven Heath (New York: Hill and Wang, 1977), 52–68.

3. See Mary H. Nooter et al., *Secrecy: African Art That Conceals and Reveals* (New York: Museum for African Art; Munich: Prestel, 1993). On the riddle's "existential expressivity," see Galit Hasan-Rokem and David Shulman, eds., *Untying the Knot: On Riddles and Other Enigmatic Modes* (New York: Oxford University Press, 1996).

Chapter Eight. Disputing Taste

Thanks to Liza Bear, Michael Griffin, Charles and Jan Hinman, Judy Hugentobler, Katharine Krizek, Carol Martin, Jane Przybysz, Jeremy Wolff, and Connecticut Muffin for taste tips.

1. These and other examples appear in Michael and Jane Stern, *The Encyclopedia of Bad Taste* (New York: HarperCollins, 1990).

2. Meyer Shapiro, quoted in Curtis Brown, *Star-Spangled Kitsch* (New York: Universe Books, 1975), 9.

3. See Stuart Hall, "Notes on Deconstructing the Popular," in *People's History and Socialist Theory*, ed. Raphael Samuel (London: Routledge & Kegan Paul, 1981), 227–240; and Arjun Appadurai, "Introduction: Commodities and the Politics of Value," in *The Social Life of Things: Commodities in Cultural Perspective*, ed. Arjun Appadurai (Cambridge: Cambridge University Press, 1986), 3–63.

4. Milan Kundera, *The Unbearable Lightness of Being*, trans. Michael Henry Hein (New York: HarperPerennial, 1991), 247.

5. Betty Cornfeld and Owen Edwards, *Quintessence: The Quality of Having It* (New York: Crown, 1983).

6. Judith Martin, *Miss Manners' Guide to Excruciatingly Correct Behavior* (New York: Atheneum), 384.

7. See Pierre Bourdieu, *Distinction: A Social Critique of the Judgment of Taste* (Cambridge, Mass.: Harvard University Press, 1984).

8. Emily Post, *Etiquette* (New York: Funk and Wagnalls, 1940), 91.

9. See Norbert Elias, *The Civilizing Process*, vol. 1, *The History of Manners*, trans. Edmund Jephcott (New York: Pantheon, 1978).

10. Lily Haxworth Wallace, ed., *The* New *American Etiquette* (New York: Books, Inc., 1941), 677, 665.

11. Mikhail Bakhtin, *Rabelais and His World*, trans. Hélène Iswolsky (Cambridge, Mass.: MIT Press, 1968), 26.

12. Ibid., 37.

13. Ibid., 26.

14. Ibid., 26–27.

15. Ibid., 39, 12.

16. Ibid., 30–31, 33, 10.

17. Stephen McKittrick, quoted in Ford Risley, "From Grass to Garages, a Litany of Don'ts," *New York Times*, 12 May 1991, p. R5.

18. Mary Douglas, "Secular Defilement," in *Purity and Danger: An Analysis of Concepts of Pollution and Taboo* (London: Routledge & Kegan Paul, 1966), 40.

19. Kundera, *Unbearable Lightness of Being*, 252.

20. See Hermann Broch, "Einige Bemerkungen zum Problem Kitsches" and "Der Kitsch," *Gesammelte Werke*, vol. 6, *Dichten und Erkennen* (Zurich: Rheim, 1955), 295–309, 342–348; Clement Greenberg, "Avant-Garde and Kitsch

[1939],” in *Art and Culture: Critical Essays* (Boston: Beacon Press, 1984), 3–21; Tomas Ybarra-Frausto, Shifra M. Goldman, and John L. Aguilar, *Chicano Aesthetics: Rasquachismo* (Phoenix: MARS, Movimento Artistico del Rio Salado, 1989); Celeste Olaquiaga, *Megalopolis: Contemporary Cultural Sensibilities* (Minneapolis: University of Minnesota Press, 1992); Gene Sculatti, ed., *The Catalog of Cool* (New York: Warner Books, 1982); and Grandmaster Blaster, *Rappin’* (Chicago: Contemporary Books, 1984).

21. Elaine Scarry, “The Interior Structure of the Artifact,” in *The Body in Pain: The Making and Unmaking of the World* (New York: Oxford University Press, 1985), 323.

22. Cornfeld and Edwards, *Quintessence,* unpaginated.

23. Ibid.

24. Ibid. See Grant McCracken, “‘Ever Dearer in Our Thoughts’: Patina and the Representation of Status before and after the Eighteenth Century,” in *Culture and Consumption: New Approaches to the Symbolic Character of Consumer Goods and Activities* (Bloomington: Indiana University Press, 1990), 31–43; Walter Benjamin, “The Work of Art in the Age of Mechanical Reproduction,” in *Illuminations: Essays and Reflections,* trans., Harry Zohn (New York: Schocken Books), 217–252.

25. Cornfeld and Edwards, *Quintessence.*

26. Ibid.

27. See Scarry, *Body in Pain,* 311 ff.

28. Ibid., 312.

29. Ibid., 314.

30. Ibid., 310. Scarry distinguishes three stages in the transformation of the object: weapon, tool, and artifact.

31. Roland Barthes, “The Plates of the *Encyclopedia,*” in *New Critical Essays,* trans. Richard Howard (New York: Hill and Wang, 1980), 23–40.

32. See George Kubler, *The Shape of Time: Remarks on the History of Things* (New Haven: Yale University Press, 1962).

33. Brook Stevens, who claims to have coined the term “planned obsolescence,” said that his job was to give “life to the object.” The object’s appearance, in his view, is what “gives it its ability to be used. . . . You can’t see function,” and still less the small improvements inside appliances. Isabel Wilkerson, “The Man Who Put Steam in Your Iron,” *New York Times,* 11 July 1991, pp. C1, 6.

34. See Iaian Finlayson, *Denim: An American Legend* (New York: Simon and Schuster, 1990), 42.

35. See Dick Hebdige, *Subculture: The Meaning of Style* (London: Methuen, 1979); and Paul Willis, *Common Culture: Symbolic Work at Play in the Everyday Cultures of the Young* (Boulder: Westview Press, 1990).

36. Walter Benjamin, “Traumkitsch,” in *Ausgewählte Schriften, Angelus*

Novus, vol. 2 (Frankfurt am Main: Suhrkamp Verlag, 1966), 158–161; Umberto Eco, "Towards a Semiological Guerilla Warfare," in *Travels in Hyperreality: Essays*, trans. William Weaver (San Francisco: Harcourt Brace Jovanovich, 1986), 135–144.

37. Barbara Ensor, "White T-Shirt Contest," *Village Voice*, 7 May 1991, p. 38.

38. See Theodor Adorno, quoted in Matei Calinescu, *Five Faces of Modernity: Modernism, Avant-Garde, Decadence, Kitsch, Postmodernism* (Durham: Duke University Press, 1987), 241.

39. See Lawrence W. Levine, *Highbrow/Lowbrow: The Emergence of Cultural Hierarchy in America* (Cambridge, Mass.: Harvard University Press, 1988); and Joseph Horowitz, *Understanding Toscanini* (New York: Faber, 1987).

40. See Andrew Ross, *No Respect: Intellectuals and Popular Culture* (New York and London: Routledge, 1989).

41. Post, *Etiquette*, 90.

42. Greenberg, "The Plight of Culture [1953]," in *Art and Culture*, 22–33.

43. Kundera, *Unbearable Lightness of Being*, 244.

44. Greenberg, "Avant-Garde and Kitsch," 11.

45. Ibid., 16.

46. Greenberg is repeating a version of the repudiated theory of *gesunkenes Kulturgut* espoused by Hans Naumann, *Grundzüge der deutschen Volkskunde* (Leipzig: Quelle & Meyer, 1922).

47. Kundera, *Unbearable Lightness of Being*, 268, 248.

Index

Hebdige, Dick, 276

Heredia, Paula, 309n19

Heritage, 1, 8, 150–51; claim of, 242; converting life into, 260; as cultural production, 149–50; culture and, 144; exhibition and, 7, 149, 151–52; genealogy and, 182; lifeworld and, 7, 260; as palimpsest, 156; as term, 243; tourism and, 153, 161–65, 167–68

Hierarchy, 260

High & Low: Modern Art, Popular Culture, 229

Hinman Charles, 312

Hinman, Jan, 312

Hirszenberg, Samuel, 114

Hollinger, David, 294

Holocaust: exhibitions of, 173–75; video games of, 265

Holy Land, displays of, 114, 118, 119

Homelands exhibitions, 78, 12, 117, 225, 292n98

Honzl, Jindřid, 227

Horan, Vince, 300n1

Horowitz, Amy, 284

Hottentot Venus. *See* Baartman, Saartjie

Household Words (Dickens), 134

Hovenweep National Monument, 148

Hsi Lai Temple (Los Angeles), 213

Hugentobler, Judy, 312

Huxley, Thomas Henry, 31, 287n28

Hybridity, 231, 243

Hyde Park Barracks, 168

Hypermedia, 195

Hypervisibility, 168

Iacocca, Lee, 179, 182

Identity, 10

Imagined community, 65, 242

Immigrants, 96; festivals and, 70, 72, 78, 225; Jewish, 104–5, 111–12, 114–15; solidarity of, 105

Immigration, 52, 111, 177–80, 183–84, 225. *See also* Ellis Island Immigration Museum

Inalienability, 9. *See also* Alienability

Inclusion, apologetics of, 246

In-context displays, 19–23

Indigeneity, 140–41

Innocents Abroad (Twain), 103

In-situ displays, 3–4, 19–20

Insley, William, 285n3

Intelligibility, 3, 11. *See also* Confusion

Interculturalism, 231, 234

Interface, 7, 8, 157, 169

International Antarctic Center, 171

International Eugenics Conference, 27

International Express, 146

International Folk-Lore Congress (Chicago, 1893), 116

Invented traditions, 79, 242

Ireland, David, 306n87

Israel, culture of, 70–72

Israel Museum, 283n2

Jackson, Michael, 215

Jackson, Naomi, 284

Jacobs, Joseph, 85, 89

Jammele, Rahlo, 100, 102

Jazz, 232, 246

Jemez Pueblo Matachines, 10, 207

Jewish Chronicle, The, 119

Jewish Denominational Congress (Chicago, 1893), 104

Jewish Home Beautiful, The, 126–28

Jewish Mothers' Club, 114

Jewish Museum of the Jewish Theological Seminary, 187, 283n2

Jewish Palestine Pavilion, 120, 122–25

Jewish people. *See* Jews

Jewish question, 80

Jewish Settlement House (Cincinnati), 112

Jewish Women's Congress (Chicago, 1893), 52, 104, 126

Jews: Festival of American Folklife and, 70–72; Diaspora and, 79, 80, 81, 85–86, 91, 95, 292n98; display and, 2, 4–7, 104; exhibition of, 70–72, 79–128, 187; image of, 6; Semitic studies and, 5, 89–91, 95; Smithsonian and, 28, 88–96; Zionism and, 6,